2001

2001

ASIAN TRADITIONS ▪ MODERN EXPRESSIONS

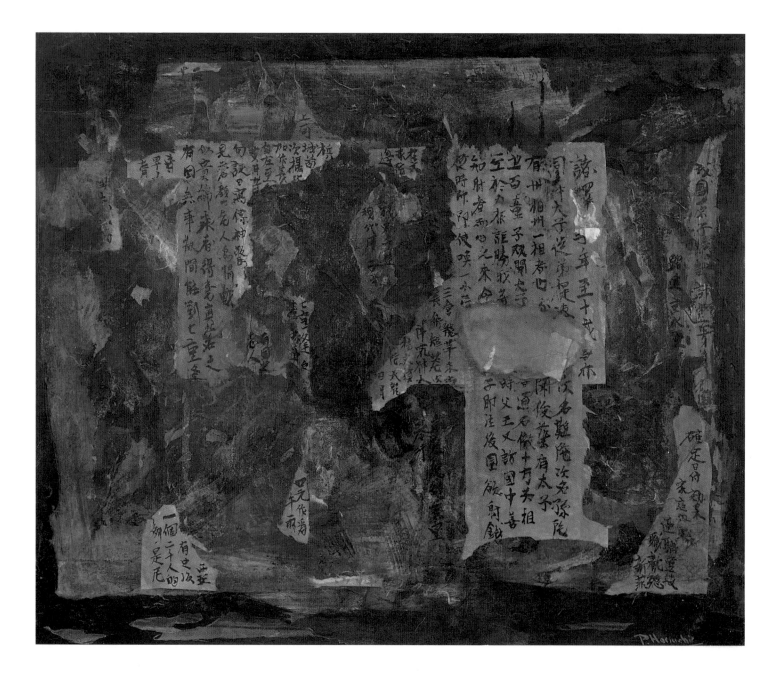

Asian Traditions
Modern Expressions

Asian American Artists and Abstraction, 1945-1970

Edited by Jeffrey Wechsler

Harry N. Abrams, Inc., Publishers, in association with the
Jane Voorhees Zimmerli Art Museum, Rutgers, The State University of New Jersey

EDITOR: Rachel Tsutsumi
DESIGNER: Ellen Nygaard Ford

Library of Congress Cataloging-in-
Publication Data

Asian traditions/modern expressions :
 Asian American artists and abstraction,
 1945–1970 / edited by Jeffrey Wechsler.
 p. cm.
 Includes bibliographical references
 and index.
 ISBN 0–8109–1976–1 (clothbound). —
 ISBN 0–8109–2682–2 (mus. pbk.)
 1. Asian American art. 2. Art, Abstract—
 United States.
 I. Wechsler, Jeffrey.
 N6538.A83A84 1997
 704'.0395' 073—dc20 96–27195

Published in 1997 by Harry N. Abrams,
Incorporated, New York
A Times Mirror Company

Printed and bound in Hong Kong

FRONT COVER: Yutaka Ohashi. *Stone Garden*
(detail), fig. 148
BACK COVER: (top) Wucius Wong. *Home Thoughts,*
fig. 61; (bottom) Don Ahn. *Zen #5,* fig. 51
FRONTISPIECE: Paul Horiuchi. *Weathered.* 1954.
Collage on board, 28 x 34¼". Tacoma Art Museum,
Gift of Mr. and Mrs. Paul Horiuchi, in memory
of Dr. Lester Baskin
PAGES 4–5 : Noriko Yamamoto. *Untitled*
(detail), fig. 187
PAGE 20: Detail of a 17th-century rubbing from
engraved script on stone tablet (c. 11th–12th
century) after original calligraphy in Huai Su's
autobiography dated 777 (detail), fig. 17
PAGES 46–47: Walasse Ting. *Life & Movement*
(detail), fig. 141

EXHIBITION ITINERARY:

Jane Voorhees Zimmerli Art Museum,
Rutgers, The State University of New Jersey,
New Brunswick, New Jersey
March 23–July 31, 1997

Chicago Cultural Center, Chicago, Illinois
September 6–November 2, 1997

Fisher Gallery, University of Southern
California, Los Angeles, and the Japanese
American National Museum, Los Angeles
(two-site presentation)
December 10, 1997–February 14, 1998

An auxiliary exhibition on the theme of
Asian Traditions/Modern Expressions will be
held at the Taipei Gallery, New York
March 28–May 9, 1997

The Taipei Gallery is operated by the Chinese
Information and Culture Center of TECO
in New York

The Zimmerli Art Museum gratefully
acknowledges the generosity of the following
businesses, corporations, and government
agencies that have provided financial support for
the exhibition, catalogue, and related
programs:

Council for Cultural Affairs,
Executive Yuan, Republic of China

AT&T

Sanwa Bank, California

Bridgewater Internal Medicine, PA,
Bridgewater, New Jersey

The National Endowment for the Arts,
Washington, D.C., a federal agency

NEW JERSEY
STATE
COUNCIL
ON THE
ARTS

Funding also has been made possible in part
by The New Jersey State Council on the Arts,
Department of State

CONTENTS

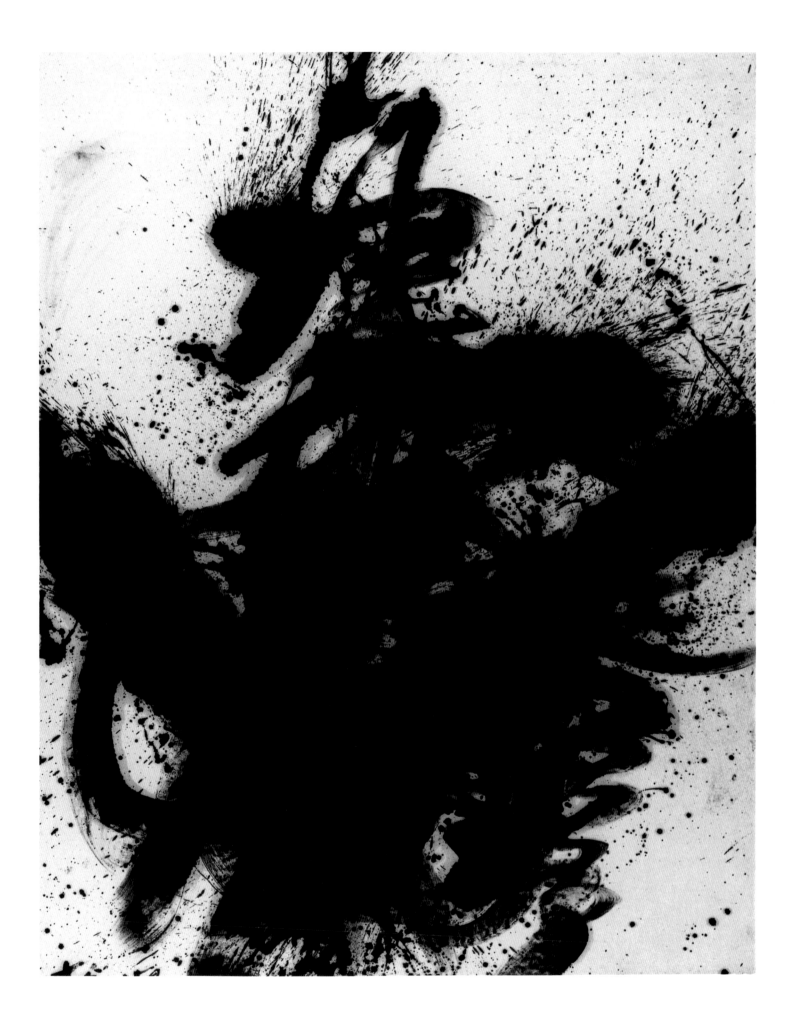

Director's Foreword

Almost from its inception, Abstract Expressionism inspired claims that it represented the first truly indigenous American art movement of consequence and that its sources are purely American, essentially unaffected by other international trends, whether contemporary or historical. These notions not only distort history by denying Abstract Expressionism's European antecedents but also, within the established conservative parameters of the movement, ignore the possibility of effects on the movement by the multiethnic composition of the United States itself. This exhibition explores in particular the contributions to the movement by Asian Americans, presenting the work of over fifty artists of Japanese, Chinese, and Korean descent who lived and worked in the United States simultaneously with the recognized Abstract Expressionists and who participated in the creation of styles that linked Abstract Expressionist aesthetics in the United States to that of traditional East Asia. That most of these Asian American artists have been neglected in studies of twentieth-century American art suggests that race rather than artistic achievement was one criterion for historians, especially when it came to defining an "American" art form. Nevertheless, as this project reveals, many Asian American artists brought to the Abstract Expressionist style a distinctive cultural heritage which has great relevance to the formal and philosophical goals of the recognized Abstract Expressionists.

I am very grateful to Jeffrey Wechsler, the Zimmerli's Senior Curator, for conceiving and organizing this groundbreaking exhibition and publication. For nearly twenty years,

Mr. Wechsler has been in the forefront of reconsidering and broadening the perception of American art history of the early and mid-twentieth century. *Asian Traditions/Modern Expressions* is an important continuation of his previous accomplishments in this vein at the museum, such as: *Surrealism and American Art, 1931–1947; Realism and Realities: The Other Side of American Painting, 1940–1960;* and *Abstract Expressionism: Other Dimensions.*

In 1986 the International Center for Japonisme was established at the Zimmerli with the purpose of presenting historical, cross-cultural influences between Japan and the Western world. *Asian Traditions/Modern Expressions* appropriately expands beyond the art of Japan the Zimmerli's interest in Far Eastern art as it specifically relates to that of the West.

Phillip Dennis Cate
Director, The Jane Voorhees Zimmerli Art Museum, Rutgers, The State University of New Jersey

Walasse Ting. *Hommage à Goya.* 1959. Oil on canvas, 90¾ x 72". Collection Mrs. John Lefebre

Acknowledgments

The organization of *Asian Traditions/Modern Expressions* could not have been possible without the cooperation of many individuals and institutions. Numerous personnel in museums and private galleries have had some hand in this project; the listing of affiliations found in the illustration captions is but the briefest practicable acknowledgment of their help. Some individuals should be noted for special assistance and they are listed below.

For hospitality at their homes, generosity from their collections, or other considerations: Dore Ashton; David Austin; Ollie Blanning; Robert J. and Mary Lou Block; Michael D. Brown; Judy Coffman; Crosby Doe; Dr. Gene and Cecilia Doo; Sookie Huskie; Martha Kingsbury; Mrs. John Lefebre; Thomas M. Messer; Joyce Rezendes; Howard and Susan Silver; Chiling Tong; Nancy Uyemera; Miko Y. Yamamoto. At museums and other institutions: Bruce Altshuler, The Isamu Noguchi Foundation, Inc.; Dolores An, Sigma Gallery, Inc., New York; Kristin Crawford, Lefebre Gallery, New York; Stacy Hoshino, Whitney Museum of American Art, New York; James Jensen, The Contemporary Museum, Honolulu; Barbara Johns, Tacoma Art Museum; Alice King, Alisan Fine Arts Limited, Hong Kong; Tom Klobe, University of Hawaii Art Gallery, Honolulu; Greg Kucera, Greg Kucera Gallery, Seattle; Jennifer Saville, Honolulu Academy of Arts; Patterson Sims, Seattle Art Museum; Carolyn Staley, Carolyn Staley Fine Prints, Seattle; Lisa Yoshihara, State Foundation on Culture and the Arts, Honolulu.

One of the great pleasures in organizing this exhibition and catalogue has been the opportunity to speak with some of the artists (or family members of artists) represented herein. Their kindness in granting interviews and providing documentation (and, of course, loans) is sincerely appreciated. For their assistance, I thank: Satoru Abe; Don Ahn; Julie Amino; Bernice Bing; Dr. Cornelius Chang; Chen Chi; Chinyee; Chuang Che; Sung-Woo Chun; Kiyoko Hasegawa; Ka-Kwong Hui; Dale Joe; Diana Kan; Minoru Kawabata; Byungki Kim; Po Kim; Sueko Kimura; Yien-Koo King; Masatoyo Kishi; Ibuki Lee; Soojai Lee; James Leong; Herman Ng and K. Mimi Ng; Minoru Niizuma; Nong; Toshio Odate; Frank Okada; Mrs. Kenzo Okada; Arthur Okamura; Sumiye Okoshi; John Pai; Tadashi Sato; James Hiroshi Suzuki; Toshiko Takaezu; Tseng Yuho; George Tsutakawa; Ansei and Toshiko Uchima; C. C. Wang; Wang Ming; Wucius Wong; Noriko Yamamoto.

I am pleased that the exhibition will reach a wider audience through the participation of several venues besides Rutgers. To Gregory Knight of the Chicago Cultural Center, to Selma Holo of the Fisher Gallery at the University of Southern California at Los Angeles, and to Karin Higa of the Japanese American National Museum, Los Angeles, I extend my thanks for appreciating the potential of a show based on an unfamiliar theme. Also, a smaller exhibition on the same theme as the Rutgers exhibition will be held at the Taipei Gallery in Manhattan; I thank Yang Shiuan-Chyn and Luchia Lee of the Chinese Information and Culture Center (CICC) for their assistance with this presentation.

The presence of essays, discussions, and reminiscences based on the knowledge and scholarship of many authors has added immeasurably to this publication. I am grate-

ful for the participation of: Don Ahn; Dore Ashton; Frank Fulai Cho; Chuang Che; Lorraine Dong; Wen Fong; Karin Higa; Marlon K. Hom; Alexandra Munroe; Kazuko Nakane; Jae-Ryung Roe; Yoshiaki Shimizu; Tseng Yuho. Two essays are reprintings of, or are based in part on, previously published materials. I thank the publishers for permission to include these writings in this project: for the Cho essay, Dr. S. Yen Lee of the Chinese American Forum; for the Tseng essay, the University of Hawaii Press.

It was rewarding to have Harry N. Abrams, Inc. as the copublisher of this book, and I appreciate the editorial and production input of Abrams staff, especially that of Phyllis Freeman, Margaret Chace, Rachel Tsutsumi, and Ellen Nygaard Ford.

The exhibition project as a whole has received funding from several sources, including: CICC; AT&T Foundation; Sanwa Bank of California; The National Endowment for the Arts, a federal agency.

Members of the staff of the Zimmerli Art Museum, Rutgers University, have been instrumental in the realization of the exhibition and its documentation in this book. I wish to thank Phillip Dennis Cate, Director; Ruth Berson, Associate Director; and Donna DeBlasis, Director of Development, for their work, which allowed the project to go forward. Anne Schneider put in an extraordinary amount of effort in her role as in-house editor under conditions complicated by the considerable complexity and time pressures involved with this project. The museum Registrar, Barbara Trelstad, efficiently managed the task of coordinating transport and insurance for the exhibition. Edd Schwab, John Nasto, and Roberto Delgado were primary among those who completed the installation and preparation of the art for the Rutgers presentation and for travel. Chan E. Pae, a museum docent, offered her time and effort with remarkable generosity, even continuing her work while on a trip to Korea. Yuko Higa, who until 1995 worked with the museum's International Center for Japonisme, helped with researching Japanese American artists. Several art history students at Rutgers assisted with research and other tasks for the exhibition: Sandra D'Amelio, Alexander Haviland, Pam Jost, and Midori Yoshimoto. Special appreciation must be given to Caroline Goeser, a doctoral candidate in art history at Rutgers University, who has been an invaluable curatorial assistant for this project for three years; she has managed to ride out the maelstrom of simultaneous activities necessary to organize the diverse components of this complex project and has done so with an admirable blend of intelligence, wit, tenacity, and grace.

Finally, in a project devoted to Asian Americans, I must record with vast appreciation the role of one particular Asian American —my wife, Violet Wang. She has been a frequent and valued (if unpaid) helper in several aspects of this project, deploying in full measure her knowledge of her Asian culture, her interest in art, her abilities in protocol and social interaction, and her tolerance (for a husband utterly consumed in time and spirit by a complex, long-term exhibition project). Her devotion has been an honor and a wonder. Many thanks, Violet—I'll even attempt using your first language and original name: *fei chang hsieh hsieh*, Wang Li-wen.

Jeffrey Wechsler
Senior Curator,
The Jane Voorhees Zimmerli Art Museum,
Rutgers, The State University of New Jersey

Introduction: Finding the Middle Path

by Jeffrey Wechsler

It is my observation that Western abstractions of the 1950s . . . do not need the influence of Japanese art to explain them. Several factors in their own historical background sufficiently account for the works of Western artists as they have emerged. By the 1940s, the whole idea of using an expressive line that would not describe things in the external world nor be determined by past forms had been a critical issue for more than fifty years.[1]

[T]here are no grounds for the fear, often expressed outside China, that the impact of modern civilization has sounded the death-knell of the Chinese tradition in painting. On the contrary, recent developments in western art— notably abstract expressionism—seem to be exploring for the first time ground which has long been familiar to the Chinese painter and calligrapher. Europe, having been the teacher, now becomes the pupil.[2]

Since the advent of Abstract Expressionism, there has been an ongoing debate, sporadic in its intensity, concerning the relationship of the more "modernistic" aspects of the traditional art of East Asia to the West's freely gestural, painterly abstraction. The tenor of the discussion has been particularly heated in the United States, largely because many American critics realized that Abstract Expressionism was the first art movement of international significance to emerge in this country, thus affording the opportunity to decisively shift the balance of power in the art world toward American shores. The use of nationalistic terms by major critics and writers—Clement Greenberg's "American-type painting," Irving Sandler's "The Triumph of American Paint- ing"—was part of a general atmosphere of

scorn against nonnative forms of abstraction that enveloped some American art writing of the Abstract Expressionist era.

Especially rankling to some American boosters of Abstract Expressionism, who already had their hands full denigrating con- temporaneous European painterly abstraction such as *Art Informel* and *tachisme*,[3] was the European embrace of Eastern art as a source of, or at least a kindred spirit to, calligraphic or gestural abstraction. Michel Tapié, the ener- getic European proselytizer for *tachisme,* was pleased to laud painterly abstractionists from Japan and saw no problem in advertising every rapid splash and *tache* he could find in historical Chinese or Japanese art. After all, here was an art tradition that could document splashed and flung pigment back to at least the eighth century and had a centuries-old, unbroken history of free brush gesture in its calligraphy right up to the Zen masters of the nineteenth and twentieth centuries. But some Americanists were thoroughly and defensive- ly dismissive of any hint of Asian influence, even to the point of downplaying a pioneer American gestural abstractionist, Mark Tobey, who clearly was influenced by Eastern art and whose leap into abstraction predated many other first-generation Abstract Expressionists (see the quotation of Clement Greenberg in the Munroe essay, page 30). Contrary to some of the critics' statements, a few original Abstract Expressionists, in particular Ad Reinhardt and Richard Pousette-Dart, were known to be very knowledgeable and deeply involved with Eastern art, aesthetics, and philosophy.[4]

To a considerable degree, the nationalistic and exclusivist fervor of the most aggressively

promotional of writers on Abstract Expressionism poisoned the atmosphere for reasoned discussion of the very significant subject of East/West interaction in modern American art and in mid-century painterly abstraction in particular. This publication will address the subject in two ways. First, the implications of the concept of abstraction in Eastern art will be presented through studies of traditional and modern Eastern art. These presentations, taking various forms and offering several points of view, lead to the second, but core, section of the project, one that focuses on abstract art by Asian Americans, a body of art that has been oddly neglected over the years.

Within Abstract Expressionism, the works of artists such as Jackson Pollock, Franz Kline, Robert Motherwell, Mark Rothko, and Adolph Gottlieb have been considered both advanced and innovative, even "break-throughs," in technical, compositional, and formal terms. This is an ironic situation for many who are familiar with traditional Asian art and recognize various formal and technical properties of traditional Eastern art that appear to be predecessors, or at least parallels, to visual elements of modern painterly modes of art. Qualities that are appreciated as "advanced" in American Abstract Expressionism have been applied for centuries in Eastern art: gestural methods (for example, the "flung ink" manner of *sumi*); frequent restriction of color range, often to only black and white; calligraphic imagery, free linearism, and aggressive or rapid brushwork; highly asymmetrical compositions, often with large areas of empty space; atmospheric or flat fields of color; a spontaneous approach to art-making that includes the acceptance of accidental effects; and the notion of the act of painting as a self-revelatory event, psychically and somatically charged and implicitly linked to the artist's emotions.

The debate over the relationship of mid-century American art to East Asian art has been skewed by the obsessive scrutiny of a few famous names of Abstract Expressionism. Such research misses a more relevant arena of inquiry that directly addresses the question: what happens when the Eastern and Western traditions truly meet within the context of modern painterly abstraction? During the period of Abstract Expressionism's development and spread, a significant number of Asian American artists comprised a largely unnoticed group of abstractionists, who, quite logically and naturally, brought together in their personal experience and practice concepts of abstraction derived from both the traditional Asian and modern American points of view. Through early education and training or personal interest, they participated in and absorbed the artistic methods and outlooks of the East. By choice, they engaged the developing styles of American painterly abstraction, often with their understanding of the "abstract" aspects of Eastern art predisposing them to Abstract Expressionist or other modern painterly methods. By virtue of their bicultural experiences, they are a bridge generation, representing a true merging of East and West, and their work is a synthesis, on various levels, of Asian and Western aesthetics. In effect, a communal experiment in East/West artistic interaction existed in our midst as we looked elsewhere for traces of Asian influence in abstraction. This current volume seeks to

bring forward for historical reconsideration and reevaluation this neglected generation of Asian American artists.

In this study, the focus of inquiry will be on the art, the vehicle through which the ideas of the Asian Americans were made manifest. Differences between the approaches of Asian American abstractionists and non–Asian American abstractionists will be explored. Through the Asian American artists' personal visual resolutions of the East/West duality, observers may be privileged to appreciate and understand a middle path of cultural interpenetration and harmony and an impressive record of artistic achievement.

Definitions and Boundaries

The topic of East/West interaction in art is a sprawling one, and it has been approached from many directions. With a manageable and circumscribed group of artists, the approach taken here is a purposefully limited one, though it is devised to allow consideration of many facets of the overall East/West theme. Because Abstract Expressionism in the United States is the accepted focus of mid-twentieth-century abstraction, it is reasonable to follow the fortunes of Asian interaction with that style in this country. The internationalism of the East/West interaction within the Abstract Expressionist movement is highly significant but is beyond the scope of this study. The chronological limits of this project, from 1945 to 1970, represent the years of the development, growth, and initial acceptance of Abstract Expressionism in the United States. It is deemed necessary here to demonstrate the relationship of Eastern and Western notions of abstraction within this historical era, only including those examples of abstraction by Asian Americans who engaged the style during its development, thereby emphasizing the implementation in tandem of Asian and American sources of abstraction and maintaining the integrity of the Asian input.

For this study, the Asian art traditions under consideration are those of East Asia—specifically China, Japan, and Korea. These are the national traditions historically recognized as encompassing various formal, technical, and theoretical elements similar to those deployed in modern abstract art, and the artists fea-

tured here trace their heritage to one of these three countries. The numerical proportions of the artists represented reflect general demographic trends of immigration to the United States. Up until 1970, Japanese Americans comprised the largest contingent of abstract artists among the three nationalities. Their dominance in this study, beyond simple statistics, is also cultural. Japan as a nation accepted modern art, or at least permitted it, to a far greater degree than did China, which is generally inclined toward cultural conservatism.[5] Koreans came to the United States in large numbers only by the 1970s and 1980s; consequently, there are relatively few Korean American pioneers of abstraction during the time period under consideration.

The term "Asian American" itself may be problematic if one is particularly precise about the sensitive matter of defining individual heritage. While many Asian-born artists had the advantage of direct, on-site experience and training in the artistic heritage of their native lands, a considerable number of American-born artists of East Asian ancestry had significant contact with their artistic heritage as well. This was accomplished in many ways: by learning painting and calligraphy directly from their parents or other relatives, by deliberate pursuit of Eastern aesthetics through travel and study in Asia, or by acquisition of traditional skills and appreciation of philosophies through personal effort. The bottom line for all artists shown here is a visual and aesthetic one: their artwork, whether by varying degrees or via different routes, is in some manner a product of the interaction of Eastern and Western methodologies of abstraction. The validity of this approach is bolstered in the person of Isamu Noguchi, who was American-born (indeed, of mixed Japanese and American parentage). Noguchi is a crucial figure in any study of the relationship of East to West in modern art in particular and is a major figure in twentieth-century sculpture in general.

Noguchi's medium, sculpture, may at first seem to stand apart from the basic principles of Asian art that relate to the modernism of the Abstract Expressionist era, which emphasized painterly, two-dimensional art. Even within the writings on advanced American sculpture from the 1940s to the 1960s, one perceives an uneasiness with calling a sculp-

ture "Abstract Expressionist" in style. But Noguchi's art, and that of other Asian American sculptors, can reveal ideas about form, process, and the linkage of art to nature that separate them from most contemporary Western abstract sculptural experiments. Indeed, the latitude of three-dimensional expression has been broadened here to include ceramic art objects. Always vital to East Asian aesthetic production, the ceramic object has only recently been seriously (though in some quarters still quite grudgingly) considered within the realm of fine art. By contrast, vessels and ceramic sculptures hold an honored place in traditional Asian art and have inspired contemporary Asian American sculptors and painters—often for their freedom of form and contour and the abstract qualities of their strikingly multicolored "action painting"-like gestural glazings and decoration.

For visual and theoretical coherence, this study excludes two styles that, though of considerable artistic significance and practiced by many Asian American artists, would distract from the carefully chosen device of using the acclaimed style of Abstract Expressionism as a focus for East/West comparison: these styles are geometric abstraction and conceptual art. Each style has important relationships, respectively, to East Asian visual and philosophical traditions—especially those of Japan. Without doubt, these are fields for fruitful inquiry and would sustain fascinating exhibitions and catalogues. In the present study, a few works created primarily from quasi-geometric shapes or repeated line, dot, or patch motifs—such as paintings by Whanki Kim (fig. 1) and Genichiro Inokuma (see fig. 146)—are represented, primarily to exemplify the suggestion of nature in abstraction or the creation of a field with repeated strokes.

Perhaps the most unfortunate limitation on the project is that every Asian American artist whose work is relevant to the main theme cannot be represented.[6] At times artists were chosen because a specific work exemplified a concept particularly well. Other artists were selected both for their recognized importance and for their regional or national influence. A broad geographic range of artists was desired, especially in light of the important Asian American population centers on the West Coast, and it is gratifying that

1. Whanki Kim. *27-II-70.* 1970. Oil on canvas, 84 x 58". The Phillips Collection, Washington, D.C., Gift of Mrs. Whanki Kim, 1979

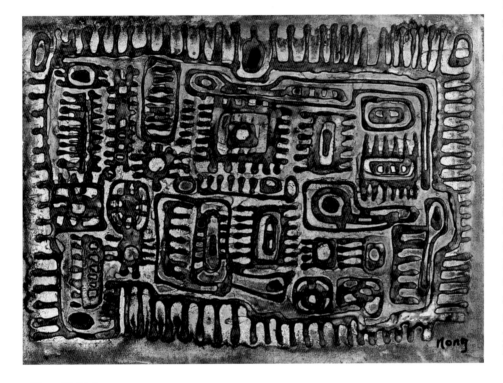

2. Nong. *Untitled.* 1960.
Acrylic, oil, gesso, and
glue on canvas, 16 x 22".
Collection the artist

artists from all over the United States are
shown—including a good number from
Hawaii, a state rarely considered in general
studies of American art. In the end, well
over fifty Asian American abstractionists
working between 1945 and 1970 are featured.
Most individuals, including historians of
modern American art, when asked to name
Asian American artists of the Abstract
Expressionist era, seem hard-pressed to get
beyond three or four, usually including
Noguchi and Kenzo Okada. In that context,
the present group is satisfyingly large.

A final characteristic of this study is less a
restriction than an appreciation of its theme's
vitality and viability. This art was gathered
together because it existed a priori as a
neglected undercurrent or subset of American
abstract art. It was less a shock than a plea-
sure to discover during the organization of
this project that an East/West synthesis had
been noticed earlier, and a small exhibition
had been organized to present it. Although it
included only seven artists from one Asian
nation, *Contemporary Painters of Japanese
Origin in America,* curated in 1958 by Thomas
M. Messer and Anne L. Jenks for the Institute
of Contemporary Art, Boston, mined the
same rich visual vein that inspired this cura-
tor to embark on a similar task over thirty
years later.[7] The opening essay of the cata-
logue, titled "A Visual Phenomenon," begins:

*The idea for this exhibition came to us about
two years ago when we realized that the work of
Japanese painters in this country is not only often
characterized by exceptional beauty but that it
also has distinguishing features enabling one
to single it out from the rest of abstract art. If
this is so, we reasoned, if the eye is able to detect a
Japanese mode, such surely must be subject to
isolation and rationalization.*

*. . . During this period of selection, the stylistic
marks became ever clearer and more convincing.
Again and again, we detected certain form con-
stellations in these abstract works which were too
insistently present in Japanese derived painting
and too thinly represented in the Western mod-
ern movement to be dismissed as accidents.*

Exactly so. *Asian Traditions/Modern Expres-
sions* updates and enlarges the earlier Boston
project by considering artists of Chinese,
Korean, and Japanese heritage and by adding

3. Dale Joe. *Writing Sentences*. 1952. Ink and gesso on Masonite, 12 x 64". Collection the artist

material on historical and contemporary East Asia. With the advantage of historical hindsight, it presents the topic to the current generation. It is hoped that the achievements of these artists, and the wider implications of a developing international synthesis of Eastern and Western traditions, will be appreciated and kept in mind more persistently this time around.

A Surveyor's Method

The approach taken in this project is purposefully broad to draw attention to a fascinating field ripe for additional investigations, a point of departure that may inspire related exhibitions, monographs, and other spin-offs that will offer more detailed studies of currently lesser known but worthy artists. Each Asian American artist will not be discussed in depth nor will the treatment of each be of equal length. However, by succinctly touching upon various aspects of individual artists' work, there should occur a cumulative effect of explaining in general terms the cultural backgrounds, intentions, methods, and products of a loosely associated group of individuals representing a complex and historically significant artistic interpenetration of East and West. Indeed, attempting to explain the linkages of Eastern and Western concepts of abstraction only through the experiences of Asian Americans seems limiting in the context of such a universalist subject. To best demonstrate the theme, it was decided to give considerable space to the illustration and explication of aspects of traditional and modern art from East Asia that relate to abstraction.

A further reason for employing a survey technique is the fact that despite the visual coherence of the art under consideration, there exists a bewildering diversity of individual histories, attitudes, and intentions at work beneath the aegis of "East/West synthesis." Let me briefly remark upon two groups of works that are symbolic of major aesthetic themes to be pursued in this study and that exemplify the varying approaches taken by each artist. First are four works related to the theme of writing and calligraphy (figs. 2–5). In the paintings by Nong (fig. 2) and Dale Joe (fig. 3), writing symbols are major parts of the composition; in the other two, writing is subsidiary, appearing on thin, irregular bands in the Tetsuo Ochikubo painting (fig. 4) and placed upon large areas of color in Chuang Che's work (fig. 5). However, it is only in the latter two works that the characters are actual words. Ochikubo's piece refers to the philosophical conception of *Infinity Manifested*, and Chuang's work portrays his reaction to a distressing political event in Taiwan. In contrast, although based on the simple line-and-dot ideograms of the *I Ching*, the Chinese "Book of Changes" that is a central theme in East Asian philosophy, the meaning in Nong's painting is indirect and the shapes are distorted and fused to become an abstract pattern. Joe's *Writing Sentences* illustrates its title only symbolically; the calligraphic forms are invented suggestions of spidery writing, rapidly set down. Unlike Joe, who is American-born and did not have early training in writing Chinese characters, Chuang Che and Nong both write as native-born Chinese and Korean, respectively. Thus, a very wide range of backgrounds and intentions has informed the usage of writing in these works.

Another group of four paintings (figs. 6–9) may initially seem to have nothing in common. Whanki Kim's work (fig. 6) appears to be an abstract scattering of colorful dots and

4. Tetsuo Ochikubo. *Infinity Manifested*. 1964. Acrylic on canvas, 40 x 29". Hawaii State Foundation on Culture and the Arts, Honolulu

semiabstract landscape in oil with impressionistic paint handling and subtly gradated tones of green and blue (fig. 9). However, Doi's landscape is the key to this group. All four works are very specifically nature-inspired images—landscapes abstracted to varying degrees. The pivotal importance of nature to East Asian art has been maintained by many Asian American abstractionists, and, as in traditional Asian landscape painting, their work often strives toward suggestion of the visual essences and emotional resonances of nature rather than its literal depiction. The presumed conservative here, Doi, was not so; he moved easily into completely abstract painting and was a major force in the initiation of many Hawaiian artists into abstract art. Interestingly, it is C. C. Wang, born in China, whose work is usually the most traditional among the four. *Abstract Landscape* is quite a radical statement within his output (see a more typical work in fig. 98), although the concept of abstraction in Chinese art has been a preoccupation for him since the 1940s. Bing's work depicts a natural scene as well— a specific one in fact, Burney Falls, in northern California, where the artist lives. Though her work appears quite close to the transparent, uncorrectable one-stroke approach of traditional Chinese ink landscape painting, American-born Bing was originally much more influenced by Californian versions of Abstract Expressionism during her years of studying art in the 1950s. And the abstraction by Whanki Kim? It is made by a Korean-born artist who has stated that nature is the sole subject of his work. This painting, *Sunny Day*, was made in New York City—the urban environment heightened his longing for the Korean landscape. As to his imagery, he has stated that "Art is mere dots like nature itself."[8]

With these examples, it should be obvious that the study of Asian American artists' interaction with the realms of Eastern tradition and Western abstract art is a complex matter. There is no absolute homogeneity of philosophy, format, technique, symbolism, or imagery. Nevertheless, by using overarching themes as guides, and with great emphasis on the visual qualities of the artworks, a reasonable introduction to the multifaceted workings and intriguing pleasures of *Asian Traditions/Modern Expressions* can be offered.

bars on a light background, painted in oil on canvas. Bernice Bing's work is in transparent watercolor on paper, with brisk strokes barely covering half the surface that serve to emphasize the blank areas of paper (fig. 7). A brusquely composed conglomeration of black bars and gestures confronts the viewer in C. C. Wang's watercolor (fig. 8). Resembling one of Franz Kline's sketches for paintings in its asymmetrical balancing act of active strokes against open areas, it is the most aggressively angular and linear of this group. Apparently the odd man out here is Isami Doi; his *Sky Mountain* is a gently atmospheric

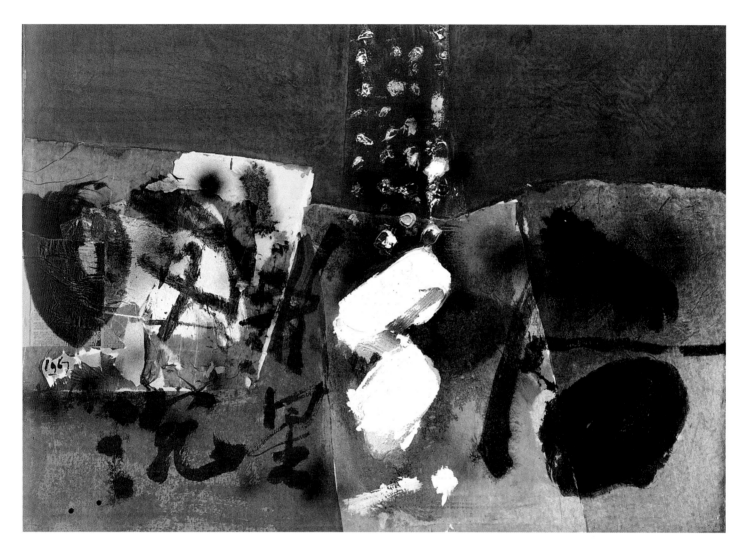

5. Chuang Che. *Sinking Star*. 1967. Oil and rice paper collage on canvas, 35¾ x 49¾". Collection the artist

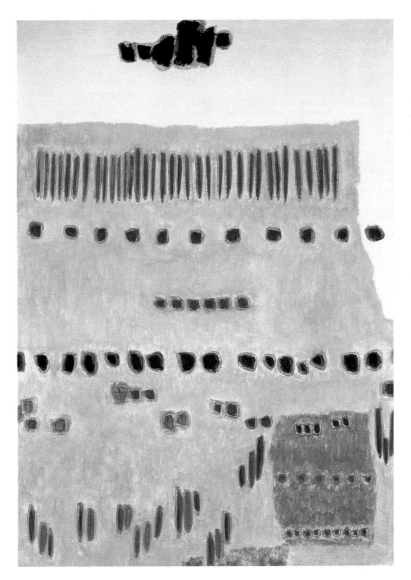

6. Whanki Kim. *Sunny Day*. 1966. Oil on canvas, 50 x 70". Private collection

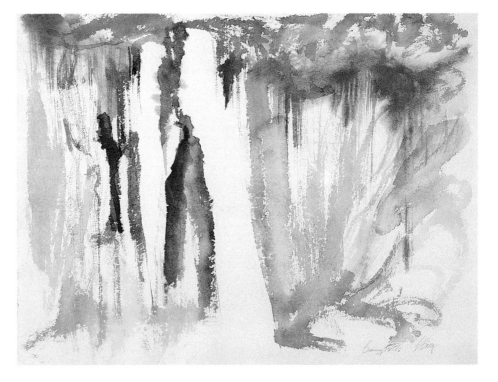

7. Bernice Bing. *Burney Falls*. 1965. Watercolor on paper, 24 x 32". Collection the artist

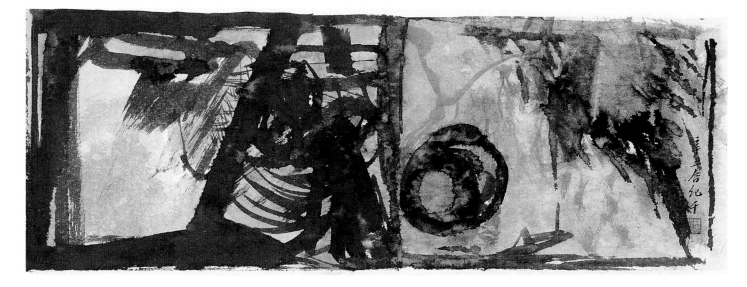

8. C. C. Wang. *Abstract Landscape*. 1969. Ink and color on paper, 8¼ x 23½". Collection the artist

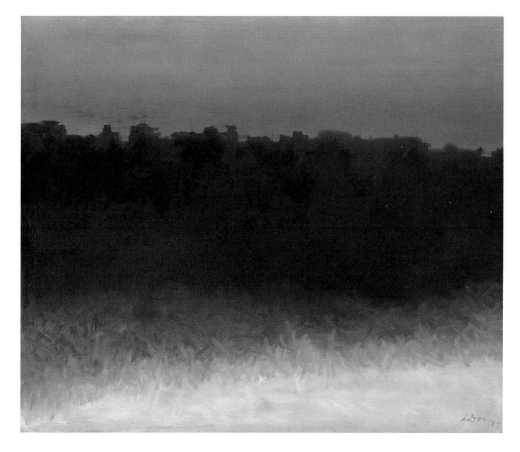

9. Isami Doi. *Sky Mountain*. 1957. Oil on canvas, 43½ x 51½". Hawaii State Foundation on Culture and the Arts, Honolulu

Abstraction
in Traditional
and Modern
East Asian Art

"Abstraction" in the Traditional Art of East Asia

by Tseng Yuho

This essay is based partially on the concept and format of the author's book Some Contemporary Elements in Classical Chinese Art *(Honolulu: University of Hawaii Press, 1963). Some commentaries on illustrations from that book have been edited and adapted for the present volume with the permission of the author and the publisher.*

In 1908 Wilhelm Worringer wrote in *Abstraction and Empathy* that the "aesthetic experience finds its gratification in the organic [as opposed] to the life-denying inorganic, in the crystalline or in general terms, of all abstract law and necessity." From humankind's fundamental linkage to nature comes "[the] urge to empathy, the urge to abstraction." This urge to abstraction was common at the beginning of all ancient civilizations, especially in East Asia where the appearance and essence of nature were at the core of art. Thirteenth-century Chinese painter Sung Ti was fascinated by the patterns that appeared on a moist, moldy wall. He hung a piece of unpainted silk against the wall and after several days found that the design of concave and convex surfaces created a kind of landscape composition. Mi Fu, of the Song period, playfully painted a picture using the spongy part of a lotus fruit in place of a brush. And Wang Yang-ming walked on his silk wearing a pair of new grass sandals; from this, with some added touches of brushwork, he produced a flower painting.

Traditional Asian art is filled with numerous examples of venturesome experiments in abstraction. Centuries of deep-seated philosophical justification and social tradition made it acceptable for Asian artists to represent the natural world through abbreviated stylization. For example, at the dawn of Chinese civilization, sacred representations of the world expressed in geometric forms—the circular *bi* symbol of heaven, the square *cong* symbol of earth—were carved in jade. Pure concept abstractions, these principles and their visual ordering as basic forms were elaborated upon extensively and enveloped the whole cosmology of Chinese thought and visual expression. In the eleventh century, the deeply introspective philosophies of Confucianism, Taoism, and Zen Buddhism intermingled in China. The followers and intellectuals of these disciplines actively engaged in art and aesthetics, in science and sorcery, and they employed cosmic charts with plans, diagrams, and designs based on circles and squares. These may not be art creations, but they were sources of creative art. Artistic expression developed with two fundamental concepts: that simple forms can hold profound meanings and, as vessels and conveyors of such meaning, the resultant simplified forms are sufficient in and of themselves as visual motifs.

The traditional East Asian artist's tendency to abstract nature was not derived from his desire for self-expression but instead from the overarching philosophies of Buddhism, Taoism, and Confucianism that call upon the self to be de-emphasized, removed from center stage, held at a distance. While eruption of raw emotion, expression of psychological angst, and personal reaction to social situations have often motivated abstract works in modern Western art, classical Asian art, at its most refined, offers a kind of religious sublimity; the artist is attuned to the continuity of past and present artistic production.

To fully explore the concept of abstraction in Asian art, one must consider numerous techniques and approaches, both bold and subtle, that manifest themselves in myriad ways: spatial and linear design, tonality of ink, textural effects, etc. Even the process of dripping colors and glazes on ceramics—revealing a conscious exploration of controlled accident and spontaneity—is a part of this abstract tradition. The following works illustrate many of these techniques and generally fall into two genres: art of the literati and the broad range of visual art encompassed by the term "folk art." The art of the literati is identified with individuals whose personalities are compassionately or rationalistically expressed through their art. Aware of his own emotion, his technique, and his aesthetic transfiguration, each of the literati is a fully self-conscious artist. On the other hand, the greatest folk art creations are generally anonymous. These unknown folk artists are not singularly "naive" artists. While their sensitivity and skill are extremely able, these artists do not analyze themselves in the same manner as the literati. They create instinctively, often representing a collective concept totally devoid of egotism. These two traditions developed side by side, sometimes even inseparably, and while each has its own respective achievements, a great many abstract tendencies can be found in both categories.

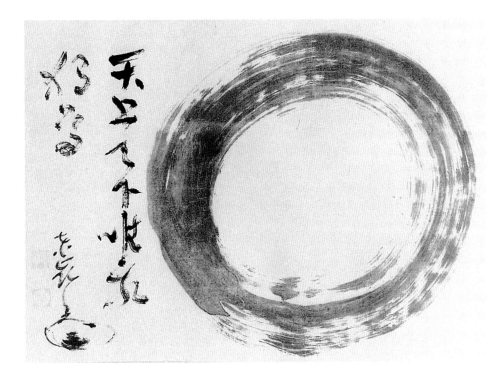

10. Torei Enji (1721–1792). *Enso*. Ink on paper, 13 x 17¾". Private collection

As a visual and philosophical symbol, the full circle is all mighty and encompassing. It represents the origin and the source of the human mind and of *taiji,* the "ultimate." In the Taoist canon breaking the full circle—the ultimate— by even the slightest crack, turns the image into a visual unit of talismanic practice. The illustrated work by Torei is an example of the *enso* (circle), an important motif within the artistic practices of Zen. Zen concepts incorporate metaphysical Taoism and Neo-Confucianism in that they deal with a form-less reality, and, most importantly, with the concept of "oneness" and the beginning of creation. Beyond the original ultimate is the great void, a state of nothingness: the original state of nonbeing (*wu*).

In the twentieth century, interest in the Zen concept of art was led by writer Daisetz T. Suzuki, who stressed sudden enlighten-ment. As a result, Zen art is identified with fast execution and limited brushwork that shows little but suggests much. By abbrevia-tion of form, by splashing ink, a work is dashed out like lightning. Admiration of this technique had been seen earlier, but it was most fervently embraced and practiced by Zen priests, especially in Japan.

11. Neolithic fish motifs. Ink drawing after painted pottery. c. 4th–3rd millennium B.C. Banpo Museum, Xian, China. Diagram from *Banpo (The Neolithic Village at Banpo, Xian)* (Beijing: Wen Wu Press, 1963), 183–84

A large quantity of funeral art of the Neolithic period, made before the development of written language, has been unearthed in Asia. Created by a culture with faith in the "Other World," in life after death, and in the ability to communicate with divinities, the funerary objects meant to accompany the deceased in their spiritual journeys included painted pottery, engraved jades, and cast bronzes. The "abstraction" of the designs on these objects held a decidedly symbolic purpose: to afford protection or supernatural strength. Although likely worked with simple tools, these prehistoric objects reveal such artistic cognition and ingenious craftsmanship that they can hardly be called "primitive art."

Metaphoric representation and suggestive symbolism have been the driving forces behind the process of abstraction in East Asia. Whether dealing with mythological or theological content, collective heritage or personal conviction, group intuition or individual expression, it is possible to follow the evolution of designs back to their sources. Scholars of Chinese Neolithic art have traced several such motifs. For example, painted and carved objects from an early Neolithic (c. 4th to 3rd millennium B.C.) village near Xian, China (now at the Banpo Museum), were used to study drawings of fish motifs. In that village, fish were a major component of the diet and their images stood as a wishful symbol of the concept "plentiful." The visual reduction of the fish motif seen here may have taken several hundred years, and it is interesting to see how the prehistoric artists abstracted and reduced figurative images to nonfigurative ones. Images of fish and their abstracted patterns are still popular in all of East Asia, and in folk art they are still used to attract blessings of the gods. A similar process of abstraction of natural images into patterns was traced by Swedish archaeologist Nils Palmgren in 1934 through the study of 3rd millennium B.C. urns unearthed in Gansu, China. He found that over time the geometrically constructed figures, described as "frog-like men," were progressively simplified, eventually losing even their heads, and ultimately appearing merely as zigzag patterns.

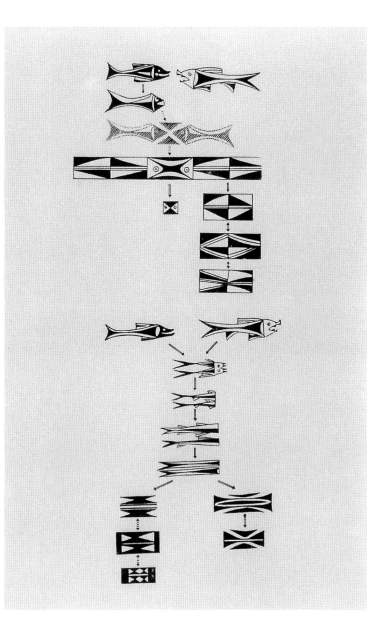

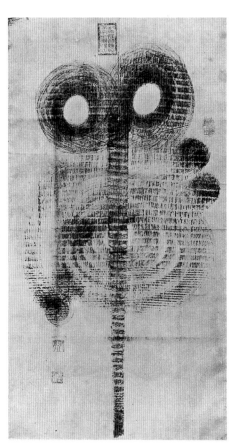

13. Liu Yungfu (1837?–1917). Chinese character for "tiger." Ink on paper. Collection unknown. From *Hepei Provincial Museum Bulletin* (August 25, 1935)

This striking image based on the Chinese character for "tiger" demonstrates how many levels of meaning can culminate in an abstracted form. Bulging, staring eyes are a traditional symbol in Chinese art, somewhat similar to the "evil eye" venerated in Islamic countries. In the Shang and Zhou periods, large, staring eyes adorned *taotien* (animal masks) and depictions of other creatures; these menacing stares were meant to ward off evil. In the Medieval period, these eyes were adapted for use on representations of Buddhist *Tenons* (heavenly kings) or *Lishi* (guardians of temple gates and the Buddha). For *Damo* or *Damura*, the monks from central Asia, exaggerated staring eyes implied that the monk was endowed with piercing insight.

Fierce bulging eyes, however, were most commonly associated with tigers, for in Asia the tiger is not only a man-eater but is also a ghost-eater. Large and dynamic characters of "tiger" are frequently hung in the front halls of East Asian houses to protect against evil spirits. The tiger character shown here was created by Liu Yungfu. Capped by great round eyes, it is mysterious, ghostly, and a boldly rendered abstraction. This image not only represents the word "tiger" but through its abstracted form conveys the symbolic meaning of a tiger that is able to scare away evil. Here word and image carry equal power.

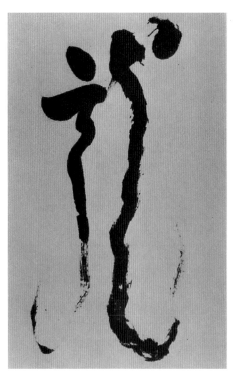

12. Evolution of Chinese characters for "sheep" or "goat" and "vehicle" (11th century B.C. to present). Drawing by author

Progressive abstraction from imagery is in fact the basis for the invention of the Chinese written language. The ancient word "ram" was represented by a frontal ram head with two horns and has been reduced to the present abstract character for "sheep" and "goat." Similarly, the ancient word for "chariot" was simplified to the present character for "vehicle." Thus, from the very beginning, the Chinese developed an ability to condense images, to think and see in terms of abstraction.

14. Teng Shih-ju (1739–1805). Chinese character for "dragon." Ink on paper. Collection unknown. From *Jin shi su hua (Painting, Calligraphy and Engravings on Metal and Stone),* second series, vol. 3/23 (Hangzhou: The Seal Art Society of Xiling, 1934)

Here one arrives at the direct relationship between calligraphy and painting. The character for "dragon" is almost a dragon itself, swiftly executed with the impact of lightning.

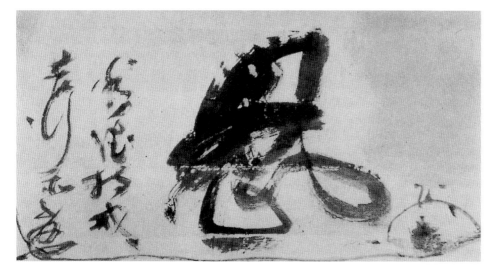

15. Torei Enji (1721–1792). Japanese character for "endurance." Ink on paper, 12 x 22¾". Collection Fukazawa Hiroshi, Mishima, Japan.

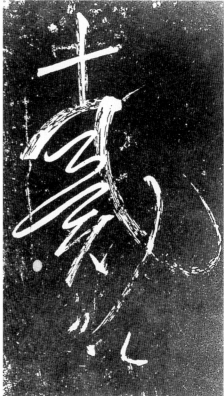

16. Korean folk art calligraphy. The character for "justice." 19th century. Ink on paper. Collection unknown. From Jean-Pierre Dubosc, *Ink Play* (Paris: C. T. Loo Antique Company, 1974)

Calligraphy from China, Japan, and Korea is well known for its wonderful use of line, which has often been compared to aspects of twentieth-century abstract art. For traditional Asian artists, calligraphy and brush painting were technically parallel, although the art of calligraphy has a longer tradition than brush painting. Long before pen and pencil were introduced to Asia, every educated person practiced calligraphy. Because of daily training from childhood, anyone could gain some proficiency in calligraphy. True calligraphy artists, however, must know the structures of thousands of characters and must develop a keen sense for space and design. Strokes and lines must flow directly from the subconscious, as if there is no distinction between hand and brush.

While the lines used in painting may be freer than those of calligraphy, the need for calligraphic forms to be readable creates an added challenge for artists to embody emotion and movement within certain practical, though flexible, boundaries. Since calligraphy itself is an accomplished form of abstraction, traditional Asian artists were able to reduce the marks and imagery of painting to relatively abbreviated, even minimalistic, forms without feeling the need to step into fully nonobjective painting.

17. Detail of a 17th-century rubbing from engraved script on stone tablet (c. 11th–12th century) after original calligraphy in Huai Su's autobiography dated 777. Ink on paper. Collection unknown. From Tseng Yuho, *Some Contemporary Elements in Classical Chinese Art* (Honolulu: University of Hawaii Press, 1963). Original Huai Su calligraphy is in the collection of the National Palace Museum, Taipei, Taiwan. The engraved stone tablets are located at Beilin, Xian, China

A rubbing technique was used to obtain this so-called "white writing." Huai Su, a Buddhist priest, was called the "saint" of this "wildly cursive script," which represents the climax of the style. Here we find something in common with modern "action painting."

19. A 20th-century impression from Han dynasty seal. End of 1st century. Red-pigment impression on paper, 1 x 1". From Tseng Yuho, *Some Contemporary Elements in Classical Chinese Art* (Honolulu: University of Hawaii Press, 1963)

18. Example of talismanic script from a 19th-century Taoist weather manual. China. Ink on paper, 8¾ x 7". Durham University Library, Durham, England

Magic talisman scripts, highly abstract in outward appearance, were a popular way to represent cosmic forces in Taoism. By the fourth century, the scripts were being produced by many priests who were outstanding calligraphers and who believed in the efficacy of such mystic writings. Invested with magical strength, these scripts could be carried on one's person, burnt and swallowed, or used as objects of prayer. They were circulated through popular cults and have survived to the present day. Examples of talismanic scripts and symbols—meant to embody mythologies related to the sun, moon, and constellations or other cosmic phenomena—literally number in the thousands.

Seal making in China began during the early part of the Eastern Han dynasty (1st century–220) and developed into an art in its own right. This development was similar to that of the ancient Greek cameo seals or that of the seals of the Indus civilization, in which complex linear designs were arranged to fit into a small, two-dimensional area. In China, Japan, and Korea, no signature was complete without a seal impression. It was used on every official document, business agreement, and letter. Most importantly, seals accompanied an artist's signature on calligraphy and paintings; as such, seal engraving as an independent art medium branched out of calligraphic art.

In the fourteenth century scholar-artists took an interest in design and began to engrave seals themselves. After the fifteenth century many scholar-artists became professional seal makers and were highly respected for this miniature art. Within a square inch of space, from one to twenty words may be composed, causing the visual contrast of lines and voids to be extremely intense. Yet a gifted seal artist creates dynamic spatial relationships with resilient engraved lines; each word becomes a living being. By the eighteenth and nineteenth centuries, almost all the best calligraphers and painters also engaged in the art of seal engraving.

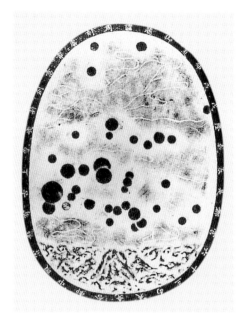

20. *Landscape*. Rubbing from a 10th-century engraving on a sculpted stela. Ink on paper. Collection unknown. From *Yiyuan Xunkan Bulletin* (October 21, 1930)

Found in Guangzhou (Canton), the engraving titled *Landscape* shows peach trees in blossom over a river. One can follow the accidental pattern out of which the composition grows. Such suggested designs were understood superbly by Chinese craftsmen, as may be seen in the jade objects of the Neolithic age and, equally, in more recent ornamental jade hangings or snuff bottles.

21. *Representation of Stars*. 17th century. Rubbing from an engraving on the reverse side of an inkstone belonging to the poet Su Shi (1036–1101). Collection unknown. From Tseng Yuho, *Some Contemporary Elements in Classical Chinese Art* (Honolulu: University of Hawaii Press, 1963)

In *Representation of Stars* the natural dots on the stone became giant stars. A tiny island represents the earth. In the border, surrounding the design, Qing dynasty emperor Ch'ien Lung wrote: "The astronomy of the Yu engraved by the Chou—how original the idea! Could this be from the dragon dignitary of yore? The image from his eyes accords with the words of the ancient sage and so filled the Spring to the whole Palace of Thirty-six Courts."

22. Ma Yuan (act. c. 1190–c. 1225). *Waves under the Moon* (detail). From the series *Views of Water*. Ink on silk. National Palace Museum, Taipei, Taiwan

Here a court painter of the twelfth century has created a texture of vibrating lines almost in the mood of Max Ernst.

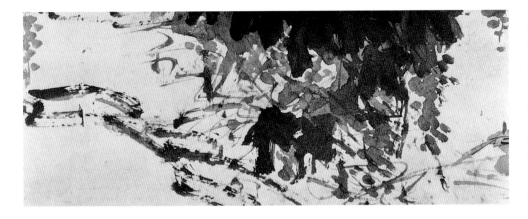

23. Hsu Wei (1521–1593). *Grapes.* Portion of a hand-scroll. Ink on paper, 11¾" x 34'6". Nanjing Museum, Nanjing, China

The artist here shows a dashing spirit close to the modern *tachistes.* An eighteenth-century art critic commenting on a similar painting by Hsu Wei said, "He achieved such a degree of freedom that he could afford to obey his impulse." Chinese writer and artist Huang Yueh (1750–1841) called this quality "splashing-dripping."

24. *Old Man Rock.* Ming Dynasty. Ying stone, h. 59". Courtesy of the Richard Roseblum Collection

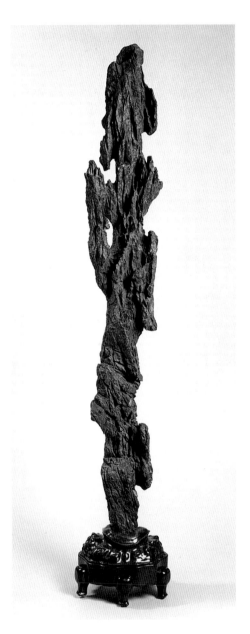

Decorative rocks were an essential component of traditional Chinese and Japanese gardens, and many gardens feature massive constructions or conglomerations of rocks. These rocks were admired solely on the basis of their sculptural abstract forms. Small aesthetically pleasing rocks were often placed on a table or desk alongside plants or fruits, and in that context the stone was called *qing gong* (invigorating ornament). Larger rocks were mounted on stands or placed in rooms or around courtyards and were honored as sculptures. These were especially relished by scholar-artists. Each sculptural rock was enjoyed for its own fantastic formation, produced entirely by nature (although at times some pieces were modified, but never enough to overwhelm their original form). Alert rock collectors with sharp eyes would hunt for unusual pieces in mountains and riverbeds. By the eleventh and twelfth centuries, several catalogues of private collections of rocks had been published, with each rock given a poetic name. The largest rock reached a height of more than forty feet; mounted on a pedestal, it reigned over a rock courtyard in the Song dynasty palace of Chinese emperor Hui Zong. While some pieces were given names of animals or birds, these titles only indicated chance resemblances sparked by imagination; in truth, the owners cherished each rock for its abstract form.

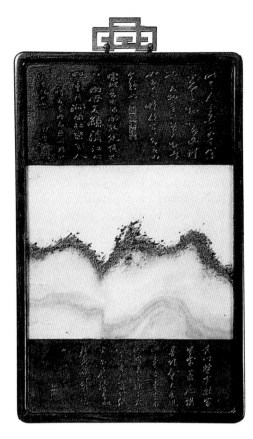

25. *Landscape*. 18th century. China. Natural marble slab mounted in wooden frame. Collection unknown. From Gerard T. T. Tsang and Hugh Moss, *Arts From the Scholar's Studio* (Hong Kong: Oriental Ceramic Society of Hong Kong in association with Fung Ping Shan Museum, University of Hong Kong, 1986), p. 147, pl. 120

The practice of finding aesthetically pleasing patterns in slabs of cut marble was another indication of an early appreciation of highly abstract imagery from the natural world. The swirling internal layerings of colored stone and geologic inclusions within rocks once exposed could be seen as wispy suggestions of hills, trees, and atmospheric conditions. These pieces of stone fascinated many collectors, who presented them in various ways: as inlaid panels on furniture, mounted in frames, or as natural "paintings" hung on walls.

26. *Roosting Bird*. Early 19th century. China. Redwood root, 9⅝ x 12". Water Pine and Stone Retreat Collection

The roots of bamboo and hardwood trees, like cut marble, were collected for their unusual natural forms. The gnarled and knotty bodies of these roots, twisted into intriguing volumes and contours, enchanted East Asian scholars and artists. Some roots were integrated into the construction of furniture; some were turned into brush holders and other desk supplies. Others, such as the root imaginatively perceived as a bird shown here, were simply polished and mounted as decorative, quite abstract sculptures.

With the Suddenness of Creation: Trends of Abstract Painting in Japan and China, 1945–1970

by Alexandra Munroe

Whenever he [Wang Xia] wanted to paint a picture, he would first drink wine, and when he was sufficiently drunk, he spattered the ink onto the painting surface. Then, laughing and singing all the while, he would stamp on it with his feet and smear it with his hands, besides swashing and sweeping it with the brush. . . . Responding to the movements of his hand and following his whims, he would bring forth clouds and mists, wash in wind and rain—all with the suddenness of creation.[1]

—Tang dynasty scholar Zhu Jingxuan on the paintings of Wang Xia (active eighth century)

In 1947 art critic Clement Greenberg heralded America's artistic "coming of age" when he identified Jackson Pollock as the "most powerful painter" in the United States.[2] By rating the work of a contemporary American artist above modern European masters—many of whom had fled persecution and immigrated to the United States—his sentiments reflected America's will to assert cultural leadership of the "free world" in the postwar era. As champion of Pollock and the burgeoning New York School, Greenberg further argued that "American-type painting" was superior to the more common terms, "abstract expressionism," which alluded to its modern European roots, or "action painting," which conjured its sources in the gestural abstraction of East Asian calligraphy and ink painting. His refutation of the latter was absolute:

[Franz] Kline's apparent allusions to Chinese or Japanese calligraphy encouraged the cant, already started by [Mark] Tobey's case, about a general Oriental influence on "abstract expres- *sionism.". . . Actually, not one of the original "abstract expressionists"—least of all Kline—has felt more than a cursory interest in Oriental art. The sources of their art lie entirely in the West.*[3]

Contrary to Greenberg's view, Asian culture was not only a conscious artistic source for several Abstract Expressionist painters in America but it also provided the philosophical alternative they sought to Western modernism—whose fundamental rationalism and imperialism they felt had resulted in the unspeakable horrors of World War II. In the wake of unprecedented mass devastation, these Americans—though not physical victims of the Pacific or European theaters—were grossly disillusioned with the modern age. They sought to escape Surrealist illusionism, the deadening machined rhythms of Neoplastic abstraction, and the misguided utopianism of Social Realism that were the legacy of the prewar modernists. The Abstract Expressionists, Robert Motherwell wrote, "value personal liberty because they do not find positive liberties in the concrete character of the modern state."[4] By choosing Eastern icons among other primitive or archaic sources, they sought to find "universal" symbols for their own alienation and liberating means to reveal their own emotional experience.

Despite Greenberg's disclaimer, Mark Tobey (1890–1976, fig. 27) offered remarkable precedent and legacy for American Abstract Expressionists in their investigations of premodern, non-European art. The New York School's focus on "expressive brushwork" evolved with some knowledge through Tobey's pursuit of Eastern methods of abstraction,

reduction, and improvisation, and his works were seen in regular exhibitions at the Willard Gallery.[5] While Greenberg saw Asian influence as superfluous to the mid-century project of establishing an independent "American-style painting," Tobey believed America's proximity to Pacific Asia bestowed upon her a special destiny and that Eastern art and thought were both natural and essential in the development of a new American art.

Introduced to Chinese brushwork as early as 1923 by a young Chinese artist in Seattle, Tobey culminated his devotion to the East in 1934 with an extended trip to China and Japan accompanied by the British ceramicist and painter Bernard Leach.[6] From Shanghai to Kyoto, Tobey studied and practiced calligraphy, ink painting, and Zen meditation, which, together with the mystical teachings of the Baha'i World Faith to which he had converted in 1918, became the foundation of his art and belief. Informed by such authors as Carl Jung, Eugene Herigel, Daisetz Suzuki, and Alan Watts whose writings shaped the American "Oriental Thought" tradition,[7] Tobey's aspiration to "animate" his paintings with "stroke energy" and "awareness of nature" evolved from his understanding of Zen's conceptual approach to painting.[8] He wrote in 1958: "We hear some artists speak today of the *act of painting*, but a State of Mind is the first preparation and from this the action proceeds. Peace of Mind is another ideal, perhaps the ideal state to be sought for in the painting and certainly preparatory to the act."[9]

The traditional Eastern culture that so disinterested Greenberg and fascinated Tobey was not, however, the static and remote ideal each imagined it to be. The realities of China and Japan's modern political, social, and cultural histories had, by 1950, long rendered European notions of the "Orient" anachronistic. Ironically, the art and philosophy of the Chinese *wenren* (literati) and Japanese Zen traditions were available to Americans precisely because they had been "rediscovered" by an East Asian avant-garde well-educated in the principles of Euro-American modernism. While American artists looked to the East to seek independence from a history of European influence, Chinese and Japanese artists used those very traditions to assert autonomy from fast-encroaching Western hegemony in the Pacific.

To be "modern" was no longer equated with being "Western." It was not tradition as a passive agent but rather the *discourse on tradition* that informed a generation of Japanese and Chinese artists devoted to synthesizing the formal innovations of Abstract Expressionist painting with the philosophical methods of East Asian poetry, calligraphy, and painting. Several Japanese and Chinese artists who became part of the international phenomenon of Abstract Expressionist painting are thus the product of complex cultural movements that shaped the history of the modern era in their respective homelands.

Two indigenous abstract painting groups, Japan's Gutai Art Association, active from 1954 to 1972, and Taiwan's Fifth Moon Group, active from 1956 to 1970, exemplify how the concept of tradition came to serve a modernist end. These groups, who worked primarily in oil paint on canvas, are discussed here in relation to outstanding figures in the history of twentieth-century ink painting and calligraphy, such as Morita Shiryū and Zhang

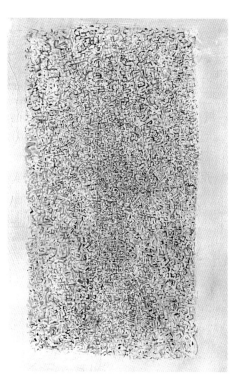

27. Mark Tobey. *Universal City*. 1951. Gouache on paper mounted on Masonite, 37½ x 25⅛". The Seattle Art Museum, Gift of Mr. and Mrs. Dan Johnson

Daqian.[10] Both attempted a similar synthesis of tradition and modernism but from within the orthodoxy they challenged but never abandoned.

Japan's Discourse on a "Logic of the East"

From the beginning of the Meiji Restoration in 1868 until World War II, Japanese culture was influenced by the debate over whether to look to "new knowlege throughout the world" or to return to the mythical, prehistoric origins of Japanese nativist spirit. This polarization of national identity profoundly influenced the development of Japan's modern social consciousness, and the antithetical but coexisting positions of adopting or refuting the West, reviving or renouncing tradition informed the course of its political history. In the realm of Japanese culture, the opposition between national and universal ideals has also been a critical issue of modern aesthetic theory, fine arts educational practice, and artistic expression.

An important figure in the early debate was the Meiji aesthete and educator Okakura Tenshin (1862–1913), author of *The Ideals of the East* (1903), *The Awakening of Japan* (1904), and *The Book of Tea* (1906)—all of which influenced the American "Oriental Thought" tradition. According to Okakura, the only way for indigenous culture to survive "the scorching drought of modern vulgarity [that] is parching the throat of life and art"[11] was to create a synthesis from within the tradition. Calling for "a restoration with a difference," he helped found the Tokyo School of Fine Arts with the American Japanologist Ernest Fenollosa in 1889. The aim of Okakura's revivalism was to create a new school of modern *Nihonga* (Japanese-style painting) that was based in classical style yet incorporated certain "modern" Western realist techniques, such as perspectival depth and chiaroscuro shading.

One of the more remarkable artists devoted to a radical synthesis of traditional aesthetics and modern Western expressionism was Onchi Kōshirō (1891–1955, figs. 28–29). Painter, book designer and illustrator, typographer, poet, and critic, Onchi is best known as a leader of the Japanese Creative Print Association (*Nippon Sōsaku Hanga Kyōkai*,

28. Onchi Kōshirō. *Jojō goshu: Itonami shufukuseraru (Blessing for efforts; from the series, Five Lyricisms).* 1915. Woodblock print, 5⅜ x 3¾". Collection Onchi Kunio, Tokyo

active from 1918 to 1930) and was one of the first Japanese artists to forge pure abstract, nonrepresentational art. The *sōsaku hanga* group was among a myriad of avant-garde associations that arose in reaction against the conservative *yōga* (Western-style oil painting in the French salon or Ecole de Paris manner), *Nihonga*, and traditional arts academies that were the legacy of the Meiji arts bureaucracy. In contrast to the *ukiyo-e* woodblock print whose process entailed several craftsmen to produce the artist's designs, the *sōsaku hanga* artists made their prints directly and used the medium as a form of modernist self-expression.[12]

Onchi's prints of decoratively composed images imbued with lyric emotion, however, owe equally as much to an evocation of the Japanese Rimpa school and calligraphic tradition. In his conscious innovation within a modernist context of Japanese culture, Onchi reflected intellectual movements of the prewar Showa period (1926–37) that argued for a return to the "native place of the spirit." Passion for what novelist Tanizaki Jun'ichirō called "this world of shadows which we are losing" as distinct from the capitalist, rational, and progressive West promoted Japanese tradition as an alternative model of culture to Western civilization.

The attempt to create original meaning from a complex admixture of Eastern and Western traditions was also the lifework of Japan's premier modern philosopher, Nishida Kitarō (1870–1945). Nishida used modern Western thought to interpret in a global context the kind of paradoxical logical structure that is the basis of the Mahayana Buddhist tradition, namely, the essential verse of the *Prajnā-Pāramitā Sūtra,* "Form is emptiness and emptiness is form." Challenging the insularity of racial or cultural bias, Nishida's "logic of the East" (*tōyō-teki ronri*) offered a paradigm to reformulate fundamental Japanese concepts of being (nothingness and contradiction) in universal terms. Nishida's sophisticated synthesis of Eastern thought and Western methodology was a model for the Japanese avant-garde, who in a similar way sought to forge a modern art of international stature founded on a "logic of the East."[13]

With the defeat in 1945 of the short-lived Japanese empire, the nationalist ideologies that had sustained the ill-fated fifteen-year

campaign collapsed, along with belief in national cultural values. In the immediate postwar years, modern artists and the long-repressed Left supported the "reformist" Occupation of Japan (1945–52)—essentially an American undertaking under the command of General Douglas MacArthur—because it aimed to replace totalitarianism and emperor-worship with democracy, freedom of expression, and new civil rights. For the pro-American modern art associations that proliferated after the war, any form of enshrined native culture conjured negative images of right-wing imperialism. Most efforts to preserve, revive, or transform the traditional Japanese arts were seen as arch-conservative, reactionary, or even nationalistic. After years of isolation from international art movements, eagerness for contact and exchange with contemporary Euro-American culture also overwhelmed any significant interest in the national arts.

Although American policy in the early Occupation era fostered social liberalization and the dismantling of the military, the rising menace of the Cold War heightened by the outbreak of the Korean conflict in 1950 led to a "reverse course" policy that enforced an anti-labor, anti-Communist, and remilitarization agenda. Increasing government control over individual civil rights culminated in 1952 with the passing of the controversial Subversive Activities Prevention Law, which liberal intellectuals vehemently opposed as an infringement of artistic freedom of expression. Artists, intellectuals, and political agitators who had earlier supported American reforms in Japan now joined in opposition to the conservative shift. Reaction against the Diet's indiscriminate pro-American orientation caused the leftist opposition to be drawn toward the political semantics of traditional culture as a means to assert autonomy and identity.

Arising from this discourse, several arts groups founded between the late 1940s and mid-1950s strove to create modernist art forms based upon radically new concepts of Japanese tradition. Foremost among them were the *Bokujin-kai* calligraphy society; the *Sōdeisha* ceramic artists; and the Panreal group of avant-garde *Nihonga* painters. Coinciding with their activities was the prominent influence of the "Japan Style," a

syncretic modernist architectural style incorporating traditional design elements expounded by such acclaimed architects as Taniguchi Yoshirō, Tange Kenzō, and Maekawa Kunio. Their common premise was to liberate tradition from rigid orthodoxies and to universalize modern art in Japan—which was mired in staid Eurocentrism—with an infusion from the East. In contrast to their more radical political counterparts, however, the new groups did not reject the West on ideological grounds. Rather, they sought to integrate Western notions of modernism with Japanese forms of culture so as to achieve an art of "world relevance."

In pursuit of its postwar cultural identity, Japan's avant-garde traditionalists applied Jōmon, Shinto, indigenous folk, Zen, and Chinese literati aesthetics to the modern abstract tradition. Central to their campaign was the belief that modern abstract art expressed a universal and transcendent image free of aesthetic, national, or cultural programming and was thus international by nature and by credo. While archaic primitivism inspired on one hand a return to nature through communion with elemental life forces, the traditional arts based in Zen Buddhist, Taoist, and Confucian practice taught rigorous self-analysis and refinement of the soul. Liberating tradition was ultimately a means to purge oneself of moral falsehoods and so attain, in the words of a contemporary critic, the purity of "a naked human being."[14] Demoralized by modern history, the Japanese avant-garde found in reexamining tradition an occasion for self-critique and cultural regeneration.

29. Onchi Kōshirō. *Imaju 9. Jibun no shibō (Image 9: My Death Mask).* 1954. Woodblock print, 28¼ x 22½". Collection Onchi Kunio, Tokyo

The Gutai Art Association

The Gutai Art Association was founded in December 1954 by Yoshihara Jirō (1905–1972, fig. 30) and included some twenty artists who gathered under his progressive tutelage in and around Ashiya, a well-to-do suburb of Osaka. Yoshihara, an influential abstract oil painter who had been active in the prewar avant-garde, promoted a bold and spirited anti-academicism by encouraging Gutai members to "Create what has never existed before!" He thought of artmaking as an act of freedom, a gesture of individual spirit, a willful rite

30. Yoshihara Jirō. *Sakuhin (Work)*. 1957. Oil on canvas, 46 x 35⅞". Hyōgo Prefectural Museum of Modern Art, Kobe

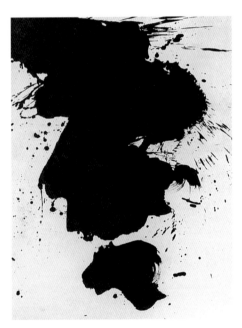

31. Morita Shiryū. *Bottom*. 1955. Ink on paper, 52 x 38½". National Museum of Modern Art, Kyoto

of destruction to create something new. Unbridled invention led the Gutai artists to experiment with unheard-of methods and materials—paint was applied with watering cans, remote-control toys, cannons, and bare feet; objects were made of industrial ruins, water, smoke, and neon bulbs. The group's legendary activities lasted until Yoshihara's death in 1972, when the group disbanded. Gutai's vast surviving corpus includes painting, sculpture, indoor and outdoor site-specific installations, action events, stage performances, experimental film and recorded sound as music, the *Gutai* journal, and related graphic arts.

The Gutai manifesto of 1956 celebrated the raw interaction between "matter" (material) and its essential property, "spirit"—a universal human consciousness as defined in Buddhist and Jungian terms, a childlike mind that is free and pure. Gutai's involvement with the innovation of Japanese traditional arts, specifically Zen calligraphy, informed its philosophical understanding of art as the direct reflection of the liberated self in the temporal here and now. The manifesto states:

Gutai Art does not alter the material. Gutai Art imparts life to the material. Gutai Art does not distort the material. . . . In Gutai Art, the human spirit and the material shake hands with each other, but keep their distance. The material never compromises itself with the spirit; the spirit never dominates the material.[15]

During the early postwar years, Yoshihara emerged as an impresario in the reconstruction of the Kansai (Osaka-Kobe) art world. Interest in liberating the traditional arts—especially calligraphy—from their obsolete orthodoxies led Yoshihara and others to establish the Osaka-based Contemporary Art Discussion Group (*Gendai Bijutsu Kondan-kai*), known as *Genbi*, in 1951. *Genbi* functioned as an intellectual forum and collaborative workshop for artists of diverse genres who aimed to foster the creation of new art forms based on integrating modernism and tradition, East and West, individualism and universality. The group drew ceramicists, dancers, *ikebana* artists, scholars, calligraphers, and abstract painters. The contemporary discourse on how to achieve "world relevance" through the innovation of

Japanese tradition was to remain a serious concern for Yoshihara throughout his career.

Working closely with Yoshihara at *Genbi* was the calligrapher Morita Shiryū (b. 1912, fig. 31), who in 1952 cofounded the *Bokujin-kai* calligraphy society, the most influential and innovative of the postwar avant-garde traditional arts groups. Acknowledging calligraphy as an essential component of Far Eastern religion, philosophy, and poetry, the *Bokujin-kai* sought to reconceptualize calligraphy as a form of contemporary expressionist painting. Through Yoshihara, Morita was exposed to international painting, leading him to foster communication between *Bokujin-kai* and several contemporary Euro-American artists, such as Georges Mathieu and William Stanley-Hayter, who were looking to Far Eastern calligraphy for inspiration. Calligraphers and painters alike, he believed, were seeking a common universal language based in gestural abstraction.

In expanding his network overseas, Morita collaborated with the artist, writer, and occasional calligrapher Hasegawa Saburō (also Sabro Hasegawa, 1906–1957), who had written on the affinities between modern art and calligraphy as early as 1939. A scholar of Western aesthetics who had traveled widely abroad (including two years in Paris, where he was active in establishing the influential Abstraction-Creation group), Hasegawa was devoted to comparative art-historical analysis in an effort to formulate an all-embracing concept of art. As a frequent contributor to Morita's journal, he would relate the line in Pollock's drip paintings, for example, to the *kyōsō* or "crazy grass" style of calligraphic script, the freest form of self-expression in Far Eastern art. At Hasegawa's recommendation, Morita featured a calligraphic Franz Kline painting on the cover of the first issue of the group's journal, *Bokubi*. Morita's efforts were culminated in 1955, when he collaborated with the visiting Belgian CoBrA artist Pierre Alechinsky on the film *Calligraphie japonaise*, which explored the relationship between *Art Informel* and calligraphy.[16]

Morita's concept of calligraphy was thus informed by a range of contemporary art theories and practices, and, like Yoshihara's Gutai group, he explored radical new methods and materials. The *Bokujin-kai* calligraphers experimented with cardboard, sticks, and broom-size brushes; tried mineral pigments, oil paint, enamel, and lacquer in place of *sumi* ink; and used canvas, wood, ceramic, and even glass for a surface other than paper. However avant-garde their art, they were deeply engaged in a rigorous reevaluation of the fundamentals of ancient calligraphy from a contemporary, global point of view. In the group's journal, Morita stated that *Bokujin-kai*'s mission aimed "To establish calligraphy on the basis of modern art and theoretical ideas" and "To expand calligraphy to a global scale."[17]

The importance of Yoshihara's exchange with the *Bokujin-kai* is evident in a series of paintings, executed from 1962 until his death in 1972, devoted to the circle, or *ensō* (fig. 32). As the ultimate form in Zen painting, the *ensō* represents void and substance, emptiness and completion, and the union of painting, calligraphy, and meditation (see also fig. 10). Rejecting the stormy impasto surfaces of his mid-Gutai period, Yoshihara composed paintings of a single circle in water-based acrylic against a white, black, or red ground. In the tradition of Zen monk-artists, Yoshihara repeatedly practiced his circle paintings as a form of spiritual discipline.

For other Gutai artists, the purpose of painting was to record the process of its creation. Manifesting the concrete presence of material, painting should not represent or suggest nature—it must embody or be a "work" of nature itself. Motonaga Sadamasa's (b. 1922, fig. 33) series of poured paintings that date from 1958 through 1966 illustrate this approach. As pools of paint flowed gradually across the surface of a tilted canvas, the colors gathered into amorphous, organic shapes, a timeless map charting the caprice of gravity and paint's viscosity. Here, the artist becomes a passive agent to his material.

The concepts of action and chance in painting were also central to Gutai. Shimamoto Shōzō (b. 1928, fig. 34) made his works by throwing bottles of paint against rocks—the explosions were both the record and content of the finished painting—while Shiraga Kazuo (b. 1924, fig. 35) painted his entire oeuvre with his bare feet on unstretched canvas attached to the floor. Balancing on a hanging rope that he grasped with his fists, Shiraga would dip and swing his weight through the thick, wet oil paint. The finished painting stands as a record of his random spins, swirls, and slips.

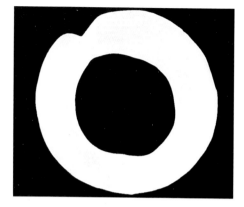

32. Yoshihara Jirō. *Kuroji no akai en (Red Circle on Black)*. 1965. Acrylic and oil on canvas, 71¾ x 89¾". Hyōgo Prefectural Museum of Modern Art, Kobe

33. Motonaga Sadamasa. *Sakuhin (Work)*. 1961. Acrylic on canvas, 71½ x 90½". Hyōgo Prefectural Museum of Modern Art, Kobe

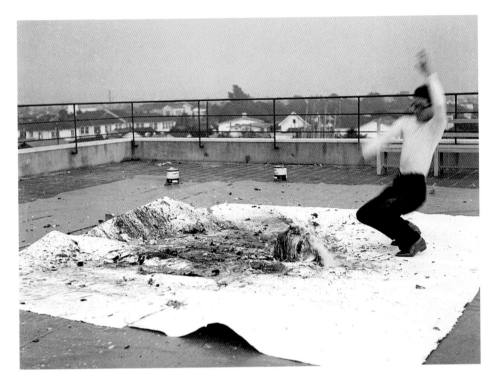

34. Shimamoto Shōzō
creating a painting by
throwing bottles filled
with paint against rocks
on an unstretched linen,
c. 1956

Gutai shares certain similarities with such European and American postwar painting movements as *Art Informel*, CoBrA, and Abstract Expressionism. Each was derived in part from Surrealist automatism but rejected aestheticism for more concrete qualities. Deeply affected by the atrocities and betrayals of the war, artists around the world found existential solace in the denial of symbolism, the freedom of gestural abstraction, and the materiality of paint itself. The correspondences were not lost on the French critic Michel Tapié, who visited Japan in the fall of 1957 and later arranged for exhibitions of Gutai art in New York, Paris, and Turin. *The International Art of a New Era:* Informel *and Gutai*—held at the Osaka International Festival in 1958—presented Gutai artists alongside such Americans as Jackson Pollock, Franz Kline, and Robert Motherwell and the Europeans Georges Mathieu, Antoni Tàpies, and Karel Appel (fig. 36).[18]

Although Tapié was correct to perceive stylistic "affinity" between the Gutai artists and contemporary American and European Abstract Expressionists, he was misled in believing that their similarities were historically coincidental or philosophically equivalent. Gutai's formal innovations arose from an early-twentieth-century legacy of Dada and Surrealist practices in the Japanese avant-garde; indeed, Yoshihara was directly involved with the development of both in the prewar decades. In his efforts to position Gutai as the Japanese manifestation of "the international art of a new era," his strategy reflected the progressive idealism of American cultural diplomacy in the 1950s, which promoted the virtues of "freedom of expression" in an "open and free society."

Whereas artists in the West perceived terror and chaos in the postwar condition, the Gutai artists experienced euphoric relief and liberation from decades of oppressive totalitarian bureaucracy. Emerging from a decade of wartime devastation, Gutai embraced Japan's new postwar idealism as a means to realize its own faith in the universality of the concrete here and now. Central to its strategy was an identification of the abstract, conceptual, and spiritual essence of Far Eastern calligraphy with the defiant force and modern transcendental premise that generated the Euro-American cult of "the spontaneous gesture."

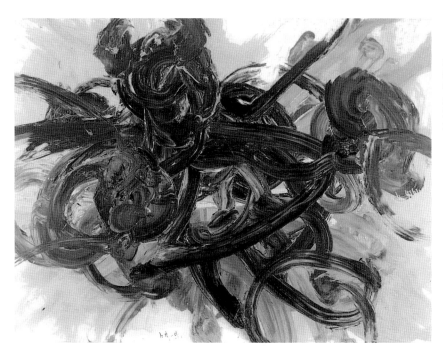

35. Shiraga Kazuo. *Sakuhin II (Work II)*. 1958. Oil on paper, mounted on canvas, 72 x 95⅞". Hyōgo Prefectural Museum of Modern Art, Kobe

Issues in Modern Chinese Ink Painting

Twentieth-century Chinese painting is an orthodoxy unto itself. In contemporary mainland China, despite frequent swings in the government's art policy, ink painting remains the mainstream. In Hong Kong, Taiwan, and the West, *guohua* (national painting) is well established as a serious field of creativity, research, and collection.[19] Studies of modern *guohua* have generally been organized in two ways: mainland versus overseas Chinese artists, and the aesthetic and political ideals of Chinese painting in the pre-Liberation versus post-1949 decades.

Ink painting had been the object of repeated attacks since before the fall of the Qing dynasty in 1912. In the early 1900s the urgency to modernize and reform China's decaying institutions prompted some artists and liberal intellectuals to criticize the reactionary and antipopulist values of traditional Chinese painting and to advocate renewal through adopting Western painting styles, much as Japan had after the Meiji Restoration of 1868. Leading modern artists subsequently synthesized European realism with Chinese techniques to create the so-called Anti-traditionalist and Westernized Chinese Painters movements that were active in the pre-Liberation decades.

36. A large painting by Gutai artist Tanaka Atsuko installed on the floor in the exhibition *The International Art of a New Era:* Informel *and* Gutai, Takashimaya Department Store, Osaka, 1958. Works by Pollock and Motherwell are on the walls

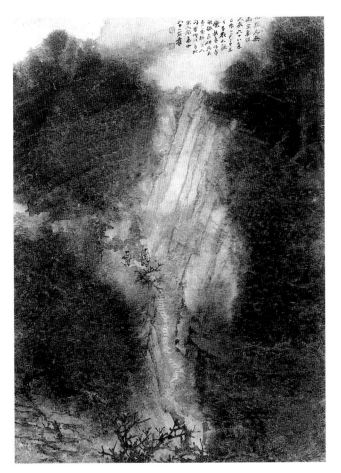

37. Zhang Daqian (Chang Dai-Chien). *Misty Mountain Path*. 1979. Hanging scroll, ink on paper, 31½ x 22⅞". Collection Robert Rosenkranz, New York

38. Wang Chi-ch'ien (C. C. Wang). *Landscape*. 1972. Ink and color on paper, 24 x 29¾". Collection Robert Rosenkranz, New York

When the Communists came to power in 1949, traditional Chinese painting and the entire social order it represented came under fire as the propaganda bureaucracy adopted Soviet Socialist Realism as the official style of the proletariat revolution. Indeed, one of the Chinese art world's major issues in the 1949 to 1957 period was what role, if any, traditional painting should play in the new society. The fundamental question was whether traditional painting should be preserved, reformed, or simply eradicated.[20] For a time, Chinese painting survived in the hands of those who managed to manipulate superb technique to depict contemporary subjects with enough realism so that Mao's masses—the worker, peasant, and soldier—would still be served. Other artists escaped abroad.

During the Cultural Revolution (1966–76), traditional Chinese painting was once again identified as an enemy of progress. Besides the willful destruction of cultural properties and private collections, thousands of Chinese artists died, committed suicide, or went insane in the decade of violent attacks against classicism and self-expression. With Deng Xiaoping's moderate reforms leading to the "open-door" policy of 1979, artists discovered the Euro-American avant-garde and proclaimed that traditional painting was "dead." Discredited by a score of cultural and political forces as backward, elitist, and now obsolete, the official world of Chinese painting continues to be an arena of conflicting positions— some righteously defending, others damning, the purpose and direction of *guohua*.

What makes "traditional" Chinese painting creative, rather than merely conservative, is the artists' innovative response to China's long cultural legacy. Since the fourteenth century, the real subject of Chinese ink painting has been the artist's personal interpretation of the existing tradition. This art was not meant to be viewed as just an apprenticeship to history, but instead as a dialogue with the past and often an oblique criticism of the present. Working with the constant variables of brush, ink, and paper, the more creative artists have sought to invent a new level of stylistic integration and a new concept of self-expression that would take the tradition forward.

One of the preeminent ink painters of the modern era is Zhang Daqian (also Chang Dai-Chien, 1899–1983, fig. 37). Recognized early in his career as a formidable talent, Zhang came of age in Shanghai's flourishing art world of the 1920s and 1930s. In spite of his commercial success as a forger of classical painting, he cultivated to the point of conspicuous eccentricity the lifestyle and ideals of the Ming dynasty (1368–1644) literati. (For a period in the early 1930s, he took up residence in the famous Wang-shih Garden of Suzhou that is associated with Wen Zhengming, one of the greatest *wenren* of the Ming period.) With the Communist takeover in 1949, Zhang left the mainland and settled abroad, where he gained international renown as a painter, calligrapher, and art collector and as an influential master to disciples of Chinese ink painting in Taiwan, Hong Kong, Japan, and the United States.

Beginning in the 1960s, Zhang began experimenting with a splashed-ink style that consciously strove toward a synthesis of the Chinese "flung-ink" tradition and new Abstract Expressionist manipulations of "chance and accident." He embarked on a series of highly abstract landscape paintings. The masterpiece, *Misty Mountain Path* (1979, fig. 37), is a culmination of Zhang's mature work in the splashed-ink style. Using a sheet of Ming dynasty paper, Zhang soaked it in water and then liberally applied the surface with ink. As the ink took on suggestive forms, the artist added texture strokes with a Chinese brush to depict trees, a pathway of steps, and a scholar and attendant passing through the misty mountainside—all details that serve to create a tenuous balance between an imagined world and the totally abstract. Unlike the Abstract Expressionists who sought to "overthrow their Western artistic heritage," the eminent art historian Shen C. Y. Fu argues that Zhang's aim in this and related splashed-ink paintings was rather "to expand the range of traditional Chinese painting, not break with it."[21]

For other artists who left Communist China, their persistence in using a classical Chinese medium at times carried certain political significance. The landscape paintings of New York–based artist and collector C. C. Wang (also Wang Chi-ch'ien, b. 1907, fig. 38) relate not only in style but also in purpose to

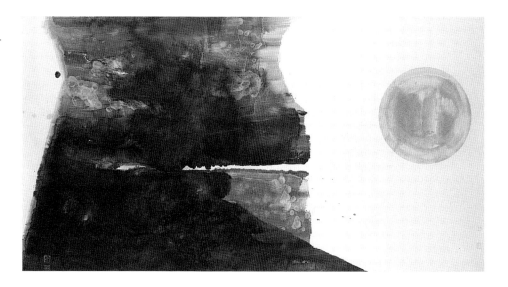

39. Lü Shou-k'un. *Untitled*. 1974. Ink and color on paper, 32¼ x 61". Collection Robert Rosenkranz, New York

the literati tradition of upholding the virtues of the past as commentary on the present. Since the Yuan dynasty (1279–1368), when native Han Chinese scholars protested the foreign Mongol rule by creating a stylistic code for ink painting that read as longing for the dynasties of China's former glory, *wenren* came to be identified with the social minority and political opposition. By persisting in his connection to the very culture that post-Liberation China wanted to eradicate, C. C. Wang's work suggests that self-expression survives ideology. His free experimentation with modern Euro-American methods and concepts of abstraction placed him at odds with the Communist *guohua* orthodoxy that shunned such influences. Other artists who left mainland China and pursued their artistic careers as modernist ink painters in a *wenren* tradition are Lü Shou-k'un, who settled in Hong Kong (also Lui Shou-kwan, 1919–1975, fig. 39); Tseng Yuho, who settled in Hawaii (b. 1923); and Hung Hsien, who settled in Chicago (b. 1933).

The Fifth Moon Group

In 1949 the long civil war between Chiang Kai-shek's Kuomintang or Nationalist forces and Mao Zedong's Communist revolutionaries culminated in Chiang's flight to Taiwan, where he established the Republic of China. This island province, which until 1945 had been occupied for some fifty years by the Japanese, suddenly became haven to millions

of mainland Chinese. Artists and intellectuals who settled in Taiwan amid these radical changes gradually began to forge an independent identity that synthesized their great Chinese heritage with a modernity and internationalism learned chiefly from America, the country that emerged as the dominant political and cultural force in postwar Taiwan.

A major factor in the development of contemporary Chinese art in Taiwan was the opening of the National Palace Museum in Taipei in 1965. The vast treasure of the Imperial Collection that had been housed in Beijing's Forbidden City was removed to Taiwan in the final days of the civil war, where it served to "legitimize" Chiang Kai-shek's claim to represent the "true China." From the mid-1950s limited access to the collection, especially distinguished for its Song, Yuan, and Ming paintings, was perforce a catalyst for artists working in Taiwan.

The most significant modernist group that emerged in the postwar period was the Fifth Moon. All mainland born and raised during the tumultuous civil war, the artists of this group met as students at Taiwan Normal University during the mid-1950s. Gathering under the leadership of Liu Kuo-sung (b. 1932, fig. 40), they shared a dissatisfaction with the conservative art system that was the legacy of Japanese occupation.[22] Under the educational system that Japan had imposed, traditional ink painting and Western oil painting were sharply divided and strictly orthodox. Liu was frustrated by the stagnant situation of traditional painting in Taiwan, on the one hand, and by the lack of exposure to modern Euro-American art on the other. He and other students would frequent the library of the U.S. Information Service in Taipei, where they eagerly sought out reproductions of contemporary international art in journals such as *Art International* and *Art News*.

Like Gutai founder Yoshihara Jirō, Liu first advocated antitraditionalism and aspired to be a painter in the modern Western tradition but later came to believe in the importance of finding a synthesis. Rejecting the attempts of China's early modern masters Lin Fengmien and Liu Haisu—who practiced what Liu perceived as a weak imitation of Fauvism—the Fifth Moon Group, founded in 1956, strove toward the creation of a new art form that

would draw eclectically from the profound tradition of Chinese art while operating within the rigorous realm of modern, international painting. The group was active until 1970, holding annual exhibitions in Taipei and frequent group shows in Hong Kong and the United States.

An important influence in the development of the Fifth Moon Group was the work of Zao Wou-ki (b. 1921, fig. 41). Born in Beijing and trained in European oil painting at the Hangzhou Fine Arts Academy, Zao immigrated to Paris in 1948 where he soon emerged as an eminent figure in the Parisian avant-garde. Curiously, in China his work was heavily influenced by Picasso, while abroad, transplanted, he was able "to find myself, to become a Chinese painter again."[23] Central to his abstractions, which suggest Chinese calligraphy and landscape painting forms, is a philosophical approach learned from the Chinese literati tradition and celebrated in the art and thought of classical masters such as Mi Fei, Ni Zan, and Shihtao.

Zao articulated an understanding of modern abstract painting that fused the teachings of Cézanne and Paul Klee with the notion of art as a manifestation of qi (or $ch'i$), the life force of the universe. Yu Kwang-chung, writing on the Fifth Moon Group, identifies the approach that Zao revived:

Inheriting the traditional temperament of the Chinese, the Fifth Moon painters have been intuitively journeying towards the mysterious center of Chinese philosophy. Fully understanding that "the heavy is at the root of the light and the silent is master of the noisy," they paint where they leave unpainted, commit where they omit, and thus realize the ideal of Chinese artistic tradition in "reaching out beyond the reach of the brush."[24]

Japan's Gutai group also played an essential role in the formation of Fifth Moon by disseminating, through example, the conceptual link between American Abstract Expressionism and East Asian tradition. The Taiwanese studied contemporary art developments in Japan by reading the monthly publications, *Geijutsu Shinchō* and the vanguard *Bijutsu Techō*, and followed Gutai's rise to international prominence from 1955 through the mid-1960s. Chuang Che (b. 1934, see fig. 47), one of the first Fifth Moon artists to

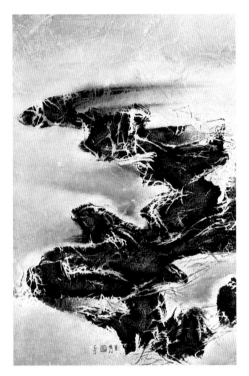

40. Liu Kuo-sung. *Intertwining.* 1964. Ink on paper, 32 x 24". Courtesy of Hugh Moss

explore pure abstract and accidental gesture, counts the Gutai painter Shiraga Kazuo (fig. 35) among the first contemporary artists he admired.[25]

It was American Abstract Expressionism that ultimately provided the theoretical and practical framework for Fifth Moon artists. Partly through following Gutai, they were able to intuit the fresh ebullience of Jackson Pollock's automatist works and aspire to the spirited energy and brute materialism that lay at the heart of his monumental drip paintings. In relinquishing the easel in favor of the floor and adopting sticks and trowels as tools, Pollock simultaneously symbolized freedom from the procedure and imagery of traditional oil painting and conjured the high East Asian tradition of "eccentric" painters.

Guided by a strong experimental spirit, Fifth Moon artists explored numerous unorthodox techniques. Fong Chung-ray, who abandoned oil painting to pursue ink and colors on paper, painted with coarse palm leaves tied into a giant brush with which he created bold and spontaneous effects. Chen Ting-shih, after working in both Chinese and Western media, discovered a local Taiwanese product—sugarcane board that was used as cheap building material—that he cut up to make large-scale monotypes of pure abstract forms. Liu Kuo-sung, who turned exclusively to ink painting in 1961, worked on coarse-fiber paper that he specially ordered from Chinese paper mills. He applied ink with a wet brush and then proceeded to pull fibers from the paper at random, creating a distinctive surface texture.

Fifth Moon's choice of American Abstract Expressionism as a model for artistic production has political significance as well. As Harold Rosenberg implied in his 1952 essay, "American Action Painters," the new American art repudiated the political motives of Socialist Realism, the moral import of the Regionalists, and the aesthetic concerns of formal abstract painting in favor of the artist's "gesture of liberation, from Value." While Soviet-style Socialist Realism dominated oil painting in Communist China, the Fifth Moon artists rejected any such ideology and regionalism. In focusing on the individual artist and the process of creation, action painting gave impetus to Fifth Moon's pursuit of a radically new art in what was, nominally anyway, the "free China."

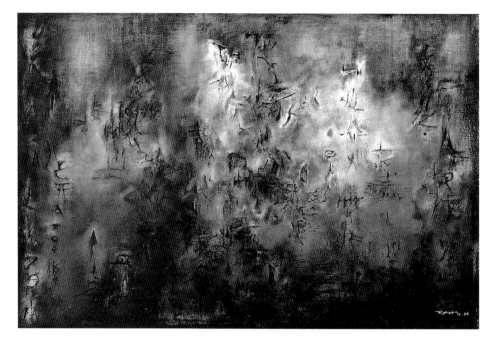

41. Zao Wou-ki. *Montagne Dechirée*. 1955–56. Oil on canvas, 50¾ x 76¾". Collection Walker Art Center, Minneapolis, Gift of the T. B. Walker Foundation, 1956

The uses of "Oriental tradition" in twentieth-century art served a specific goal for the modern project as it was articulated and pursued by Western and Asian artists alike. Whereas the Impressionists appropriated formal and decorative *motifs* from an arbitrary repository of Asian artifacts as an aspect of aesthetic "Primitivism," the postwar action painters studied the philosophical *content* embodied in the high art of China and Japan to advance their ideal of "universality." Unlike Primitivism, which embraced the fantastic and unschooled "premodern" in non-Western cultures as a rejection of the modern era's mass industrial society, the tradition of Asian thought offered a system for the individual mind to contemplate and transcend the horrors of the Holocaust and the nuclear age. It was not "tradition" as a conservative or anti-modern ideal but rather Asian civilization as a distinctly "other" construct from the modern West (whose spiritual values were so gruesomely bankrupt) that appealed to the international postwar avant-garde. Chinese and Japanese artists were naturally drawn to the subversive, individualistic, and elitist "traditions" of literati and Zen culture in their creation of an art that was original but not regional or nationalist, modern but not necessarily Western—in a word, universal.

International Abstraction in a National Context: Abstract Painting in Korea, 1910–1965

by Jae-Ryung Roe

The development of modern abstract painting in Korea is closely connected to the political and social history of the country. The old kingdom of Korea, dubbed the "Hermit Kingdom," had attempted to close its borders to foreign influences. However, by the mid-nineteenth century, Korea became increasingly exposed to the international community and was confronted with forces of integration such as pressure to conduct overseas commerce, military aggressions from foreign empires, religious missions, and tourism. Along with the onslaught of such forces came cultural forms from the West, including a novel mode of painting using new materials, techniques, and aesthetics called *suh'yang hwa* (Western-style painting). Introduced to Korea via Japan, *suh'yang hwa* soon gained followers and secured footing in the art community, making it necessary to define traditional painting in terms of its differences from Western-style painting. The designations *suh'yang hwa* and *dong'yang hwa* (Korean-style painting) came to denote two separate painting cultures, perpetuating the notion that Korean painting was bound to tradition and conventions while Western-style painting was novel and modern.[1]

In 1910 Japan formally annexed Korea and assumed rule of the country. Japanese Army troops shut down local newspapers and political organizations and took control of the educational system. Under colonialism Koreans were required to adopt the Japanese language, the Shinto religion, and Japanese names. A communist movement began in 1921 to regain Korean independence through solidarity among the proletariat.[2] Communism became popular among the cultural elites, and they formed the Korean Artists Proletariat Federation (KAPF) in 1925.[3] Through its national networking and publications, KAPF expanded into a full-fledged cultural movement but failed to expand into a widespread grassroots movement. It did, however, generate genuine debates about art and created an interest in realism and the social function of art.

Despair and anger about a nation under the shackles of colonialism motivated one artist, Chu Kyung (1905–1976), to create pioneering works of abstraction in the *suh'yang hwa* style as early as 1923 (fig. 42). In describing the motive behind his abstract paintings in the 1920s and 1930s, Chu stated: "It was a time when I didn't even understand what being avant-garde was . . . regardless, the paintings came about naturally from my intentions to organize the dark recesses of my emotions into a structured composition. I found release of my sorrows in my work."[4] Chu's paintings were not the outcome of aesthetic investigation of the fundamental properties in painting, as was the case with the various modes of abstraction in Europe, but instead were expressions of his feelings about the current political situation.

The defeat of Japan and the end of World War II in 1945 marked the end of colonialism. Korean nationalists split between "rightists," those who looked to Western Europe and the United States as models for the liberated nation, and "leftists," those who saw the Soviet Union as the means of national salvation. The Allied forces occupied South Korea for an interim period of 1945 to 1948 and the Soviet Union occupied the North. The U.S. position was to support the rightist faction

and enforce its agenda by massive arrests of leftists and by closing down presses.[5] With the Left suffering a major setback, artists of the politically neutral and Right who were previously marginalized came to dominate the art scene.

It was during these postwar years that a number of artists came together to form the *Shin sashil pa* (New Realism Group) in 1947. These artists were trained in Japan, where they had familiarized themselves with the new ideas and modes of painting from the West. Two leading figures of the group were Kim Whanki (1913–1974) and You Young Kuk (b. 1916). Both graduates of Tokyo University, they were associated with noted Japanese modernists such as Sabro Hasegawa and Murai Masmagodo.[6] After studying in Japan, Kim lived in Paris during the 1950s and later moved to New York, where he spent the last ten years of his life. In the late 1930s he began painting abstractions. *Rondo* (1938, fig. 43), which was exhibited in a group show in Japan, is an important example of his early assimilation of synthetic Cubism. His work is generally characterized by a brevity of line, bright colors, and repeated forms. As an avid collector of Korean artifacts, he was especially drawn to celadon ware and stated that the imagery of moon, mountains, women, or birds, as well as the colors of these ceramics, gave inspiration to his own works.[7]

Like Kim, You Young Kuk became interested in abstraction in the 1930s. He actively participated in the avant-garde circles in Japan and his work during this time shows a great deal of experimentation. Using collage, photomontage, and assemblage, You investigated the conceptual and physical properties of

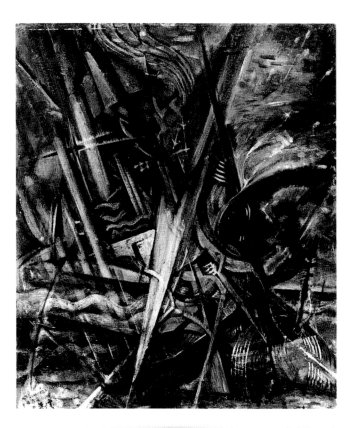

42. Chu Kyung. *Hardship*. 1923. Oil on canvas, 21 x 18". The National Museum of Contemporary Art, Korea

43. Kim Whanki. *Rondo*. 1938. Oil on canvas, 24 x 28⅜". The National Museum of Contemporary Art, Korea

44. You Young Kuk.
Mountain (Topography).
1959. Oil on canvas,
51⅜ x 76⅛". The National
Museum of Contemporary
Art, Korea

different materials and the basic properties of painting. He also developed an increasing interest in pure Constructivist and Minimalist abstraction. In the 1950s You began a process of simplifying and rendering into archetypal forms the shapes found in nature such as mountains, the sky, the sea, rocks, the sun, fish, and birds. This was not nature observed but iconographical and conceptual imagery— an abstraction of landscape into a composite of lines, colors, and shapes (fig. 44). In reference to painting, You said that "the basic act of creation is to explore the many diverse forms in nature through the process of composition." Nature served not so much as subject matter but as a means to pursue the painterly in abstraction.

The oeuvres of Kim Whanki and You Young Kuk constitute an important phase in the history of modern painting in Korea. Their abstract paintings set them apart from the academic and realist styles that were prevalent in the mid-twentieth century. The advanced level of abstraction in their work cannot be viewed as an extension of a native school of abstraction, since there was none to speak of, but as an isolated phenomenon and a result of their training and experiences in Japan.

The art community in Korea in the 1950s was dominated by conservative academicism

and trite figurative painting that had become institutionalized through the *Daehan Min'kuk Misul Dae'jun* (Korean Art Exhibition inaugurated in 1949 by the then Ministry of Culture and Education, referred to in its abbreviated form, *Kuk'jun*). Art historians have surmised that the *Kuk'jun* was a means to police the art community and that it provided a system for official sanction of rightist artists who had been overwhelmed by the activities of the leftists. For some time the *Kuk'jun* was the only major venue for artists to show work and to receive publicity and recognition. The exhibition was touted as a major national cultural event each year and received extensive press coverage and throngs of viewers who gathered at the exhibition venue as if on an annual pilgrimage.

Founded with the intention to "encourage the development and growth of art in Korea," the power brokerage institution continued its annual exhibition for the next thirty years, finally terminating in 1979, no doubt the longest surviving art institution in modern Korean art history. Only briefly interrupted by the Korean War (1950–53), the *Kuk'jun* persisted in South Korea despite military coups d'état, political upheavals, and changes in administration. It was operated on a mammoth scale: the categories included *dong'yang hwa*, *suh'yang hwa*, sculpture, crafts, and calligraphy. Submissions to each category were screened by a panel of jurors. This format imitated the *Sun'jun*, the annual exhibition inaugurated in 1922 by the governor-general of Japan in Korea as a mechanism of intervention and surveillance. The conservative academicism and figurative painting that were favored by *Kuk'jun* came to dominate the mainstream, and *Kuk'jun* became a notorious breeding ground for sectarianism and cronyism.

The new administration that came to power in 1963 proclaimed sweeping changes to reorganize *Kuk'jun* under the banner to "unite all artists," and the structure of the exhibition was expanded to incorporate such categories as "figuration," "semiabstraction," and "abstraction." This brought about the participation of mid-career painters working with abstraction who were previously marginalized by the *Kuk'jun* system. That year, for the first time, an abstract painting received the grand prize in the *suh'yang hwa* category. This

sudden change was, predictably, perceived as a threat by the *Kuk'jun* establishment artists and they reacted with immediate and fierce resistance and lobbying.

Despite the predominance of the *Kuk'jun*, Korean artists were able to maintain a continuous flow of information about the international art community either via Japan or directly from Europe and the United States. Abstract painting was practiced by a comparatively small number of artists, however, as there was not yet a widespread school or organized group. The progress of modern art in Korea was made possible only by those few individual artists who worked outside of the *Kuk'jun* system, striving to formulate a mode of painting that engaged contemporary art in the international arena and was expressive of the sensibilities and lived experiences of the younger generation. These artists eventually formed groups in order to differentiate their art from that of the establishment.

The *Hyundai mil'sul hyup'hoe* (Modern Art Association) was founded in 1957. Its members were mostly in their twenties, of the generation that had experienced colonialism, liberation coupled with the ideological battle between Left and Right, and the Korean War. They were also the first generation to have been trained not in Japan but in art colleges in Korea. This group was the leading force behind the first major abstract art movement in Korea, known as *Informel*, that remained strong until 1965. The artists associated with *Informel* regularly held group exhibitions that presented mural-scale nonrepresentational paintings encrusted with thick layers of paint that were applied with sweeping and vigorous brushstrokes. A central artist to this movement, Park Seo-Bo, previously had been painting monochromatic black canvases of distorted human figures which developed into a series that he titled *Primordialis* (fig. 45). Begun after Park's return from a year's visit to Paris in 1961, the *Primordialis* series consists of mostly black backgrounds from which shapes appear, built up with thick layers of encrusted paint that the artist leveled with the palette knife and scraped with a fine toothed comb. The coarse paint surface was sometimes further emphasized by the addition of hempcloth or the creation of craterlike holes that punctuate the picture surface. During his stay in Paris, Park was impressed by the art

of Jean Dubuffet and Antoni Tàpies, whose works also depicted deformed human figures with a vigorous energy and primitivism. Human fate, original sin, and primordial humanity became central tenets of the *Informel* group.

Park Seo-Bo recalls that the elimination of imagery and the transition to large-scale gestural painting came as a sudden revelation one evening. He found the traces of the very act of painting, the simple yet basic factor of painting a true liberation. Park thereby dismisses any notion of *Informel* as being simply derivative of European and American schools of painting. Such rhetoric about the autonomy and independence of *Informel* painting from foreign influences derives from the desire to construct nativist and nationalist art histories and can create a distorted picture of what actually happened. Rather, art historians have evaluated this mode of painting as the synthesis between the national and international or foreign. The *Informel* movement has therefore been of most significance in the history of modern art in Korea as it was a phenomena that was not directly influenced by the art scene in Japan, predicated on a postcolonial relationship, but rather was born from the national context—an autonomous movement that was still a part of the international art scene.

Informel by the mid-1960s had become a mannerism onto itself and had lost its vigor and excitement. However, the movement bore many followers, and artists assimilated and quoted the traits of *Informel* painting in their work. The artists of the *Informel* movement were no longer the renegade young generation that defied the establishment but instead had become highly visible artists and represented Korea in such international venues as the Paris Biennale and the São Paulo Biennale. Thus, *Informel* of the 1950s, which had been to some extent dependent on its Western predecessors, was followed by a mode of abstraction that engaged ideas about native traditional aesthetics, as well as by the assimilation of geometrical abstraction and variations of Op art. Expansion and ruptures of boundaries within the art community continued into the 1970s as the number of art institutions grew and as artists experimented with assemblage and conceptual art, happenings and performance art.

45. Park Seo-Bo. *Primordialis 62–1*. 1962. Oil on canvas, 63¾ x 51⅛". Collection unknown. From *Contemporary Art Exhibition of 1960s: Selected from the Works of the Biennale of Paris* (Seoul: Duson Gallery, 1984)

Asian American Artists and Abstraction

Roundtable Discussion

The following text is derived from recorded and transcribed remarks at a roundtable discussion on themes related to the *Asian Traditions/Modern Expressions* exhibition. The transcribed conversation has been edited for continuity and clarity. The participants were: Don Ahn, artist; Dore Ashton, author and art critic, Professor of Art History, The Cooper Union; Chuang Che, artist; Wen Fong, Professor, Department of Art and Archaeology, Princeton University, and Special Consultant, Asian Affairs, for the Metropolitan Museum of Art, New York; and Yoshiaki Shimizu, Professor, Department of Art and Archaeology, Princeton University. Acting as moderator was Jeffrey Wechsler, exhibition curator and catalogue editor of *Asian Traditions/Modern Expressions.* The discussion was held at the offices of Dr. Fong at the Metropolitan Museum of Art, New York, on September 23, 1995.

JEFFREY WECHSLER: Let me begin our discussion with a rather provocative quotation from Paul W. Kroll, a noted China scholar: "In the history of painting, East or West, there are only so many basic methods and techniques. Even the more unusual modes of 'action painting' of some mid-twentieth-century artists, when considered from a sufficiently broad perspective, seem to be merely distorted replications of methods practiced by certain Chinese painters of the late eighth century . . . [whose habits] have, of course, been unknowingly imitated by dozens of modern neoteric daubers, attempting to discover 'new' forms in painting."

This seems to be a rather strong indictment and dismissal of the notion held by certain American art critics that modern gestural abstraction and Abstract Expressionism represent a unique artistic breakthrough into new techniques and approaches to abstraction.

WEN FONG: You won't get away easily with a quote like this today, I'm afraid. How can you simply call Western "action painting" a "distorted replication of methods" practiced by some ancient Chinese painters (fig. 46)? But that really is not the point, is it? The point is not which is more original and who influenced whom. If you see Western influence on modern Chinese painters, that is considered bad imitation. But if you have some Eastern sources rediscovered by so-and-so in the West, it becomes a great breakthrough. We have to talk about something more fundamental than that.

YOSHIAKI SHIMIZU: To follow up on what Wen is saying, we cannot always take on face value those statements about the early precedents [for abstraction] in China because we may be talking about a totally different intent. Taking Pollock's action painting activities—dripping paint, throwing paint all over a huge canvas spread on the floor—and saying, "yes, the Chinese did that in the eighth century," is a kind of pointless comparison. The intention of the Chinese artist in the eighth century is still very representational. He was not purely defining the surface into an abstract form and the materiality of paper.

To try to appropriate this precedent is, I think, a kind of colonialism, kind of biting a little bit off from whatever you want and just discarding the rest. You don't really place that particular precedent in context. I don't think that this is going on any more in our field, at least in art history.

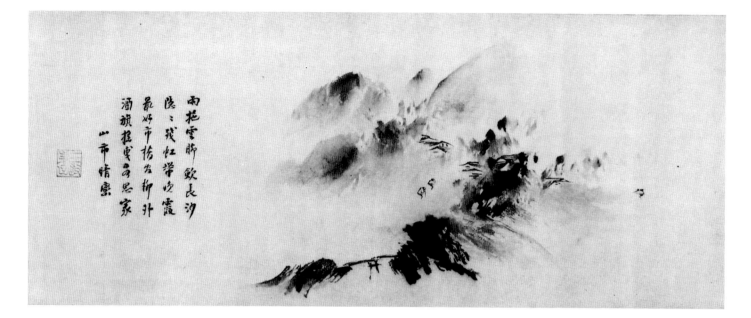

雨　收
烟　雲
澹　脇
澹　歛
殘　長
虹　沙
當　　
晚　最
霞　好
　　市
酒　橋
旗　先
搖　柳
曳　扶
多　　
思　山
家　市
　　晴
　　嵐

46. Yü Chien. *Mountain Village in Clearing Mist.* Late 13th century. Portion of a handscroll. Ink on paper, 11⅞ x 32⅞". Idemitsu Museum of Arts, Tokyo

49

47. Chuang Che.
Melancholy. 1965. Ink
on rice paper on canvas,
34 x 46". Collection the
artist

DORE ASHTON: I find it very troubling, this whole discussion, because in my experience—and as a former art student myself—I think you have to take into account the nature of a driving curiosity in an artist. Philip Guston, in the last two years of his life, kept referring all of the time to ancient Chinese art. I really believe—without his knowing the language, without having the same purpose as the Chinese artist—that he understood what he had managed to read about Chinese art and in some way felt an affinity with some artists, somewhere else, in some other period, in some other place. There is some level on which artists, and only artists, do understand each other, whether they live here, in China, or wherever.

I had a graduate student from Columbia University three years ago. She came from a normal school in Chungking, I think. She was doing her thesis on Abstract Expressionism and Asian art. She had the most vivid imagination. Almost nothing that she wrote would I have said in quite that way; she hardly spoke English. Yet somehow or other she caught the ambience of the people she was studying—she understood. So I don't like to assume too much.

My point is that there are elements in the formation of artists that do transcend national boundaries and periods and time. You can't assume that because it is a whole other culture . . .

WEN FONG: It is a question of stimulation, isn't it? That's what really this whole thing is about—when there is something new, something coming together. In a mysterious way it came together in New York City in the 1940s and 1950s. It didn't come together anywhere else. And surely it would not have happened in Beijing or Shanghai at the same time. That's what matters, isn't it?

JEFFREY WECHSLER: Let's get the artists' point of view on that. There were certain fundamental concepts or techniques of traditional painting which both of you had learned by the 1950s. And with that background at that time, you became abstract artists.

CHUANG CHE: I come from a family in which my father was curator of the National Palace Museum in China. So I learned at a very early age to study traditional painting. I always looked at calligraphy, and I had in my early stages very good training in the traditional Chinese brush. My teachers worked in the so-called Western style. Coming from academies like that in Honchu, they divided all art training into Chinese painting and Western painting, each using a totally different approach. When they worked in the Palace Museum, gradually they tried to switch to Chinese painting. Mr. Liu, one of my teachers, tried to imitate Shi Tao. He was very good, a very good craftsman of imitation. Although he just imitated the old painters, I learned technique from him.

In my college in Taiwan it was the same thing; the art school still taught about Chinese painting and Western painting in two distinct groups. But they didn't really teach. They would pass around a drawing for everybody to study or copy. So I was very upset because at a young age I had already learned how to imitate the old masters' techniques. So I switched to learning Western style. But in China at that time, all the teachers of the Western style had been to Paris and painted from models. After four years I felt very disappointed because I had learned nothing from either school.

In the late 1950s, the one man who influenced me, I think, was Zao Wou-ki (fig. 41).

At that time he was in Paris. His work touched something in me because I felt it was sort of Oriental, yet international. Zao thought he was part of the School of Paris. But people in the School of Paris came from many places; they just worked in Paris together. Just like Abstract Expressionism—the members come from many places, even different countries. They just happened to meet in New York. So in that period of time I feel art was really international. No matter if you are from China or whatever country. If you can touch something in your art, and that language can just, as you say, transfer, there are no boundaries.

JEFFREY WECHSLER: Don, can you speak to the same thing in terms of your own experience?

DON AHN: I started out the same. In a traditional Korean art school, you know, it was the same—we copied the masters, copied calligraphy, copied a thousand times. We also did Western painting, and we drew from plaster casts. At that time, my generation in Korea was kind of divided; we grew up in two artistic cultures. So when we graduated school, one person goes completely to Oriental art and one person goes completely Western. In my case, I started more in a Western style of oil painting but with Oriental subject matter. I was taking art classes in the 1950s, and my teachers were born around 1900. Their Western painting was kind of a 1930s, 1940s style; it was the same in Japan, the same in China—nostalgic, traditional. So first I did that.

Then I used to go to Buddhist monasteries; I saw Zen paintings, Korean, Chinese, Japanese—my first exposure. I also had a teacher who studied in Paris and was one of the first Korean abstract painters, but not really in Abstract Expressionism, which had a lot more colors. But his paintings were abstract, kind of similar to landscapes.

I came to America in 1962 and then I saw all of the painters of Abstract Expressionism, like de Kooning. I found that after being exposed to Chinese, Korean, and Japanese paintings that I felt the Americans didn't understand what we call *ch'i*. But they understood composition. In the Orient, when I was studying, they worked with traditional Chinese composition, which is not as dynam-

ic as Abstract Expressionists' compositions, like Franz Kline. So then in the 1950s and 1960s I started working in an Abstract Expressionist style, but a little more like Zen Buddhist tradition. I feel like I am standing with one foot in my parents' culture and one foot in a totally different, Western culture. And yet I feel comfortable with both. I went to Pratt Institute [New York] and I learned composition, structure, light, and color. But I still believe in the *ch'i*.

WEN FONG: Can you expand on that? If you notice, by observing, that there is a difference between East and West in terms of what you call this *ch'i,* what do you do with that concept in your own work?

DON AHN: When I look at the Western painters, they have *ch'i*, but it is not refined. I'm familiar with a lot of Oriental painters, like Wen Cheng-ming [sixteenth-century Chinese artist], because they are calligraphers, and I learned the Chinese way of how to do calligraphy. You see, in the West, when, say, Franz Kline is painting Abstract Expressionism, he's more concerned with the whole canvas. He puts one stroke here, one stroke here, like that. Wen Cheng-ming—when he paints he is aware of composition, but he is *more* aware of each stroke. He puts some kind of energy into it. There is a kind of strength. Kline's stroke has a strength, but I feel it does not really have that kind of *ch'i*. It is a different kind of *ch'i*, a little coarse.

WEN FONG: Now you are getting very personal.

DORE ASHTON: He should be.

DON AHN: I feel I have a reason. I learned Chinese calligraphy in Korea over many, many years, drawing vertical lines a thousand times. I have the feeling in my hand how to do lines and things like that. Then I learned color and composition here. In Korea, in Oriental painting, they looked down on color; color was "cheap," so you have to work with the values of black and white, you know. I see the value of both black and white and color.

One thing about Abstract Expressionism, it has a lot more visual impact than a small calligraphy. Abstract Expressionism is more emotional, immediate. They call it "action

48. Don Ahn. *Zen #9*. 1963. Ink on rice paper, 50 x 28". Collection the artist

painting" but it really comes out of the heart. It is kind of crude, but I'm still attracted to it.

WEN FONG: What does that mean, coming out of your heart? Is that something you have difficulty with? Does your painting come out from your heart?

DON AHN: Yes.

WEN FONG: So what's the difference?

DON AHN: Well, if it comes from the heart, somehow I have a connection. It is like a signature. I put down a brushstroke, there is a signature. In Abstract Expressionism they work like that, too. But I feel it is a little crude in terms of refinement. My challenge is that I've been exposed to Oriental traditional education—I studied all of the classics, Confucius, all of that. When I came to New York City I was exposed to a totally different culture; I met lots of Abstract Expressionist painters at that time. I'm right in the middle. I like to do things which I feel express my *ch'i*, but at the same time I would like to have a structure, an impact that people can see when they look at it.

It was very exciting back then. I was teaching college, and I kept having shows. But my painting career in commercial terms was not as successful. Most Koreans of my age group went back to Korea. Commercially, they are very successful in Korea.

DORE ASHTON: It is the only place left to go.

DON AHN: They all have paintings in Korean museums. When I came back to Korea three years ago, they said, "Why don't you have a show once a year in a Korean museum?" I said, "No, I'm more comfortable in New York. I'm going to stay." I feel it is kind of a challenge.

JEFFREY WECHSLER: To back up to one of the interesting things you just said: you said you found Kline's stroke not to have *ch'i*. I've spoken to Asian American artists who, when they look at Pollock's or Kline's work, say it *looks* like calligraphy, but it is *bad* calligraphy. They feel the work does not have *ch'i*, does not relate to life, and is rather cold. And

you can read statements about Abstract Expressionism that tend to divorce it from more "delicate" or personal feelings. Or they claim to transcend nature in a way that the Asian artist never would.

DORE ASHTON: You are talking about so-called critics and not artists, I hope?

JEFFREY WECHSLER: Right, the critics, not the artists.

DORE ASHTON: You have to be careful when you talk in terms of critics. Some were very stupid, some were not observant, some were not . . .

JEFFREY WECHSLER: I'm referring to what's come down to us as art history.

DORE ASHTON: And it's still coming down to us.

JEFFREY WECHSLER: That's right. And to a good extent, I'm dealing with the [*Asian Traditions/ Modern Expressions*] exhibition on a visual level, trying to see what is actually *in* the Asian American art. And I've talked to many artists, and they talk about nature. For example, in Chuang Che's work, to my American eyes, I see some Asian characteristics: the way the paint is handled, the way that the brush moves, and the use of nature, the acceptance of nature. At one time, Pollock was asked about nature, and he implied that he transcends, or is better than nature. Such a notion is unthinkable for most Asian American artists that I've spoken to.

DORE ASHTON: I don't know if you are going to use that one quote from Pollock and one quote from another. . . . Actually a lot of the more literary painters among the Abstract Expressionist group were pretty cultured. They read a lot, knew about a lot of other points of view. When I was a student, a lot of books came out about Asian art, for example, [books by Ananda] Coomaraswamy. Also you have to go back to John Dewey's *Art as Experience*. Artists recognized certain principles. Even the principle of *ch'i*, as I gather what it means to an artist or to a scholar, was recognizable to them. That's why I feel we have to be very careful how we speak about these things. Pollock may have one day said,

"I am nature," but another day he would have argued against you if you would say he wasn't interested in nature. Certainly de Kooning always was interested in nature and said so. You can't just say Oriental artists were always attached to nature and Western artists were not attached to nature. You have to be really careful.

JEFFREY WECHSLER: I agree. It is much more slippery than that. We agree such views often arise more from the critics' mouths than from the artists' mouths. Jackson Pollock was in a certain sense seen by the general public as a painter of drips because of the critics when he was much more than that.

DORE ASHTON: He was figurative, too.

JEFFREY WECHSLER: Exactly. That was considered unimportant by certain individuals and critics at that time. And, therefore, the rest is sloughed off, unfortunately.

DORE ASHTON: You are right about that.

JEFFREY WECHSLER: Still, there is a question whether a visual distinction can be made between Asian American and other abstractions at that time. Personally, I can see certain visual characteristics coming together in some work.

DORE ASHTON: I'm going to say one more thing on this point. When I was a kid in Paris I got to be friendly with a Japanese artist, [Hisao] Domoto, and we talked on this subject. Four years ago when I was in Japan, we sat down and we talked about it again. Finally he said, "You know, I think it could be reduced to this. We [Japanese] always painted with water-base paints and you [Westerners] always painted with oil-base paints." So I accepted that, of course. He is very intelligent, witty. He reduced it to that to finish up the afternoon, you see.

YOSHIAKI SHIMIZU: You know, I heard that Domoto, having lived for years in Paris, used oil paint. Then when he came back to Japan, he said the artistic climate just made it impossible for him to use oil so he went back to water.

DORE ASHTON: He calls acrylic water-base.

YOSHIAKI SHIMIZU: Can I just go back and respond to an observation on two different modes of painting? When you look at, let's say, Kline's painting, it is almost a reductionist type of painting. But what shocked me when I saw it was how tormented and how labored his painting was. It is not like Japanese calligraphy where each character is a given, repeated form and you repeat the movements needed to form it from memory. There can be all kinds of permutations of forms, but it is a spontaneous act because you know that A follows B and B follows C. When I saw Kline's work, I felt there were so many directions—he has to eliminate as he goes on composing. I felt the same way with the square paintings of Guston. I can see the elimination process; it is not spontaneous, even though the brush-strokes may recall Japanese or Chinese characters. But the whole premise of composition, of getting the work done, is different. This we have to understand first. Kline or Guston must have spent hours in creating what seems to be instant creation because it is constructed by reduction, by elimination. Spontaneity, the "ink blot" idea, should not be seen there. You can't look for *ch'i*.

DON AHN: If you look at Franz Kline's or de Kooning's drawings, they are spontaneous drawings.

WEN FONG: You find similar spontaneity in Rembrandt's drawings, by the way.

DON AHN: I knew a fellow who knew Kline personally. I thought Kline used speed in making those lines. My friend told me no, he worked on it . . .

WEN FONG: Very slowly. Not really spontaneously?

DON AHN: He used a small brush. So he wanted to give a spontaneous impression, but the process was like a Western painting, like a nineteenth-century painting.

DORE ASHTON: Same for de Kooning.

DON AHN: The result, to me, is that it has

49. Chu Yün-ming
(1460–1526). *Flowers of
the Seasons.* 1519. Portion
of a handscroll. Ink on
paper, 18 x 52⅜". The Art
Museum, Princeton Uni-
versity, Anonymous loan

that dynamic power and impact that most
Oriental painting does not have. It is almost
like looking at a small portion, a close-up, of
Yang Jing-Ming's [seventeenth-century
Chinese artist] painting with a magnifying
glass. Somehow it gives that impact. Also de
Kooning is very concerned with the four
edges, the whole abstract concept of how to
compose in the frame. But the Oriental
painters don't think too much about the four
edges. Structurally, designwise, de Kooning's
are much more tightly composed.

When I visited Korea in 1970, I found there
were a lot of abstract painters, but they did
not have the ability to compose like that.
Somehow the Westerners, I feel, have this
awareness of the structure. When I look at
Leonardo da Vinci's paintings, they are per-
fectly structured. But the majority of Oriental
painters, I find, are aware of this structure,
but not as much.

WEN FONG: I think this is also Shimizu's basic
point here—a really essential difference
between East and West.

JEFFREY WECHSLER: Right. And Don Ahn was
saying essentially that differences are immedi-
ately apparent in the way that the work was
done. It is interesting and somewhat paradox-
ical that art regarded as being immensely
spontaneous, incredibly quick, in the context
of American painting and American criticism,
was, from the point of view of an Asian-born
artist, not that at all but a visibly worked and
carefully structured process.

WEN FONG: Nevertheless, there is a coming
together.

DON AHN: It still has spontaneous expression
to it.

YOSHIAKI SHIMIZU: I agree with you. I mean,
going back to Guston, I think he has a group
of wonderful ink drawings.

CHUANG CHE: You are talking about early
Guston or late Guston?

YOSHIAKI SHIMIZU: Not very late, but—

CHUANG CHE: Middle Guston?

YOSHIAKI SHIMIZU: Yes.

DORE ASHTON: In the 1960s when he was doing figurative painting, he was doing abstract ink drawings.

CHUANG CHE: At the same time?

DORE ASHTON: Yes, at the same time.

YOSHIAKI SHIMIZU: When I saw them they are like Chu Ta [eighteenth-century Chinese artist]—Chu Ta's composition, his concept of space.

WEN FONG: Wait a minute. At the risk of sounding academic, I think there are cultural differences in how art is practiced. Eastern art is based on conventions. Whether it is dance or calligraphy, A follows B. So right away I have trouble with this word "abstraction." To talk about abstract calligraphy is a contradiction in terms. You can have calligraphic abstraction; but abstract calligraphy?

DON AHN: Like children's painting, a five-year-old child's scribbles.

WEN FONG: I would have difficulty using this word "abstraction" with traditional Chinese art. Calligraphy does not represent the visible world. It is different from painting.

CHUANG CHE: Right.

WEN FONG: But in fact calligraphy does *represent*. It represents a character (fig. 49). Painting is about visual representation. In Western figural representation, it has to do with imitation of nature. You have something in your mind. Chinese calligraphy does not imitate nature; it imitates a character—although at one point in the eighth century, theorists did talk about imitating natural imageries. Now, to go from the Eastern tradition to the Western tradition, there is a sense of emancipation and liberation: you are not bound to paint in black and white, and you can do anything you want. But the truth is: the beauty, the greatness of Chinese art and Chinese calligraphy is that you learn to do anything you want by *not wanting* what you cannot do. That's the basis of calligraphy.

DON AHN: The next step is what you call expressing your feelings, artistic *expression*. For instance, when I see some of the more dynamic calligraphy, some of the fast writing, some of the calligraphers . . .

WEN FONG: Traditional or modern?

DON AHN: Traditional, like Chin Nung [eighteenth-century Chinese artist], or modern, like Shi Lu [twentieth-century Chinese artist]. Both were wild calligraphers for their time. Their writing was totally their own; no other person had that signature. In that sense, they were using the written character to express their feelings, coming from the heart.

CHUANG CHE: They call it avant-garde calligraphy in Japan. They use one word as a whole composition.

WEN FONG: It is different.

CHUANG CHE: They destroyed the original structure of the calligraphy.

WEN FONG: That's fine, but it is still totally different from the way de Kooning works.

DORE ASHTON: Not totally. At times, de Kooning would begin a painting very much like those people in Japan. He would take, let's say, the number "3" or the letter "A." The post-World War II so-called calligraphic artists in Japan, abstract calligraphers—they themselves insisted upon understanding the paradox. When you read what they said, you understood very well what his [Wen Fong's] point is: that you really can't be an abstract calligrapher, but you can do calligraphy as an abstract artist. They knew that they were pushing the boundaries.

WEN FONG: I think in artmaking the starting point is important. In China, it goes back to our language, and Chinese is a conventionalist language. Our ways of understanding, of meaning, of conducting rituals are through conventions. Western academics like to interpret meaning through semiotics: art as sign. But the meaning of the sign depends on the sign-maker; and language—or art—is not always objective or transparent. It is really Plato versus Aristotle.

55

DORE ASHTON: First of all, it is not always Platonic; it could be Aristotelian. Aristotelian is not exactly the same. It is imitation of the action; it is not imitation of the thing. This is a very important distinction to make. Also, many visual artists today would bristle to think that their painting could be read through semiotics since they feel far closer to what you're talking about when you mention *ch'i*. That's why I am very careful about writers with socioeconomic, historic interests in interpreting context, and all of that. It is a whole other world from the studio world that I am more sympathetic to.

WEN FONG: This concept of *ch'i* has magic behind it. The *ch'i* of the brushwork is the *ch'i* of the artist. Infused with the artist's *ch'i,* the representation comes alive, so it becomes magic.

One way or another, I see a difference in how art is conceived in East and West. In the West, art is more concerned with logic, system, structure, and virtuality. In the East, there is *spontaneous creation* by *yin* and *yang.* The difference not only goes back to language; it goes back to their respective cosmologies.

DON AHN: What he is saying is: de Kooning arrived at that freedom *after* he learned figure drawing and everything. Then one day he says, "forget about the whole thing."

DORE ASHTON: De Kooning never said that.

DON AHN: But in his paintings of women, you don't see the careful rendering of a figure. I used to go to Tenth Street meetings, stuff like that. He talked about calligraphy and Oriental paintings.

CHUANG CHE: Did you notice that the last time de Kooning had a show someone called the work "melting Cubism"? Very interesting because I think de Kooning, of course, came a lot from Cubism. I think he tried to break through it. When Abstract Expressionism happened, it was just like a bomb, all the rules were broken, or at least you could be very free. But within the earlier rules, I think de Kooning is still very European.

DON AHN: He learned the structure, how to put the figure into the classical triangular composition, all of that.

JEFFREY WECHSLER: Chuang Che, if somebody saw a show of your work and described it as "melting landscapes," would they be way off the mark?

CHUANG CHE: I don't know, but I try to still link my work to older pieces—I mean, nature is still my way of thinking. They always said that what Abstract Expressionists were really about was making a form or a mark. Like Gottlieb—when they found their mark, they put all of their energy into it and tried to develop and refine it. But for me, I still think about the environment and nature, and I try to bring that out.

JEFFREY WECHSLER: I have to interject here that we are toward the end of our time. Can I ask each of you for a final comment on the subject of the exhibition project in general or its basic theme: Asian American artists producing abstraction in the context of their Eastern and Western experience. In essence: can the twain meet?

YOSHIAKI SHIMIZU: I think during the late 1940s through the 1950s—after World War II, let's say—in America, particularly in urban areas, there were different responses to Asia. That is to say, there were practitioners of Zen, some meditated, many people read [Daisetz] Suzuki, and Buddhism, in general, was a very big thing. Some of them were absorbing it on a philosophical basis.

Yes, the twain seems to meet, but we Asians realize that, boy, we are in a different world; we come from different roots. This notion comes from doing your own work, as well as seeing other people's work—for example, Mark Tobey. It was probably in his correspondence that I read that he must have seen much Japanese cursive calligraphy. But his use of the Japanese paintbrush, even the ink, is different. He is not writing a given character; his art is the dynamics of strokes. In other words, what I'm saying is: the tools are similar, but there are different cultural roots of what these tools should be used for. I find there the different *expectations* between East and West.

DORE ASHTON: I would agree, but I would add this. I have a friend who's teaching at Keio University. Her name is Hide Ishiguro. She taught at Columbia. When I asked her about the significance of certain earlier Japanese philosophic tendencies up through the late nineteenth century, Hide said, "For every Western concept that you bring to me, I will find you a similar concept in Asia." And she did, to my satisfaction. So she taught me a lesson. I take that lesson and I agree with her. As you said, there is always something similar. Gertrude Stein said, "Everything is always the same and everything is always different." That's about it.

CHUANG CHE: I feel the [*Asian Traditions/Modern Expressions*] show may point out the difficulties of the group of Asian artists with roots in their own culture who meet and work here in the United States. For instance, I have had many shows in this country, and art critics always say "East meets West"—and that's it. They don't make any definitions: what is East, what is West? There must be historical background showing aesthetic values different from what is now in New York. I hope if this show can reach the public, at least they will know more about what the "East" means, originally or culturally for the artists and for themselves.

DON AHN: I think what happened in the 1950s and 1960s is still going on, but in a totally different way. Right after World War II people were together, there was more camaraderie; something crystallized—a whole attitude. But I grew up in the Abstract Expressionist period, so I'm closer to it. I think that Abstract Expressionism was the strongest, purest art so far in America. Right now it is more individualistic. I see young Korean painters, young Chinese painters, some of them working in Pop art, all of these different things.

This meeting of East and West is always going to go on. Now there are Asian artists born *here*, and things probably will be different to them. But still, their parents are Asian. There will always be a cultural mixture—like the Chinese movie, *The Wedding Banquet* [1993], other traditions. There is still Chinese culture in the movie, but it is done in the Western style. It is interesting to me; how valuable it is depends on how good the quality is, which depends on each individual's capability.

WEN FONG: I think we are talking about two problems. One is about "East and West" and the other is about "past, present, and future." I believe, in the future, the two traditions will mix and stimulate each other; but I am skeptical about any basic methods or techniques that will create modern expression. I can relate to Asian American artists as an Asian working in America with Asian roots. But my roots and basic mind-set are Asian.

For this reason, I think it is enormously difficult for Asian-born artists to function here. I can't say that for my children because they are born here . . .

DON AHN: When they are born here it is very different.

WEN FONG: Exactly. They have grown up American, they have everything Western. In their early years they may even, for very social reasons, sociological phenomena, reject their Asian roots.

DON AHN: They don't even want to use chopsticks.

WEN FONG: When they grow up, the Asian part of their heritage will reassert itself—powerfully. Noguchi is a very good example. I am an optimist. People in Asia, especially the Chinese, had a very rough time for the last couple of hundred years. But if they do well economically, their heritage is strong, and they will create their own modern expression. That's my own personal feeling.

From Asian Traditions to Modern Expressions: Abstract Art by Asian Americans, 1945–1970

by Jeffrey Wechsler

"Abstraction" is the modern occidental attitude in search of the "absolute." [The] Oriental way of thinking in metaphysics, philosophy, religion, general culture and art, [and] also the way of living itself, have for centuries been tending toward the "absolute" through "abstractions."[1]
—Sabro Hasegawa

Among the most valued of aesthetic goals in traditional East Asian art is that of harmony. A consonance of all elements, including a balance between qualities that are apparent opposites (active/restful, dark/light), is crucial to a successful work of art. For Westerners, a simple, comprehensible symbol of this concept is the *yin-yang*. By means of a gently curving internal line, the two halves of the symbol flow around each other, intimately joined within the perfect wholeness of the circle. The *yin-yang* occasionally appears in the work of Asian American artists, at times dominating the composition as an abstract icon of contemplation (fig. 50). Many other traditional Eastern symbols and styles can be found in certain works by Asian American abstractionists. How graceful is the sweeping gesture by Don Ahn (fig. 51), an admirer of both Zen calligraphy and the gestural methods of American Abstract Expressionism. Another calligraphic work, *Dream Writing (Yume-no-ji)* by Matsumi Kanemitsu (fig. 52), demonstrates a fluent *sumi* ink and brush technique yet divorces the inked glyphs from actual meaning in a Westernized approach to abstract linear motifs. Dale Joe's *Sungscape* (fig. 53) honors its sources in its title: it converts the atmospheric essence of a Song dynasty landscape into a broadly gestural motif that adheres to the traditional use of

black and white even while reversing the overall effect to white on black.

In viewing these appealing abstractions that so artfully blend elements of East and West, one may be lulled into believing that they arise from a nearly effortless equanimity of artistic harmony between cultures. Indeed, the opening quotation by the artist Sabro Hasegawa implies that for artists of Eastern heritage the creation of abstract paintings is all but inevitable. But such paintings represent only specific stages within very personal and complicated processes of artistic adaptation for an entire generation of Asian American artists whose individual histories and artistic inclinations are quite diverse. Many roads have been followed to meet the rather open-ended stylistic criteria gathered by *Asian Traditions/Modern Expressions*.

The term "Asian American" encompasses many life experiences; the interest in joining East and West in art springs from various sources. Many Asian-born artists came to the United States simply because their parents had determined to make the journey. Others came specifically to pursue study of Western art. Scholarships directed toward Asian or international student interchange, such as grants from the Rockefeller Foundation, afforded many Asians the opportunity to come to America. Some had especially rich introductions to Eastern art before they left: Chuang Che's father was curator of the Palace Museum in Beijing and Chuang was surrounded by the fruits of his cultural heritage since childhood; Sung-Woo Chun's father was the founder of the Kansong Art Museum, one of Korea's largest and best collections of Korean art. Such direct contact with major

50. Nong. *Composition.* 1969–70. Oil and gold leaf on canvas, 18 x 21½". Collection the artist

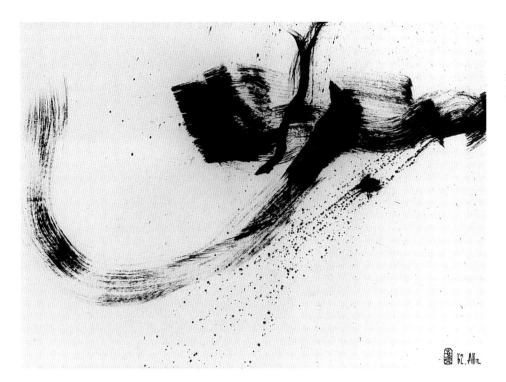

51. Don Ahn. *Zen #5*. 1962.
Ink on paper, 24 x 36".
Collection the artist

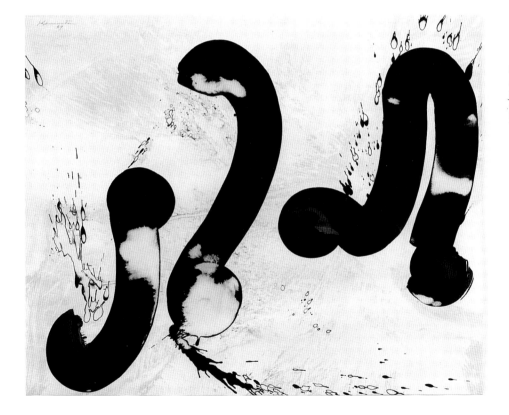

52. Matsumi Kanemitsu.
Dream Writing (Yume-no-ji). 1969. India ink on
paper, 23 x 29". Collection
Nancy Uyemura

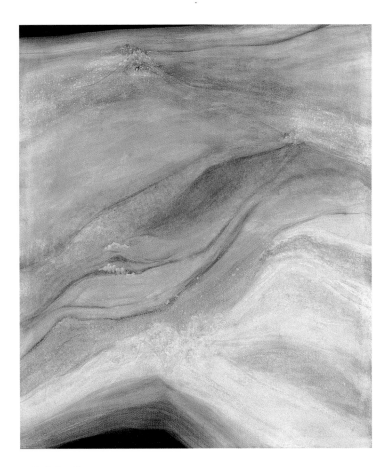

53. Dale Joe. *Sungscape*.
1957. Oil on canvas, 59 x 52".
Collection the artist

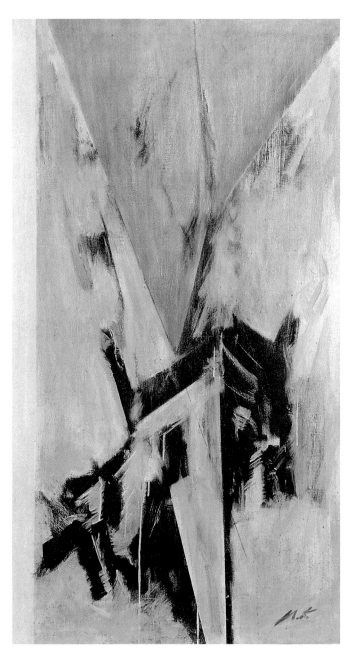

54. Byungki Kim. *View
of the South Side of the
Mountain*. c. 1966–67.
Oil on canvas, 50 x 28".
Collection the artist

collections might have been exceptional for Asian-born artists, but contact with paintings, and particularly the art form of calligraphy, was not unusual. After all, in China, Korea, and Japan, the art of calligraphy is a natural outgrowth of the necessity of learning how to write. C. C. Wang acknowledged its centrality by succinctly stating that "all Chinese art is an extension of calligraphy."[2]

Some Asian artists, intrigued by the modern Western art that they received in small doses through reproductions in publications or the occasional progressive teacher, felt it imperative to visit the West. Disappointed with academic training in both Eastern and Western art, they sought artistic freedom. One can sympathize with Don Ahn's complaint that art school instruction in Korea was nothing but copying and more copying.[3] But instruction at home could be no less onerous. Noriko Yamamoto recalls the calligraphy training regimen set by her father in Japan with some ambivalence: "Father would make me do calligraphy from seven A.M. to eight A.M. or else no breakfast."[4] Although she feels "I had too much discipline," she appreciates the abilities she gained with the brush and was ready to transfer her strokes into more abstract forms upon her arrival in the United States (figs. 170, 187).

On the whole, artists yearning to break out from the restraints of Asian art education felt that their liberation was available in the United States. Even artists with firmly established and successful careers decided to pursue modern art in what they perceived as a more congenial environment. Byungki Kim had been a professor of art at Seoul University for fourteen years and received the national honor of appointment as Commissioner for the Korean Pavilion at the 1965 São Paulo Biennale, but he still chose to emigrate. Louis Pal Chang also capped a distinguished career in art in Korea by leaving the country. A teacher of painting since 1926, he was named the first Dean of the College of Fine Arts at Seoul National University. Upon his retirement, he left for America to become a full-time artist and immediately began to create abstract pictures, something he felt he was not able to do in Korea. Similarly, Sabro Hasegawa declared that he could not do the abstract art he wished to do in Japan (figs. 55–57). He "had broken with tradition" by making an abstraction of calligraphy, "which is sacred," and therefore felt he could no longer teach in his native country.[5]

Although Asian immigrant artists had come for release from the academicism that fettered them in their native lands, the multiplicity of painting styles in the United States sometimes provoked a kind of artistic culture shock. Sung-Woo Chun "was amazed to see so many kinds of art existing" together.[6] Even the very materials used to make art were, if not totally unfamiliar, assigned a different status. The water-based paints and inks and silk or paper supports that comprised the physical essence of Eastern art were considered rather insignificant in the Western hierarchy of fine art production that relied on oil-based paints and primed canvases. The kaleidoscope of color used in painting was a revelation to many Asian newcomers. Even the way of holding one's brush (relatively straight up and down for ink painting, at an angle just off the horizontal for most Westerners) and the orientation of one's picture (horizontal in the East, vertical in the West) were sources of fascination and confusion.

In certain instances, as artists began to assimilate both art traditions, their individual responses to the American visual milieu were expressed in intriguing, amusing, or even poignant ways. Chuang Che had always been interested in the visual impact of Chinese calligraphic ideograms and the formal, abstract properties of their linear components. He was delighted by the advertising billboards and posters he found in New York City: it seemed like bold, word-based art and design on every street corner. Of great interest to him was the graffiti he saw on walls, something he had never experienced in Taiwan. To Chuang, graffiti was American public calligraphic art, with vigorous gestures and linear energy. He was also unfamiliar with the graffitists' major medium, spray paint. Chuang related it to the traditional techniques of the "spattered ink" style, called *p'o-mo*. So here was an American technological wonder: *p'o-mo* in a can. This new medium inspired him to do a series of works combining free linearism in spray paint with oil, acrylic, and collage in compositions using the restrained colors and metallic accents of Chinese paintings (fig. 58).

Ceramist Ka-Kwong Hui quickly incorporated the bright colors of the American Pop

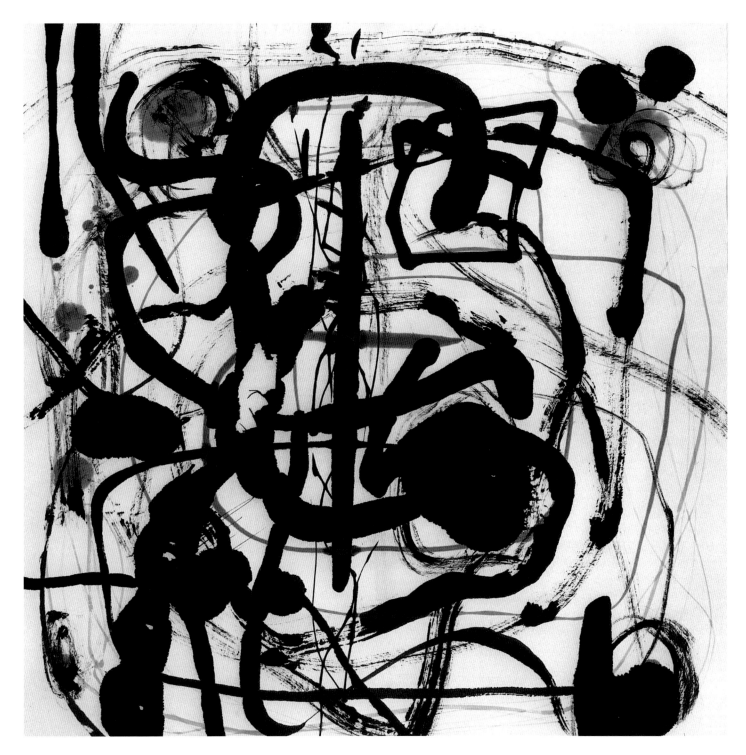

55. Sabro Hasegawa.
Untitled. 1954. Ink on
paper, 26½ x 26½". Collection
Mrs. Kiyoko Hasegawa

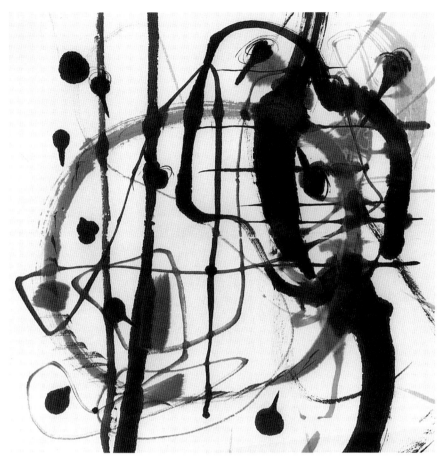

56. Sabro Hasegawa.
Untitled. 1954. Ink on
paper, 13¼ x 13". Collection
Mrs. Kiyoko Hasegawa

57. Sabro Hasegawa.
*Supreme Goodness Is Like
Water.* 1954. Ink on paper,
27½ x 26½". Collection
Mrs. Kiyoko Hasegawa

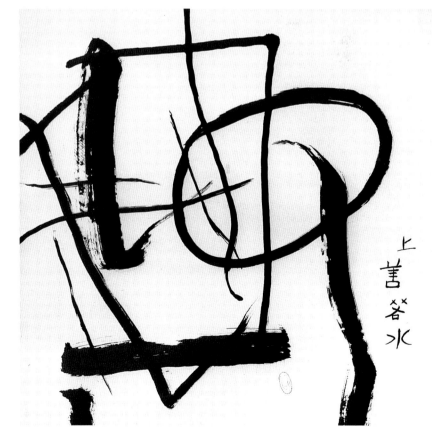

58. Chuang Che.
Astronomer. 1967. Oil
and rice paper collage
on canvas, 48½ x 34¾".
Collection the artist

sensibility into his palette of glazes (fig. 59). These objects' forms are abstractions of venerable symmetrical prototypes in Chinese vessels, and their functionality as lamps or mirror holders echoes the utilitarian basis of the earlier Chinese ware.

For Wucius Wong, adoption of Western styles and techniques was a more difficult process. Toward the end of a period of study in America he used his art to meditate on whether he should stay in America or return to Hong Kong. He wondered if after studying Western styles he would be able to "seek individuality but at the same time . . . not be completely divorced from the Chinese tradition."[7] He created a set of semiabstractions that "contained complicated superimposition of images, . . . Chinese characters and English lettering, rubbings from rough surfaces, . . . shapes and patterns, revealing his mental state at the time, a deep sense of anxiety, hesitancy and nostalgia."[8] In *Home Thoughts* (fig. 61), forms cut off by the picture's edges, rushes and gestures of ink, the English word "Go," and the Chinese character for "Go" all symbolize movement. The division of the image represents the artist's "divided loyalty" between East and West.

American-born artists of Asian heritage came to know their artistic roots in many ways. Those of first-generation immigrant parents often learned calligraphy and other art forms from family members; sometimes they were sent to schools promoting Asian ethnic education. In addition, there were many fine collections of Asian art in American museums, such as the Metropolitan Museum of Art in New York and the Museum of Fine Arts in Boston. On the Pacific coast, where Asian cultural influence has been most pervasive in the United States, large collections of Asian art, such as those of the Asian Art Museum of San Francisco and the Seattle Art Museum, have been focal points of local artistic circles. In some areas, the Asian art atmosphere has so suffused the regional art that the major Euro-American artists have become known for the Asian character of their work; the "Northwest School" centered in Seattle is the best example of this phenomenon.

In a curious twist of East/West interaction, the American painter Mark Tobey, a significant figure in the application of Eastern art within Western modernism (see fig. 27), was a

59. Ka-Kwong Hui. Left: *Ceramic Form with Mirror*. c. 1968. Glazed ceramic with mirror, h. 22"; right: *Ceramic Form (lamp)*. c. 1965. Glazed ceramic with light bulbs, h. 22". Collection the artist

60. Ka-Kwong Hui. *Ceramic Form in Gold (lamp)*. c. 1965. Ceramic with luster glaze, light bulb, h. 22". Collection the artist

61. Wucius Wong. *Home Thoughts*. 1965. Ink on paper, 38 x 73". Collection the artist

62. Paul Horiuchi. *Echoes of the Temple Bell*. 1959. Collage and gouache on paper, 23 x 11". The Seattle Art Museum, Gift of Paul C. Horiuchi

crucial inspiration for several Asian American artists, including Paul Horiuchi, Kenjiro Nomura, Sumiye Okoshi, Fay Chong, George Tsutakawa, and Frank Okada (figs. 62–69). Aspects of these artists' works were influenced by Tobey's knowledge and practice of *sumi* painting, brush gesture, and calligraphic form, as well as his development of all-over compositions.[9] Although the artists were certainly familiar with the forms and techniques before, Tobey's learned but open-minded approach to Eastern art added sparks of insight to their own knowledge and practice.

The interweaving of Asian and Western experience in individual artists' lives was often a complicated matter. It has been said of Tsutakawa: "He came to his Japanese schooling through the detour of being born in the United States. He came to his study of art in America through the detour of Japanese education."[10] Born in Seattle, he lived in Japan from age ten to twenty-one, returned to Seattle, and took several mid-life trips to Japan and other Asian countries. For Horiuchi, such travels, allowing close study of traditional Japanese art, led him to "reaffirm [his] conviction in the Oriental view of nature which sees [that] man must live in harmony with the rest of nature." His *sumi* drawings were considered "a direct response to nature."[11] American-born Isamu Noguchi also had extensive training in Japan. Despite a stormy relationship with his Japanese father, Noguchi dug deep into the aesthetics of Japan and the East to develop an entirely unique body of work. In particular, his ceramic works broke free from the masterful but tradition-bound practice of ceramics in Japan, while at the same time integrating those very traditions into a novel East/West fusion. One Japanese critic acknowledged that Noguchi's "personality exercised a powerful influence on the birth of artistic pottery" in Japan.[12] His varied oeuvre exemplifies how a staggering range of traditional Asian visual principles and philosophies can be elegantly overlaid upon modern sculptural expression (figs. 70–73). Like Tsutakawa, Noguchi spent many of his early years in Japan (1906–18). Noguchi, however, traveled more widely and frequently between the United States and Asia and maintained a studio in Japan while basing his artistic operations in New York. As early as 1946, a perceptive American critic declared that Noguchi had "fused in his art the East and the West as they were fused in his body."[13]

63. Paul Horiuchi. *Zephyr*.
1957. Casein, 23½ x 30¾".
Private collection

64. Kenjiro Nomura.
Untitled. 1952. Gouache
on paper, 17¼ x 22¼".
The Seattle Art Museum,
Gift of the Estate of
Mr. Nomura

65. Sumiye Okoshi. *The
Beginning of Incarnation*.
1958. Oil and spackle on
canvas, 40 x 30". Collection
the artist

67. George Tsutakawa. *Reflection, Abstract*. 1959. *Sumi* with *dansai* on scroll, 36 x 26". Collection the artist

66. Fay Chong. *Calligraphic Lines No. 1*. 1958. Watercolor and Chinese ink on paper, 22 x 10½". Carolyn Staley Fine Prints, Seattle

69. Frank Okada. *Untitled*. Early 1960s. *Sumi* ink on paper, 36 x 30". Private collection

68. Frank Okada. *Non-Objective Composition*. 1958. Casein on paper, 16⅞ x 13¾". The Seattle Art Museum, Gift of Mrs. Thomas Stimson

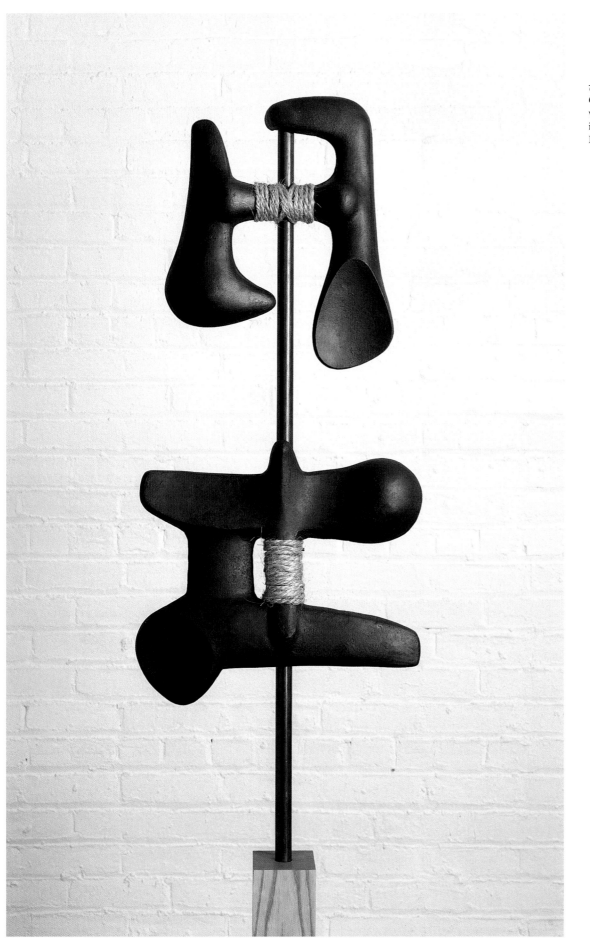

70. Isamu Noguchi. *Calligraphics.* 1957. Iron with rope, h. 70½" (including base). The Estate of Isamu Noguchi

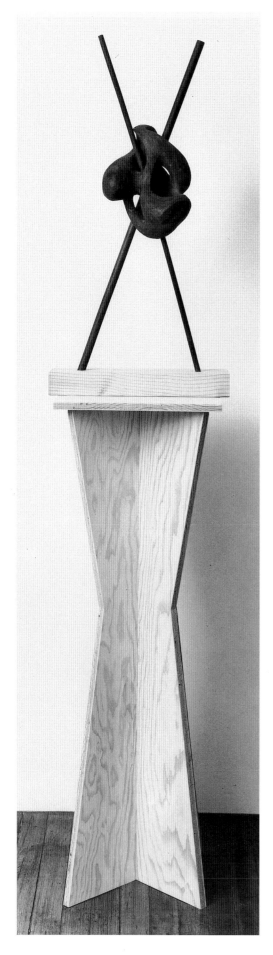

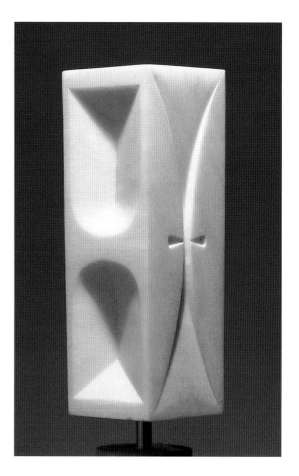

72. Isamu Noguchi. *Lekythos.*
1958. Marble, 13 x 4⅜ x 4⅜".
Hirshhorn Museum and
Sculpture Garden, Smith-
sonian Institution, Gift of
Joseph H. Hirshhorn, 1966

71. Isamu Noguchi.
Untitled. 1943. Wood,
8¾ x 6¼ x 6". The Estate
of Isamu Noguchi

The current stature of Noguchi as a major twentieth-century artist who successfully linked two cultures is of rather recent vintage. The fact that his work straddles both East and West was troubling to many mid-century observers because it simply did not fit neatly within a category. This is an all too frequent dilemma for such art and the artists who produce it. Dore Ashton, art critic and a great admirer of Noguchi's work, recognizes the artist as part of a "tradition of unresolved dualities."[14] Many Asian American artists are aware of the precarious role of one who combines cultures. "The Chinese say I'm a Western painter," noted Wang Ming, "and the Westerners say I'm an Eastern painter."[15]

In the postwar years, one might expect American reserve or even distaste for the promotion of Asian culture, in particular that of Japan. The country had been through a period of intensive anti-Japanese propaganda, and the grim episode of the placement of many Japanese American citizens in relocation camps, often stripped of their homes and all possessions, was still a fresh memory. Instead, at least within the art world, Japanese and other Asian art and culture enjoyed a period of blossoming interest. As early as 1948 the Metropolitan Museum of Art displayed an exhibition of contemporary Chinese paintings in which one reviewer found "disciplined expressionism" and "surprising energy . . . [in] a few bravura strokes of the brush."[16] Japan, however, quickly dominated the scene, especially in terms of contemporary art. *New Japanese Abstract Calligraphy,* one of the most important shows because it placed examples of this art directly in the home base of the New York School, was held at the Museum of Modern Art in 1954. Survey exhibitions of American art, of which there were many more in the 1950s and 1960s than at present, seemed anxious not just to include Asian Americans but to claim them as simply American, even if they had been in the country only a few years. At the Whitney Museum of American Art, New York, among the thirty artists chosen to represent *Young America 1960* four were Asian American, including Sung-Woo Chun, who entered the United States in 1953.

Other major group shows of Japanese artists—living in Japan or emigrants—were organized by Japanese and American institu-

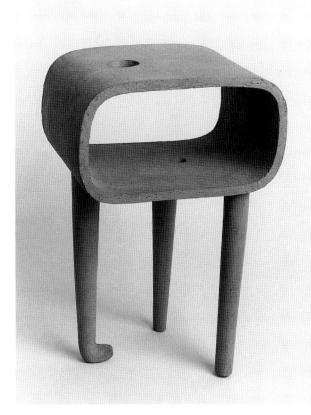

73. Isamu Noguchi. *My Mu.* 1950. Shigaraki ceramic, 13½ x 9½ x 6⅝". The Isamu Noguchi Foundation, Inc.

74. Wang Ming. *Reversed
Dimension*. 1963.
Wood relief print with
oil pigment, 50½ x 14".
Collection the artist

75. Emiko Nakano. *1954 No. 1.* 1954. Ink and collage on paper, 24¾ x 30½". The Michael D. Brown Collection

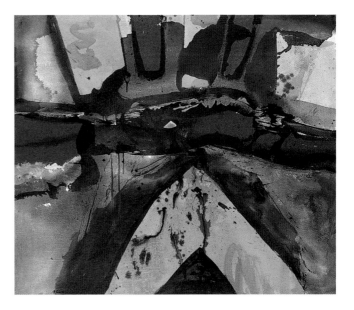

76. Po Kim. *Together and Apart*. 1962. Oil on canvas, 60 x 72". Collection the artist

77. Chao Chung-hsiang. *Between Man and Woman*. 1965–80. Ink and acrylic on paper, 72 x 36". Alisan Fine Arts Ltd., Hong Kong

tions and were seen on both American coasts. Two large exhibitions of this type actually came to San Francisco at the same time, leading one critic to grumble about the unnecessary overlapping and duplication of effort.[17] American artists revealed their interest in the topic by giving Japanese artists, whom they saw as kindred spirits, the chance to exhibit with them. For example, the American Abstract Artists set aside a room adjacent to their own display exclusively for their Japanese colleagues in an exhibition held at the Riverside Museum, New York City, in 1954. One observer felt that "with few exceptions, the [Japanese] pieces might have been hung among the Americans without anyone being aware that here was art from another country done by artists whose . . . artistic traditions are largely different from those of the West." It was also suggested that "the most moving . . . are those which attempt a sincere fusion of the traditional and the abstract."[18]

Contact with the East, especially Japan, was being sought with some energy in the American intellectual circles of the Abstract Expressionist era. The artist Satoru Abe, who had come to New York from Hawaii in 1948, remembers the phenomenon as no less than "a Japanese craze."[19] A widespread curiosity in the art and philosophy of Japan was satisfied by a burgeoning of books and university courses on the subject and an influx of Japanese scholars and artists who could provide firsthand knowledge. The writings and lectures of Daisetz Suzuki were among the best known and received amid the explicators of Buddhism, Zen, and Asian philosophy. Sabro Hasegawa enthralled artists, art students, and others on both coasts with his demonstrations and classes in Japanese painting and calligraphy.

However, in the more hermetic world of the inner circle of critics who would become the arbiters of what was to be defined as Abstract Expressionism, individual accomplishments of Asian American abstractionists were of secondary concern. More important was maintaining the distinction of Abstract Expressionism as an American style, free from external influence. The growing knowledge of Eastern art and a perception that such processes as flung pigment, free gesturalism, spontaneity, and chance—even the very concept of abstraction itself—might find ancestry in foreign soil caused great concern among certain New York critics. They sought to fight off this undermining of American originality by emphasizing qualities of Abstract Expressionism that they deemed particularly American and contrasting them with qualities of Eastern art that they felt were unrelated to the style. One favored device was to emphasize the aggressive, no-holds-barred "action painting" side of Abstract Expressionism. This was seen to go beyond the sense of calm and meditative restraint inherent to much Eastern art, as well as its gently nuanced and subtle color harmonies. At times the critical preference for the aggressive spirit in abstraction could degenerate into something resembling a "macho" aesthetic. One critic stated that an authentic artist puts "himself in tune with natural laws . . . [dancing] as he would with a woman—and if he is a *masculine* artist, he leads" (italics in original).[20] Another wrote that Clyfford Still's work is to be praised for its "masculine, dramatic, pounding expression."[21] Asian American artists, in some instances, were virtually warned not to step into areas where they could not succeed, as when Kenzo Okada was informed that "where he tries to endow empty background space with the dynamism of Abstract-Expressionism," he will produce "monotonous structural hues . . . paradoxically lifeless."[22] The Asian tradition of black-and-white art was conveniently forgotten when Americans praised themselves for the "modern" and "reductive" qualities of their similarly colored works. Further, the subdued colors of many Asian American works often caused consternation. A negative view of Teiji Takai's paintings bemoans their "bands of dimly-edged color [that] lean toward greenish yellow and gray mauve, and are soothing and bland."[23]

A little-noticed trend among some Asian American abstractionists, occurring simultaneously with the use of muted tonalities (and perhaps ignored because it reversed the stereotypical cultural expectation), was the use of extraordinarily bright colors. The immigrant artists, at first bedazzled by the range of colors commonly available to them in America, sought comparable use of color from their own heritage. They found it not in "fine art" but in the folk arts and crafts of their cultures. In the traditional ornaments, packagings,

paper cuttings, and costumes of East Asia were joyful colors aplenty. Po Kim admired the splendid and vivid colors of women's formal robes in Korea, and his painting *Together and Apart* (fig. 76) suggests a robe spread outward, displaying its bright bands of red, green, and yellow. Japanese artists recalled the exuberance of decorative papers, often strewn with colorful flakelike shapes. Indeed, some Asian American artists became almost fearless in their use of color, juxtaposing saturated primaries and secondaries; using the intense hues of traditional mineral colors that included glistening greens and acid yellows; experimenting with the hot pinks and oranges of Chinese inks; or mixing up pastel shades that approached bubble-gum pinks and swooning lavenders. The painter Chao Chunghsiang pursued this trend to the point of adding phosphorescent pigments into his ink and acrylic media (fig. 77). Such color effects, due to their complexity as much as their "prettiness," were rarely attempted by most American Abstract Expressionists.

The American critics' oversight about issues of color and their refusal to consider Asian influences on Abstract Expressionism did not go unnoticed by those who tried to remain objective about the internationalism of modern art. Dore Ashton, for example, feels that there was an a priori bias against Noguchi by some New York critics for his purposeful cultivation of the Japanese aesthetic. Although Asian American artists had opportunities to show, their work seemed to be critically predetermined as secondary. "New York critics would basically never appreciate or give full credit to Asian American artists," recalled Satoru Abe, who returned to Hawaii after several years in New York.[24] Another Hawaiian-born artist, Ralph Iwamoto, was bluntly advised by artist Matsumi Kanemitsu to get out of New York. Kanemitsu asserted that Iwamoto, with his style of pale, drifting forms derived from nature and Japanese decorative motifs (figs. 154–55), "would never be able to make it there."[25] Several Asian American artists in New York, including Kanemitsu, were friendly with many Abstract Expressionists, and even frequented the Cedar Bar, the Abstract Expressionists' legendary hangout, though their presence there generally has gone unnoticed. Ad Reinhardt, whose aesthetic philosophies were deeply affected by Asian

art, recognized the cultural bind that Kanemitsu's art put him in. "Don't go along with crazy J. P. [Jackson Pollock]," he told Kanemitsu. "You're not an Expressionist—you're a natural romantic Impressionist."[26] Kanemitsu took his own advice to Iwamoto (though the latter decided to stay), moving to California and establishing a quite successful artistic career. His paintings encompass many styles, including works in *sumi* (figs. 78–79) and in oil that combine calligraphic inspiration with the gestures and fieldlike compositions of Abstract Expressionism (fig. 80).

In contrast to New York, the American Pacific coast has a history of relatively straightforward acceptance of cultural and artistic influence from Asia. This has been documented in many exhibitions and scholarly writings, which give frank appreciation of the benefits of openness to the East.[27] The region's receptivity to Eastern art and ideas was manifested so strongly that a cross-country dichotomy of attitude was noticeable even to people from Asia. One Japanese curator wrote that the Pacific coast radiates "a calm, peaceful mellowness different from the turmoil of New York" and that Japanese artists living there "aim to attain refinement and profoundness" in their work, "rather than digging at new experiments."[28] American writers native to the Pacific coast pointed to the Asian contacts of their regional art with pride. Since the West Coast saw fit to associate its brand of American modernism with Asia, New York critics, of course, had to try to undercut their efforts. Consequently, when French art writers, considered archenemies by New York School critics, had the audacity to take Pacific coast writers and artists at their word, this gave one New Yorker the chance to launch a three-pronged attack. Simultaneously tweaking France, the Pacific coast, and East Asia he smeared the lot of them with mutual guilt by association: "[The] Pacific School was always something of a myth, a French invention designed to soften whatever blow to national self-esteem the rising international prestige the New York School represented. . . . But the French adored the notion that what was original in the new American painting somehow drew its inspiration from Pacific—rather than American—sources, and they clung to it until the authority of the New York School became too evident to deny."[29]

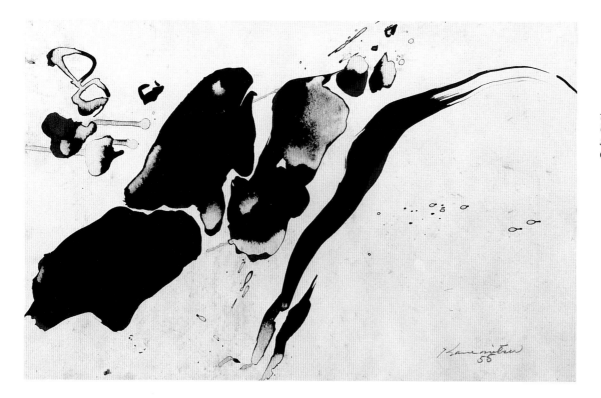

78. Matsumi Kanemitsu.
Untitled sumi #01. 1955.
Sumi ink on paper, 12 x 19".
Collection Nancy Uyemura

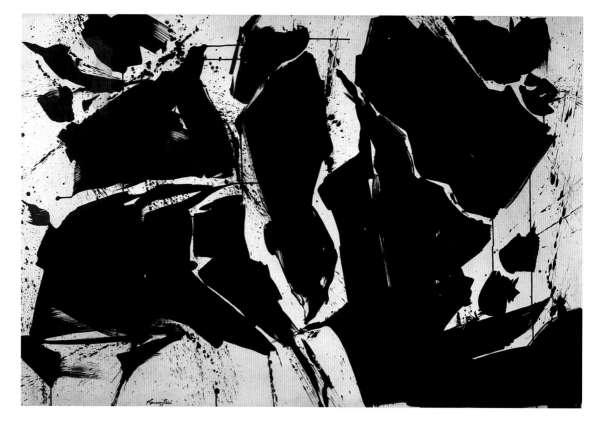

79. Matsumi Kanemitsu.
For Marty. 1959. *Sumi* ink
on paper, 40 x 60". Collec-
tion Nancy Uyemura

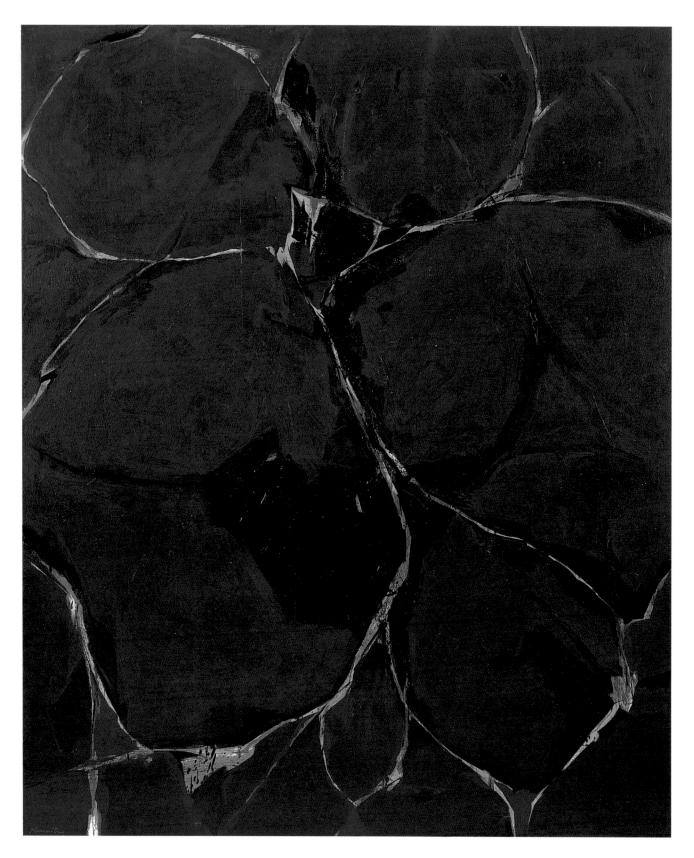

80. Matsumi Kanemitsu.
The Hunter. 1960. Oil on
canvas, 72 x 60". Collection
Nancy Uyemura

Reflecting on New York critics' avid defense of the Americanness of Abstract Expressionism against the taint of foreign influence, it seems reasonable to assume that there would be no need for such commotion if there were absolutely nothing formally or technically comparable in traditional East Asian art to Abstract Expressionism. Such historical precedents do exist; however, they must be taken in the context of the cultures and eras whence they arose. Let us look at four aspects of traditional Eastern artistic expression that may objectively qualify, in some measure, as prefigurations of modern concerns. Some of them will be well visualized in the East/West bridging work of Asian American abstractionists.

The relationship of pigment and support. Perhaps the major physical difference in the traditional art methods of East and West is that the fine art of the East was created essentially using water-based mediums, especially ink, on paper or silk, and that Western painting is based on opaque mediums, especially oil paint, on sealed or relatively nonporous supports. If one treats traditional ink painting in terms of its obvious physical properties—liquid ink will sink into and suffuse an absorbent ground—a specifically modernist quality becomes implicit in its use. The influential critic Clement Greenberg felt that the inherent aesthetic qualities of painting grew directly out of the materials and process-es of painting itself—the application of the pigment, the flatness of the painted surface. Thus Greenberg lauded "stain painting," in which the pigment soaks into the canvas sur-face to integrate color and surface, as a partic-ularly important formal refinement. Artists who stained pigment into their canvases, such

as Helen Frankenthaler, Morris Louis, and Kenneth Noland, became for Greenberg the vanguard of international art, their stained canvases the epitome of advanced painting. Now, the integration of pigment and surface may or may not be justified as representing the furthest edge of the "truth to materials" philosophy of modern art. But whether or not, it seems a remarkable historical error was committed in waiting around for oil or acrylic on canvas to reach that stage. Undeniably, the application of water-based pigments and inks had attained this physical formalism long before Abstract Expressionism. In its purest form ink painting is nothing else if not a stain. The appreciation of this irreversible method long ago led to the "one-stroke" method of Eastern ink painting. The impossi-bility of correcting such a work elicited a respect for, and accommodation to, spontane-ity of gesture. If one takes an objective, inter-nationalist view of art and considers the millennium-old Eastern tradition of water-based inks and colorants soaked into paper or silk, the fuss over the appearance of stain paintings in the 1940s and 1950s seems almost ludicrous.

Field paintings and "abstract imagists." A field painting can be described as one in which the visual incident is of such a reduced, evenly dispersed, or homogenous nature that no tra-ditional points of focus occur. However, in Abstract Expressionism, very few paintings were purely monochromatic, uninflected surfaces. Often the composition would be anchored by a stroke or blotch, asymmetri-cally placed. Such compositions abound in traditional Eastern art, whether in paintings of objects nearly overwhelmed by the voids of the paper around them, in screens in which

several sections might truly be blank, or in panels covered by large areas of metallic paint or foil, creating spatially confusing, flattened fields. Tseng Yuho updated this tradition in her variations (which she calls *dsui-hua*, or "put-together painting") on the older techniques of metal foil application (fig. 82).

Painters such as Adolph Gottlieb, who placed an abstract mark of some sort within a field, were sometimes designated as "abstract imagists." This term could also apply to Louis Pal Chang, in whose untitled work a dark shape almost seems to be floating amid a haze of purple (fig. 85). Abstract forms take on a specifically Eastern derivation in a series of paintings by Sung-Woo Chun. Here the artist suspends a circular motif, representing a mandala, in murky fields of mottled color (figs. 84, 86, 136). A work by Chen Chi (fig. 87), a richly atmospheric field of irregular but fluid gradations of red pigment, on which is brushed a Chinese text, straddles both field painting and abstract imagist work.

Words in paintings. The introduction of words and lettering into the imagery of Western easel painting was received as a startling breakthrough in modern pictorial aesthetics. During the early phases of Cubism, the use of letters was lauded as an act "of vital significance" for modern painting. As one scholar of Cubism put it, "in a style in which one of the fundamental problems had always been the reconciliation of solid form with the picture plane, the letters written or stencilled across the surface are the most conclusive way of emphasizing its two-dimensional character," and further explained that "the stencilled letters and numbers have yet another effect on the paintings in that they serve to stress their quality as *objects*."[30] Again, we find this

method prefigured in Eastern art. The words placed within Chinese paintings, for example, were wholly integrated into the overall composition (fig. 88). Sometimes the words were written in a rapid calligraphy whose gestural effect complemented a swift style of drawing. The words might invade well into the central spaces of the pictures, forcing word and image to be completely equal elements in the composition and meaning of the work. Chen Chi's work (fig. 87) harkens back to this early mode of Chinese painting by placing a long text in midair. The text in this painting is by Lao Tzu, the great philosopher, and the presence of his words in this infinite, cosmic skyscape redounds to the all-encompassing range of his ideas of universal interrelationship and spiritual harmony.

Nonart as art. Use of materials generally considered of no aesthetic value is also seen as a modern, twentieth-century innovation usually associated with the two-dimensional collages of Cubism or the three-dimensional found-object constructions of Dada. In China there is a long history of appreciating rocks purely for their aesthetic qualities. Particularly interesting rocks were mounted on bases as "natural sculptures" and were objects of artistic delectation for scholars and collectors, who valued them highly and even catalogued them (see fig. 24).

While it is visually useful to show stylistic and technical parallels between traditional Asian art and modern art, it is really the underlying Eastern philosophies about art—indeed about life—that have informed Asian American abstractionists. These philosophies give Eastern aesthetics its unique character and raison d'être. When investigating Eastern

81. Sumiye Okoshi. *Ruins
at Sunset*. 1960. Oil on
canvas, 36 x 30¼". Jane
Voorhees Zimmerli Art
Museum, Rutgers, The State
University of New Jersey,
Gift of the artist

82. Tseng Yuho. *Dragonland*. 1964. *Dsui* painting with gold and lacquer, 36 x 71". Hawaii State Foundation on Culture and the Arts, Honolulu

83. Louis Pal Chang. *Untitled*. 1965. India ink and tempera watercolor on paper, 22⅜ x 34⅞". Collection Cornelius Chang

84. Sung-Woo Chun. *Lunar Mandala*. 1962. Oil on canvas, 39¾ x 30½". The Fine Arts Museums of San Francisco, Museum Collection

influence on postwar American art, David J. Clarke took care to indicate that the outer appearance of art and the inner intention of the artist are two very different things, in particular when one is searching for cross-cultural understanding:

Mere borrowings of subject matter or formal devices can be clearly pointed out, but the influence of philosophical concepts occurs at a level below the "surface" of art, although . . . these influences will have repercussions on the "grammar" of artists' formal language. Cases of unassimilated influence (of whatever kind) are more easy to document, and have often drawn art historical interest, but they represent less important events in aesthetic terms. True creative artists tend to respond to influences in a more complex way than that suggested by the mechanistic model of "stimulus-response" which seems to underlie a lot of art historical thinking on the subject.[31]

When we look at a work that appears to have borrowed an Eastern method or motif, we are justified in asking whether the Asian influence is "properly" used. Although not necessarily the case, it is more likely that an individual with direct contact with Eastern culture will employ aspects of that culture with understanding and respect, and that any work of art resulting from such a borrowing will possess a more authentic cultural resonance. For example, Tseng Yuho's *A Sung Ballad* (fig. 89) is equally an attempt to re-create visually the cultural messages of an ancient Chinese poem as it is a modern adaptation of traditional metal foil techniques. To Minoru Niizuma, patterns of concentric grooves or concave and convex forms placed on opposite sides of a stone block are not mere decorative devices (figs. 127–28). They tell of the necessity of working in harmony with one's materials and represent the *yin-yang* duality inherent in all things: "I am always aware of harmony in carving stone . . . the harmony in nature itself and the harmony between man and nature. To bring out this harmony I always use rhythm and strike a contrast between the polished and the natural rough surfaces of the stone. To me, this symbolizes the dual aspect of nature: its beauty and its pathos: This also signifies man's twofold nature."[32]

85. Louis Pal Chang.
Untitled. 1965. India ink
and tempera watercolor
on paper (two panels),
39⅞ x 52½". Collection
Cornelius Chang

86. Sung-Woo Chun.
Hyang-to (Homeland). 1960.
Oil on canvas, 71 x 63".
Sarah Lawrence College

87. Chen Chi. *The Canon of Tranquil Peace*. 1961. Watercolor on paper, 36 x 72". Collection the artist

88. Chin Nung (1687–1764). *Plum Blossoms and Calligraphy*. Hanging scroll. Ink on paper, 45¾ x 16⅜". Yale University Art Gallery, The Leonard C. Hanna, B.A. 1913, Fund

Similarly, the extended progression of alternating black-on-white and white-on-black panels by Wang Ming is another visualization of *yin-yang* and the interdependence of opposites (fig. 90). The unitary forms on each panel express the meeting of opposites through their alternating contained and bursting shapes. And no stroke, no matter how random-looking, is without purpose: "Every dot, every line, and every form in my paintings serve as symbols for things in the universe."[33]

Even the prosaic ceramic vessel, so taken for granted in the West, can become a container of cultural philosophy. By the simple but radical step of pinching closed the tops of her vessels, making them functionless and impractical in the traditional sense, Toshiko Takaezu fills them with internal spiritual meaning (fig. 91). It has been remarked that the "Zen concepts to simplify to absolute minimum and perceive intuitively" are realized in her closed forms and that their nonfunctionality renders them as "spiritual forms . . . arrived at after removing unnecessary parts one by one."[34]

The aesthetic of East Asia is intrinsically intuitive and reflective of complex systems of philosophy of life, nature, and art developed over many, many centuries. Thus, in the abstract art of Asian Americans, one of the

89. Tseng Yuho. *A Sung Ballad*. 1967. *Dsui* painting, 35¾ x 41". Hawaii State Foundation on Culture and the Arts, Honolulu

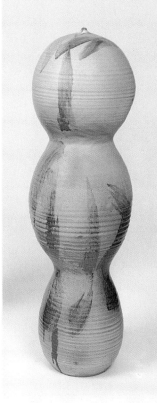

91. Toshiko Takaezu. *Tamarind*. 1963. Glazed stoneware, h. 35". Collection the artist

90. Wang Ming. *The Transition of Yin and Yang* (detail). 1970. Acrylic on rag board, 18 x 93". Collection the artist

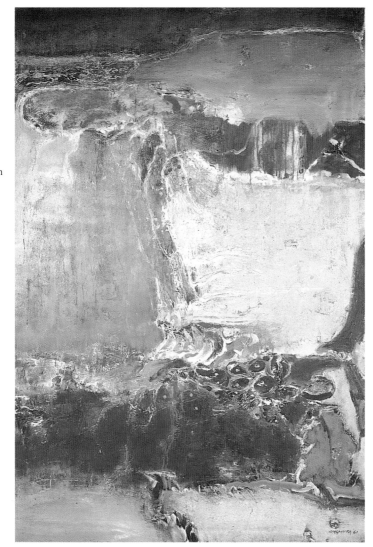

92. Arthur Okamura. *Untitled.* 1961. Oil on canvas, 52 x 36". The Michael D. Brown Collection

sense than in the West (see fig. 46). Consider this passage on the contrasting Chinese and Western approaches to simplification, abstraction, and pictorial content:

[B]ecause Chinese painting and "modern" painting are both more intuitive, abstract, and suggestive than western painting has been since the Middle Ages, it does not follow that these superficialities stem from similar motivations. Chinese intuition is far removed from contemporary subjectivism; the abstract quality of Chinese design arose from simplification and elimination rather than from mechanization and distortion of forms; and suggestion in Chinese painting, although used to heighten the awareness of the unknown, seldom departs from the laws of nature. Today our painters strain after the new and startling, while the Chinese artists built upon the old and the mature. If we look at Chinese painting through "modern" eyes we will miss its meaning.[36]

That Chinese artists "built upon the old and the mature" is highly significant, for modern artists emerging from such a culture will find the application of tradition natural and beneficial. The Eastern road to modernism will merge with, not diverge from, the past.

Abstraction and Nature

The "abstraction of simplification and elimination" is part of the Eastern heritage but so is the tradition that "seldom departs from the laws of nature." This partially explains why modern artists living in Asia who had a heritage extraordinarily free in its abstraction of nature were often resistant to making the step into completely nonobjective art. An imaginative envisioning of reality could be stretched nearly indefinitely but not snapped and released to drift without any connection to it. Consequently, nature imagery has been incorporated in the work of many Asian American artists. Their refusal to discard all vestiges of nature from their art and their decision to work in the realm of semiabstraction were contrary to the critical tenor of the Abstract Expressionist era. Referring to Japanese-born artists, James Suzuki reflected that "most of our abstraction is a nature abstraction." In his own early abstract styles (figs. 94–95), he

most fruitful courses of appreciation may be to first view the art in the context of significant parts of these intellectual and spiritual constructs. As Clarke indicated, when a "less simplistic approach to the question of influence is adopted, . . . a particular influence will not be felt to be a denigration of that artist's creative talents. Response to an influence can itself be a creative act."[35]

Scholars of Asian art who have tackled the problem of East/West interaction in modern art have generally been more perceptive in their appraisals of such art simply because they understand the principles behind Asian art. The Asianists also have the advantage of familiarity with the cultural tendency toward abstraction in traditional Eastern art and realize that "abstraction" as a concept is assuredly there, but is used in a different

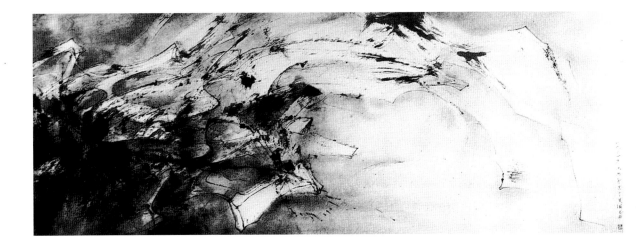

93. Wucius Wong.
Infinite Landscape. 1964.
Ink on paper, 18½ x 52".
Collection the artist

94. James Hiroshi Suzuki.
Lost Word of Love. 1957.
Oil on canvas, 51 x 60".
Sarah G. Austin Foundation

95. James Hiroshi Suzuki.
View Across the River. 1958.
Oil on canvas, 54 x 44".
In the Collection of The
Corcoran Gallery of Art,
Gift of Larry L. Aldrich

97. Diana Kan. *The Valley Awakes*. 1961. Mineral colors on silk, 10½ x 25¼". Collection Howard and Susan Silver

retained suggestions of the flattened, simplified landscape forms of traditional Japanese screens, with patches of paint fluttering over the surface like an exaggerated snow shower.[37]

At a time when even so prominent a figure as Willem de Kooning could be seen as a "traitor" to the Abstract Expressionist cause by initiating a series of paintings based on women, it did not bode well to be regarded as a landscapist, no matter how freely brushed was one's depiction. However, to the Eastern mind, nature is the irrefutable, ultimate source of all things, including artistic expression. In fact, humanity and its creative acts are themselves part of nature; one does not attempt to deny one's part in the larger natural cycle or try to supersede it. The human being is considered but a very small, insignificant entity, who must humbly accede to nature's vastness and overpowering grandeur. The individualism of Western thought, on the other hand, reaches extremes in the statements of some American Abstract Expressionists. When Pollock was asked if his work was in any way inspired by nature, he responded, "I am nature." Clyfford Still, in a similar vein, stated "I paint myself, not nature." Such remarks are unthinkable to the traditional Eastern mind. Virtually all Asian American artists in this study regard nature as central to artistic creativity, whatever the degree of apparent abstraction in their work.

A good proportion of Chinese American artists experimented with abstraction through landscape, some believing that abstraction is inherent in their work because the Chinese artist does not seek imitation of nature, but the momentary capturing of an essence or mood perceived in a fragment of nature. It was a common practice of Chinese artists not to paint in front of nature but to paint from the memory of an encounter with nature so that mere scenic reproduction gave way to a superior, internalized expression of experience and emotion. Diana Kan's work illuminates a widespread modern Chinese methodology, respectful of tradition yet pushing accepted techniques a bit further within the limits of representation (figs. 96–97). For Kan, landscape painting "stress[es] a philosophical preoccupation with the immensity of nature and the overall rhythm of life."[38] Her lush washes of mineral pigments and adaptations of *p'o-mo* and other particularly free methods of earlier painting have led to progressive stages of abstraction throughout her career.

With deep understanding of Chinese ink and brush methods as well as Chinese art history, artist and art collector C. C. Wang has explored the wide range of abstract technique and imagery. His artistic production is marked by works of remarkable diversity that range from relatively traditional landscapes (fig. 98) to ones that almost seem to take leave of recognizable content (figs. 8, 100). According to Wang, Chinese artists of past centuries in their quest for "the spirit of nature realized the skill of precise rendering was not necessary."[39] The abstract qualities of Wang's brushwork (fig. 99), informed by that

OPPOSITE:
96. Diana Kan. *Mountain Village*. 1960. Mineral colors on silk, 23½ x 17¾". Collection Howard and Susan Silver

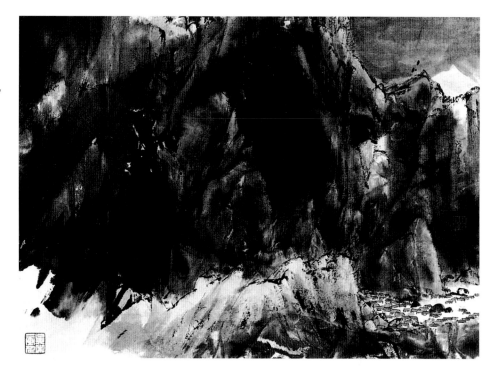

98. C. C. Wang. *Landscape*.
1969. Ink on paper, 23 x 33"
(image), 64 x 35½" (scroll).
Collection the artist

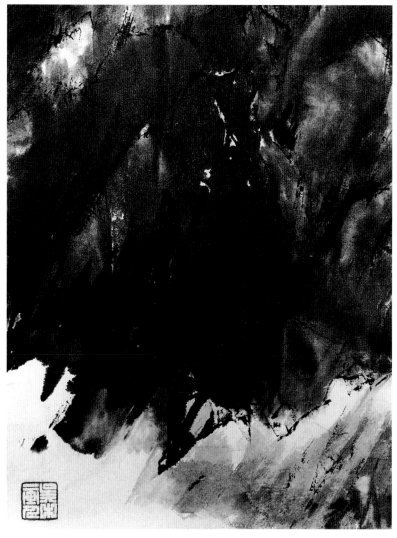

99. C. C. Wang.
Landscape
(detail of fig. 98)

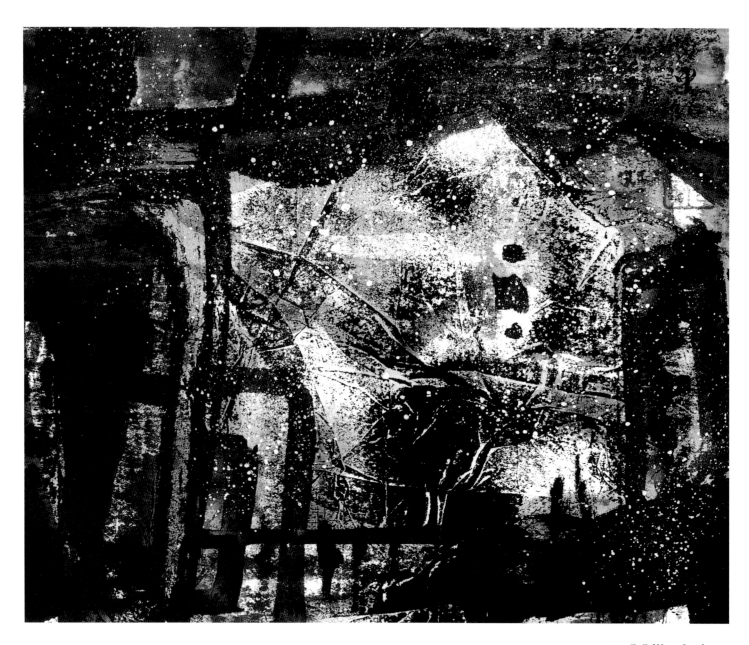

100. C. C. Wang. *Landscape*.
1969. Ink on paper, 8¼ x 9¾".
Collection the artist

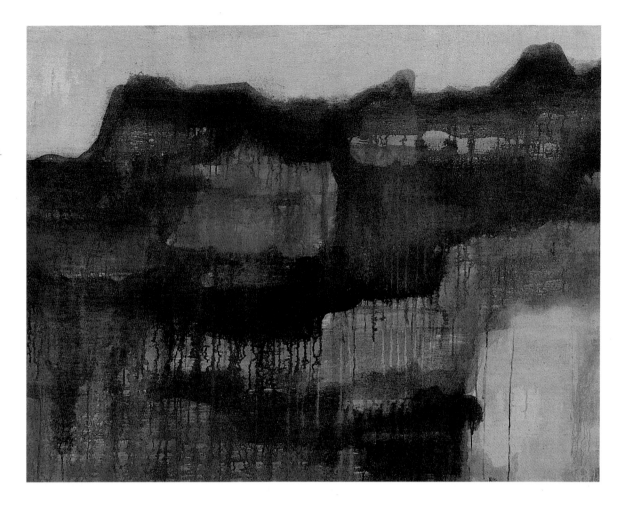

101. James Leong.
erosions on a timeless face.
1959. Mixed mediums
on canvas, 45½ x 57".
Collection the artist

102. James Leong.
corridors. 1961. Mixed
mediums on canvas,
35½ x 59". Collection
the artist

idea, are contemporary extensions of this traditional viewpoint. James Leong's work, while it maintains landscape references, is positioned at another point along the scale of relative abstraction of image. Through effects related to aspects of a linear chiaroscuro that the artist perceives in Chinese brush painting, his surfaces may optically verge on the monochromatic. Scenes that overpower the viewer —Leong regards many Chinese landscapes as projecting an "untouchable" quality with mountains that can't be scaled—have great meaning to him; they awe the individual as "a dot in the majesty of nature."[40] The landscapes also act as symbols of longevity and incalculable time, as indicated in their titles: *erosions on a timeless face* and *passage into black*, for example. These richly painted, brooding images, Leong says, were direct expressions of his mood at the time (figs. 101–2).

For artists with more fully abstract leanings, there was no need for outright rejection of natural forms. Wang Ming had no intention of creating realistic imagery while he worked on a painting of vigorously applied short strokes and a few circles (fig. 103). But the accumulation of strokes had a bramble-like visual effect, and the artist titled the work *Garden of Infinity* to acknowledge both the abstract and natural aspects of the final image. Some artists updated venerable themes of Asian nature painting, such as that of a delicate plum blossom or other type of branch reaching into the picture. In Kenzo Okada's *Moon Is Down* this motif is transformed into a softly inflected field of beautifully nuanced pale colors (fig. 104). The same motif is imaginatively brought into the arena of both "action painting" and radical Zen brush gesture in Don Ahn's *Broken Branch in the Rain* (fig. 105). Here, the traditional Japanese device of a strongly silhouetted shape set on a spatially "empty" background is used to striking effect. The explosive trails of flung ink work perfectly to capture the natural essence of the scene—what could better represent rain than drops of liquid that have been propelled onto the paper like so many wind-driven rain-

103. Wang Ming. *Garden of Infinity*. 1962. Acrylic on rice paper, 80½ x 25¼". Collection the artist

104. Kenzo Okada. *Moon Is Down*. 1950. Oil on canvas, 30 x 25". Collection of The Montclair Art Museum

106. Walasse Ting.
Sunrise. 1962. Oil on
canvas, 50⅜ x 59½".
Opengate, Somers, N.Y.,
Gift of Mrs. John Lefebre

105. Don Ahn. *Broken
Branch in the Rain*. 1963.
Ink on rice paper, 50 x 28".
Collection the artist

107. Walasse Ting.
All Month Rain. 1969.
Acrylic on canvas, 88 x 82".
The Carnegie Museum of
Art, Pittsburgh, Gift of
Women's Committee,
70.52.4

drops? In this aesthetic context, any spatter-
ing of paint, any effulgence of color could be
coaxed to display nature in its infinite variety.
In Walasse Ting's hands, multicolored spurts
of paint dashed about a circular gesture sug-
gest a *Sunrise* (fig. 106); a canvas strafed with
paint congealing into a mass above and scat-
tering into dripped trails below indicates an
All Month Rain (fig. 107). Even without the
initial intention of referring to standard for-
mats of landscape or natural elements, many
Asian American artists found that its
presence could erupt spontaneously, almost
unbidden. A series of brush gesture paintings
by Chinyee, as implied by their collective title,
Markings, was primarily intended as an exer-
cise in abstraction. But intermittently the
artist's quick strokes would hint at a natural
motif—a mountain, perhaps—and, with the
addition of a dashed-in ground line and an
orb set high, an abbreviated landscape would
emerge (fig. 108).

The practice of nonobjective abstraction
in the West afforded enormous latitude to
Asian American artists working with natural
imagery. The artist was free to move beyond
the internal factural abstraction of the East
into the pictorial abstraction of the West. In
effect, nature abstraction for Asian Americans,
depending on their inclination, could proceed
from the outside in (rendering abstract
impressions of nature or its forces) or from
the inside out (using one's latent emotional
and spiritual ties to nature to imbue abstrac-
tion with essences of natural properties).
Certain works by Tadashi Sato and Fay
Chong are examples of the former manner.
Sato's painting *Submerged Rocks* depicts a
favored early subject of the artist, submerged
rocks on the coast of the island of Maui (fig.
109). Moving water and dappled light made
the rock forms indistinct, and in Sato's mind's
eye the scene evolved into a pattern of dissolv-
ing shapes. The core visual effect was translat-
ed into the traditional black, white, and gray
of Asian landscape. Through this blurring of
objects and color reduction, Sato felt that he
came closer to "creating the poetry" that was
the crux of nature.[41] Reduction of natural
visual effects to a minimum is also key to Fay
Chong's pictures. *Cliff Formations No. 2* (fig.
110) is an extreme example of Chong's sim-
plification of observed nature—in this case,
the vertical edges of a jagged cliff—to brief

108. Chinyee. *Markings
2 A.M.* 1965. Watercolor on
paper, 18 x 24". Collection
the artist

109. Tadashi Sato.
Submerged Rocks. 1958.
Oil on canvas, 36 x 42".
Collection of Whitney
Museum of American Art,
New York, Purchase, with
funds from the Neysa
McMein Purchase Award

110. Fay Chong. *Cliff Formations No. 2*. 1960. Chinese ink on paper, 22¾ x 16". Collection Dennis and Sandra Chinn

111. Dale Joe. *White Nights.* 1958. Oil on Masonite, 48 x 25" (diptych). Collection the artist

calligraphic marks, a method in which the artist "submerged everything but the essentials," and caused a writer to dub Chong "an Oriental [Lyonel] Feininger."[42]

Alternatively, works by Paul Horiuchi, Sueko Kimura, Soojai Lee, and Dale Joe (fig. 111) represent an interest in capturing natural processes or imagery, consciously or subconsciously. Horiuchi's collages, abstract though they may be, often seemed attuned to nature, their juxtapositions of planes of torn paper suggesting the subtly colored planes of weathered rock surfaces, noted in titles such as *Remaining Snow in the Rockies* and *Winter Mountain*. The grayed, subdued color scheme of *December #2* (fig. 112) evokes the chill climate of that month. Kimura's painting process seems to mimic the unpredictability of organic growth itself. In *Lost Garden* (fig. 113), Kimura allowed floating forms and gestures to coalesce, letting the image come together almost of its own volition, like some strange aggregation of living cells. The color scheme is reticent; pale and grayish greens are evocative of growth in a sequestered, shadowed place. Because of the liquidity of her thinned medium, the painting took six months to complete, allowing a centralized, indistinct image to appear over time. Finally, enough of a form emerged at the center to consider the painting complete. Through patient painterly wandering "a lovely thing" had been found as if stumbled upon "amid an abandoned garden." The central form is something "like a pearl, that emerges unseen" through a slow, hidden natural process.[43] In Soojai Lee's *Work* (fig. 114), a few rapid strokes toward the bottom suggest mountain peaks, and the rest of the surface is given over to a region of indeterminate atmospherics. The artist seeks moments while painting when her "very being is in perfect harmony with nature . . . and metaphysical phenomena," and she feels that her works "are studies of the relationship between my ego and the universe."[44]

Several Asian American sculptors have also made references to nature in their works. A simplification of form is often the preferred method in this endeavor, as in *Twin Trees* by Satoru Abe (fig. 115), where trees and branches are reduced to prototypical, symbolic shapes. (The angular shapes of Abe's tree-signs are also related to early forms of calligraphy since the pictographs of Asian languages are

112. Paul Horiuchi.
December #2. 1959.
Gouache and paper
collage on canvas,
34½ x 60¼". The
Seattle Art Museum,
Northwest Annual
Purchase Fund

113. Sueko Kimura.
Lost Garden. 1964.
Oil on canvas, 28 x 40".
Collection the artist

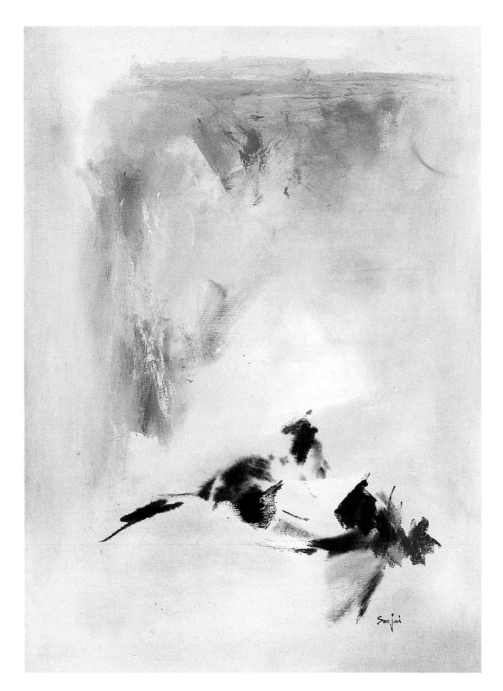

114. Soojai Lee. *Work*. 1967.
Oil on canvas, 53½ x 39½".
Collection the artist

themselves visual abstractions.) For John Pai, artistic outlooks that are "parallels with the traditions of Eastern thought" encourage a natural sculptural process, "emerging with no conscious effort on my part."[45] Though working in metal, Pai works with "no preconceived ideas," building up forms piece by piece: "Welding is a fluid process like painting with a sable brush. Flame makes a droplet of molten metal. The wire makes a line." Pai understands that Western abstraction, in its own way, tries to reduce images to essences, but feels the formalistic essences revealed by the Cubism of Picasso and Braque, for example, are not very interesting.[46] Instead, he turns to Eastern concepts of organic essences. "If painting a tree," Pai declares, "the artist must feel the strength which flows through the branches. . . . Confucians, Taoists and Buddhists have stressed that to understand a thing, one must become that thing. . . . One must harmonize one's consciousness with one's subject."[47] Thus, Pai's early sculptures (figs. 116–17), which suggest accumulative growth, as of coral or plants, "came out of [his] interest in structures in nature, and how cells form membranes and organisms."[48]

Sculptor Leo Amino's inclination toward expressing natural growth processes was at first applied in sculptures of carved wood such as *Stamen* (fig. 118), a suavely formed plantlike vertical with delicate rods spatially suggesting an enveloping pod. But Amino found a new medium that cleverly permitted remarkable visualization of organic processes. He became one of the first Americans to consistently use plastic as a sculptural medium and pioneered the use of cast plastics during the late 1940s. Liquid plastic is itself a viscous material reminiscent of amoeboid protoplasm; when hardened, its transparency literally permitted a view of the "inner life" of Amino's sculptures. In *Carnivorous Plant* (fig. 119), with wisps of dye and scattered inclusions visibly embedded in its body, Amino found a perfect, if somewhat unsettling, subject for presenting a palpable organic vitalism in sculptural terms.

If abstraction in the service of organic properties marks the path taken by some Asian American artists, other artists sought to focus even more precisely on the Asian philosophical attitudes toward nature. As the spirit of nature flows through all things, ani-

115. Satoru Abe. *Twin Trees*.
1961. Bronze, copper,
and steel on wood base,
26⅜ x 38¾ x 8½" (includ-
ing base). Collection of
Whitney Museum of
American Art, Purchase,
with funds from Mr. and
Mrs. George W. Headley

116. John Pai. *Untitled*.
1963. Bronze, 34 x 38 x 21".
Permanent Collection,
Pratt Institute, Brooklyn

117. John Pai. *Untitled*.
1968. Welded steel,
58 x 38 x 38". Collection
the artist

118. Leo Amino. *Stamen*. 1950. Maplewood, 51½ x 4½ x 4½". Jane Voorhees Zimmerli Art Museum, Rutgers, The State University of New Jersey, Gift of Mrs. Julie Amino

119. Leo Amino. *Carnivorous Plant*. 1952. Polyester resin, wood, thread, and wire, 23½ x 6½ x 4". Jane Voorhees Zimmerli Art Museum, Rutgers, The State University of New Jersey, Gift of Mrs. Julie Amino

mate and inanimate, the physical components of nature themselves have an inherent aesthetic as part of the cosmic harmony of existence, which may be apprehended by sentient beings. The earliest art traditions of many cultures, especially Eastern ones, perceived an aesthetic quality in simple natural forms, revealed through animistic religions, and the creation of objects from relatively unmodified natural materials. From burial mounds, grave markers, and the like, rough stone formations became progressively acculturated, evolving into nature-based art forms such as the Chinese mounted rock and the Japanese rock gardens. In the modern era, the West came to recognize the validity of the "truth to materials" dictum, and the natural qualities of sculptural materials were increasingly respected. In the East, however, this respect for nature's handicraft had been continuous. For Asian Americans, both traditions merged, though the Asian admiration for natural materials, untouched or nearly so, resonated more fully as a culturally grounded, philosophical impetus. The series of sculptures of simple stacked forms that George Tsutakawa started making in the 1950s (figs. 120–22) bears a tempting visual relationship to the products of popular Japanese practices. Small *seki-to* (stone towers) are found throughout Japan. "Their locations are varied, their meanings are fluid and often obscure. . . . [H]eaps of little stones [are] thrown up onto the beams of the *torii* gates at shrines. . . . Japanese pilgrims made more careful piles of single stones on a single axis as prayers for safe passage. . . . [The] Buddhist protector of infants [was] signified by a carefully balanced stack of rounded and well-shaped rocks."[49] Tsutakawa's series of stacked-

120. George Tsutakawa. *Obos No. 15*. 1961. Cedar, 30½ x 26 x 18". Collection Ayame Tsutakawa

form sculptures, *Obos*, takes its name from stacked piles of stones found in the Himalayas.

From an Eastern viewpoint, the artist and the art material are both parts of nature, so the carving of a natural material is an intrinsically cooperative act—and for the artist, an event fraught with feeling. Toshio Odate, on seeing a raw wooden log, understands that "the log is a world in and of itself" and that his concern is "how to act as a conduit for the form of that world." In producing a sculpture from wood (figs. 124–25), Odate is obliged to offer it "a new life, without destroying its essential nature."[50] Retaining this essential nature was also a preoccupation of Minoru Niizuma. The protuberances of an early wood piece (fig. 126), he noted, are irregular, organic, and intuitively carved, but represent an overlay of the artist's vision on the material. By working in stone (figs. 127–28), the artist felt that meaningful dualities could be harmonized: the untouched/altered duality of parallel radiating grooves and the symbolic duality of solid/void or concave/convex. "Each stone has a philosophy," the artist says.[51] Niizuma has generously remarked that it was Noguchi who "best translated what stone is all about" in his work. Noguchi made a lifelong study of the principles and philosophies behind the artistic presentation of stone in Eastern culture, assimilating lessons from ancient sculptures and rock gardens alike. Noguchi "imbued his materials with symbolic significance," in particular the passage of time or nature's relative permanence and humanity's impermanence. "The slow pace of carving very hard stone . . . engaged the still greater time of geological process, leading toward that of

121. George Tsutakawa. *Obos No. 1*. 1956. Teak, 23¼ x 9¾ x 9¾". The Seattle Art Museum, Gift of Seattle Art Museum Guild

122. George Tsutakawa. *Obos No. 5*. 1957. Cedar, 34 x 19½ x 19½". Santa Barbara Museum of Art, Museum purchase, Third Pacific Coast Biennial Fund

123. Nong. *I Ching*. c. 1968.
Walnut with bronze base,
82 x 10 x 10". Collection
the artist

124. Toshio Odate.
Messenger from Xanadu.
1962. Oak, h. 30".
Collection the artist

125. Toshio Odate.
Tokobashira. 1962. Oak,
h. 30". Hirshhorn
Museum and Sculpture
Garden, Smithsonian
Institution, Gift of
Joseph H. Hirshhorn,
1966

126. Minoru Niizuma.
Untitled. 1961. Carved
cherry wood, 48½ x 33 x 3⅝".
Collection the artist

127. Minoru Niizuma.
Untitled. c. 1961–62.
White marble, 22 x 18 x 9½".
Collection the artist

128. Minoru Niizuma.
Castle of the Eye. c. 1961.
Marble, with wood and
metal base, 20 x 19 x 10"
(height with base: 60½").
Collection Doris and
Melvin Sirow

129. Isamu Noguchi.
Worm Pyramid. c. 1965.
Granite, 12½ x 23½ x 23½".
The Isamu Noguchi
Foundation, Inc.

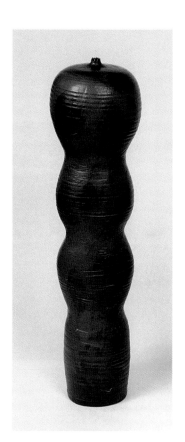

130. Toshiko Takaezu.
Stacked Form. 1962. Glazed
stoneware, h. 30".
Collection the artist

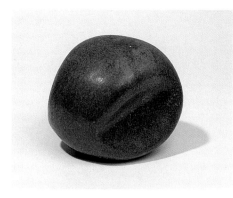

131. Yien-Koo King. *Stone*.
c. 1959. Glazed ceramic, h. 4".
Collection Minoru Niizuma

cosmological formation. The phenomenology of carving became, for Noguchi, an engagement with metaphysics and a means of situating himself within the cosmos."[52] Even among Noguchi's smallest pieces, allusions can be found to the importance of stone in preserving echoes of past civilizations and to the continuity and universality of cultural understanding of the symbolic power of simple shapes (fig. 129).

To some extent, those who toil in the more malleable medium of clay partake of the richness of this philosophical notion of natural art materials, inasmuch as their medium is also the substance of the earth itself. Just as Odate finds continued life in a log or Noguchi plumbs the depths of a stone's physical existence, Toshiko Takaezu regards her work with clay as an artist/nature collaboration. Through her travels in Japan, including residence in a Zen monastery, she strengthened her original cultural receptivity to the spirit of natural materials. To her, "clay is a sentient being, alive, animate, and responsive," a material entity that "has much to say."[53] That clay can represent the unaltered presence of natural forms, despite the necessity of some sort of physical manipulation, is pointedly and poignantly illustrated by a sculpture by Yien-Koo King (fig. 131). This piece is a very simple ceramic form shaped to look like a

rounded stone or a pebble that has been naturally polished over time by the action of water. It is a paradoxical object: an artificially formed sculpture made only of earthen (and originally soft) materials replicating a natural object (intrinsically hard) wrested from its source and smoothed without human assistance. This very modestly sized, unassuming object (one of several similarly conceived pieces simply called *Stones*) cleverly recalls the Eastern acceptance of bits of nature as art, such as Chinese mounted rocks, and conceptually summarizes, in an inside-out way, a modern Asian American approach to natural form in art.

Ancient Philosophy in Modern Forms

The paradox of a stone-that-is-not-a-stone, yet *is* of the earth, reminds us that the workings of the aesthetics philosophies of the East, though venerable, are still not always easily understood by Western observers. To approach a true understanding of these works, some further investigation of fundamental Eastern philosophical concepts is necessary. Significantly, these concepts have more to do with spirituality, metaphysics, and the workings of the universe than with pure formal aesthetics. This is a fact that cannot be over-

emphasized when evaluating Asian American abstraction during the Abstract Expressionist era because much of the substance of the "advancement" of art in America in those years was described in purely formalistic terms.

Abstraction of form in the East comes from an a priori understanding that what one paints is not reality and is not meant to imitate it. Eastern art is impelled by the creation of moods, the elicitation of emotion, and the striving for a spiritual vitalism of technique. To the Western mind, Eastern art is, in a sense, based on nonartistic principles such as religious and philosophical beliefs. For example: "Buddhism teaches that things are created by the mind rather than that the mind perceives existing things. It is therefore concerned with interpreting values rather than describing facts."[54] This premise, when applied "in the field of artistic activity . . . is a definition of the highest form of conception, the purest kind of inspiration. . . . [If the artist] possesses the proper means of exteriorization, he will transmit in symbols or shapes something which contains a spark of that eternal stream of life or consciousness."[55] From a Western viewpoint, taking both a "conception" and "pure inspiration" to "transmit in symbols or shapes" sounds like a fair approximation of the process of artistic abstraction. "The eternal stream of life or consciousness" is altogether another matter. Yet, it is crucial to the Eastern artistic process, which sees art as but another manifestation of the spiritual, vital forces that connect all things and must be incorporated into art.

Thus, the spiritual content of art is neither a small issue in Eastern culture nor is it merely a pretty theoretical construct with no impact on actual experience. As an example, consider an event that took place at the studio of Tadashi Sato. The paintings of Sato represent one type of abstraction frequently pursued by Asian American artists: a sensitively balanced arrangement of simplified organic or rounded forms painted in muted hues and very subtle tonal relationships. It is a reticent and nuanced art, intentionally quiet, poetic, and meditative in mood. Sato's paintings, which often employ nothing more than several carefully placed lines and a few restful shapes in shades of white, are certainly exemplars of this approach (figs. 132–33). It is not surprising that he has been drawn to the

132. Tadashi Sato. *Untitled.* 1957. Oil on canvas, 30 x 40". Collection Mr. and Mrs. Crosby DeCarteret Doe

133. Tadashi Sato. *Untitled.* 1957. Oil on canvas, 36 x 50". Collection Mr. and Mrs. Crosby DeCarteret Doe

134. Wang Ming. *Flow*.
1969. Acrylic on rice
paper, fabric-bound cover,
9½ x 182¼" (fully extended).
Collection the artist

study of Zen and has spent time in a Zen monastery; he admits to being fascinated by rituals of contemplation and concentration. Nevertheless, he was rather unprepared for the reaction of a Buddhist priest who recently entered his studio. The priest saw Sato's works and was transfixed. So stunned was the priest by what he later said was the spiritual quality in the art, that he likened the paintings' effect to that of a sutra and stopped amid them to pray. Afterward, the priest told Sato that he would like to use a painting that particularly moved him as the cover for a publication marking the centenary of his Buddhist temple.[56] With these sacred and secular recommendations, let us look at some of the basic tenets of Eastern philosophy that bear on the production and appreciation of art and at some examples of work by Asian American artists that are informed by them.

A fundamental concept in Eastern thought is that of the Tao, sometimes translated as the "way." A metaphysical entity of bewildering omnipresence, the Tao is no less than the existence and actions of all things in the universe, known and unknown, "the all-pervading, self-existent, eternal cosmic unity, the source from which all created things emanate and to which they will all return."[57] The Tao is the essence of being, therefore all natural actions and occurrences that flow unencumbered, unfolding as they will through time, are models of the Tao. Movement, flux, the vitality of nature itself are manifestations of the Tao. It has a strong connection to traditional Chinese painting: "By the single daring assumption of the cos-

mic principle of the Tao, the Chinese focussed on the notion of one power permeating the whole universe, instead of emphasizing the western dualisms of spirit and matter, creator and created, animate and inanimate, and human and nonhuman. This concept of the Tao was the touchstone of Chinese painting which affected the creative imagination."[58]

All time, unending, is a manifestation of the Tao. It is reasonable that under such an influence, a sense of nonceasing natural process, of endlessness, would emerge in Eastern painting. This quality appears in an image by Wang Ming (fig. 134) that is so extremely extended as to seem almost endless. Significantly, it is titled *Flow,* and in its abstraction it suggests more than rushing water; it also represents natural energy, transitoriness, and change. Furthermore, its creation was virtually an act of artistic spontaneous generation since the work was expertly brushed in less than a minute—a veritable "action painting." Indeed, Wang Ming describes one of his approaches to art as "Taoist metaphysical Abstract Expressionism."[59] This notion, the artist relates, "is very natural to me. Since the beginning of Chinese civilization, pioneers have recorded their thinking through abstract art. Because of my Chinese background, original Chinese thoughts about art are deeply buried in my soul."

The Tao is unimaginably vast, incomprehensible. Yet because it resides everywhere, it is intimate in its immanence. It touches us and connects us to everything. One scholar of Chinese art noted that a connoisseur of the

Song period, Tung Yu, invoked the Tao when contemplating the sources of pictorial conception:

. . . one spirit causes all transformations.
This moving power influences in a mysterious way
All objects and gives them a fitness.
No one knows what it is, yet it is something natural.[60]

How may one presume to produce a visualization of the Tao? As its description is beyond words, its picturing is beyond images. This was the quandary Chen Chi encountered when he determined to create a series of paintings about the Chinese sage Lao Tzu and his explication of the Tao, the *Tao Te Ching.* Chen Chi is a masterful technician who had considerable experience with Chinese ink painting and great success and popularity with representational paintings in watercolor. He realized straightaway that he "could not use objects to represent it [the Tao]. The subjects of 'non-being' and such made it necessary to use abstraction."[61] In a series of six paintings of the same size, Chen Chi embraced near nonobjectivity to reify the thoughts evoked by Lao Tzu and the Tao. The third in the series (fig. 135) is representative of the overall approach.

At first glance, this seems an utterly nonobjective work. The surface is essentially a seething, mottled wash of yellowish tints, insubstantial in all parts except perhaps for the dark spot at the upper right, which itself

appears to float and dissolve into the swirling
atmospherics. The universal flux of the Tao is
evoked through a glowing miasma, reminis-
cent of traditional gold-covered surfaces in
Eastern art that represent a timeless, ambient,
and infinite space—a cosmic space with impli-
cations extending much further than the ref-
erence points of the sun and moon given by
the work's title. A *yin-yang* arrangement may
be perceived by the opposition of the dark
spot and a small heart-shaped patch of golden
pigment across a curving, imprecise boundary
of pale color that gently divides the painting
on a diagonal. The inscriptions that flank the
composition are rendered in particularly
archaic ideograms, stressing the continuity of
the Tao (and of Chinese civilization) through
vast reaches of time. In modern formal terms,
this is a field painting. But it is an abstract
field in the service of abstract thought, a logi-
cal and effective adaptation of traditional ink
techniques to suggest the unknowable core of
reality. The spiritual strivings of various
artists have naturally developed into "color
fields." The indistinct, nebulous qualities of
fluidly applied color became Sung-Woo
Chun's method of "symbolizing the state of
mind where one could achieve the absolute
and the eternal tranquility." He seized upon
the Mandala, "the pictorial bible of ancient
Buddhism," as an artistic icon since it could
be reduced to the merest hint of a circular
form, an abstract presence within his softly
inflected fields (fig. 136). "Symbolically, nature
simplifies," believes Chun, "in order to express
the complex meaning and expression."[62]

135. Chen Chi. *The Great
Way Desireless, the Sun
and Moon Move in Their
Orbits.* 1961. Watercolor
on paper, 36 x 72".
Collection the artist

136. Sung-Woo Chun.
*The Nature Mandala,
Number 9.* 1961. Oil
on canvas, 63 x 45".
Collection of Whitney
Museum of American
Art, Gift of John S.
Bolles, A.I.A.

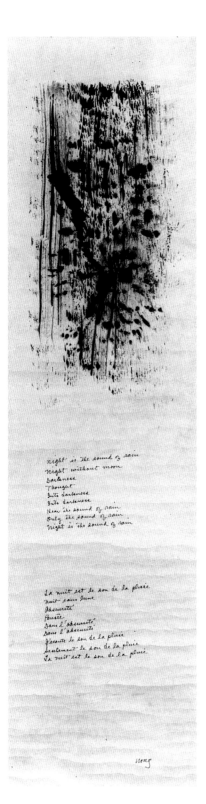

137. Nong. *Untitled (night is the sound of rain . . .)*. 1967. Chinese ink on rice paper mounted on scroll, 48 x 13" (image), 69 x 18" (scroll). Collection the artist

The idea that any painting that is nearly devoid of perceptible imagery may actually be a visualization of a metaphysical reality demonstrates another central concept in Eastern thought. An uninformed viewer might say that Chen Chi's painting has no subject, that it is empty. But "empty" space is not so to the Eastern mind. It is filled with Tao, with the energy of existence, and the objects of common experience are merely half a *yin-yang* duality completed by the void. "Void is vital for all life," according to Wang Ming. "It gives an artist the vision to fill in his or her ideas." Thus the "void" is an active, meaningful entity, and in aesthetic terms it has led to the great pictorial significance given to open space in Eastern pictorial composition. "Empty space is the most useful space," says the artist Nong, among whose varied productions are screens and scrolls with delicate imagery and handwritten poems (fig. 137) suspended within generous areas of untouched paper.[63] As Chinese tradition has it: "The picture should be empty at the top and the bottom and spacious at the sides, so that it looks agreeable. If the whole format is filled up, it no longer has any expression." Furthermore, "if the empty places are right, the whole [pictorial] body is alive, and the more such places there are, the less boring the whole thing becomes."[64]

The word "alive" is key in the last statement, for the void, like all things, is invested with *ch'i*, the spirit of the universe:

The word ch'i, *or spirit, summed up the presence of the Tao in painting. If an artist caught* ch'i *everything else followed; but if he missed* ch'i, *no amount of likeness, embellishment, skill, or even genius could save the work from lifelessness. . . . Hsieh Ho used the famous but vague phrase* ch'i-yun sheng-tung *(spirit-resonance life-movement), but by the time Sung humanism and philosophy dominated thinking,* ch'i *became an isolated concept in Ching Hao's list of the "Six Essentials" of painting, and was finally identified with painting by Han Cho when he said that "painting works with the 'creative forces' and shares the same spring as the Tao." In other words, the spirit of art was identified with the spirit of the universe. . . . When Chang Keng called* ch'i-yun *the "moving power of heaven which is suddenly disclosed" and claimed that "only those who are quiet can understand it," he*

was dealing with the three essentials of a mystical experience—the absolute, meditation and illumination. "In painting, ch'i-yun *grows out of the wanderings of the heart; it is obtained through the inspiration of heaven.". . . [The artist Wu Chen] "concentrated his spirit and harmonized it with the working of the Tao." The Tao is made manifest in art as* ch'i, *and* ch'i, *being spirit, can only be known by its fruits.*[65]

The mysterious presence of *ch'i*, in general and as it affected the art of Asian Americans, can perhaps best be visualized through abstraction based on calligraphy and gesture, in part because that was the mode of Eastern art most frequently and easily compared to Abstract Expressionism. Usually singled out for this comparison were artists of the New York School whose work emphasized line and gesture, such as Jackson Pollock, Robert Motherwell, and, in particular, Franz Kline because of the many works he produced using only black and white. The debate over any correspondence between calligraphic expression and Abstract Expressionism, while heated in years of the latter's development, has continued, and the general concept can still be found presented in various guises today. For example, a 1995 exhibition at the China Institute in New York was suggestively titled *Abstraction and Expression in Chinese Calligraphy*. A review of the exhibition was headlined "Seeing Franz Kline in Eastern Scrolls."[66]

The fact that Western-style gestural abstraction and Eastern-style calligraphic abstraction both used black pigment on a white ground somehow muscled aside any perception of the differences between them. The most basic difference is that artists with an Eastern cultural heritage usually had exhaustive training in the methods of calligraphy, as well as knowledge of the Taoist aesthetic philosophy behind it. The use of the brush in Eastern art, no matter how gestural or spontaneous-looking its product, is highly controlled through experience. There are myriad nuances of movement in brush control that are so internalized that the most subtle variations of shape can be defined through specific directional actions. The deliberately brusque, aggressive strokes of the New York School had no history of, or use for, that expertise. There is also the matter of the artwork being so attuned to the natural flow of

the Tao that it takes on *ch'i*. The New York School did not have that either, and Asian American artists knew it. What is more important, they could *see* it—or rather, saw the lack of it.

To C. C. Wang, the brush is an extension of the artist's spirit, and working with *ch'i* the brush can "discover the principle of nature." While throwing paint, Pollock "is still *an agent for* nature" to Wang, but not yet attuned *to* nature. Through the *ch'i*, art expresses itself like music, finding a voice. For Wang, Kline's art is "noise, not voice."[67] Tadashi Sato remembers that many years ago he was comparing a work by Kenzo Okada to one by Kline. When recently recounting his reactions, an expression of deep thought and concern still came over him as he recalled thinking "there's something missing [in the Kline]."[68] When Po Kim first encountered Kline's art, he thought it was perhaps a purely calligraphic work but felt it was not good calligraphy. It seemed to use "a very poor brushstroke," was "false," and "had no life in it."[69] These responses to Kline seem harsh but were originally filtered through specifically Eastern criteria of aesthetic quality. Of Kline's art, Sato says he was eventually able to "enjoy it— but with limits."

Po Kim also realized the need to differentiate Western and Eastern approaches to art. He now considers Kline's brushstroke as a purely pictorial device; its purpose is to become part of a composition. Without *ch'i*, Kline's stroke is *not* speed, touch, or weight. It simply functions on a different, non-*ch'i* level. With his training in calligraphy and *sumi*, Kim values the preparation of mind and body that must precede the act of painting. At the moment of painting the mind and body must work together, and, importantly, there can be no corrections or changes in the painting process. Despite the apparent spontaneity of his strokes, Kline's paintings were planned and enlarged from small studies, and there is much reworking and overpainting in white atop black. Po Kim's calligraphic abstractions reflect the uncorrected, single-go Eastern method, its elegantly developed linear gestures and, more importantly, its concern for open space (fig. 139). Whether in painting or calligraphy, the Eastern use of untouched white paper as a pictorial element went beyond the Western notion of "negative space," a

138. Po Kim. *Untitled.* 1957. Oil on canvas, 80 x 70". Collection the artist

139. Po Kim. *Untitled.* 1957. Oil on canvas, 85¼ x 71¾". Collection the artist

140. Franz Kline.
Wanamaker Block. 1955.
Oil on canvas, 78½ x 71".
Yale University Art
Gallery, New Haven, Gift
of Richard Brown Baker,
B.A. 1935

term that itself implied the superiority of the mark over the void. As "being" and "non-being" are equal in the Tao, there is really no such thing as a pictorial "nothing" in the East. "Nothingness" itself is a metaphysical entity. This concept lies behind the Eastern technique of brush gesture known as "flying white" (see figs. 10, 49), named not for the visual effect of the ink but instead for where the ink is not. The streamers of untouched white paper left *between* the ink deposited by divided bristles of a brush are the visual focus, and the presence of *ch'i* invests these voids with the vitalized physical activity of "flying."

A pairing of paintings by Kline (fig. 140) and Walasse Ting (fig. 141)—the latter was one of the more prominent Asian American abstractionists on the New York scene—further clarifies differences in approach. One first notices how Kline's strokes are all angular, beamlike affairs that build hulking, block-like shapes. Rather than brushed onto the canvas, his image seems constructed. There are no curved lines in the Kline, whereas strokes in the Ting swoop, bend back on themselves, and twist through space. Ting's strokes are manifested in many ways, with varied thicknesses and amounts of pigment deposited on the surface, some in wide swathes, some in halting curves, some in flings and spatters. Kline's strokes seem relatively consistent, as broad marks cross and huddle together to form masses by abutment. Although both pictures generally read as single, if complex, forms on a background, Kline's derives compositional power by pushing out against the edges of the confining canvas, shouldering for extra room, so to speak. On the other hand, Ting's painting occupies its space more lightly, and here the particular importance of the void and energized space to Eastern art comes to the fore. While the Kline's main form does not touch the bottom edge, it is securely pinioned in place at the sides as if by so many supporting girders. The shape seems weighty and dominates the space. Half of the Ting, including nearly all its left side, is open space. Where a mark advances well into the picture's primary void, it is a jet of spattered pigment, almost imma-terial, suffusing itself into the space. In the Kline, the potential for openness in the small area at the lower right is compromised by

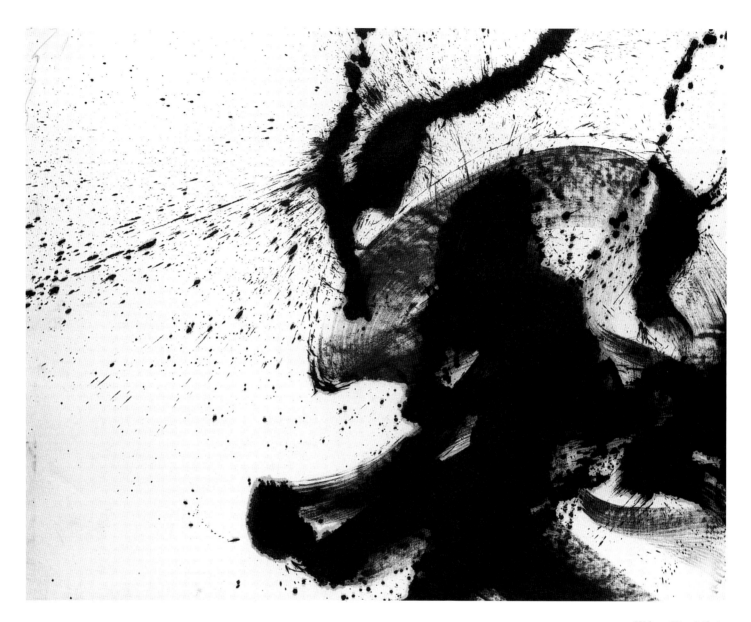

141. Walasse Ting. *Life & Movement*. 1959. Oil on canvas, 49 x 62". Grey Art Gallery & Study Center, New York University Art Collection, Gift of Leo Mnuchin, 1961.43

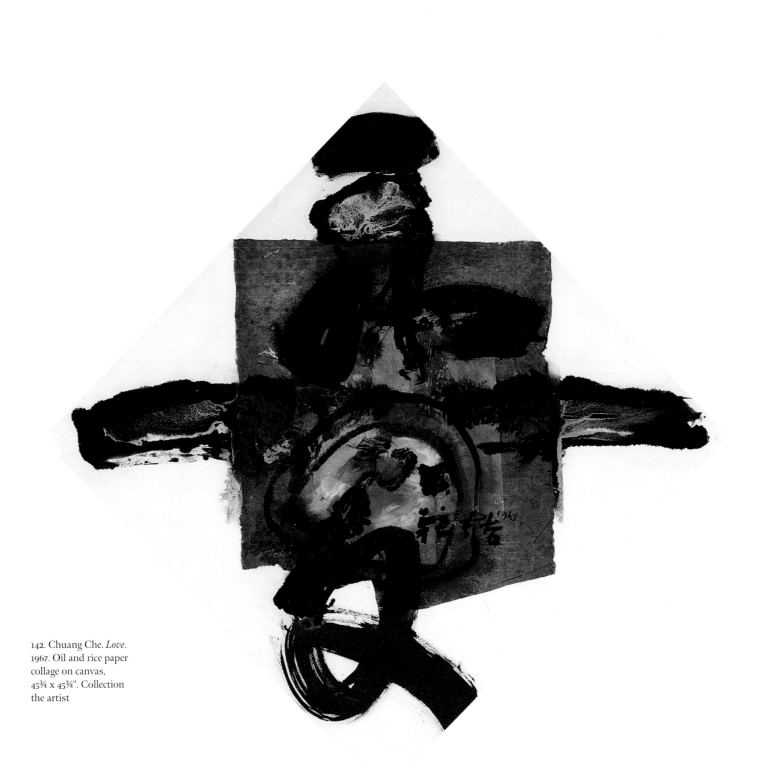

142. Chuang Che. *Love*.
1967. Oil and rice paper
collage on canvas,
45¾ x 45¾". Collection
the artist

a bar reaching undiminished in thickness to the edge—yet another straight, stiff strut to support the bulky main form. The gestural entities of the Ting appear to have drifted into our field of view, perhaps from the lower right, incompletely seen, and they are still sputtering and spitting, flapping and writhing.

Ultimately, the intentions of the artists are reflected in the titles they gave to their creations. Kline's painting is called *Wanamaker Block,* a reference to a massive urban department store. In stark contrast, Ting's *Life & Movement* embodies those two essential forces within all that is touched by *ch'i.* Kline's Western approach deals with the heavy physicality of the products of human activity, artificial constructs that are aggressive and even industrial in effect; Ting's Eastern approach summons up nature, the organic, the transitory, the metaphysical. Thus the American picture defines itself by its objecthood; within the four sides of its allotted space, it is an independent thing. The Asian American painting is part of a continuum that extends in space and time beyond the making of a given unitary pictorial image and organically occupies the space with which it shares its existence.

Eastern thought gives Eastern brush gesture its unique qualities, its inner life. The principles of the use of the brush were first applied through the calligraphy of the written language. Because Eastern writing is pictographic in its sources (see fig. 12) and was developed through the successive simplification, or abstraction, of linear images, brush movements and lines were inextricably associated with conceptual content and meaning. Eastern artists are fully aware that their writing is inherently a system of abstraction —as are many of the East's most "radical" methodologies of pictorial art (see fig. 14). In this context, a random line or gesture created for nothing more than purely formal reasons (that is, a painted mark without linguistic content or *ch'i*) is fundamentally lacking in communicative function on either a narrative or philosophical level. This is why artist Sato felt something was "missing" in Abstract Expressionism and why art historian Wen Fong said that the notion of abstract calligraphy is ridiculous (see the roundtable discussion, page 55). Artists and theoreticians alike

who are close to their Eastern heritage view the random linearism of Western abstraction, which lacks the cultural purposes of calligraphy, to be devoid of content. The pourings of Pollock, the blotches of Motherwell, the swathes of Kline: to Eastern observers, all of these markings are—in the most literal sense—meaningless gestures.

An imaginative use of calligraphy imbued with several levels of meaning can be found in Chuang Che's *Love* (fig. 142). As mentioned earlier, Chuang was fascinated by aspects of the urban visual environment that included words within pictorial formats: billboards, posters, commercial signage, and the like. He also was interested in how Pop artists were using words and was quite intrigued by Robert Indiana's work, in particular his image of the word "love," which had become something of a cultural icon (fig. 143). To the Chinese mind, using the word "love" in art was in no way mawkish. The evocation of feelings (one human manifestation of *ch'i*) is a perfectly acceptable goal of art. Chuang determined to create a painting based on the Chinese character for love (fig. 144). To relate the work to Chinese experience, he rotated Indiana's square format forty-five degrees to present a diamond-shaped image. This new format recalled the diamond-shaped signs bearing characters for prosperity, luck, happiness, or other positive messages that are traditionally placed in Chinese homes above doors or in other prominent places (especially for New Year's or other celebrations). Chuang altered the form of the Chinese character to fit the diamond and deleted parts of its component strokes. The character for love is a compound one, with the independent symbol for "heart" (see fig. 184 for this character) set near its center. Altering the normal procedure of pictographic abstraction, Chuang replaced the character for heart with a rendering of an actual human heart. But to indicate that this entire enterprise is hovering between Eastern and Western notions of abstraction, Chuang abstracts the heart in the Western sense, reducing it to an organic object of orangish hue encircled by a red ring. This clever hybrid is a double inversion of cultural content because it combines Eastern abstraction of ideographic writing and Western concepts of abstraction as simplification and nonobjectivity. This work demonstrates how immigrant

143. Robert Indiana. *Love.* 1966. Oil on canvas, 71⅞ x 71⅞". Indianapolis Museum of Art, James E. Roberts Fund

144. Chinese character for "love"

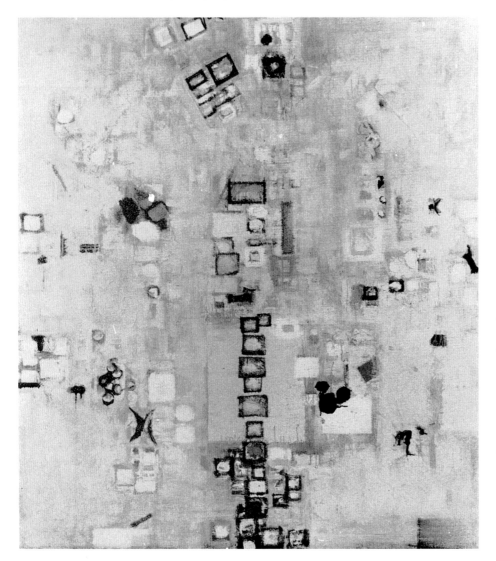

145. Genichiro Inokuma.
Accumulate. 1956–57.
Oil on canvas, 56¼ x 50".
Collection unknown. From
Anne L. Jenks and Thomas
M. Messer, *Contemporary
Painters of Japanese Origin
in America* (Boston:
Institute of Contemporary
Art, 1958), plate 9

left to those willing to advocate sensitivity to the qualities of Eastern aesthetics, but who realized that these qualities were best analyzed and most easily explained to general audiences primarily in visual terms.

"Nipponism"

For a high degree of understanding and a sophisticated explanation of the fruitful interpenetration of cultures in abstraction by Asian Americans, one can hardly do better than to study two related, pithy discussions of the topic: the twelve short columns of the main text in the small catalogue printed to accompany the 1958 exhibition, *Contemporary Painters of Japanese Origin in America*, and a two-and-one-half-column magazine essay previewing the concept of the exhibition. The exhibition and its catalogue were produced by Thomas M. Messer, then Director of the Institute of Contemporary Art in Boston, and Anne L. Jenks; Messer wrote the article.[70]

The exhibition advanced the curators' conviction that a unique coalesence of the fundamental aesthetic views of Japanese traditional art and modern Western art was visibly occurring in the work of certain Japanese artists in the United States. This art was impelled primarily by its Eastern sources and took on the guise of Western abstraction in a natural evolution of each artist's desire to find a more contemporary personal expression. To the artists of this exhibition, abstraction in the Western sense was only a means to an end, not an end pursued in itself, and was leavened by the formal and philosophical underpinnings of the East. By stressing the Japanese sources of the abstraction of these artists during a time when American critics were promoting the "Americanness" of Abstract Expressionism, the catalogue authors took a principled, but highly unpopular, position. "Appearance notwithstanding, there is not much fundamental connection between this emerging style and the western abstraction with which it has apparent similarities," the catalogue stated. A brief analysis of the history of modern art was offered to bolster the claim: "The sequence is not hard to trace: Japanese artists contributed, without any doubt, to the formulation of a modern style which removed scientific perspective in favor

artists were well aware that their art represented a mixing of cultural metaphors.

The foundations of Eastern aesthetics, whether the rarefied philosophical conceptions of *ch'i* and the Tao or the literal meanings of Eastern ideographic languages, were generally unknown to most Western observers of Asian American abstract art. American critics were therefore often uninformed when making value judgments of the art. This is, however, a completely ordinary and reasonable situation, one that arises constantly when cultures with very different outlooks on aesthetics and life make contact. After all, when Asian Americans found some Abstract Expressionist art unsatisfying, they were seeking that which the American artists could not offer: artwork influenced by Eastern philosophy. Appreciation of abstraction representing East/West interaction was therefore

of surface movement and which substituted a uniform color concept for the graded 19th century palette. This modern European style, whose chief components are Cubism and expressionism . . . contains strong admixtures of Oriental derivation."[71]

Much twentieth-century scholarship has been devoted to investigating the Eastern sources of modernism. An art historical term had already been devised to describe the late-nineteenth-century influence of Japanese art on Western art: Japonisme.[72] Cognizant of this precedent, a name for the contemporary style was suggested: Nipponism. This was the title of Messer's article on the style, which preceded the exhibition by several months, and the term Nipponism is forthrightly used throughout the article. In the catalogue, however, some professional circumspection may have occurred; the new term is not used as the exhibition title and is found only twice in the text as an uncapitalized adjectival form and set within quotation marks as "nipponist."

The aesthetic case for the style itself, however, was presented firmly and lucidly. The exhibition organizers emphasized the visual qualities of the style as "too insistently present in Japanese-derived painting and too thinly represented in the Western modern movement to be dismissed as accidents," and the catalogue's main essay reflected this approach in its title, "A Visual Phenomenon." The artists' interest in traditional Japanese art was documented: Genichiro Inokuma particularly favored Sesshu, Tessai, Hiroshige, and Sharaku; Teiji Takai was impressed by the "broad, decorative, and gorgeous" method of Korin; Noriko Yamamoto admired the calligraphy of the Zen monk Ryokan and the prints of Utamaro and Sharaku. Their knowledge was shown to extend into scholarly pursuits: Sabro Hasegawa wrote a thesis on Sesshu; Yutaka Ohashi wrote a thesis on "The Korin School" of Korin, Sotatsu, and Kenzan.

The catalogue set out the formal and pictorial sources of the new style through illustration and description. A twelfth-century scroll painting was noted for its "Triangular forms [that] played against graceful curves [to] create flat simplified shapes. These shapes seem to float in a space established by overlapping forms. Rich colors combine with silver and gold in a sumptuous effect." A seventeenth-century screen is distinguished by small

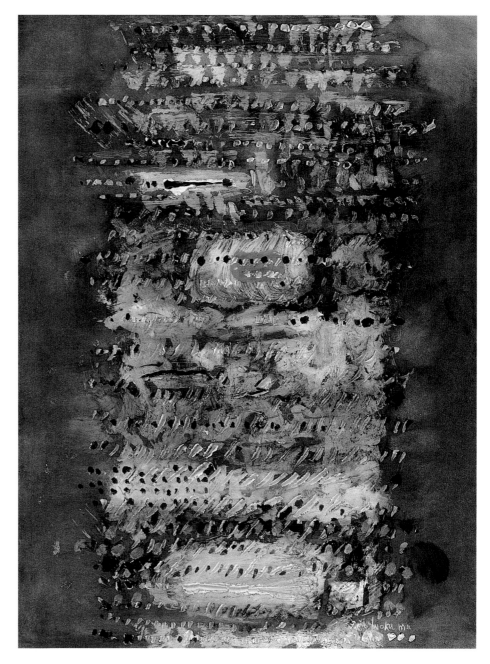

146. Genichiro Inokuma. *Untitled.* c. 1963–64. Tempera on board, 40 x 30". Solomon R. Guggenheim Museum, New York

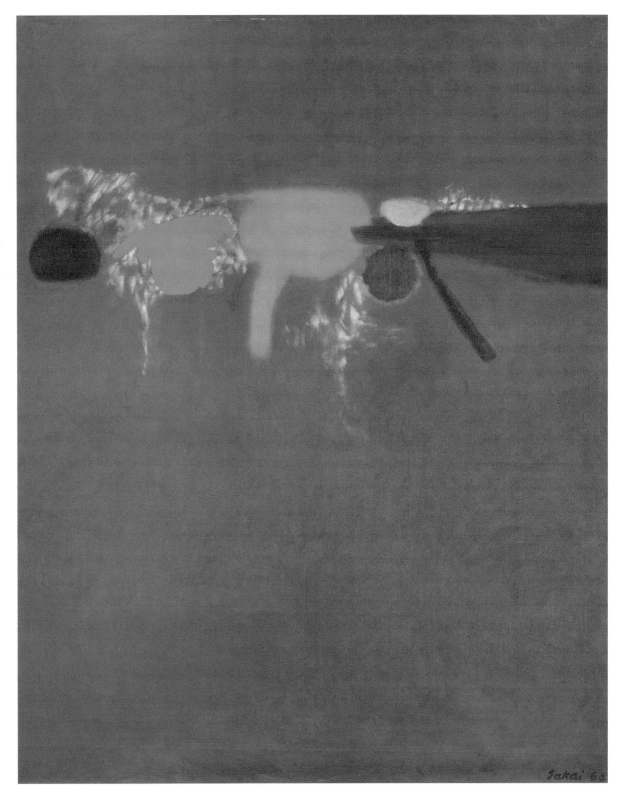

147. Teiji Takai. *Aka*. 1962. Oil on canvas, 82 x 70". In the Collection of The Corcoran Gallery of Art, Exchange for the painting, 61–4

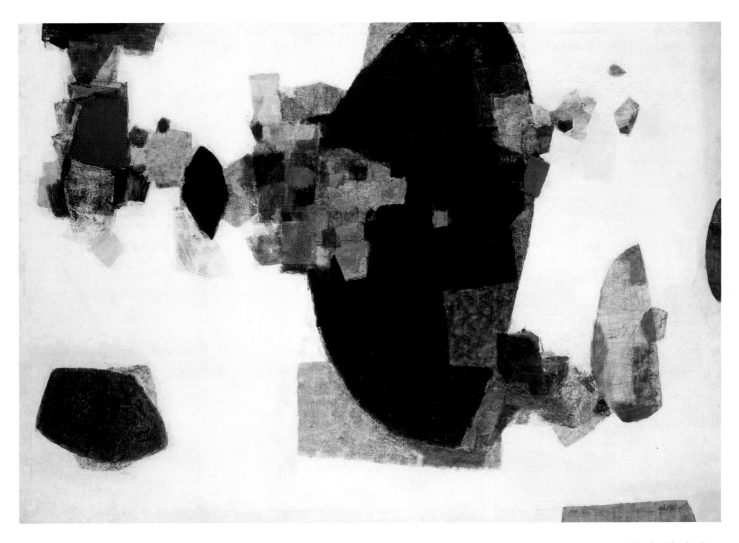

148. Yutaka Ohashi. *Stone Garden*. 1955. Oil with gold on canvas, 49¾ x 72". Solomon R. Guggenheim Museum, New York

149. Kenzo Okada. *Dynasty*. 1956. Oil on canvas, 80 x 60". Albright-Knox Art Gallery, Buffalo, New York, Gift of Seymour H. Knox, 1957

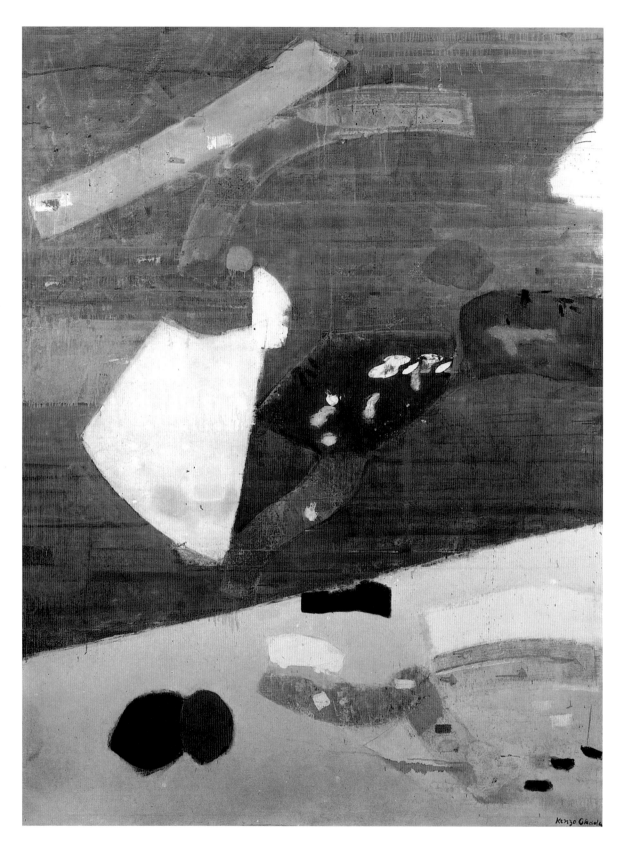

"squares and triangles [that] float within the oval-shaped clouds. Large and simple forms [are] arranged in startlingly bold patterns." The use of these early devices—and the evidence of their "contemporary projection" into the work of the modern artists—was then detailed. One shared trait among the modern artists, exemplified here by Kenzo Okada's work (figs. 149–51), was the creation of relatively uniform, sometimes monochromatic fields that were painted with great sensitivity to nuanced tones and contained what the authors called "elemental shapes." These shapes included

circles of all sizes, ovals, squares, triangular areas, bars and combinations of all these forms [that] act as the syntax of this contemporary abstract art. The artists appear to have created these forms freely yet with a pronounced element of control. In large areas, one experiences the long, full, and frequently graceful swing of the painter's arm. In the smaller shapes, one feels the expert movement of the artist's wrist. There is no rigidity. The painter feels his circle or his square; he never measures it. The shapes are neither violent nor hurried. Nor are they the result of intense intellectual analysis. Their easy rhythmic quality suggests a philosophy foreign to the West.

The same correspondence and adaptation of image and technique, passed effortlessly from traditional to modern painters, were illustrated for many other traditional aspects of Eastern (here Japanese) art that have been mentioned earlier in the present essay. Indeed, the Boston catalogue text on "The Visual Vocabulary" is divided into four subheadings: tradition, calligraphy, subject, and philosophy. Each theme had its examples and explanations. The artists' relationships to nature were also described, as well as the culturally endowed philosophical concepts motivating their personal expressions. Okada was shown to combine both of these traditional sources —a duality of subject and subjectivity, as it were—in his art.

Kenzo Okada has emphasized the importance of nature in a statement that carries overtones of the philosophy of Zen. "There is certainly a relationship between my work and nature. Sometimes it is a conscious relationship, sometimes otherwise. . . . I can feel myself in nature,

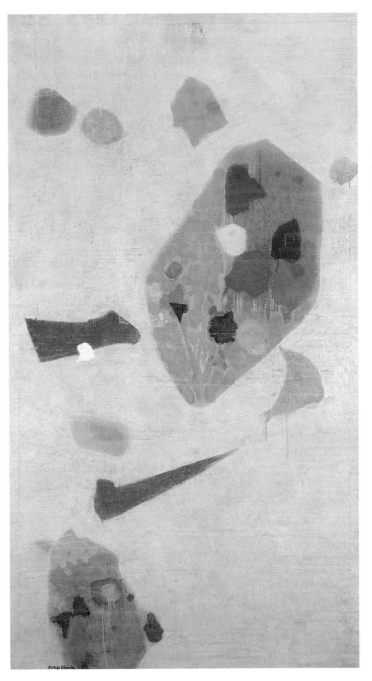

150. Kenzo Okada. *Coral No. 8.* 1955. Oil on canvas, 38 x 30". Munson-Williams-Proctor Institute, Museum of Art, Utica, New York

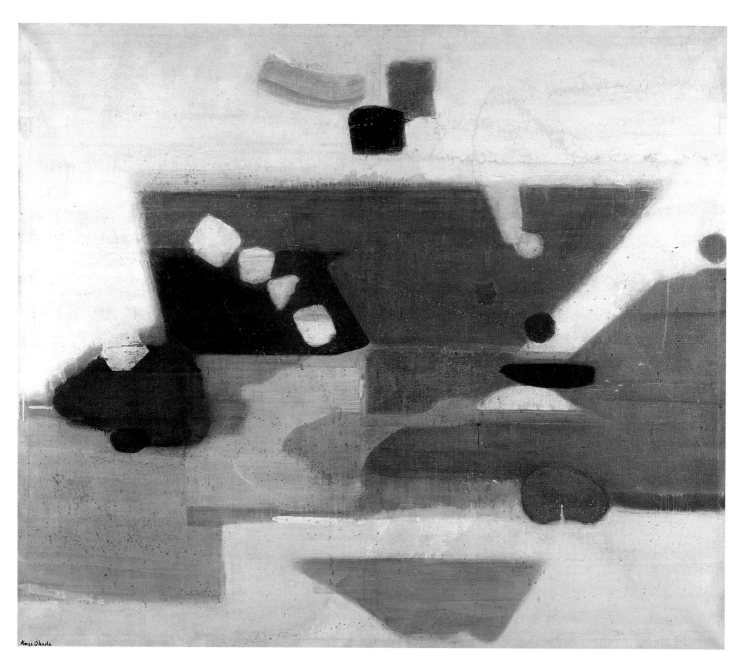

151. Kenzo Okada.
Decision. 1956. Oil on
canvas, 67¼ x 70⅝".
Solomon R. Guggenheim
Museum, New York

and I find nature in myself." Although Okada's forms have that quality of "purposelessness" already observed . . . his paintings do not have the essentially unordered and raw quality of nature as we know it in the West and especially in America. In [Okada's art] the simple and monumentally defined elemental shapes speak their own language. . . . Pattern intervenes and nature is seen as majestically ordered.

Overall, the Nipponism project did yeoman's work in making a serious effort to understand a developing trend. Its organizers realized the strongest evidence of its central thesis was visual and they emphasized that notion while marshaling historical perspectives on art history, culture, and philosophy in further support of their claims. The catalogue graciously rejected the confrontational critical attitudes of its day and promoted an art that not only was "characterized by its exceptional beauty" but was also openly internationalist. That the organizers' perceptiveness was not appreciated at the time takes nothing away from the historical insight the exhibition represented.

Although it was a groundbreaking show, the Nipponism exhibition only included seven artists. Obviously there were many more artists who could fit within the visual parameters defined by the exhibition, and the number of artists selected probably had to do with practical concerns, such as the size of the exhibition space. With hindsight, one can mention several other artists who could have joined the ranks of Nipponism. Tetsuo Ochikubo's paintings of simple shapes with gently curved edges dispersed over fields of soft colors (figs. 152–53) perfectly illustrate the style's methods and motifs. The arrangement of the small squarish shapes in conjunction with larger forms, all embedded in whitened or sand-colored areas, is strongly evocative of Japanese gardens. In Ralph Iwamoto's paintings, the "elemental shapes" are enlarged and gently nudge or slide past each other (figs. 154–55). The color scheme is cool and restrained, and many outlines derive directly from traditional Japanese motifs: stone lanterns, *torii*, and other architectural elements.

Masatoyo Kishi entered the United States two years too late for the Nipponism show. His work, however, would have been entirely at home there (figs. 156–57). Set down on back-

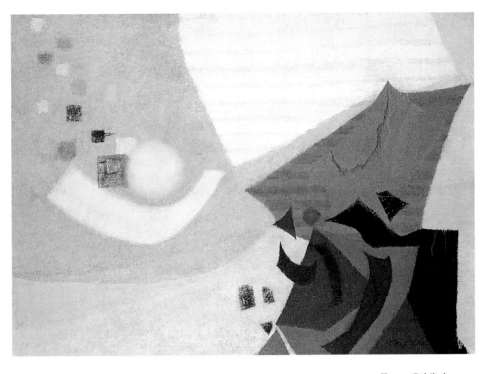

152. Tetsuo Ochikubo. *Resonance #8.* 1958. Oil on canvas, 52 x 72". The Contemporary Museum, Honolulu, Gift of The Honolulu Advertiser Collection, a Persis Corporation, 1983

153. Tetsuo Ochikubo. *Far the Stillness.* 1958. Oil on canvas, 41 x 61". Hawaii State Foundation on Culture and the Arts, Honolulu

154. Ralph Iwamoto.
Centurion. 1957. Casein
and varnish on linen,
49½ x 71½". Jane
Voorhees Zimmerli Art
Museum, Rutgers, The
State University of New
Jersey, Gift of the artist

155. Ralph Iwamoto.
Winter Mist. 1958.
Casein and varnish on
linen, 51¾ x 71¼".
Collection the artist

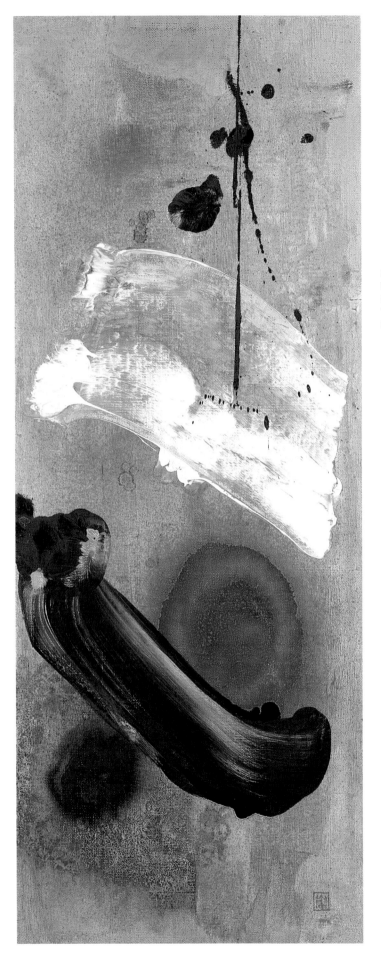

156. Masatoyo Kishi.
Opus #63–511. 1963.
Oil on canvas, 36 x 14".
The Michael D. Brown
Collection

157. Masatoyo Kishi. *Opus #63–901*. 1963. Oil on canvas, 50 x 50". The Michael D. Brown Collection

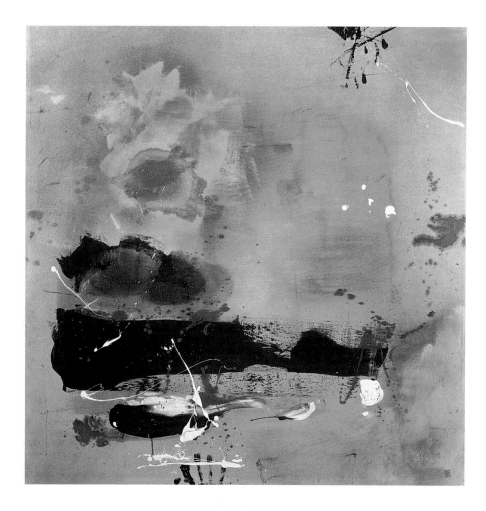

158. Masatoyo Kishi. *Opus #61–313*. 1961. Oil on canvas, 58 x 94". Collection the artist

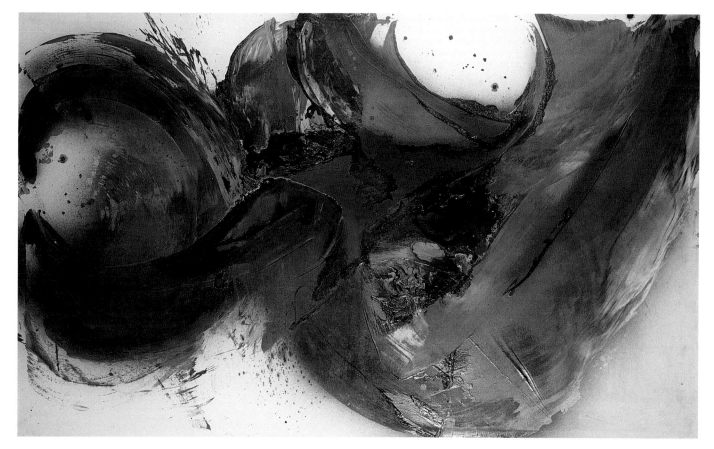

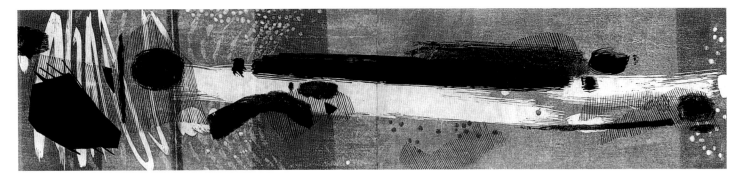

159. Ansei Uchima. *Tide Rhythm*. 1957. Color woodcut, 15 x 66½". Collection the artist

grounds that are usually pale monochromes (often just white) are strokes of paint that fulfill the functions of Nipponism's elemental shapes—here a curved bar derived from calligraphy, there a thick patch of pigment. Kishi always works in the traditional Japanese manner, with the support horizontally situated (on the floor for his large works). His colors are frequently attuned to those of traditional Japanese art objects. Red, black, and white combinations appear, as well as gold. Kishi's calligraphic impulses sometimes led to virtuoso gestures of monumental size (fig. 158), comparable to the most grandiose conceptions of the modern Japanese schools of calligraphic abstraction or the extremes of Zen practice.

The Nipponism exhibit included only one artist involved with printmaking, Hasegawa. The graphic arts are a very fertile field for exploring the imagery of Nipponism, as the woodblock print was of key importance to the Japanese aesthetic, especially in the *ukiyo-e* prints that so affected the art of the West beginning in the nineteenth century. Ansei Uchima followed an interesting path to printmaking in the Japanese mode. Born in the United States, he visited Japan in 1940 to study architecture, only to be cut off from home by the eruption of World War II. He became drawn into the world of modern Japanese woodblock printmaking and stayed in the country until 1959. In an extremely extended format, his *Tide Rhythm* (fig. 159) evidences the gentle floating forms and evocations of nature noted by Messer and Jenks. Sensitivity to the ephemeral qualities of nature—wind, temperature, seasonal changes —was a hallmark of his style. In subtly toned

prints such as *Spring Breeze* (fig. 160) Uchima achieved a state in which his abstract shapes "seemed to float in space, frozen in moments of delicate balance and dancelike grace," composing "poetic landscapes, as balanced and simple as Zen gardens."[73] The revelatory nature of Zen thought is implied in his print *Katsu!* (fig. 161), titled after the shout of Zen monks as they urge their students to spiritual discovery. It is spontaneous in its own right, with a conglomeration of irregular forms pressed swiftly against the paper. Ansei's wife, Toshiko Uchima, is an accomplished printmaker as well. Contact with nature appears quite literally in her work through both her acute use of wood grain (fig. 162) and her repeated handprints in *Expectation* (fig. 163). Both prints suggest an invention of a hybrid race of natural entities—flower/insect, wood grain/field—that speaks to a particularly engaging, even puckish, sensibility. Yet another talented printmaker, Sueo Serisawa, merges Japanese woodblock traditions, Western fracturing of form, and the Nipponist motif of floating irregular shapes in his *Metamorphosis of a Zen Bull* (fig. 164). Once again the color range is restricted and muted, and snippets of organic form intermingle with more linear structural elements.

It is important to realize that not every abstractionist with a Japanese heritage automatically qualified for the Nipponist label, and not all sought that artistic path. Artists of considerable international stature, such as Minoru Kawabata, were moving through many variations of style in the quest for personal modern expression. Paintings made by Kawabata before he came to America, in which large blocky calligraphic shapes jostled

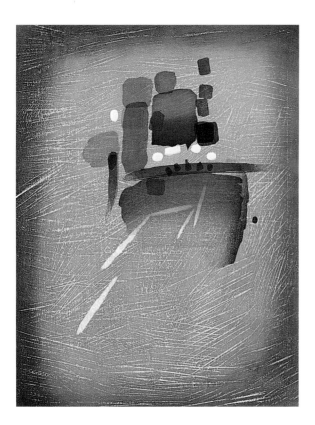

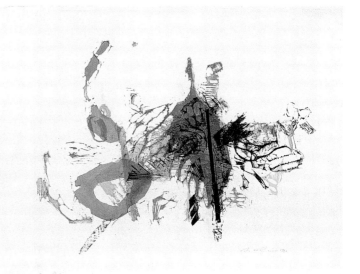

160. Ansei Uchima.
Spring Breeze. 1964. Color
woodcut, 22 x 15".
Collection the artist

161. Ansei Uchima.
Katsu! 1960. Color
woodcut, 18 x 22".
Collection the artist

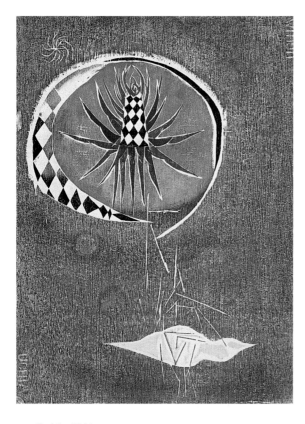

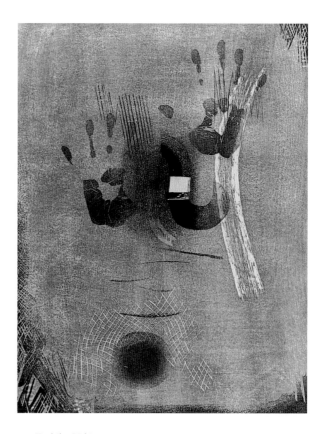

162. Toshiko Uchima.
Forest Fantasy. 1957. Color
woodcut, 23¼ x 17⅜".
Collection the artist

163. Toshiko Uchima.
Expectation. 1965. Color
woodcut, 22½ x 17".
Collection the artist

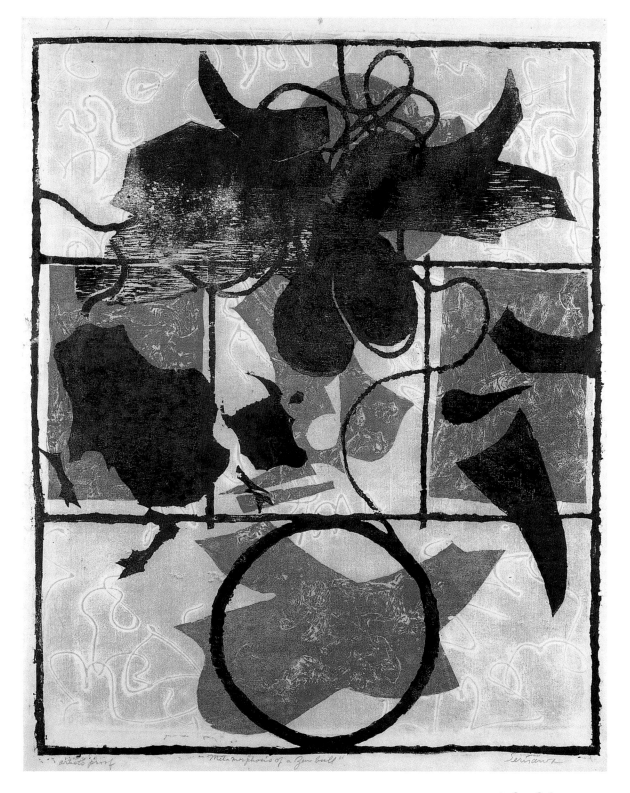

"artist's proof" *"Metamorphosis of a Zen Bull"* *Serisawa*

164. Sueo Serisawa.
Metamorphosis of a Zen Bull.
1955. Woodcut, 29¾ x 23½".
The Michael D. Brown
Collection

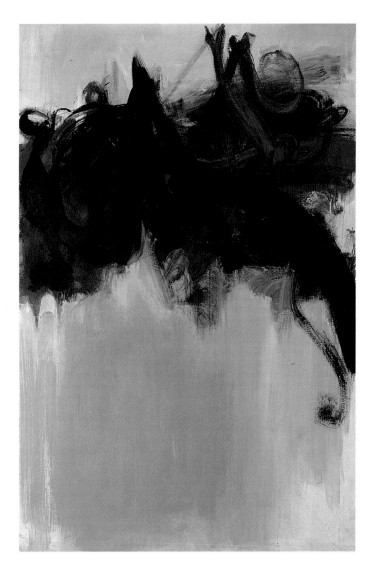

165. Minoru Kawabata.
Work No. 1. 1965. Oil on
canvas, 76 x 51". Collection
the artist

166. Minoru Kawabata.
Untitled. c. 1964.
Watercolor on paper,
20 x 13". Jane Voorhees
Zimmerli Art Museum,
Rutgers, The State
University of New Jersey,
Gift of Betty Parsons
Foundation

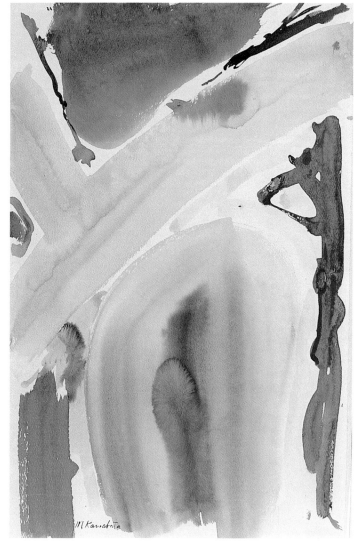

upon the picture surface, might have fit within the Nipponist purview. His style on these shores, however, constantly and rapidly changed over time, moving from vigorous expressionist gestural fields marked by calligraphic outbursts (fig. 165) to lively works in watercolor that broadened the marks of traditional ink painting in size while intensifying their coloristic potential (fig. 166). Although she was included in the exhibition, Noriko Yamamoto's later works of rapid-fire experimentation broke with the Nipponist style. By 1960, she had abandoned her style of scattered, rounded shapes moving over the picture surface to tackle a much more aggressive style of painting, complete with smacked-on bursts and running trails of paint (figs. 168–70). A calligraphic impulse still informs all of these works, and *Kakizome* strongly suggests a response to nature with its celestial orb glimmering through a mist-filled atmosphere. James Suzuki would also later enter the realm of highly expressionist calligraphy with a vengeance, producing roiling clouds of spinning gestures, often in high-key colors (figs. 171–72).

Although Nipponism dealt specifically with Japan, the style it describes is broad enough to embrace work by artists from other Eastern nations. Japan's artistic traditions were derived from Chinese art, as were those of Korea. Each nation shares basic aesthetic motifs and philosophies, and the modern artists of each have consequently responded to Western trends in forms that are congruent to Nipponism's essential themes. Thus, it is not surprising to find "elemental shapes" floating in softly inflected color fields in the work of Korean-born Louis Pal Chang (fig. 85), the prints of Yien-Koo King (fig. 173), or in the dancing compositions of color shapes, lines, and flakes in the prints of Chinese-born Seong Moy (figs. 174–75). Some of Moy's compositions are directly based on transformations of Chinese ideograms, of which the blockier, more archaic forms are best adaptable to the ruggedly cut surfaces of woodblocks (fig. 176). A work by the Chinese American sculptor Win Ng (fig. 177) is virtually a three-dimensional projection of the gently curving bar shape that inhabits so many Nipponist works. In fact, the ceramic surface itself becomes the support for more floating shapes created from glazes in subdued hues.

167. Minoru Kawabata. *Work No. 2*. 1969. Oil on canvas, 13½ x 9½". Collection the artist

168. Noriko Yamamoto. *Wakanohana*. 1961. Oil and collage on canvas, 71 x 67¼". Collection the artist

169. Noriko Yamamoto.
Kakizome. 1961. Oil
on canvas, 69¾ x 65⅛".
Collection the artist

170. Noriko Yamamoto.
Semtua. 1959. Oil on
canvas, 70 x 66".
Collection the artist

171. James Hiroshi Suzuki.
Firebird. 1959. Oil on
canvas, 76½ x 57".
Collection Toshio Odate

172. James Hiroshi Suzuki. *Tuonela*. 1959. Oil on canvas, 50 x 60". The Michael D. Brown Collection

Ng's *Wave*, an abstraction of a fleeting natural motif, shares the allusive reference to natural phenomenon seen in the Nipponist concept.

The formal criteria developed for the 1958 exhibition are still seen today in the works of artists born in Japan or of Japanese descent, in America and other lands. Thomas Messer saw the rise of Nipponism as an aesthetic event of great historical importance. He wrote in his article: "In the recent past, major museum exhibitions and publications have crystallized our perception of stylistic trends such as 'Romantic Realism' and 'Abstract Expressionism.' As we gain distance, we believe that 'Nipponism' will emerge more forcefully and that the leading Nipponists will loom large as painters of great beauty and invention."[74] In his comparison of Nipponism to Abstract Expressionism, he was setting the new style head-to-head with what was by 1958 generally lauded, by the American art world at least, as the most important art style since the development of abstraction itself.

173. Yien-Koo King. *Untitled*. 1958. Lithograph, 8⅞ x 10⅛". Collection the artist

174. Seong Moy. *Dancer in Motion*. 1952. Color woodcut, 16 x 11½". Jane Voorhees Zimmerli Art Museum, Rutgers, The State University of New Jersey, Gift of the International Council of the Museum of Modern Art

175. Seong Moy. *Yen Shang*. 1952. Color woodcut, 19⅝ x 10⅛". Jane Voorhees Zimmerli Art Museum, Rutgers, The State University of New Jersey, Gift of Grace Borgenicht Brandt

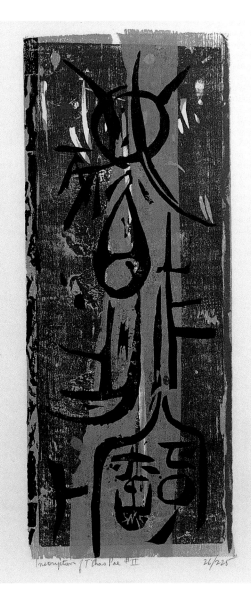

176. Seong Moy.
*Inscription of T'Chao Pae
#II*. 1952. Color woodcut,
19⅜ x 11⅜". Jane Voorhees
Zimmerli Art Museum,
Rutgers, The State
University of New Jersey,
Gift of the International
Council of the Museum of
Modern Art

177. Win Ng. *Wave*.
1959. Glazed earthen-
ware, 18 x 39 x 6".
Collection Herman Ng
and K. Mimi Ng

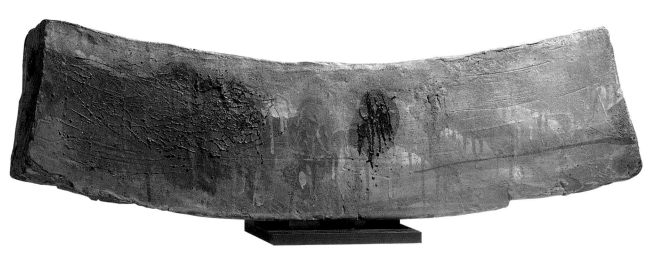

178. Sueko Kimura. *Untitled*. 1969. Ink on illustration board, mounted on wood, 61½ x 14¾". Collection the artist

As we know now, Nipponism did not have the art historical staying power of even so shunned a genre as "Romantic Realism." Messer himself now acknowledges the situation with equanimity. In retrospect, he realizes that the meeting of East and West in abstraction was not a theme to thrill the critics of the time. Many qualities of Nipponism —the refinement, the quietness, the integration of decorative qualities—were diametrically opposite to those being promoted by American critics when the Nipponism exhibition occurred. Messer now maintains that "the [exhibition's] original visual approach was viable" but that the timing of its presentation was unfortunate. "It was perfectly clear that the tastemakers of the time were not interested in this. The critical and museum worlds were closed by the tyranny of Abstract Expressionism."[75] It is also probable that Messer's early optimism for the historical role of Nipponism was colored by an otherwise wholly commendable trait: an open-minded, internationalist approach to modern art. He was among the few curatorial minds prepared to embrace this style for what it was, a true intermingling of Eastern and Western art occurring in the era of mid-twentieth-century modernism—one that continues today as yet unperturbed by the tastemakers of art history, as it nonetheless grows in size and range of participating nationalities.

Bridging the East/West Divide

This essay and the exhibition on which it is based highlight a very specific type of art, created in a specific place, within a limited time period: art by Asian Americans produced during the era of Abstract Expressionism that incorporates the technical and philosophical precedents and parallels to abstraction found in traditional Eastern art. The style of Abstract Expressionism—which saw its heyday of activity extend perhaps three decades at the most—looms large in the modern American perception of visual art. How is it that the splashing of paint in a style that is no more than a speck in chronological terms has led to such partisan bickering about its status compared to the staggeringly long and complex history of Eastern art?[76]

The East and West approached abstraction from two complementary, although opposite, approaches. In the East, the "breakthrough" of abstract art was at first simply ignored, not as nonart but as irrelevant to—or insignificant within—the great continuity of Eastern art whose ideas of abstraction were tied to the expression of emotion or other meaningful artistic purposes. The spiritually based East had all the technical and philosophical inclinations toward abstraction for centuries; but Eastern artists did not move into pure nonobjectivity because they saw no need to do so. The more individualistic and literal-minded Western aesthetic viewed abstraction more as a pictorial achievement, a further step on an assumed road of artistic progress. For example, an American art historian conceptualized Jackson Pollock's attainment of nonobjectivity in painting as a progressive pictorial search based on the swirling motifs of his teacher, the realist, Thomas Hart Benton: "[Pollock] found his independence not so much in reaction to Benton but *through* him, by recreating, amplifying, and exaggerating his first teacher's rhythmic distortions under conditions of greater intensity, until his forms achieved a different order of life. In a sense, Pollock arrived at abstraction by pushing Expressionism to a point where subject matter was so improbable that there was no need to retain it."[77] In sum, the East stood with its abstract tradition for a long, long time on the brink of nonobjectivity and said "Why?" The West, catching up all in a rush with a newfound gesturalism, finally reached the same brink and said, "Why not?"

Now that abstract painting is practiced in the East and in the West, the East wonders if there can be a definition of a prototypically Eastern abstract painting, an abstraction it can call its own. One Chinese writer has acknowledged that "many have upheld that there is an absolute gap between Western and Eastern painting that cannot be bridged."[78] Significantly, part of the argument centers not so much on degrees of abstraction or nonobjectivity but on mediums. Since most Western abstraction is produced in oil and acrylic paint on canvas, must an Eastern abstraction be based on ink on paper, thereby maintaining a technical link to tradition and a rationale of historical continuity? Some progressive Eastern critics reject this notion. They

179. Chao Chung-hsiang. *Abstract*. 1962. Oil on canvas, 41 x 49½". Alisan Fine Arts Ltd., Hong Kong

consider artists such as Chuang Che, who has leavened his experimentation of Western mediums with an Eastern respect for nature, as representatives of a new art and authentic East/West interaction. By "undertaking an exploration of nature's meaning through abstract expression," Chuang Che is seen by one such critic as succeeding in "his goal . . . to create a new East Asian, Chinese abstract painting."[79]

Although there are common cultural links among the work of many Asian American artists, there is no unified art historical entity known as "Asian American Art." The artists discussed in this essay are representative of a circumscribed set of technical and philosophical characteristics gathered to illustrate a particular point. Nevertheless, the classification

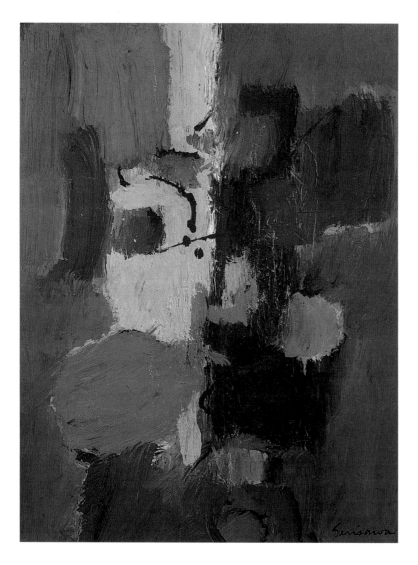

180. Sueo Serisawa.
Untitled. 1961. Acrylic
on board, 18 x 14". The
Michael D. Brown
Collection

181. Chinyee. *At Last*. 1965.
Oil on canvas, 42 x 59".
Collection the artist

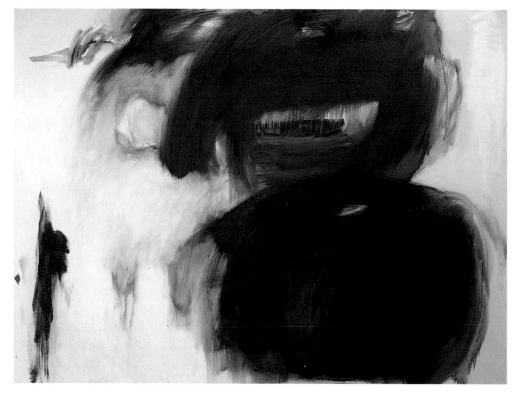

and categorization of any group of artists on the basis of their ethnicity, whether their work is similar or not, can be a risky business. There is understandably something unsettling about attempting to define individuals in terms of ancestry, as if this were an immutable and all-powerful force controlling their lives. In dealing with ethnic heritage, no matter how delicately one treads, there appears the very hazy boundary demarcating the reasonably firm ground of cultural influences from the quicksand of ethnic stereotypes. In recent years, this has become the subject of intense discussion within the Asian American community. Where this matter touches the realm of art, the exhibitions devoted to it have tended to take a sociological approach. A good example of this trend is the widely traveled exhibition *Asia/America: Identities in Contemporary Asian American Art,* organized in 1994 for the Asia Society Galleries in New York. As elements of a sociologically based project, the works in the exhibition had no common stylistic bond. Rather, the "primary goal" of the exhibition "was neither to deny nor to exaggerate differences or similarities between contemporary Eastern and Western cultures, but instead to explore some of the ways Asian American artists manifest their identity."[80] The quandary of ethnic or cultural definition can become problematic even when the presumed cultural traits are regarded as praiseworthy—for example, the notion of Asian Americans as the "model minority" and the overexpectations and resentments that ensue from this perception, from within and without the Asian American community.

Yet, if we deny the perception or relevance of cultural traits to broad aspects of human endeavor, we deny the existence of culture itself. Moreover, generally accepted cultural principles as applied to art can be taken as positive qualities. This has been commented upon frequently, especially as it pertains to the meditative, inward-looking traditions of the East and their effect on art. It has been written that a fundamental cultural tendency affecting the art of Japan "is introspective and insular, and fosters a creative urge to unparalleled delicacy and poetic imagery. Innate potentials, fully realized, gave birth to art forms and expressions unique to Japan. One is even tempted to propose that the subtlety, poignancy and sense of vulnerability in

Japanese culture in general are protected from external disturbance and survive precisely by means of the public arts."[81]

It has been noted that in the East the outward appearance of a work of art is secondary to the sense of emotion or spirit it communicates to the viewer. Over and over, Asian American artists have spoken of the success of an artwork not in terms of how it looks but how it *feels:* that is, how it makes the observer feel, how it touches one's spirit. During discussions about their work, a remarkable proportion of the artists interviewed for this project referred, unprompted, to the quality of emotion in art as "heart"—as did Don Ahn earlier in this text (see page 52)— and several, to emphasize the point, struck their hands against their chests. Chinyee spoke of how her paintings were direct reflections of emotions and needed to express her heart.[82] Tseng Yuho based one of her calligraphic abstractions on the Taoist concept of the direct, pure emotion within the *Heart of a Baby,* which a true artist would seek to emulate (fig. 182). Chen Chi titled a book on his art *Heart and Chance,* printed in it a poem "Buddha Has Four Hearts" (adding that "An artist should have these four hearts"), and reproduced an image of a huge carving of the Chinese character for "heart" that he had hewn into a rockface on an island in China. He wrote: "The creative process is a process of receptive reflection. . . . Thus beauty is created. Here now; heart-chance, space-time are in unison."[83] For a photograph to illustrate a brochure publicizing a show of his work, Sabro Hasegawa chose to pose before a large calligraphy work consisting only of the character for "heart" (fig. 184). This artistic conception of "heart" has recently even influenced the thoughts of the organizers of an exhibition documenting Asian American artists in Washington State. The exhibition was titled, *They Painted from Their Hearts.*[84]

Herewith, a personal observance: over the past fifteen years or so in my capacity as a curator, I have met and spoken with many artists active in the decades of the 1940s, 1950s, and 1960s. As with no other group, the approach to art taken by Asian American artists (especially those born in Asia) has been overwhelmingly intuitive and free of formalistic cant or theorizing and consistently linked to human feelings and emotions.

182. Tseng Yuho. *Heart of a Baby.* 1966. Ink on paper, 30 x 20". Collection the artist

183. Chen Chi. *Realm of Zen*. 1954. Watercolor on paper, 54 x 28". Collection the artist

184. Sabro Hasegawa standing in front of a large work of calligraphy of the character for "heart"

Unafraid of what may be perceived as sentimentality, they appear quite comfortable with the idea of wearing one's heart on one's sleeve, as it were, in their art. Art can be a personal release for emotions, whether tender, as in Tseng Yuho's calligraphic piece (fig. 182), or highly personal and oppressive, as in Hisako Hibi's *Fear* (fig. 185), which expresses her emotional response to being alone in the world after the death of her husband and transforms the general insignificance of small figures in Eastern landscapes into a vehicle for symbolizing her individual feelings of isolation and apprehension.

Another personal observation: as opposed to many other artists of their generation who have become bitter in the belief that they have not received the fame they deserve, many Asian American artists, even when considering their relative neglect during the Abstract Expressionist era, generally broach the subject good-naturedly. They have produced their work to the best of their abilities and continue to do so; their "place in history" matters little. The teachings of Confucius, of Buddhism, and of the Tao—with their concepts of the insignificance of the individual in the cosmic scheme of things and the acceptance of the flow of life—have likely been taken to heart. Emblematic of this attitude are comments by Satoru Abe. He was pleased to have his art included in this exhibition but saw no need for any further focus on himself in the catalogue. "You can show my work," he said with a smile, "You don't have to write about *me*."[85] This attitude is a natural outgrowth of the Eastern tradition of de-emphasizing the individual, of subsuming one's unique personality within the larger society. A further development of this cultural trait may be the lack of concern many Asian American artists have about creating a "signature style" —a single recognizable method or motif that becomes uniquely identified with an artist. Concerned more with making art that is true to their inner feelings and infused with *ch'i*, many Asian American artists change styles as the spirit moves them, moving back and forth between styles—even between abstraction and realism—and sometimes practicing several quite different styles simultaneously.[86]

During interviews with artists for *Asian Traditions/Modern Expressions*, it was frequently the artists themselves who elucidated the

185. Hisako Hibi. *Fear*.
1948. Oil on canvas,
25½ x 21½". The Michael
D. Brown Collection

186. Satoru Abe. *Untitled
(screen).* 1966. Painted
illustration board over
plywood with metal leaf,
48½ x 61½ x ¾".
Collection the artist

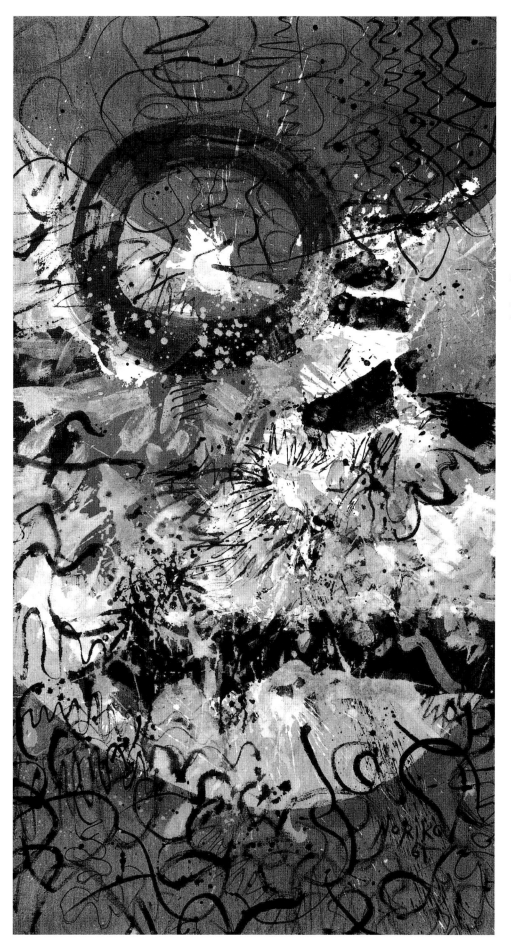

187. Noriko Yamamoto. *Untitled.* 1961. Oil on canvas, 62½ x 34½". Collection the artist

188. Chinyee. *The Necessary Attempt*. 1966. Oil on canvas, 48 x 65". Collection the artist

centrality of culturally transmitted qualities in their work. It cannot be predicted whether or not their work and similar efforts will ultimately convince the art establishments of the West and East to accept the validity of a culturally bipartite aesthetic. Regardless, it is fascinating to realize that a phenomenon so vast in its implications—the meeting of the two major cultural entities that exist on this planet—can often be made manifest through a single artist's vision. According to art historian Michael Sullivan, "[T]he work of art, while outwardly the product or illustration of a cultural situation, is in the final analysis the creation of an individual. Where East meets West is in the mind of the artist himself, and the processes of acceptance and transformation depend ultimately on the choices that he makes."[87]

Many artists have revealed, often through personal anecdotes marked by both directness and touching humility, their dedication to their chosen path, as in these words by Noriko Yamamoto: "My background comes from my intense calligraphy training since childhood (six years old). My tremendous respect is for the old Zen masters. Because of my Japanese and western background, I am trying to integrate both cultures . . . to synthesize the greatness of both. . . . I would like to create something beautiful through my feeling and experience with respect to harmony and serenity."[88]

Sympathetic observers of the burgeoning East/West interaction have wished it well but wonder if something may be lost in the blending of cultures. Can the act of sharing one's initially Eastern creative traditions with Western methods be enlivening—or must it be vitiating and an abandonment of a unique cultural identity for an intermediate and perhaps bland admixture? Michael Sullivan positions the situation within the venerable philosophy of *yin* and *yang:* "To the Chinese view, it is not the synthesis of *yang* and *yin*, but the eternal, dynamic interaction of these opposite but complementary forces that is life-giving. So also should we regard the interaction between East and West, as a process in which the great civilizations, while preserving their own character, will stimulate and enrich each other."[89]

This benevolent resolution may be visualized, appropriately, through the imagination of an Asian American artist who will be given, if not the last word, the concluding image. It is a 1966 painting by Chinyee, a deceptively simple image (fig. 188). At first glance, the picture is simply two abutting areas of gently brushed paint, typical of many reductive field paintings produced in America at the time. However, the fields subtly intrude upon each other in a slight curve, especially toward the bottom. Slowly, one realizes the resemblance of the format to the *yin-yang*. In fact, the painting is an opposition of black and white, the starkest of graphic opposites, and is suggestive of the importance of black and white in traditional Eastern art. The only other marks or bits of color on the canvas are small red patches at the lower right. In position, size, and color, they symbolize the traditional signature seals of Eastern art. But the "seals" are merely blurs; they are illegible and do not represent a name. The identity of the artist is made anonymous and the Chinese character of the maker and her cultural sources are unreadable. Thus, various prototypical aspects of the Eastern artistic heritage—philosophy, color, cultural identity—are melded within the reductive format of an American Color Field painting. Nevertheless, with its powerful, abrupt composition and its mysterious, evocative qualities it is an effective painting, combining aspects of East and West. Is the difficult task of bridging two very different cultures worth the effort? If the question is posed to this artist, she has answered through her art, and the painting's title implies a positive response. It is called *The Necessary Attempt*.

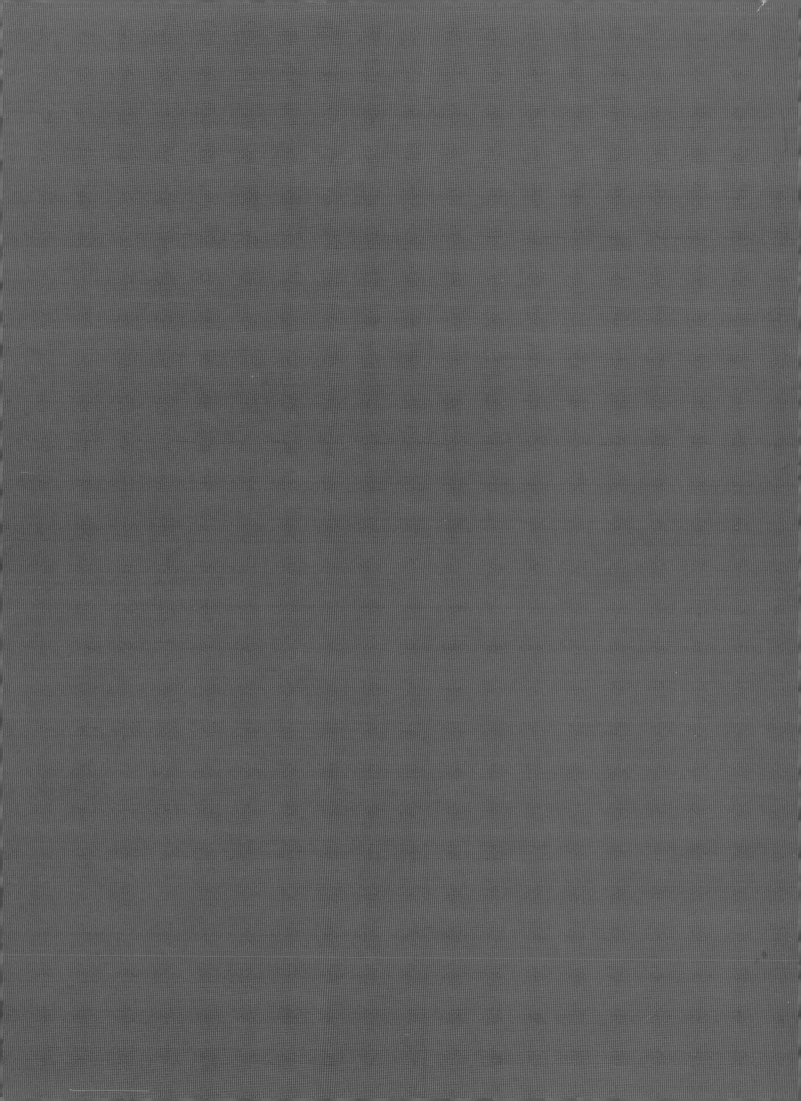

Artists' Biographies

by Caroline Goeser and Yuko Higa

Family names of the artists are in capital letters. If an artist uses the traditional East Asian method of placing family name first, that format is maintained in this listing.

Satoru ABE

Born 1926, Honolulu, Hawaii; lives in Honolulu

In 1948 Abe decided to pursue an artistic career at the Art Students League in New York, where he studied under Louis Bouche, John Carroll, and George Grosz. Abe also studied at the California School of Fine Arts. He returned to Hawaii in 1950, where he met Isami Doi, who had a great spiritual and aesthetic influence on him. In 1952 Abe went to Japan to "find a cultural identity" and had two one-person shows in Tokyo. He revisited New York in 1956 and joined the Sculpture Center.

Primarily known for his welded metal and wood sculptures, Abe also has explored painting ("I started as a painter and evolved into a sculptor"). Abe's sculptures are an embodiment of nature's never-ending cycles. The sculptures' forms are suggestive of nature, especially trees, with networks of branches and roots, majestic columnar trunks, leaves, and tiny seedpods. For Abe, creating sculpture is fundamentally hard labor with three "moments of ecstasy": when the artistic idea is conceived; in the midst of the work, when one knows the artistic dream will be realized; and the final moment when the work is completed. *Y.H.*

SELECTED EXHIBITIONS: 1951 Honolulu Academy of Arts; 1958 Sculpture Center, New York; 1959 *New Talents of America* (traveling group show sponsored by *Art in America* magazine); 1962 Virginia Museum of Fine Arts, Richmond; 1971, 1982 Contemporary Arts Center, Honolulu.

SELECTED COLLECTIONS: Hawaii State Foundation on Culture and the Arts, Honolulu; Honolulu Academy of Arts; Contemporary Arts Center, Honolulu; Philbrook Museum of Art, Tulsa, Okla.; Virginia Museum of Fine Arts, Richmond; Whitney Museum of American Art, New York.

SELECTED BIBLIOGRAPHY: *Retrospective 1967–1987* (Honolulu: Hawaii State Foundation on Culture and the Arts, 1987); *Satoru Abe* (Honolulu: Contemporary Arts Center, 1982); *Satoru Abe: Sculptures and Paintings* (Honolulu: Contemporary Arts Center, 1988)

Don (Dongkuk) AHN

Born 1937, Seoul, Korea; lives in New York, New York

Don Ahn began to study calligraphy and painting at the age of eight. He received a BFA in industrial design at Seoul University in 1960. Immigrating to the United States to study art in 1962, he received his MFA in painting and graphic arts at Pratt Institute in New York in 1965. He completed his course and exam requirements toward a PhD in art history at New York University in 1970. Ahn was a print instructor at C. W. Post College, Long Island University, from 1964 to 1968; assistant professor of painting at New York Institute of Technology from 1965 to 1977; and painting instructor at Cooper Union from 1966 to 1971.

While still in Korea, Ahn studied philosophy at a Buddhist monastery, an experience that has influenced his painting. During the

1960s, Ahn's style reflected his interest in American Abstract Expressionism and also incorporated aspects of the rapid brushwork of Zen calligraphy and painting. Many works of that period were in black and white. He has never seen fit to limit himself to a particular style, however, and has alternated between phases of abstraction and representation. *C.G.*

SELECTED EXHIBITIONS: 1962 Korea Art Exhibition, Seattle World's Fair; 1963 Dayton Art Museum, Ohio; 1965 Evansville Museum, Ind.; 1968 6th Invitational International Print Biennial, National Museum of Modern Art, Tokyo; 1971 National Museum of Modern Art, Tokyo; 1982 Hankuk Gallery, New York; 1996 Walter Wickiser Gallery, New York.
SELECTED COLLECTIONS: C. W. Post College, Long Island University, N.Y.; Dayton Art Museum, Ohio; Evansville Museum, Ind.; Museum of Modern Art, New York.
SELECTED BIBLIOGRAPHY: Canaday, John. "Old Drawings That Do Turn Up," *New York Times* (December 11, 1971); Canaday, John. "2 Shows South of Houston," *New York Times* (September 30, 1972); *Dongkuk Ahn* (Dayton, Ohio: Dayton Art Museum, 1963); Schwartz, Barbara. "Westbeth Artists," *Art News* (December 1971)

Leo AMINO

Born 1911, Taiwan; died 1989, New York, New York

Amino was born of Japanese parents and spent the better part of his childhood in Tokyo. As a child Amino did not receive any formal artistic training but grew up surrounded by various kinds of artistic activities; his mother practiced formal flower arranging and his father calligraphy. In 1929 Amino traveled to the United States, where he pursued a two-year course of study at a junior college in San Mateo, California. He briefly attended the liberal arts program at New York University in 1935. After independent experiments in carving, in 1937 Amino studied sculpture formally at the American Artists School in New York under Chaim Gross, a leading exponent of the direct-carving aesthetic in American sculpture. In the late 1930s Amino's sculptures became more expressive and biomorphic; from the early 1940s on, his reference to the figure lessened to emphasize

spatial effects. In 1945 Amino was one of the first American artists to use plastic as a primary sculptural material, most notably for casting. He was an instructor of sculpture at Black Mountain College in 1946 and 1950, and also at Cooper Union School of Art between 1952 and 1977. *Y.H.*

SELECTED EXHIBITIONS: 1950 *Carvers, Modelers and Welders*, Museum of Modern Art, New York; 1951 *American Sculpture*, Metropolitan Museum of Art, New York; 1956 *Sculpture Today*, Whitney Museum of American Art, New York; 1970 *A Plastic Presence*, Jewish Museum, New York; 1981 *Decade of Transition: 1940–1950*, Whitney Museum of American Art, New York; 1985 *Leo Amino, Sculpture 1945–1974*, Jane Voorhees Zimmerli Art Museum, Rutgers, The State University of New Jersey, New Brunswick.
SELECTED COLLECTIONS: Des Moines Art Center; Jane Voorhees Zimmerli Art Museum, Rutgers, The State University of New Jersey, New Brunswick; Museum of Modern Art, New York; National Museum of American Art, Washington, D.C.; Provincetown Art Association and Museum, Mass.; Whitney Museum of American Art, New York.
SELECTED BIBLIOGRAPHY: Anderson, Wayne. *American Sculpture in Process: 1930–1970* (Boston: New York Graphic Society, 1975); Gilbert, Gregory. *Leo Amino: Sculpture 1945–1974* (New Brunswick: Jane Voorhees Zimmerli Art Museum, Rutgers, The State University of New Jersey, 1985); Schnier, Jacques. *Sculpture in Modern America* (Berkeley: University of California Press, 1948); Swarz, Sahl. *Leo Amino: Sculpture* (New York: Clay Club Sculpture Center, 1946); Wada, Taxie Kusunoki. "Amino Finds New Values in Plastic," *The Hokubei Shimpo* (October 28, 1954)

Bernice BING

Born 1936, San Francisco, California; lives in Philo, California

Born in Chinatown, San Francisco, Bernice Bing attended the California College of Arts and Crafts in Oakland in 1957, studying with Nathan Oliveira, Sabro Hasegawa, and Richard Diebenkorn. She transferred to the California School of Fine Arts (renamed the San Francisco Art Institute in 1960), where

she received her BFA in 1959 and her MFA in 1961, studying with Elmer Bischoff and Frank Lobdell. Under the auspices of CETA and the Neighborhood Arts Program for the Chinatown–North Beach area in San Francisco, Bing and two other artists created the Scroungers Center for Reusable Art Parts (SCRAP), where they created "junk" sculpture. In 1970 Bing taught at the California College of Arts and Crafts, and in 1980 she was appointed Director of the South of Market Cultural Center (SOMAR) in San Francisco.

Bing's large, brightly colored, gestural paintings combine influences from Bay Area Abstract Expressionism, chiefly Clyfford Still's painting style, with her knowledge of Chinese calligraphy and painting. She states: "Chinese calligraphy has been evolving for six thousand years, whereas in our Western society we are but primitives experiencing a new aesthetic. In my abstract imagery, I am attempting to create a new synthesis with a very old world." *C.G.*

SELECTED EXHIBITIONS: 1960, 1966 San Francisco Annual Exhibition, San Francisco Museum of Art; 1968 California College of Arts and Crafts Gallery, Oakland; 1980 San Francisco Art Institute Alumnae Exhibition, SOMAR Cultural Center, San Francisco; 1991 SOMAR Cultural Center, San Francisco; 1993 *Milieu: Part I,* Asian American Arts Center, New York; 1995 *With New Eyes, Toward an Asian American Art History in the West,* San Francisco State University; 1996 Rose Art Museum, Brandeis University, Waltham, Mass.

SELECTED BIBLIOGRAPHY: Bing, Bernice. "Artist Statement," in *Completing the Circle: Six Artists,* eds. Florence Wong and George Rivera (Santa Clara, Calif.: Asian Heritage Council, 1990); Roth, Moira and Diane Tani. *Bernice Bing* (Berkeley and San Francisco: Visibility Press, 1991); *With New Eyes, Toward an Asian American Art History in the West* (San Francisco: San Francisco State University, 1995)

Louis Pal CHANG (Chang Bal)
Born 1901, Seoul, Korea; lives in Pittsburgh, Pennsylvania

Louis Pal Chang attended the Tokyo Art Institute from 1922 to 1923. He finished his art education in the United States, graduating from the Fine Art Department at Columbia College in New York in 1925. He returned to Seoul in 1926, commencing a long teaching career that lasted until his retirement in 1962, when he moved to the United States. Chang was a major force in the establishment of the College of Fine Arts at Seoul National University and was named the first Dean of the College in 1953. In 1960 he was elected Vice President of the National Academy of Arts in Seoul.

Chang championed the cause of Western art and artistic internationalism in Korea. In his classes, he required all Eastern students to work with Western mediums and required all Western students to study Eastern ink painting. In his own work, he employed the artistic methods of both East and West. However, he did not create abstract paintings until he came to the United States, where he felt freer to experiment with a variety of new artistic approaches. *C.G.*

SELECTED EXHIBITIONS: 1976 Retrospective exhibition, Shin-Segae Art Museum, in association with the Seoul National University Museum.
SELECTED COLLECTIONS: National Museum of Modern Art, Seoul; Seoul National University Museum; Sokang University, Seoul; St. Vincent Archabbey, Latrobe, Pa.
SELECTED BIBLIOGRAPHY: *Retrospective Exhibition of Louis Pal Chang* (Seoul: Shin-Segae Art Museum, in association with the Seoul National University Museum, 1976)

CHAO Chung-hsiang
Born 1913, Henan, China; died 1991, Miaoli, Taiwan

Chao Chung-hsiang began to study painting with his father in 1920. From 1932 to 1935 he studied art at Henan Teachers' Normal School; from 1935 to 1939 he studied at the Hangzhou National Academy of Art. In 1948 Chao left China for Taipei, Taiwan, where he became Associate Professor of Arts at the

National Normal University. In 1958 he immigrated to the United States, where he met leading members of the New York art scene. He painted in New York until 1984, that year returning to Taipei to establish a studio.

Many have noted Chao's ability to successfully integrate Eastern and Western styles in his art. In his paintings of the 1960s he tended to combine geometric, "rational" Western forms with freer brushstrokes in a Chinese calligraphic style. In the late 1960s and early 1970s Chao began to experiment with superimposing brightly colored acrylic pigment over splashed ink on Chinese rice paper. *C.G.*

SELECTED EXHIBITIONS: 1963 Represented China in International Exhibition on Abstract Expressionism, Solomon R. Guggenheim Museum, New York; 1965 Solomon R. Guggenheim Museum, New York; 1977 Queens Museum, Flushing, N.Y.; 1981 Brooklyn Museum; 1984 Taipei Fine Arts Museum; 1991 Miaoli Cultural Centre, Taiwan.

SELECTED COLLECTIONS: Brooklyn Museum; Grey Art Gallery and Study Center, New York University, New York; Hudson River Museum, Yonkers, N.Y.; Metropolitan Museum of Art, New York; Queens Museum, Flushing, N.Y.; Taipei Fine Arts Museum.

SELECTED BIBLIOGRAPHY: *Chao Chung-hsiang* (Hong Kong: Alisan Fine Arts, 1992); Hantover, Jeffrey. "Culture Yin Yang: The Art of Chao Chung-hsiang," *Artention* 28 (September 1992); *Paintings by Chao Chung-hsiang* (Taipei: Taipei Fine Arts Museum, 1984)

CHEN Chi

Born 1912, Wuxi, Jiangsu, China; lives in New York, New York

Chen Chi received formal training in traditional Chinese calligraphy and watercolor painting on silk. In 1926 he moved to Shanghai, where he began to blend his training in Eastern art with Western techniques and joined the avant-garde White Swan Art Club in the 1930s. From 1942 to 1946 Chen taught watercolor and drawing at the School of Architecture at St. John's University in Shanghai. Moving to the United States in 1947, he began to exhibit his work through a cultural exchange program of the World Student's Relief in New York. In 1949 he became a member of the American Water-

color Society. During the 1950s Chen traveled throughout the country, painting scenes of American cities for *Collier's* magazine and the Ford Motor Company magazines. By 1955 his work had been exhibited in museums in New York, California, Texas, and Florida. He was a visiting professor of watercolor at Pennsylvania State University from 1959 to 1960, and was an artist-in-residence at the Ogden City Schools in Utah in 1967, and at Utah State University in 1971. Always a watercolorist with deep feelings for the natural world, Chen Chi has nevertheless produced many paintings of extremely abstract character when a particular mood or philosophical theme seemed to call for that treatment. *C.G.*

SELECTED EXHIBITIONS: 1952 *American Watercolors, Drawings, and Prints,* Metropolitan Museum of Art, New York; 1963 *22nd International Watercolor Exhibition,* Brooklyn Museum; 1988 National Museum of History, Taipei; 1989 Retrospective exhibition, Columbus Museum, Ga.; 1992 Retrospective exhibition, Gilcrease Museum, Tulsa, Okla.; 1993 National Arts Club, New York; 1994 Butler Institute of American Art, Youngstown, Ohio.

SELECTED COLLECTIONS: Butler Institute of American Art, Youngstown, Ohio; Charles and Emma Frye Museum, Seattle; Fort Worth Art Museum; Metropolitan Museum of Art, New York; Pennsylvania Academy of Fine Arts, Philadelphia.

SELECTED BIBLIOGRAPHY: Chen Chi. *Aquarelles de Chen Chi* (Shanghai, 1942); *Chen Chi: Watercolors, Drawings, Sketches* (New York: Chen Chi Studio, 1980); Hall, Paula. "Chen Chi, 'A Journey to Achieve at 80,'" *International Fine Art Collector* 2 (March 1992): 40–47; Hall, Paula. "Rendezvous Artist: Chen Chi," *Gilcrease Magazine of American History and Art* (April–July, 1992): 1–15; Norelli, Martina Roudabush. *East Meets West, Chen Chi Watercolors* (Columbus, Ga.: Columbus Museum, 1989)

CHINYEE

Born 1929, Nanjing, China; lives in White Plains, New York

Chinyee immigrated to the United States in 1947. She received her BFA at the College of Mount Saint Vincent in New York City and

her MA in art education from New York University in 1952. For more than twenty years she worked as a simultaneous interpreter at the United Nations. Since her retirement in 1987, she has devoted her time to painting.

The concept and experience of change are central to Chinyee's abstract art of the last four decades. Rather than developing "signature" motifs, Chinyee always varies her approach to painting. While she acknowledges the centrality of nature in her painting, which stems from her understanding of traditional Chinese art, she also admits that she strives toward a direct engagement with the properties of her mediums before referring to the external world. She may begin a painting, for example, with an intuitive reaction to a color, which she conveys visually with a wide variety of brushstrokes: dabs, sweeping calligraphic gestures, and zigzags of thick pigmentation. Her use of several mediums, including oil, acrylic, watercolor, ink, and collage, reveals her commitment to experimentation. *C.G.*

SELECTED EXHIBITIONS: 1953, 1965 Mi Chou Gallery, New York; 1971 China Institute, New York; 1990 SUNY Performing Arts Center, Purchase, N.Y.; 1992 Viridian Gallery, New York; 1995 *Chinyee, Retrospective Exhibition 1965–1995,* East Asia Gallery, Taipei.
SELECTED COLLECTIONS: Chemical Bank, New York; St. Doras Enterprises Co., Ltd., Taipei; UNICEF, New York.
SELECTED BIBLIOGRAPHY: "The Art of Chinyee," *Secretariat News, United Nations* (November 1971); *Between Interpretations: Recent Paintings by Chinyee* (New York: Viridian Gallery, 1994); *Chinyee: Retrospective Exhibition, 1965–1995* (Taipei: East Asia Gallery, 1995); McCormack, Ed. "A Painter of Surpassing Lyricism," *Artspeak* (October 1994); Wepman, Dennis. "Chinyee Translates Emotion into Color," *Manhattan Arts* (November 1989)

Fay CHONG

Born 1912, Guangzhou (Canton), China; died 1973, Seattle, Washington

Fay Chong immigrated to the United States with his family in 1920. He studied art with Hannah Jones at Broadway High School in Seattle, along with his classmates Morris Graves and George Tsutakawa. After graduat-ing he pursued study at the Leon Derbyshire School of Art in Seattle. He traveled to China in 1929 and 1935 to study calligraphy, and from 1939 through the 1950s he studied sporadically with Mark Tobey. Chong received a BA in 1968 and an MA in art education in 1971 from the University of Washington.

While making linoleum block prints for the WPA between 1939 and 1940, Chong discovered the creative and immediate medium of watercolor. During the 1940s and through the 1950s, Chong developed his mature style, abstracting natural and industrial forms in watercolor. He fused Asian calligraphic brushwork with a modern Western taste for vast space and all-over compositions within the smaller-scale format of watercolor paintings. *C.G.*

SELECTED EXHIBITIONS: 1942 Seattle Art Museum; 1953 Charles and Emma Frye Museum, Seattle; 1954 Reed College, Portland, Oreg.; 1956 Santa Barbara Museum of Art; 1965 Portland State University, Oreg.; 1976 Retrospective memorial exhibition, Bellevue Art Museum, Wash.; 1990 Retrospective exhibition, Carolyn Staley Fine Prints, Seattle.
SELECTED COLLECTIONS: Phillips Collection, Washington, D.C.; Seattle Art Museum; Seattle Public Library; University of Kansas Art Museum, Topeka; University of Oregon Museum of Art, Eugene.
SELECTED BIBLIOGRAPHY: Brunsman, Laura. *Fay Chong, Northwest Watercolorist: A Look Back* (Seattle: Carolyn Staley Fine Prints, 1990); *With New Eyes, Toward an Asian American Art History in the West* (San Francisco: San Francisco State University, 1995)

CHUANG Che

Born 1934, Beijing, China; lives in Yonkers, New York

In 1940 Chuang studied painting with Liu Yi-Shih and Huang Yi in Sichuan. In 1948 he moved to Taichung, Taiwan, where he studied sketching with Wang E-chang. He entered the Fine Arts Department at National Taiwan Normal University in 1954, and began his teaching career in 1957. Invited by the architect Chen Chi-kwan, Chuang taught at Tunghai University in Taiwan in 1963. Awarded a J. D. Rockefeller III Fund Travel grant in 1966, Chuang studied at Iowa University and

became Seymour Lipton's assistant in New York. He returned to his teaching post at Tunghai University in 1968, from which he resigned in 1973. He moved to the United States that year, settling in the country near Ann Arbor, Michigan, and in 1988 moved to Yonkers, New York.

Chuang Che has successfully explored abstraction in his paintings for over three decades. A member of the Fifth Moon Group in Taiwan in the 1950s, he embraced the development of gestural abstraction in America, although his work differs subtly but visibly from modern Western abstract paintings. For example, while American Abstract Expressionist compositions tend toward unity, Chuang Che's paintings are complicated with interpenetrating and overlapping forms and lines, and are closely linked to natural forms. *C.G.*

SELECTED EXHIBITIONS: 1968 Taiwan Provincial Museum, Taipei; 1970 Flint Institute of Arts, Mich.; 1972 Chinese Culture Center, New York; 1977 Kalamazoo Institute of Art, Mich.; 1980 National Museum of History, Taipei; 1982 Arts Center, Hong Kong; 1992 Retrospective exhibition, Taipei Fine Arts Museum. SELECTED COLLECTIONS: Cleveland Museum of Art; Detroit Institute of Arts, Mich.; Herbert F. Johnson Museum of Art, Cornell University, Ithaca, N.Y.; Hong Kong Museum of Art; National Museum of History, Taipei; Spencer Art Museum, University of Kansas, Lawrence; Taipei Fine Arts Museum. SELECTED BIBLIOGRAPHY: *Chuang Che, Recent Landscapes*, essay by Jeffrey Wechsler (Hong Kong: Alisan Fine Arts Ltd., 1993); Liu Wen-tan. *Chuang Che* (Taichung, Taiwan: Galerie Pierre, 1993); Stanley-Baker, Joan, et al. *Chuang Che* (Taipei: Taipei Fine Arts Museum, 1992)

Sung-Woo CHUN
Born 1934, Seoul, Korea; lives in Seoul

Chun attended Seoul National University in 1953 before coming to the United States later that year. He first attended San Francisco State College and transferred to San Francisco Art Institute in 1955, receiving his BFA in 1958. He received his MFA from Mills College in Oakland, California, in 1960, and his PhD in art history from Ohio State University in 1964. From 1964 to 1965 he taught at the Richmond School of Art in California, and from 1968 to 1971 he taught at the College of Fine Arts at Seoul National University. Chun received considerable critical attention in the United States during the 1960s with his subtly colored fieldlike paintings that frequently incorporate a mandala motif. Upon the death of his father in 1971, Chun assumed his father's positions as principal of Posung High School and as curator of the Kansong Art Museum, Korea (both institutions were also founded by his father). For many years, these activities constrained the time available to him to paint; in June of 1994, Chun had his first solo exhibition in Korea in twenty-six years. *C.G.*

SELECTED EXHIBITIONS: 1958 Invitational exhibition, San Francisco Museum of Modern Art; 1960 *Young America,* Whitney Museum of American Art, New York; 1961, 1963, 1967 Biennial Exhibition of Painting and Sculpture, University of Illinois at Urbana-Champaign; 1961–65 Bolles Gallery, San Francisco; 1961 Mi Chou Gallery, New York; 1962 Invitational Exhibition, American Painting and Sculpture, Whitney Museum of American Art, New York; 1983–93 Invitational exhibitions, National Museum of Modern Art, Seoul. SELECTED COLLECTIONS: California Palace of the Legion of Honor, San Francisco; Herbert F. Johnson Museum of Art, Cornell University, Ithaca, N.Y.; National Museum of Contemporary Art, Seoul; San Francisco Museum of Modern Art; Sarah Lawrence College, Bronxville, N.Y.; Whitney Museum of American Art, New York. SELECTED BIBLIOGRAPHY: Kwon Byung-Rin. "Painting States of Mind," *Seoul* (July 1995): 31–35; *Sung-Woo Chun* (Seoul: Gana Art Gallery, 1994)

Isami DOI
Born 1903, Ewa Beach, Oahu, Hawaii; died 1965, Kauai, Hawaii

Isami Doi grew up in Kalaheo, Kauai, and studied at the University of Hawaii at Manoa from 1921 to 1923. He moved to New York and studied at Columbia University, where he received a BS in 1927. He studied art in Paris from 1930 to 1931 and finally returned to Hawaii in 1958, where he continued to paint

until his death. He first gained national prominence when his print, *Woodstock Village*, was chosen as one of the fifty best prints by the American Institute of Graphic Arts.

Doi is often considered the "spiritual and aesthetic father" of many of the Japanese American artists working in Hawaii after World War II. He befriended many of them in New York and gave them encouragement and advice. He created paintings, watercolors, prints, and even jewelry. His early works portray the rolling hills of Kauai with its rich red dirt and verdant trees and forests. His sensual treatment of female figures was informed by the richness of the local landscape forms. He always returned to the beautiful and serene images of his beloved Kauai and transformed them into timeless abstractions of subtle and rich hues. His later works also reflect a deeply esoteric and mystical Buddhist spirituality. *Y.H.*

SELECTED EXHIBITIONS: 1960 *Artists of Hawaii,* Downtown Gallery, New York; 1960 Honolulu Academy of Arts; 1960–64 Carnegie Institute, Pittsburgh; 1961 University of Nebraska, Lincoln; 1961 Art Institute of Chicago.
SELECTED COLLECTIONS: Albright-Knox Art Gallery, Buffalo; Corcoran Gallery of Art, Washington, D.C.; Hawaii State Foundation on Culture and the Arts, Honolulu; Honolulu Academy of Arts; Museum of Modern Art, New York.
SELECTED BIBLIOGRAPHY: "Isami Doi, A Tribute," *The Beacon* (October 1971); *Isami Doi, 1903–1965: A Memorial Retrospective* (Honolulu: Honolulu Academy of Arts, 1966)

Sabro HASEGAWA

Born 1906, Yamaguchi, Japan; died 1957, San Francisco, California

Hasegawa's interest in both traditional calligraphy and modern Western art was evident from an early age. At the Imperial University in Tokyo he studied art history and wrote his thesis on the life and work of Sesshu. From 1929 to 1932 he studied in the United States, England, Italy, Spain, and France. He began to paint abstract works in 1935 and wrote the first book on abstract art in Japanese. He was also active in the avant-garde scene, founding the Jiyubitjutsu or "Free Artists' Group" in 1937. In about 1940 he began to immerse himself in the study of Zen Buddhism and retreated to a remote farm to study Taoist and Zen classics. During World War II he was arrested for refusing to create art for propaganda purposes. In 1951 he began to work almost exclusively in black and white in many techniques, such as brush, woodblock, and ink rubbing. His style is thought to have reached full expression at this time.

After arriving in California in 1956, he taught at the American Academy of Asian Studies in San Francisco and at the California College of Arts and Crafts in Oakland. He exerted a profound influence on artists of the Bay Area through his gifts both as a teacher and as an artist. His widely acknowledged expertise and sensitivity to abstract tendencies in modern Japanese art led to his participation in selecting artists for the 1953 *Contemporary Japanese Graphic Art* exhibition at the Museum of Modern Art, New York. He also lectured in New York, and his ideas, which combined Eastern philosophy with Western painting, were well received. Among those who attended his lectures were Franz Kline, Willem de Kooning, and other artists who found interest in his theories on the relationship of calligraphy to abstract painting. Isamu Noguchi spent considerable time in Hasegawa's company during a trip to Japan in 1950; they developed a close relationship of mutual respect and influence that deeply affected the philosophy and artistic production of both artists. *Y.H.*

SELECTED EXHIBITIONS: 1932 19th Nika Exhibition, Tokyo Art Museum; 1936 Bijutsushinron-sha Gallery, Osaka; 1936 Nichido Gallery, Tokyo; 1937 Nihon Bijutsuka Kyokai Exhibitions I, II, III, IV, Tokyo; 1949 Second Modern Art Exhibition, Mitsukoshi Gallery, Tokyo; 1952 Tokyo Biennial; 1954 Contemporaries Gallery, New York; 1956 Gump's Gallery, San Francisco; 1957 Oakland Museum, Calif.; 1957 Willard Gallery, New York; 1958 *Contemporary Painters of Japanese Origin in America,* Institute of Contemporary Art, Boston.
SELECTED COLLECTIONS: National Museum of Modern Art, Tokyo; Oakland Museum, Calif.; Sabro Hasegawa Memorial Gallery, Konan School, Hyogo Prefecture, Japan.
SELECTED BIBLIOGRAPHY: Fujimoto, Shozo, ed. *Sabro Hasegawa Treatise* (Tokyo: Sansai-sha,

1977); Hasegawa, Sabro. "Abstract Art in Japan," *The World of Abstract Art* (New York: Abstract American Artists, 1957); Hasegawa, Sabro. "Five Calligraphic Drawings," *New World Writing* (The New American Library of World Literature, Inc., 1954); Hasegawa, Sabro. "My Time with Isamu Noguchi" (1951), trans. Christopher Blasdel (Tokyo, 1977); Hasegawa, Sabro. "To Situate Avant-Garde Painting" (1937), in Vera Linhartova's essay in *Japon des Avant-Gardes, 1910–1970* (Paris: Centre Georges Pompidou, 1986): 165; Jenks, Anne L., and Thomas M. Messer. *Contemporary Painters of Japanese Origin in America* (Boston: Institute of Contemporary Art, 1958)

Hisako HIBI

Born 1907, Fukui-ken, Japan; died 1991, San Francisco, California

Living in Japan until 1920, Hibi's aesthetic sensibilities were instilled by her grandmother. After graduating from high school in San Francisco, she attended the California School of Fine Arts from 1926 to 1929. Her teachers included Otis Oldfield, Gottardo Piazzoni, and Spencer Macky. In May of 1942 Hibi was sent to internment camps first in Tanforan, California, and then in Topaz, Utah, with her artist-husband Matsusaburo George Hibi and their two children. After internment the family moved to New York City where she continued her art studies with Victor D'Amico at the Museum of Modern Art. In 1954 she returned to San Francisco.

Although Hibi painted figurative and landscape subjects early in her long career, she later explored abstraction. Her works often attempt to capture ethereal aspects of nature, such as the breeze, space, and heat. She painted her oils very thinly as she tried to show the influence of Japanese-style watercolors and did not use varnish so as not to "trap" the painting. Hibi wanted to be organic, not simply nonobjective, in her observations. Betty Kano describes Hibi's late work as "in layers, developed from a Buddhist understanding of life as a transparent, ephemeral voyage to be lived with compassion and modesty." *Y.H.*

SELECTED EXHIBITIONS: 1934, 1937, 1967–70 California State Fair; 1937, 1939 Oakland Art Gallery, Calif.; 1939 Golden Gate International Exposition, San Francisco; 1970 Lucien Labaudt Gallery, Los Angeles; 1992 Japanese American National Museum and Wight Art Gallery, University of California, Los Angeles; Crocker Art Museum, Sacramento; Oakland Museum, Calif.

SELECTED COLLECTIONS: Japanese American National Museum, Los Angeles; Oakland Museum of California.

SELECTED BIBLIOGRAPHY: Brown, Michael D. *Views from Asian California 1920–1965, An Illustrated History* (San Francisco: Michael D. Brown, 1992); Kano, Betty, "Four Northern California Artists: Hisako Hibi, Norine Nishimura, Yong Soon Min and Miran Ahn," *Feminist Studies* 19, no. 3 (1993): 628–42

Paul HORIUCHI

Born 1906, Kawaguchi-Ko, Japan; lives in Seattle, Washington

Horiuchi came to the United States in 1921 at the age of sixteen, joining his parents in Rock Springs, Wyoming. Although his mother left for Japan after his father's death, Horiuchi determined to settle in the United States and became a naturalized citizen in 1928, moving to Seattle in 1946. Horiuchi is essentially self-taught as a painter, although he had some art training in Japan, in particular, the study of *sumi* ink with the artist Iketani. Like many other Seattle artists, he was close to Mark Tobey, whose knowledge and interpretation of East Asian art and philosophy affected many Pacific Northwest artists. Horiuchi began to paint full-time in 1951. In 1956 he began to work in collage after becoming inspired by an informally arranged bulletin board covered with many layers of torn and overlapped papers in Seattle's Chinatown. Of his chosen technique, Horiuchi has said, "I use rice paper because it is so delicate, sensitive, and expressive. . . . I believe that the art of painting . . . should convey a feeling of serene satisfaction and inner harmony. I have not been able to attain that sensitivity and subtleness through the medium of oils." *Y.H.*

SELECTED EXHIBITIONS: 1954 Seattle Art Museum; 1961 Carnegie International Exhibition, Carnegie Institute, Pittsburgh; 1962 *Art Since 1950,* Seattle World's Fair; 1964 Reed College, Portland, Oreg.; 1965 Munson-Williams-

Proctor Institute Museum of Art, Utica, N.Y.; 1969 University of Oregon Museum of Art, Eugene, and Seattle Art Museum; 1970 National Museum of Modern Art, Tokyo; 1987 Tacoma Art Museum, Wash.

SELECTED COLLECTIONS: Denver Art Museum; Fogg Art Museum, Harvard University, Cambridge, Mass.; Imperial Household, Tokyo; Reed College, Portland, Oreg.; Santa Barbara Museum of Art; Seattle Art Museum; Vancouver Art Museum, Canada; Wadsworth Atheneum, Hartford, Conn.

SELECTED BIBLIOGRAPHY: Faber, Ann. "Paul Horiuchi," *Art International* (May 1961): 50; Griffin, Rachel, and Martha Kingsbury. *Art of the Pacific Northwest, From the 1930s to the Present* (Washington, D.C.: National Collection of Fine Arts, Smithsonian Institution, 1974); Lane, Barbara E. *Paul Horiuchi: 50 Years of Painting* (Eugene, Oreg.: University of Oregon Museum of Art in association with Seattle Art Museum, 1969); *Paul Horiuchi* (Seattle: Seattle Art Museum, 1958); *Paul Horiuchi, Master of the Collage* (Tacoma, Wash.: Tacoma Art Museum, 1987)

Ka-Kwong HUI

Born 1922, Hong Kong; lives in Caldwell, New Jersey

Hui attended the Shanghai School of Fine Arts in Shanghai and the Kwong Tung School of Art in Guangzhou (Canton). He was an apprentice to the sculptor Cheng Ho before moving to California in 1948. He attended New York State College of Ceramics at Alfred University, receiving his BFA in 1951 and his MFA in 1952. From 1964 to 1965 Roy Lichtenstein invited Hui to be his technical collaborator on a series of cup sculptures and ceramic mannequin heads. Hui has taught sculpture and ceramics at the Brooklyn Museum School (1952–62) and at Douglass College and Mason Gross School of the Arts, both at Rutgers University (1957–88).

In the late 1950s and early 1960s Hui created asymmetrical, organic ceramic forms with matte, earthy glazes. Partly as a result of his collaboration with Lichtenstein, Hui's style changed in the mid-1960s. He began to create carefully thrown, symmetrical pots, which he would then assemble and paint with whimsical designs in bright, clear colors. He characterized his impulse to put forms together symmetrically as more traditionally Chinese

since the Japanese predilection is to set ceramic forms off center. *C.G.*

SELECTED EXHIBITIONS: 1955 Cannes International Ceramic Exhibition; 1958 *Ceramic International Exhibition,* Metropolitan Museum of Art, New York; 1959 Munson-Williams-Proctor Institute Museum of Art, Utica, N.Y.; 1960 Brooklyn Museum; 1964 International Exhibit of Contemporary Ceramics, Tokyo; 1965 Newark Museum, N.J.; 1967 Museum of Contemporary Crafts, New York; 1970 *Objects: USA,* Memorial Art Gallery, University of Rochester, N.Y. (with national and international tour through 1974); 1988 New Jersey State Museum, Trenton.

SELECTED COLLECTIONS: Cooper Union Museum of Decorative Arts, New York; Everson Museum of Art, Syracuse; Johnson Wax Collection, Racine, Wis.; Museum of Contemporary Crafts, New York; Newark Museum, N.J.; University of Michigan Art Museum, Ann Arbor.

SELECTED BIBLIOGRAPHY: Hendricks, Bici. "Hui Ka Kwong," *Craft Horizon* 27 (May 1967): 40–43, 73; Hui, Ka-Kwong, and James Crumrine. "Dialogue in a Museum," *Craft Horizon* 27 (July 1967): 18–22+; *Objects: USA* (Rochester, N.Y.: University of Rochester Memorial Art Gallery, 1970); Slivka, Rose. *Crafts of the Modern World* (New York: Horizon Press, 1968)

Genichiro INOKUMA

Born 1902, Takamatsu, Japan; died 1993, Tokyo, Japan

Self-taught in painting as a youth, Inokuma received formal art training at the Tokyo School of Fine Arts from 1922 to 1926. In 1936, during a period when the Japanese government stood against artistic influence from the West, Inokuma was one of a number of artists working in the Western style to form the *Shinseisaku-ho Kyokai* group, an anti-government association that promoted new art forms. He taught oil painting at the Japanese Academy of Fine Arts (1937–40) and established an art school in Japan in 1945. Upon his arrival in New York in 1955, Inokuma created abstract paintings that featured Japanese folk images, encouraged by Marion Willard of the Willard Gallery to explore his Japanese heritage.

During the 1940s and early 1950s Inokuma's painting style was indebted to the French modernists, especially Picasso and Matisse. In the mid-1960s Inokuma focused on the city, creating abstractions with energetic brush-work that were suggestive of aerial city views. His technique was likened to a traditional Japanese painting technique, in which white paint is splattered onto blue cloth. Beginning in 1970 Inokuma was increasingly attracted to combinations of bright primary colors, which replaced his 1960s predilection for monochromatic compositions. His 1972 *Landscape* series emphasizes an expansive horizontal axis and reveals a growing interest in nature. Inokuma returned to Japan in 1975. *C.G.*

SELECTED EXHIBITIONS: 1937 First Shinseisaku-ho Kyokai exhibition, Tokyo; 1955 18th International Watercolor Painting Biennial, Brooklyn Museum; 1956 Willard Gallery, New York; 1960 Yale University Art Gallery, New Haven, Conn.; 1965 *Japanese Artists Abroad,* National Museum of Modern Art, Tokyo; 1965–67 *The New Japanese Painting and Sculpture,* San Francisco Museum of Art and Museum of Modern Art, New York; 1982 Retrospective exhibition, Kagawa Prefectural Cultural Centre, Japan.

SELECTED COLLECTIONS: Marugame Genichiro-Inokuma Museum of Contemporary Art, Marugame, Japan; Museum of Modern Art, Kamakura, Japan; Museum of Modern Art, New York; National Museum of Modern Art, Tokyo and Kyoto; San Francisco Museum of Modern Art; Solomon R. Guggenheim Museum, New York.

SELECTED BIBLIOGRAPHY: *Genichiro Inokuma* (Marugame, Japan: Marugame Genichiro-Inokuma Museum of Contemporary Art, 1991); *Genichiro Inokuma: Guen Inokuma 1902–1993—A Legacy of Vitality* (Marugame, Japan: Marugame Genichiro-Inokuma Museum of Contemporary Art, 1994); *Genichiro Inokuma: Retrospective Exhibition* (Kagawa, Japan: Kagawa Prefectural Cultural Centre, 1982); Inokuma, Genichiro. Introduction to *Dear Heartfelt Friend, Isamu Noguchi* (Marugame, Japan: Marugame Genichiro-Inokuma Museum of Contemporary Art, 1992); Jenks, Anne L., and Thomas M. Messer. *Contemporary Painters of Japanese Origin in America* (Boston: Institute of Contemporary Art, 1958)

Ralph IWAMOTO

Born 1927, Honolulu, Hawaii; lives in New York, New York

Iwamoto's art instruction began in high school (1942–45), where he studied with Shirley Russel. Upon graduation he worked in the art department of the *Honolulu Star-Bulletin,* with the artist Sueko Kimura as supervisor. After serving in the U.S. Army from 1946 to 1948, Iwamoto was able to study under the G.I. Bill at the Art Students League in New York with, among others, Vaclav Vytacil and Byron Browne. In New York Iwamoto met several other Japanese American artists, including Tetsuo Ochikubo, Tadashi Sato, Jerry Okimoto, Tad Miyashita, Joseph Goto, and Satoru Abe, sharing living quarters with the last. His first one-person show in New York was held at the Rugina Gallery in 1955; in a group show that year, he exhibited with Alfred Leslie and Louise Nevelson. With other Japanese American artists, Iwamoto frequented the active bar scene (including the famous Cedar Bar) associated with the New York Abstract Expressionists. In the 1970s he curated several exhibitions, including seven solo shows at the Westbeth Galleries, and assisted the American Abstract Artists in obtaining exhibition space for their fortieth anniversary show, at which time he was invited to become a member of that group.

Over the course of his career, Iwamoto's painting has undergone several variations of style and technique, including periods emphasizing organic or geometric forms. In the late 1950s he developed imagery that combined motifs from traditional Japanese art with organic shapes. The paintings of this period display the muted coloration and sensitively placed, flattened shapes of Japanese design. *C.G.*

SELECTED EXHIBITIONS: 1948 Honolulu Academy of Arts; 1957 *22nd Annual Exhibition,* Butler Institute of American Art, Youngstown, Ohio; 1958 *Annual Exhibition of Painting and Sculpture,* Whitney Museum of American Art, New York; 1976 *40th Anniversary Show, American Abstract Artists,* Westbeth Gallery, New York; 1979 *Nippon Ten,* Japanese-American Association Hall, New York; 1983 *New Direction—Ten Japanese American Artists,* Newark Museum, N.J.

SELECTED COLLECTIONS: Butler Institute of American Art, Youngstown, Ohio; Hawaii State Foundation on Culture and the Arts, Honolulu; Herbert F. Johnson Museum of Art, Cornell University, Ithaca, N.Y.; Jane Voorhees Zimmerli Art Museum, Rutgers, The State University of New Jersey, New Brunswick; Wadsworth Atheneum, Hartford, Conn.

SELECTED BIBLIOGRAPHY: Harrison, Helen A. "Japanese Abstraction: Looking West," *New York Times,* Long Island Edition (December 29, 1985); Mellow, James R. "Art Review: Display by 7 at Westbeth," *New York Times* (February 17, 1973); Watkins, Eileen. "Newark Museum Exhibits Contrast Traditional, Contemporary Japan Art," *Newark Star-Ledger* (October 22, 1983); Weigl, Jean Kondo. *Works by Japanese-American Visual Artists and Craftsmen* (Salt Lake City: University of Utah, 1978)

Dale JOE

Born 1928, San Bernardino, California; lives in New York, New York

Dale Joe received his BA in English literature from the University of California at Berkeley in 1950. He then studied painting with Felix Ruvulo and printmaking with Leon Goldin at the California College of Arts and Crafts in Oakland, and he began to exhibit his work at the San Francisco Museum of Modern Art, the M. H. de Young Memorial Museum, and the Oakland Museum. Relocating to New York in 1953, Joe was the recipient of a John Hay Whitney Fellowship (1953–54), which funded his project to examine Western handwriting at the Pierpont Morgan Library and to study calligraphy with C. C. Wang, who had a studio at Carnegie Hall. Subsequently, Joe received a Fulbright Award for travel to Paris from 1956 to 1957.

Joe is a great admirer of Bradley Walker Tomlin's calligraphic approach to painting, and his interest in Western and Eastern writing and calligraphy is evident in his early style. These works from the mid to late 1950s combine moderately impastoed surfaces with delicate linear markings. This style was followed by paintings that revealed Joe's interest in the atmospheric effects in traditional Chinese landscape paintings. These works were generally restricted to black, white, and gray, and were suggestive of windswept mists. During the 1970s Joe was forced to supplement his painting career with alternative employment and soon became a full-time freelance designer for a variety of magazines. *C.G.*

SELECTED EXHIBITIONS: 1954–63 Solo exhibitions at Urban Gallery, New York, and Mi Chou Gallery, New York; 1954–55 Bokujin Group exhibitions, Japan; 1957 *Peintres Américains Fulbright,* Paris; 1958 *Five Whitney Fellows,* Mi Chou Gallery, New York; 1958 *Fulbright Painters Exhibition,* Smithsonian Institution traveling exhibition; 1960 *Young America,* Whitney Museum of American Art, New York; 1960 *Young America,* Mi Chou Gallery, New York.

SELECTED COLLECTIONS: Grey Art Gallery and Study Center, New York University, New York; Newark Museum, N.J.; San Francisco Museum of Modern Art.

SELECTED BIBLIOGRAPHY: *Contemporary Art 1954–55* (New York: Urban Gallery, 1954); O'Hara, Frank. "Dale Joe," *Art News* 53 (October 1954): 58; *Young America* (New York: Whitney Museum of American Art, 1960)

Diana KAN

Born 1926, Hong Kong; lives in New York, New York

Diana Kan learned the art of calligraphy as a child from her father, Kan Kam Shek. She was a precocious artist, honored by a solo exhibition at the National Academy of Fine Arts in Shanghai at the tender age of nine. At age twelve she had already published her first book of poetry, *White Clouds.* She studied painting with Chang Dai Chien in China beginning in 1946 and was his appointed successor in the tradition of lotus painting. In New York, Kan studied with Robert Johnson and Robert Hale at the Art Students League from 1949 to 1951, and in Paris with Paul Lavelle at the Ecole des Beaux-Arts from 1952 to 1954. Kan was selected for membership in The Pen and Brush in 1965 and the American Watercolor Society in 1968.

As the chosen successor of her Chinese painting professor, Kan extended the tradition of Chinese painting, though not without personal variation. Inheriting the technique from her teacher, Kan has used handmade brushes (some more than two hundred years old),

watercolors ground from semiprecious stones, and occasionally gold leaf. Her imagery is inspired by nature and by Chinese paintings of nature, but her shimmering and colorful painted surfaces are impressionistic and reminiscent of the work of Western landscape painters, such as Turner, who were important influences for Kan as well. *C.G.*

SELECTED EXHIBITIONS: 1947 Gloucester Art Galleries, Hong Kong; 1963 Royal Academy of Fine Arts, London; 1964 National Arts Club, New York; 1965 American Watercolor Society, New York; 1971 National Museum of History, Taipei; 1972 New York Cultural Center, New York; 1982 Headley-Whitney Museum, Lexington, Ky.; 1986 Retrospective exhibition, Elliott Museum, Stuart, Fla.

SELECTED COLLECTIONS: David Winton Bell Gallery, List Art Center, Brown University, Providence, R.I.; Metropolitan Museum of Art, New York; National Academy of Design, New York; National Museum of History, Taipei; Nelson-Atkins Museum of Art, Kansas City, Mo.; Philadelphia Museum of Art; St. John's University, Shanghai.

SELECTED BIBLIOGRAPHY: Kan, Diana. *The How and Why of Chinese Painting* (New York: Prentice-Hall, Inc., 1974); Sommers, Daria, director. *Eastern Spirit, Western World, A Profile of Diana Kan*, film produced by the Elliott Museum, Stuart, Fla., 1988; Wender, Leon and Karen. *Diana Kan: Eastern Spirit, Western World* (New York: L. J. Wender Fine Chinese Paintings, 1993); Whitney, Louise. "East Comes West," *Where*, Vancouver edition (February 1993): 18–20; Wright, Barbara. "Diana Kan," *Arts Revolution*, London (1964)

Matsumi KANEMITSU

Born 1922, Ogden, Utah; died 1992, Los Angeles, California

Born to Japanese parents in the United States, Kanemitsu was raised in a suburb of Hiroshima, Japan, until he was eighteen. He came alone to the United States in 1940 to pursue a higher education and enlisted in the U.S. Army in 1941, giving up his dual citizenship. However, after the Japanese attack on Pearl Harbor he was arrested and sent to a series of army detention camps. In the postwar years Kanemitsu moved to the East Coast, first studying sculpture with Karl Metzler in Baltimore before moving to New York. In New York, he attended the Art Students League under the instruction of teachers such as Harry Sternberg and Yasuo Kuniyoshi. Kuniyoshi, and later Ad Reinhardt, were influential mentors. In 1961 he earned a Ford Foundation grant to work at the Tamarind Lithography Workshop in Los Angeles and readily translated the techniques of *sumi* painting into lithography. He taught at the Chouinard Art School from 1965 to 1970 and at the Otis Art Institute from 1971 to 1983, both in Los Angeles.

Kanemitsu was proficient in four separate mediums: *sumi* (Japanese ink drawing), watercolor, lithography, and painting on canvas. He painted with acrylics and used a complex technique that involved brushing, staining, pouring, and glazing to achieve abstract imagery that often reflected landscapes and the forces of nature. He worked all of his life with Japanese *sumi* ink and brushes, maintaining that the dramatic effects of color painting could also be achieved in black and white and the gradations between them. *Y.H.*

SELECTED EXHIBITIONS: 1950 Corcoran Art Gallery, Washington, D.C.; 1954 Wadsworth Atheneum, Hartford, Conn.; 1956 *Recent Drawings, U.S.A*, Museum of Modern Art, New York; 1957 New School for Social Research, New York; 1962 *14 Americans*, Museum of Modern Art, New York; 1971 *Black and White Drawings and Watercolors*, San Francisco Museum of Modern Art; 1972 Laguna Art Museum, Laguna Beach, Calif.; 1986 *Japanese Artists Who Studied in U.S.A., 1875–1960*, Hiroshima Museum of Modern Art; 1988 Japanese American Cultural and Community Center, Los Angeles; 1990 Yamaki Art Gallery, Osaka.

SELECTED COLLECTIONS: Baltimore Museum of Art; Corcoran Gallery of Art, Washington, D.C.; Hiroshima Museum of Modern Art; Honolulu Academy of Arts; Los Angeles County Museum of Art; Metropolitan Museum of Art, New York; Museum of Modern Art, New York; National Gallery of Art, Washington, D.C.; National Museum of Modern Art, Tokyo; Philadelphia Museum of Art; San Francisco Museum of Modern Art.

SELECTED BIBLIOGRAPHY: Brown, Michael D. *Views from Asian California 1920–1965, An*

Illustrated History (San Francisco: Michael D. Brown, 1992); *Matsumi Kanemitsu Lithographs 1961–1990* (Osaka: Yamaki Art Gallery, 1990); *Matsumi Kanemitsu, Works in Black and White, 1958–1988* (Los Angeles: Japanese American Cultural and Community Center, 1988); Nordland, Gerald. *Matsumi Kanemitsu (1922–1992) A Retrospective* (Beverly Hills: Louis Newman Galleries, 1993); Uyemura, Nancy. "Portrait of an Artist," *Tozai Times* 5, issue 51 (December 1988): 1, 10

Minoru KAWABATA
Born 1911, Tokyo, Japan; lives in New York, New York

Kawabata's paternal ancestors were painters of the Maruyama school, yet he was drawn instead to contemporary Western-style oil painting and chose to be a modernist. Kawabata entered the Department of Western Painting at the Tokyo Academy of Fine Arts in 1929 and studied under Fujishima. He graduated in 1934 and went on to study in Paris and Italy from 1937 to 1939. Kawabata became a Professor of Art at Tama University of Fine Arts in Tokyo from 1950 to 1955 and participated in the formation of an art group known as *Shinseisaku Kyokai* (the New Creation Society). In 1940 he was accorded his first one-person show by the Mitsukoshi Gallery in Tokyo; that same year he won the Saburi Prize. Moving to New York in 1958, Kawabata began teaching at the New School for Social Research and remained there until 1985. In 1958 he won prizes at both the São Paulo Biennial and the Guggenheim International, and in 1960 he had his first U.S. solo exhibition at the Betty Parsons Gallery.

Acclaimed by the Japanese critic Atso Imaizumi as "the first full fledged international modern artist produced by Japan," Kawabata was among the few Asian Americans to be recognized within the context of the New York School of Abstract Expressionism. As he explored abstraction, the size of his canvases became larger, and he began to move through stylistic phases. He worked on a number of series, employing the oval motif from 1964 to 1966, the rhombus in 1967, and hard-edged forms from 1968 to 1970. Kawabata then began to manifest a new awareness of his Japanese origins, as in the *Gate* series based on the motif of the Japanese

character for the word, and the *Robe* series inspired from the shape of the kimono. *Y.H.*

SELECTED EXHIBITIONS: 1960–61, 1963, 1969, 1971, 1977, 1980–81 Betty Parsons Gallery, New York; 1962 Venice Biennial, representing Japan; 1963, 1978, 1983 Tokyo Gallery, Tokyo; 1966 *New Japanese Painting and Sculpture,* Museum of Modern Art, New York; 1973 *Japanese Artists in U.S.A.,* Museum of Modern Art, Kyoto; 1974 Everson Museum of Art, Syracuse; 1975 Museum of Modern Art, Kamakura, Japan; 1983, 1985, 1988 Jack Tilton Gallery, New York; 1992 Museum of Modern Art, Kyoto, and Ohara Art Museum, Tokyo.
SELECTED COLLECTIONS: Albright-Knox Art Gallery, Buffalo; Everson Museum of Art, Syracuse; Museum of Modern Art, São Paulo, Brazil; National Museum of Modern Art, Tokyo; Newark Museum, N.J.; Solomon R. Guggenheim Museum, New York; Yokohama Museum of Art, Japan.
SELECTED BIBLIOGRAPHY: Harada, Osamu, and Masahiro Shintani. *Kawabata in New York* (Tokyo: Dusty Miller Co., 1992); Harithas, James. *Minoru Kawabata* (Syracuse: Everson Museum of Art, 1974); *Minoru Kawabata* (New York: Jack Tilton Gallery, 1985); *Minoru Kawabata Retrospective* (Kyoto: National Museum of Modern Art and Ohara Museum of Art, 1992); *The New Japanese Painting and Sculpture* (New York: Museum of Modern Art, 1966)

Byungki KIM
Born 1916, Pyongyang, North Korea; lives in Hartsdale, New York

Kim went to Japan to study at the Tokyo Avant-Garde Art Institute at the age of seventeen. In 1939 he graduated from the Department of Fine Arts of the Tokyo Cultural Institute. His first works were shown in 1948 at an exhibition sponsored by the Association of Cultural Fine Arts in Korea. In the following years, he became an important force in the education and promotion of modern art in Korea through his many teaching positions. In 1950 Kim served briefly as the Associate Director of Military Art for the Ministry of National Defense. From 1951 to 1958 he taught at the College of Fine Arts at Seoul National University. During this time, he also served as the Chairman of the

Department of Fine Arts at the High School of Fine Arts, Seoul. In 1964 he served as Board Chairman of the Korean Fine Arts. He was appointed the Korean Commissioner to the International Art exhibition at São Paulo, Brazil, in 1965. Upon receiving Rockefeller grants, Kim was able to come to the United States to tour educational facilities and art museums. He was later appointed as a visiting professor at Skidmore College in New York. Kim exhibited his work for the first time in the United States in 1972 at the Polyarts Gallery in Boston. In 1978 he was appointed professor within the Department of Fine Arts at Empire State College in New York; he retired from teaching in 1988. After a twenty-year absence from his native land, Kim returned to Korea in 1986 to exhibit his work at the Gana Gallery in Seoul. *Sandra Mae D'Amelio*

SELECTED EXHIBITIONS: 1948 Association of Cultural Fine Arts, Seoul; 1958 Contemporary Artists, Association of Korean Arts; 1966 Skidmore College, Sarasota Springs, N.Y.; 1972 Polyarts Gallery, Boston; 1977 National Museum of Contemporary Art, Seoul; 1986, 1990 Gana Gallery, Seoul.
SELECTED BIBLIOGRAPHY: *Byungki Kim* (Seoul: Gana Gallery, 1990); *Byungki Kim Retrospective Exhibition* (Seoul: Gana Gallery, 1986)

Po (Po-Hyun) KIM

Born 1917, Changnyung, Kyung-nam, Korea; lives in New York, New York

Po Kim studied at the Academy of Art in Tokyo. During the 1940s he was professor and chairman of the Fine Arts Department at Chosun University in Kwangju, Korea. Entering the United States in 1955, he studied on a fellowship at the University of Illinois at Urbana-Champaign, where he received his MFA in 1957. He taught art at Pratt Institute in the late 1950s and at New York University from 1961 to 1962.

Kim's painting style of the mid to late 1950s was very much a conscious combination of Western Abstract Expressionism and East Asian artistic traditions. His gestural abstractions are created using the Eastern concept of "single-go" or uncorrected strokes, in which the painted marks or imagery are set down in an uninterrupted flow. During this period, Kim's imagery tended toward freely linear and calligraphic expression. In the early 1960s his art took on certain aspects of Color Field painting with bright primary or secondary colors thinly stained onto the canvas. *C.G.*

SELECTED EXHIBITIONS: 1962 Kornblee Gallery, New York; 1975 *Bertoia, Miles, Noguchi, Seawright, Kim,* Hunterdon Art Center, Clinton, N.J.; 1978 *Painting and Sculpture Today,* Indianapolis Museum of Art; 1980 Art Alliance, Philadelphia; 1981 *Korean Drawing Now,* Brooklyn Museum; 1983 Gallery Hahn, Munich; 1992 Haenah-Kent Gallery, New York and Seoul; 1995 Retrospective exhibition, Hankaram Art Museum, Seoul Arts Center.
SELECTED COLLECTIONS: Art Institute of Chicago; Oklahoma City Art Museum; Seoul Arts Center; Solomon R. Guggenheim Museum, New York; Tennessee Fine Arts Center, Nashville.
SELECTED BIBLIOGRAPHY: *Po Kim* (Seoul: Hankaram Art Museum, Seoul Arts Center, 1995)

Whanki KIM (WHANKI)

Born 1913, Kijwa Island, Cholla Narndo, Korea; died 1974, New York, New York

Whanki Kim studied art in Seoul in 1933 and graduated from the Fine Arts Department of Nihon University in Tokyo in 1936. He returned to Korea in 1937 and taught at the Fine Arts Department of the National University in Seoul and then at the Hong Ik Fine Arts College. In 1948 he organized the avant-garde group known as the Neo-Realists with artists You Young Kuk and Kyonsang Lee. In 1956 he made a three-year sojourn to Paris, exhibiting in many galleries. Kim immigrated to New York in 1963, where he stayed until his death. In 1992 the Whanki Foundation sponsored the building of the new Whanki Museum in Seoul, which was dedicated to Kim's art and life.

When Kim arrived in Tokyo in 1935, he found contemporary artists influenced by the abstraction of the European Cubists and Piet Mondrian. He responded to this impulse toward abstraction, though always drawing his inspiration directly from nature. In New York he continued to work with four images from nature (moon, mountain, tree, and

crane) that had preoccupied him before but in a new and simplified manner, influenced in part by contemporary artistic trends in New York. A single natural motif would occupy his canvas but flattened and squared, acting as a unifying structure for the composition. Porcelain patterns that he had emulated in his paintings while in France became stylized concentric squares in his New York paintings, strung across the canvas in a rhythmic, flattened arrangement. *C.G.*

SELECTED EXHIBITIONS: 1948 First exhibition of the Neo-Realists, Hwa Shin Gallery, Seoul; 1953 Neo-Realists exhibition, National Museum, Pusan, Korea; 1954 U.S.I.S. Gallery, Seoul; 1959 Central Information Center Gallery, Seoul; 1971 Poindexter Gallery, New York; 1975 *Kim Whanki: A Retrospective,* National Museum of Modern Art, Seoul; 1977 *Kim Whanki Retrospective: 1954–74,* Hyundai Gallery, Seoul; 1984 *The 10th Anniversary of Kim Whanki's Death: A Memorial Retrospective,* National Museum of Modern Art, Seoul; 1987 *10 Years of Kim Whanki in New York,* Centre Nationale des Arts Plastiques, Paris; 1991 *Kim Whanki: New York 1966–69,* Hyundai Gallery, Seoul; 1992 *The Inaugural Exhibition of Whanki Museum,* Whanki Museum, Seoul.

SELECTED COLLECTIONS: Museum of Modern Art, São Paulo, Brazil; Phillips Collection, Washington, D.C.; San Francisco Museum of Modern Art; Solomon R. Guggenheim Museum, New York; Whanki Museum, Seoul.

SELECTED BIBLIOGRAPHY: *Kim Whanki: A Retrospective* (Seoul: National Museum of Modern Art, 1975); *Kim Whanki Retrospective: 1954–74* (Seoul: Hyundai Gallery, 1977); *Retrospective Exhibition—20 Years Since Whanki Passed Away* (Seoul: Whanki Museum, 1994); *Whanki Museum* (Seoul: Whanki Museum, 1993)

Sueko M. KIMURA

Born 1912, Papaikou, Hawaii; lives in Honolulu, Hawaii

Kimura received her formal art training at the University of Hawaii at Manoa in Oahu, where she obtained her BA in 1936 and her MFA in 1959. She also attended Chouinard Art Institute, Los Angeles, Columbia University, the Brooklyn Museum Art School, and the Art Students League in New York, where she studied with Yasuo Kuniyoshi. During a trip to Kyoto, Kimura studied gardens, temples, and *No* drama in order to apply their visual principles to her work. She has worked in advertising and graphic arts and was the head of the *Honolulu Star-Bulletin* art department. She considers herself both an artist and an educator, having taught at the University of Hawaii from 1952 to 1977. *Y.H.*

SELECTED EXHIBITIONS: 1951 Brooklyn Museum; 1952–57 Honolulu Academy of Arts; 1956 Long Island Art Gallery, N.Y.; 1958 Wichita Art Museum, Kans.; 1965 IBM Gallery, New York; 1965 San Diego Art Museum; 1967 National Museum of Modern Art, Kyoto.

SELECTED COLLECTIONS: Bilger Hall, University of Hawaii; Contemporary Arts Center, Honolulu; Hawaii State Foundation on Culture and the Arts, Honolulu; Honolulu Academy of Arts; International Savings & Loans, Honolulu; Kaiser Hawaii-Kai Development Corporation, Honolulu; State Department of Education Artmobile, Honolulu.

SELECTED BIBLIOGRAPHY: Illustration, cover design, and drawings for *Philosophy and Culture, East & West* (Honolulu: University of Hawaii Press, 1962)

Yien-Koo KING

Born 1936, Shanghai, China; lives in New York, New York

Yien-Koo King followed in the footsteps of her father, the well-known artist C. C. Wang, by choosing a career in art. She and her parents emigrated to the United States in 1949, settling in New York. King studied at the High School for Music and Art in New York City and later earned her BFA in Ceramic Design at Alfred University in 1959. She also received a scholarship to continue her study of ceramics at the Brooklyn Museum Art School. She has taught ceramics at the Brooklyn Museum Art School, the Greenwich House Pottery, the 92nd Street YM-YWCA in New York, and the Newark Museum.

Yien-Koo King's ceramics have often been cited as purposefully combining aspects of the Chinese tradition of ceramic vessels with modern Western techniques and styles. In producing one series of ceramic bowls, the

artist collaborated with her father, who applied the painted decoration. Her work has been acquired extensively by private collectors. *C.G.*

SELECTED EXHIBITIONS: 1958–59 Mi Chou Gallery, New York; 1968 M. H. de Young Memorial Museum, San Francisco; 1971 Los Angeles County Museum of Art; 1972 Honolulu Academy of Arts; 1973 Fogg Art Museum, Harvard University, Cambridge, Mass.; 1982 Chinese Culture Center, San Francisco; 1982 *Contemporary American Ceramics,* Azuma Gallery, New York.
SELECTED BIBLIOGRAPHY: Ashton, Dore. "Art: Kabak's Triangle," *New York Times* (May 15, 1958); "Made in America Highlights Chinese," *Asian Week* (September 23, 1982)

Masatoyo KISHI
Born 1924, Sakai, Japan; lives in Grass Valley, California

Kishi graduated from Tokyo University of Science in 1953 with a BS in Physics and Mathematics. In 1958 he was one of the organizers of the Tekkeikai Group of artists, and in 1959 he became associated with the Yamada Gallery in Kyoto. He came to California in 1960 and taught at Holy Names College in Oakland from 1965 to 1966. He also taught at the Dominican College in San Rafael from 1964 to 1974, and was chairman of that art department from 1969 to 1974.

Kishi's paintings of the 1960s are characterized by monochromatic backgrounds interrupted by strokes and shapes of varying sizes. The color range of these works is often restricted to combinations of black, white, red, and sometimes gold, hearkening back to traditional Japanese art. Many of Kishi's painted shapes and strokes recall the active gestural methods of calligraphy. In the Japanese manner, Kishi paints on surfaces held in a horizontal position, with his larger canvases lying on the floor. *Y.H.*

SELECTED EXHIBITIONS: 1961 Annual International Exhibition, Carnegie Institute, Pittsburgh; 1961 Bolles Gallery, San Francisco; 1963, 1965, 1967 *Contemporary American Painting and Sculpture,* University of Illinois, Urbana-Champaign; 1964 *Fifth Winter Invitational,* Palace of the Legion of Honor, San Francisco; 1965 Annual Exhibition, San Francisco Museum of Art; 1972 *John Bolles Collection,* Oakland Museum, Calif.; 1973 *Japanese Artists in America,* National Museum of Modern Art, Kyoto; 1984 Mary Porter Sesnon Art Gallery, University of California, Santa Cruz.
SELECTED COLLECTIONS: Barlow Building, Washington, D.C.; National Museum of Modern Art, Kyoto; Oakland Museum, Calif.; San Francisco Conservatory of Music; Stanford University Museum of Art and T. W. Stanford Art Gallery, Calif.; State University College at Potsdam, N.Y.
SELECTED BIBLIOGRAPHY: *Contemporary American Painting and Sculpture: Circles, Men & Others* (Urbana-Champaign: University of Illinois, 1965); *Contemporary American Painting and Sculpture: Subject, Object & Content* (Urbana-Champaign: University of Illinois, 1963); Frankenstein, Alfred. "A 'Classic' Retrospective," *San Francisco Chronicle* (May 23, 1974): 44; *Japanese Artists in America* (Kyoto: National Museum of Modern Art, 1973); Monte, James. "San Francisco," *Artforum* (June 1966): 19–20

Soojai LEE
Born 1933, Seoul, Korea; lives in Seoul

Earning her BA from Ewha Woman's University in Seoul, Soojai Lee was awarded the Institute of International Education Scholarship to the University of Colorado, Boulder. Studying art under Carl Morris, she received her MA in 1958. She returned to Seoul that year and taught at the College of Fine Arts at Ewha Woman's University from 1958 to 1962. In 1962 Lee moved back to the United States, attending the School of the Art Institute of Chicago until 1964. In 1983 she resumed her teaching career at Ewha Woman's University, where she currently holds a professorship.

Much of Soojai Lee's art has relationships to so-called "lyrical abstraction," painting that softens the more aggressive aspects of Abstract Expressionism with delicate colors, often thinly applied, and calm, atmospheric qualities. Her work continues Eastern painting traditions in that it generally derives from nature, whether abstracting actual landscapes and natural forms, or simply suggesting light, air, and other ephemeral aspects of the

natural world through allusive use of color and gesture. *C.G.*

SELECTED EXHIBITIONS: 1958 Obelisk Gallery, Washington, D.C.; 1968 Vincent Price Gallery, Chicago; 1975 Hyundai Gallery, Seoul; 1982 *Korean Artists Abroad,* National Museum of Modern Art, Seoul; 1984 *Korean Modern Art in the 60's,* Walker Hill Museum, Seoul; 1985 *Pan-Pacific Art Exhibition,* Korean Cultural Center, Seoul; 1988 *Korean Contemporary Art Festival,* National Museum of Modern Art, Seoul; 1993 *Exhibition of Korean Contemporary Art,* Seoul Arts Center; 1993 Gallery 63, Seoul.

SELECTED BIBLIOGRAPHY: *Contemporary Korean Painting* (Tokyo: National Museum of Modern Art, 1968); *Invitational Alumni Show* (Seoul: Ewha Art Museum, Ewha Woman's University, 1992); "Korean Art on Exhibit," *The Evening Star,* Washington D.C. (January 15, 1958): B2; "University Graduate Making Debut in Washington, Two Man Art Show," *The Boulder Daily Camera* (December 24, 1957): 24; Yoon Nan-Jie. "A Space for Contemplation on Nature," in *Soojai Lee* (Seoul: Gallery 63, 1993)

James LEONG

Born 1929, San Francisco, California; lives in Seattle, Washington

James Leong earned his BFA and MFA at the California College of Arts and Crafts in Oakland and his MA at San Francisco State College. Following a Fulbright scholarship to Norway, Leong was awarded a Guggenheim grant for 1958 to 1959 to study in Rome at the American Academy. When the year was over, he decided to stay in Rome and at that time became interested in rediscovering his Chinese heritage. Leong exhibited widely in Rome and in Norway and also taught frequently, including a year-long visiting professorship at the University of Georgia in 1970. He returned to the United States in 1991.

During the 1960s Leong created soft, hazy oil-and-paper collages based on landscape abstractions. In these works, he adhered paper or rag strips to the canvas, which he had stained with washes and runs of pastel hues. In the late 1960s and early 1970s Leong changed his style dramatically, creating oil paintings and serigraphs in an ultrarealistic style showing volumetric objects suspended

in space, such as a fluted slab of stone or an architectural element. *C.G.*

SELECTED EXHIBITIONS: 1955 Annual exhibition, Whitney Museum of American Art, New York; 1957 Galleri Paletten, Oslo; 1960–61 Galleria dell-Obelisco, Rome; 1967 Temple University, Tyler School of Art in Rome; 1971 College of Arts and Architecture, Pennsylvania State University; 1976 Studio Due, Rome; 1988 Canadian Cultural Centre, Rome; 1994 Lasater Gallery, Seattle.

SELECTED COLLECTIONS: Art Museum, Princeton University, N.J.; Dallas Museum of Fine Arts; Fogg Art Museum, Harvard University, Cambridge, Mass.; Grey Art Gallery and Study Center, New York University, New York; Indianapolis Museum of Art; Neuberger Museum, State University of New York at Purchase.

SELECTED BIBLIOGRAPHY: Asaf, Dawn. "Master Painter James Leong Opens Show," *Northwest Asian Weekly* 13, no. 22 (June 4, 1994): 1; Findlay, Ian. "In from Exile," *Asian Art News* 4, no. 6 (November/December 1994): 88–92; Leong, Charles. "James Leong, A Profile," *Jade Magazine* 3, no. 1 (April 1979): 28–29; "The Non-Beatniks," *Time* (June 8, 1955): 66

Seong MOY

Born 1921, Guangzhou (Canton), China; lives in New York, New York

Moy came to the United States in 1931 and lived in St. Paul, Minnesota, until 1940. Following his training at the St. Paul Gallery and School of Art from 1936 to 1940 and at the WPA Graphic Workshop at the Walker Art Center in Minneapolis from 1940 to 1941, he studied in New York with Hans Hofmann at Hofmann's school and at the Art Students League with Vaclav Vytlacil and Will Barnet in 1941 and 1942. He served as a photographer for the U.S. Air Force with the Flying Tigers in the China-Burma-India theater during World War II. Returning to civilian life, he received a fellowship to study at Atelier 17 with Stanley Hayter from 1948 to 1950. In the summer of 1954 he established the Seong Moy School of Painting and Graphic Arts in Provincetown, Massachusetts. Moy has taught art at Smith College (1954–55), Vassar College (1955), Cooper Union (1957–70), Columbia University (1959–70), Art Students

League (1963–present), and City College of New York (1970–87).

Both a painter and graphic artist, Moy has worked in the woodcut medium since 1941. During the 1940s, 1950s, and 1960s he created works that blended his experience of life in the United States with his Chinese heritage. He writes: "My aim is to . . . re-create in the abstract idiom of contemporary time some of the ideas of ancient Chinese art forms" (Moy, 1954). In his paintings and woodcuts his swirling, dancing calligraphic forms are on the one hand abstract, intuitive, and exuberant, and on the other hand, skillfully controlled. *C.G.*

SELECTED EXHIBITIONS: 1947 *The Printmakers,* Jacques Seligmann Galleries, New York; 1950 Metropolitan Museum of Art, New York; 1950 Whitney Museum of American Art, New York; 1951, 1953–54 University of Illinois at Urbana-Champaign; 1952, 1955 Carnegie Institute, Pittsburgh; 1955 *The 14 Painters-Printmakers,* Brooklyn Museum; 1957 Group exhibition, Mi Chou Gallery, New York; 1958 *Five Whitney Fellows,* Mi Chou Gallery, New York; 1964–65 New York World's Fair; 1977 Provincetown Artists Group, Mass.; 1978 Summit Gallery, New York; 1990 Sylvan Cole Gallery, New York; 1991 *Seong Moy: Color Prints,* Provincetown Art Association and Museum, Mass.

SELECTED COLLECTIONS: Brooklyn Museum; Library of Congress, Washington, D.C.; Metropolitan Museum of Art, New York; Museum of Modern Art, New York; New York Public Library; Pennsylvania Academy of Fine Arts, Philadelphia; Philadelphia Museum of Art; Smithsonian Institution, Washington, D.C.; Tel Aviv Museum; Whitney Museum of American Art, New York.

SELECTED BIBLIOGRAPHY: *Five American Printmakers*, film produced by USIA, State Department, Washington, D.C., 1957; Moy, Seong. *Portfolio*, intro. Una Johnson (New York: Rio Grande Graphics, Ted Gotthelt Publisher, 1952); Moy, Seong. "A Statement," *The Palette* 34/2 (Spring 1954): 6–7; Saff, Donald, and Deli Sacilatto. *Printmaking—History and Process* (New York: Holt-Reinhardt Winston, 1970); *Seong Moy: Color Prints* (Provincetown, Mass.: Provincetown Art Association and Museum, 1991)

Emiko NAKANO
Born 1925, Sacramento, California; died 1990, California

Nakano studied art at the California School of Fine Arts and at Mills College in Oakland, California. During the summer of 1952 she taught children's art classes at Mills College. She was an early Abstract Expressionist, combining her Western training with traces of Orientalism (Brown 1992). *Y.H.*

SELECTED EXHIBITIONS: 1951–58 Annual Drawing and Print Exhibitions, San Francisco Art Association, San Francisco Museum of Art; 1952 Metropolitan Museum of Art, New York; 1952, 1953, 1955 Richmond Art Center; 1957 Santa Barbara Museum of Art; 1958 M. H. de Young Memorial Museum, San Francisco; Oakland Museum, Calif.; Pomona College, Calif.

SELECTED BIBLIOGRAPHY: Brown, Michael, D. *Views from Asian California 1920–1965, An Illustrated History* (San Francisco: Michael D. Brown, 1992)

Win NG
Born 1936, San Francisco, California; died 1991, San Francisco

Win Ng was born in San Francisco's Chinatown, and his first art studio was in the basement of his parents' home. He attended Washington High School, Saint Mary Academy (where he studied Chinese for six years), and received his BFA in ceramics from the San Francisco Art Institute in 1959. One year later, he received his MFA from Mills College in Oakland. Ng was cofounder of Taylor & Ng, a company that designed and sold a wide variety of utilitarian and giftware items. He produced art consistently until his death, exploring additional mediums later in life, including acrylic, watercolor, and printmaking.

In 1964 Ng made the following statement about his interest in and approach to ceramic sculpture: "With clay I can record the immediacy of my thoughts and explore a wide range of surface textures and color treatments. Structurally, my sculpture occurs in two forms—the angular or square shaped and the round or curvilinear. The first is intended to express form in space; the second, to express

fluidity. I try to suggest specific qualities through proportion, weight, movement. My sculptures are not really complete until I glaze them: it's the glazing that unifies them. I use color to enhance, redistribute or encase form. I also use color to reveal or conceal the spirit of the form, depending on the mood which the sculpture inspires. Some sculptures wait for years to be glazed" (Schafer 1964, 15). *C.G.*

SELECTED EXHIBITIONS: 1959–62 Mi Chou Gallery, New York; 1961 *8th International Exhibition of Ceramic Arts,* Smithsonian Institution, Washington, D.C.; 1962 *3rd International Exhibit of Contemporary Ceramics,* Seattle World's Fair; 1963 *California Sculptures,* Oakland Museum, Calif.; 1968 Quay Gallery, San Francisco; 1985 Braunstein/Quay Gallery, San Francisco; 1986 *American Potters Today,* Victoria and Albert Museum, London; 1990 *Bay Area Sculptors of the 1960s: Then and Now,* Braunstein/Quay Gallery, San Francisco.

SELECTED COLLECTIONS: Everson Museum of Art, Syracuse; Museum of Contemporary Crafts, New York; Oakland Museum, Calif.; San Francisco Art Commission Collection; San Francisco Bay Area Rapid Transit System, Orinda Station; San Francisco Museum of Modern Art.

SELECTED BIBLIOGRAPHY: Bloomfield, Arthur. "Art That Stays Together," *San Francisco Examiner* (January 5, 1967); Riegger, Hal. "The Pottery of Win Ng," *Ceramics Monthly* (April 1963); Schafer, Charles and Vi. "Win Ng Sculptures," *Utah Architect* (Summer 1964): 15–18; *With New Eyes, Toward an Asian American Art History in the West* (San Francisco: San Francisco State University, 1995)

Minoru NIIZUMA
Born 1930, Tokyo, Japan; lives in Hoboken, New Jersey

Niizuma received his BFA studying under Professor Ishii at the National Tokyo University of Arts and came to New York in 1959 with a scholarship to the Brooklyn Museum Art School. He taught sculpture there from 1964 to 1970 and was an adjunct professor of stone carving at Columbia University from 1972 to 1984. Niizuma helped found the Stone Institute of New York and served as its first director in 1983. His work has been exhibited worldwide and he has been active in international symposiums on stone sculpture since 1968. He creates his sculpture in Spain, Italy, Belgium, and Portugal as well as in America.

Recognized internationally as a major twentieth-century sculptor in stone, Niizuma has been referred to by Thomas M. Messer, former director of the Solomon R. Guggenheim Museum, as part of "a vanishing breed of stone carvers." Although Niizuma works in both large and small scales, he actively seeks opportunities for large, public projects. Many of his formal devices derive from a purposeful contrast of simple dualities: rough and smooth, convex and concave, void and solid. One of his favorite motifs is a cubic form incised with concentric grooves. At the outset of his career, Niizuma used various colorful or veined stones; recently he has preferred to work with granite, seeking out pure black-and-white coloring. Traditional Japanese philosophies and attitudes toward stone and the working of stone have become increasingly important to the artist throughout his career. *Y.H.*

SELECTED EXHIBITIONS: 1965 *Japanese Artists Abroad: Europe and America,* National Museum of Modern Art, Tokyo; 1966, 1968 *Sculpture Annual,* Whitney Museum of American Art, New York; 1967 *Pittsburgh International Exhibition,* Carnegie Institute, Pittsburgh; 1973–74 *Japanese Artists in the Americas,* National Museum of Modern Art, Kyoto and Tokyo; 1977 Guild Hall Museum, East Hampton, N.Y.; 1979 Contemporary Sculpture Center, Tokyo and Osaka; 1981 *The 1960's—A Decade of Change in Contemporary Japanese Art,* National Museum of Modern Art, Tokyo and Kyoto; 1989 Galerie Nichido, Tokyo.

SELECTED COLLECTIONS: Albright-Knox Art Gallery, Buffalo; Hirshhorn Museum and Sculpture Garden, Smithsonian Institution, Washington, D.C.; Museum of Modern Art, New York; National Museum of Art, Osaka; National Museum of Modern Art, Tokyo and Kyoto; San Francisco Museum of Modern Art; Solomon R. Guggenheim Museum, New York.

SELECTED BIBLIOGRAPHY: *Annual Exhibition 1966, Sculpture and Prints* (New York: Whitney Museum of American Art, 1966);

Japanese Artists Abroad—Europe and America
(Tokyo: National Museum of Modern Art,
1965); *Japanese Artists in the Americas* (Kyoto:
National Museum of Modern Art, 1973);
Minoru Niizuma (Tokyo: Galerie Nichido,
1989); *The New Japanese Painting and
Sculpture* (New York: Museum of Modern
Art, 1965); *Niizuma Minoru: Sculptures*
(Tokyo: Seibu Museum of Art, 1976)

Isamu NOGUCHI

Born 1904, Los Angeles, California; died 1988,
New York, New York

Born of an American writer, Leonie Gilmour,
and a Japanese poet, Yonejiro Noguchi, Isamu
moved with his mother to Tokyo in 1906.
After spending his childhood years in Japan,
Noguchi was sent to boarding school in
Rolling Prairie, Indiana. Following an appren-
ticeship with Gutzon Borglum, Noguchi
attended Columbia University, though he left
in 1924 to devote full time to his sculpture
career. In 1927 Noguchi was awarded a
Guggenheim Fellowship for travel to Paris and
Asia. While in Paris he worked as the assis-
tant of the sculptor Constantin Brancusi,
whose direct carving of natural materials with
premodern tools would leave a lasting imprint
on Noguchi's sculptural method. In 1930
Noguchi traveled to Beijing, where he spent
seven months studying ink-brush techniques
with Ch'i Pai-shih. He traveled further to
Tokyo and then Kyoto, where he first encoun-
tered Zen gardens and ancient *haniwa* sculp-
ture, and worked in the pottery studio of
Jinmatsu Uno.

With this multifaceted background,
Noguchi proceeded to create highly innovative
sculpture in a variety of scales and mediums.
From the mid-1930s through the mid-1960s, he
created a number of set designs, perhaps one
of the most memorable for Martha Graham's
dance performance of *Appalachian Spring* in
1944. His commitment to public action took a
variety of forms, from his voluntary intern-
ment in the Colorado River "Relocation"
Center in Poston, Arizona, in 1942, to his
many designs for large-scale public projects,
such as his Western version of a traditional
Japanese Zen garden at *The Billy Rose
Sculpture Garden* (1960–65, Israel Museum,
Jerusalem). However, Noguchi never aban-
doned freestanding sculpture, creating works

in marble, wood, and other materials in the
1940s that combined a Japanese predilection
for fragility with biomorphic forms dominat-
ing postwar Western art. During the early
1950s, when he made his home in Kamakura,
Japan, he turned increasingly to the produc-
tion of abstracted ceramic figurines based on
the simple shapes of ancient *haniwa* sculp-
ture. In the late 1950s Noguchi had a renewed
interest in freestanding stone sculpture that
would continue until the end of his career.
Employing the technique of direct carving,
Noguchi came to perceive the medium of
stone as symbolic of "humanity's relationship
with the environment, both local and cosmic"
(Altshuler 1994, 91). *C.G.*

SELECTED EXHIBITIONS: 1942 San Francisco
Museum of Art; 1952 Museum of Modern Art,
Kamakura, Japan; 1955 *Fifty Years of American
Art,* Museum of Modern Art, New York; 1967
American Sculpture of the Sixties, Los Angeles
County Museum of Art; 1968 Whitney
Museum of American Art, New York; 1977
Museum of Modern Art, New York; 1978
Walker Art Center, Minneapolis; 1980
Whitney Museum of American Art, New
York; 1992 National Museum of Modern
Art, Tokyo.

SELECTED COLLECTIONS: Hirshhorn Museum
and Sculpture Garden, Smithsonian
Institution, Washington, D.C.; Isamu
Noguchi Garden Museum, Long Island City,
N.Y.; Los Angeles County Museum of Art;
Metropolitan Museum of Art, New York;
Museum of Modern Art, New York; National
Gallery of Art, Washington, D.C.; National
Museum of Modern Art, Tokyo; Solomon R.
Guggenheim Museum, New York; Whitney
Museum of American Art, New York.

SELECTED BIBLIOGRAPHY: Altshuler, Bruce.
Isamu Noguchi, Modern Masters series, vol. 16
(New York: Abbeville Press, 1994); Ashton,
Dore. *Noguchi East and West* (New York:
Alfred A. Knopf, 1992); Grove, Nancy, and
Diane Botnick. *The Sculpture of Isamu
Noguchi: A Catalogue* (New York: Garland
Publishing, 1980); Hasegawa, Sabro. "My
Time with Isamu Noguchi" (1951), trans.
Christopher Blasdel (Tokyo, 1977); Noguchi,
Isamu. *The Isamu Noguchi Garden Museum*
(New York: Harry N. Abrams, 1987); Noguchi,
Isamu. *Isamu Noguchi: The Sculpture of Spaces*
(New York: Whitney Museum of American

Art, 1980); Noguchi, Isamu. "Meanings in Modern Sculpture," *Art News* 48 (March 1949); Noguchi, Isamu. *A Sculptor's World* (New York: Harper & Row, 1968)

NONG
Born 1930, Seoul, Korea; lives in Centreville, Virginia

Born Robert Han, the artist took the professional name Nong, which means "farmer" in Korean. This name underscores Nong's belief that, like a farmer, an artist also works with nature, attempting to understand and coexist with it. He was tutored privately as a child and received a classical education in Korea. After obtaining his law degree, he came to the United States in 1952, becoming a civilian instructor at the U.S. Defense Language Institute in Monterey, California. A self-taught artist, Nong experimented with a variety of techniques and mediums during the ten years he lived on the Monterey Peninsula and established his own gallery in Carmel. In the 1960s Nong went to Paris to work and exhibit in the international salons, returning to San Francisco in the early 1970s.

Nong has worked in many artistic mediums, including painting, sculpture, graphic arts, ceramic objects, scrolls, and screens. His work has alternated between representational and abstract imagery throughout his career. Many of his abstractions are based on the colors and textures of traditional Korean art and material culture. In several works he has sought to capture the worn or burnished colors of Korean ceramic or metal vessels. A deep interest in the *I Ching* (the Book of Changes) has led Nong to create compositions for paintings and sculptures based on the *I Ching*'s dot-and-dash motifs. *C.G.*

SELECTED EXHIBITIONS: 1965 E. B. Crocker Art Gallery, Sacramento; 1965 Santa Barbara Museum of Art; 1967 Georgia Museum of Art, University of Georgia, Athens; 1971 National Museum of History, Taipei; 1975 National Museum of Modern Art, Seoul; 1983 Art Gallery, Korean Cultural Service, New York; 1985 Leema Art Museum, Seoul; 1986 Han Kwang Art Museum, Pusan, Korea; 1987 Union de Arte, Barcelona.
SELECTED COLLECTIONS: Asian Art Museum of San Francisco; Musée Nationale des Beaux-Arts, Monte Carlo; Museo de Arte, Lima; National Gallery of Modern Art, New Delhi; National Museum of History, Taipei; National Museum of Modern Art, Seoul; Oakland Museum of California; Santa Barbara Museum of Art.
SELECTED BIBLIOGRAPHY: "Artist Nong a Focal Point of USA-Korea Centennial," *Beverly Hills Today* (August 25, 1982); *Nong* (Rockville, Md.: Sasco Art Gallery in association with Korean Cultural Center, Fort Lee, N.J., 1995); *Nong* (Seoul: National Museum of Modern Art, 1975); "Nong Questions," *The Korean Weekly* (March 13, 1995): 20–21; Stewart, Marion C. "Maturity Through Understanding," *Southwest Art* (June 1980): 72–79

Tetsuo OCHIKUBO
Born 1923, Waipahu, Oahu, Hawaii; died 1975, Hawaii

Tetsuo Ochikubo studied at the University of Hawaii at Manoa and began his career as a commercial artist. From 1947 to 1948 he studied under the G.I. Bill at the Art Institute of Chicago, moving to New York for instruction at the Art Students League (1951–52, 1956–60) with Morris Kantor and Byron Browne, among others, and at Pratt Institute (1960). A year's hiatus in 1953 was spent in Japan, where he studied traditional Japanese brush painting with Takehiko Mohri in Tokyo. In 1968 he earned an MFA at the University of Syracuse, becoming an associate professor of art there until 1974. He then returned to Hawaii and taught at the University of Hawaii in Hilo until his death in 1975. During his artistic career he was a recipient of the John Hay Whitney Fellowship in 1957, a Guggenheim Fellowship in 1958, and a Tamarind Lithography Fellowship in 1960.

Although Ochikubo often painted, he preferred printmaking, especially lithography and etching. His lithographs and paintings feature his characteristic floating shapes and calligraphic imagery and have been described as a sensitive "fusion of Oriental art and philosophy with the contemporary sophistication of Western ideas." The forms in his art, which initially appear to be abstract, are drawn from aspects of nature. The muted colors, atmospheric qualities, and often centralized images of Ochikubo's art reflect a philosophical approach to painting. Ochikubo has stated:

"My ultimate purpose in painting is . . . to understand and to be understood . . . to be able to understand life in its thousands of facets, to eliminate arbitrary and contrary truth, to have the function and command of beauty at the tip of my brush." *Y.H.*

SELECTED EXHIBITIONS: 1958–61 Krasner Gallery, New York; 1959 Columbia Museum of Art, S.C.; 1964 Joe and Emily Lowe Art Center, Syracuse University, N.Y.; 1970 Fairleigh Dickinson University, Teaneck, N.J.; 1987 Hawaii State Foundation on Culture and the Arts, Honolulu; Contemporary Arts Center, Honolulu.

SELECTED COLLECTIONS: Albright-Knox Art Gallery, Buffalo; Cincinnati Art Museum; De Cordova Museum and Sculpture Park, Lincoln, Mass.; Hawaii State Foundation on Culture and the Arts, Honolulu; Hirshhorn Museum and Sculpture Garden, Smithsonian Institution, Washington, D.C.; Honolulu Academy of Arts; Los Angeles County Museum of Art.

SELECTED BIBLIOGRAPHY: Schmeckebier, Laurence. *Tetsuo Ochikubo: Paintings, Drawings, Lithographs* (Syracuse: Lowe Art Center, Syracuse University, 1964)

Toshio ODATE
Born 1930, Tokyo, Japan; lives in Woodbury, Connecticut

Odate studied at the Tokyo Art School from 1950 to 1954, and at National Chiba University in 1957. He left school in 1958 to come to the United States. He has been a sculpture instructor at the Pratt Institute since 1968 and has taught at the Brooklyn Museum Art School (1963–79) and at Cooper Union (1977–78). He also has taught sculpture, Japanese toy making, and Japanese screen making at the Brookfield Craft Center in Brookfield, Connecticut, since 1978. Odate's expertise with traditional Japanese woodworking techniques is widely acknowledged and is reflected in an extensive record of articles in specialized woodworking journals, as well as in his many guest lectures and seminars at institutions such as the Wendell Castle Workshop, Scottsville, New York; the Appalachian Center for Crafts, Smithville, Tennessee; and the Cooper-Hewitt Museum, New York.

Odate has often combined, in philosophy and practice, the activities of a traditional Japanese woodcrafter with the modernist stance of an abstract sculptor. His concern with the philosophy behind the creation of objects in wood has led him to refer to some of his creations as conceptual art, although they may be completely utilitarian objects. His wood sculptures of the 1950s and 1960s often combine a rough-hewn aspect, showing the artist's respect for the natural material, with forms suggestive of traditional Japanese architectural forms. *Y.H.*

SELECTED EXHIBITIONS: 1959 *Waning Moon and Rising Sun—Japanese Artists,* Museum of Fine Arts, Houston; 1962 *Joseph H. Hirshhorn Collection,* Solomon R. Guggenheim Museum, New York; 1965 *Japanese Artists Abroad,* National Museum of Modern Art, Tokyo; 1965 Whitney Museum of American Art, New York; 1970 *Attitudes,* Brooklyn Museum; 1980 Wadsworth Athenaeum, Hartford, Conn.

SELECTED COLLECTIONS: Brooklyn Museum; Hirshhorn Museum and Sculpture Garden, Smithsonian Institution, Washington, D.C.; Memorial Art Gallery, University of Rochester, N.Y.; Norton Gallery of Art, West Palm Beach, Fla.

SELECTED BIBLIOGRAPHY: "Asian Art—Soul of the Tool," *Bulletin of the Arthur M. Sackler Gallery, Smithsonian Institution* 4, no. 3 (Summer 1991); D. J. "Toshio Odate," *Arts Magazine* 37 (April 1963): 58–59; *Japanese Artists Abroad* (Tokyo: National Museum of Modern Art, 1965)

Yutaka OHASHI
Born 1923, Kure, Hiroshima, Japan; died 1989, Shiki, Saitama, Japan

Ohashi entered the Tokyo Academy of Fine Arts at age seventeen. In 1950 he came to the United States to attend the School of the Museum of Fine Arts, Boston, where he studied with David Aronson and Karl Zerbe. From 1955 to 1958 Ohashi painted and studied in Europe under the auspices of a William Paige Traveling Scholarship awarded to him from the Museum of Fine Arts, Boston. A Guggenheim Fellowship made possible a year's stay in Japan in 1959. Ohashi taught art during his years at the Boston Museum School and later taught as a visiting lecturer at Cornell University in 1961, 1967, and 1969.

Ohashi's first abstract compositions, created in the United States, very consciously combine aspects of traditional Japanese color and design with prevailing American abstract trends. Utilizing oil and gold leaf, Ohashi's paintings reflect a traditional Japanese palette, often dominated by black, white, and touches of muted earth tones. Ohashi stated that Abstract Expressionism might yield to an art that "is a less accidental, less spontaneous form of abstract art and will come about through the deep understanding of the materials artists use." *Y.H.*

SELECTED EXHIBITIONS: 1958 Pittsburgh Bicentennial International Exhibition of Contemporary Paintings and Sculptures; 1959 Carnegie Institute, Pittsburgh; 1962 Solomon R. Guggenheim Museum, New York; 1965 *Japanese Artists Abroad,* National Museum of Modern Art, Tokyo; 1970 Montclair Art Museum, N.J.; 1975 Boston Atheneum Gallery; 1977 *Art in Transition,* Museum of Fine Arts, Boston; 1977 *Half Century of Japanese Artists in New York,* Azuma Gallery, New York.
SELECTED COLLECTIONS: Addison Gallery of American Art, Andover, Mass.; Herbert F. Johnson Museum of Art, Cornell University, Ithaca, N.Y.; Museum of Fine Arts, Boston; National Museum of Modern Art, Tokyo; Solomon R. Guggenheim Museum, New York; Yale University Art Gallery, New Haven, Conn.
SELECTED BIBLIOGRAPHY: *Carnegie International Exhibition of Contemporary Paintings and Sculpture* (Pittsburgh: Carnegie Institute, 1958); Jenks, Anne L., and Thomas M. Messer. *Contemporary Painters of Japanese Origin in America* (Boston: Institute of Contemporary Art, 1958)

Frank OKADA
Born 1931, Seattle, Washington; lives in Eugene, Oregon

Frank Okada earned his BFA at Cranbrook Academy of Art in Bloomfield Hills, Michigan, in 1957. Okada had already had contact with developments in Abstract Expressionism through a visit to New York in 1954. He was awarded a Whitney Fellowship in 1957 (for study in New York), a Fulbright Fellowship in 1959 (for study in Japan), and a Guggenheim Fellowship in 1967 (for study in

Paris). He currently teaches painting at the University of Oregon in Eugene.

Okada's art of the late 1950s and early 1960s was influenced by a mode of abstraction prevalent in Seattle and the Pacific Northwest that often integrated contemporary modes of gestural abstraction with calligraphic techniques and imagery derived from Asia. Okada's work of those years includes gestural abstractions in all-over compositions, as well as works in black *sumi* ink, which emphasize open space and very spontaneous strokes, drips, and gestures. *C.G.*

SELECTED EXHIBITIONS: 1958 *Tenth Street Annual Invitational,* Brata Gallery, New York; 1962 *Northwest Art Today,* Seattle World's Fair, Seattle Center; 1970 Portland Museum Art School, Oreg.; 1972 Portland Art Museum, Oreg.; 1976 University of Oregon Museum, Eugene; 1982 *Japan and the Northwest,* National Museum of Art, Osaka; 1990 *Views and Visions in the Pacific Northwest,* Seattle Art Museum.
SELECTED COLLECTIONS: Portland Art Museum, Oreg.; Seattle Art Museum; Tacoma Art Museum, Wash.; University of Oregon Museum of Art, Eugene; Whatcom Museum of History and Art, Bellingham, Wash.
SELECTED BIBLIOGRAPHY: Kangas, Matthew. "Abstract Works by Two Asian Artists Meld Past and Present, East and West," *The Seattle Times* (January 9, 1994): 1, 7; *Northwest Art Today Exhibition* (Seattle: Seattle World's Fair, Seattle Center, 1961); *Pacific Northwest Artists and Japan* (Seattle: Seattle Art Museum, 1982); *Seattle Show* (Santa Barbara: Santa Barbara Museum of Art, 1975); *Younger Washington Artists* (Seattle: Henry Gallery, University of Washington, 1963)

Kenzo OKADA
Born 1902, Yokohama, Japan; died 1982, New York, New York

Okada studied at Meijigakuin Middle School, at Tokyo Fine Arts University, and in Paris from 1924 to 1927, where he exhibited at the Salon d'Automne. In Japan from 1938 to 1950 he exhibited with Nikakai, the largest association of modern Japanese painters, held a number of one-person shows in private galleries in Tokyo, and taught at several art schools, such as Nippon University (1940–42), Musashino

Art Institute (1947–50), and Tama Fine Arts College (1949–50). He moved to the United States in 1950 and became an American citizen in 1960. Okada received a Ford Foundation grant in 1959.

Okada may be considered the Asian American painter most closely associated with the New York School of Abstract Expressionism. He created fully nonobjective work by 1950 and had a long exhibition record at a prime venue of Abstract Expressionism, the Betty Parsons Gallery, between 1953 and 1978. While Okada incorporated many aspects of American painterly abstraction in his art, he always emphasized the importance of maintaining contact with Japanese aesthetics and philosophies and is remembered for his inspiring commentary to that effect given to many Japanese-born artists in New York. His own ties to Japanese visual traditions are seen in his use of a flattened space suggestive of landscape and a characteristically subtle and light color palette, often incorporating earth tones and pastel shades. Although he generally embraced the large scale of Abstract Expressionist art, Okada shunned its explosive methods of paint handling. Instead, he created balanced compositions of abutting areas of restrained color, sometimes accenting them with a drip or two or a patch of textured strokes. *Y.H.*

SELECTED EXHIBITIONS: 1953, 1959, 1962, 1964, 1969 Betty Parsons Gallery, New York; 1955 São Paulo Biennial, Brazil, representing the U.S.; 1958 Venice Biennial, representing Japan; 1960 *60 American Painters: Abstract Expressionist Painting of the Fifties,* Walker Art Center, Minneapolis; 1963 Massachusetts Institute of Technology, Cambridge; 1965 Albright-Knox Art Gallery, Buffalo; 1966 National Museum of Modern Art, Kyoto; 1967 M. H. de Young Memorial Museum, San Francisco; 1982 Seibu Art Museum, Tokyo.
SELECTED COLLECTIONS: Albright-Knox Art Gallery, Buffalo; Art Institute of Chicago; Brooklyn Museum; Carnegie Institute, Pittsburgh; Metropolitan Museum of Art, New York; Munson-Williams-Proctor Institute, Utica, N.Y.; Museum of Fine Arts, Boston; Museum of Modern Art, New York; Phillips Collection, Washington, D.C.; San Francisco Museum of Modern Art; Solomon R. Guggenheim Museum, New York; Whitney

Museum of American Art, New York.
SELECTED BIBLIOGRAPHY: Hunter, Sam. "Kenzo Okada," *Art in America* 44 (February 1955): 17–19; Jenks, Anne L., and Thomas M. Messer. *Contemporary Painters of Japanese Origin in America* (Boston: Institute of Contemporary Art, 1958); *Kenzo Okada* (Tokyo: Asahi Shinbun Publishing Company, 1982); *Kenzo Okada, Paintings* (New York: Betty Parsons Gallery, 1969); *Kenzo Okada, Paintings 1931–1965* (Buffalo: Albright-Knox Art Gallery, 1965); *60 American Painters: Abstract Expressionist Painting of the Fifties* (Minneapolis: Walker Art Center, 1960)

Arthur OKAMURA

Born 1932, Long Beach, California; lives in Bolinas, California

Okamura attended the Art Institute of Chicago from 1950 to 1954 and the Yale University Summer Art Seminar in 1954. At this time he received the Edward Ryerson Foreign Travel Fellowship from the School of the Art Institute of Chicago. Okamura was an instructor at the Evanston Art Center in Illinois (1956–57), the Art Institute of Chicago, the Academy of Art in San Francisco (1957), and the Saugatuck Summer Art School in Michigan (1959 and 1962). He was a professor of art at the California College of Arts and Crafts (1958–59 and 1966–83) and a guest lecturer at the University of Utah (1964 and 1975).

During the 1950s and 1960s Okamura's paintings were essentially highly abstracted landscapes. In their painterly qualities, they had some relation to the prevalent style of the Bay Area school of "Abstract Expressionist" landscape painting. However, his work is distinguished by its use of indistinct and hazy forms rendered in subtle and grayed tonalities that convey an Eastern sensibility. The artist has spoken of his interest in Eastern art and philosophy in relation to his method and imagery, including his interest in Zen art and thought. *Y.H.*

SELECTED EXHIBITIONS: 1957 *Art in Asia & in the West,* Art Institute of Chicago; 1958 *West Coast Painters,* American Federation of Arts, New York; 1959 Oakland Museum, Calif.; 1961 California Palace of the Legion of Honor, San Francisco; 1964 *40 under 40,* Corcoran Gallery of Art, Washington, D.C.; 1964 Whitney Museum of American Art, New

York; 1965 *Pacific Heritage,* Municipal Art Gallery, Los Angeles; 1968 San Francisco Museum of Modern Art; 1971 *Asian Artists,* Oakland Museum, Calif.; 1988 *Tropical Topics,* Monterey Peninsula Museum of Art, Calif.

SELECTED COLLECTIONS: Art Institute of Chicago; Denver Art Museum; National Museum of American Art, Washington, D.C.; San Francisco Museum of Modern Art; Santa Barbara Museum of Art; Whitney Museum of American Art, New York.

SELECTED BIBLIOGRAPHY: *Annual Exhibition of American Painting and Sculpture* (Urbana-Champaign: University of Illinois, 1963 and 1969); Brown, Michael, D. *Views from Asian California 1920–1965, An Illustrated History* (San Francisco: Michael D. Brown, 1992); Nordness, Lee, ed. *Art: USA Now* (New York: C. J. Bucher, 1962)

Sumiye OKOSHI

Born 1921, Seattle, Washington; lives in New York, New York

Okoshi was raised and educated in Japan, graduating from Rikkyo Jo-Gakuin, Futaba, Kojo-Futaba-Kai in Tokyo. Returning to the United States at the end of World War II, she started her artistic career. She studied art with Fay Chong between 1951 and 1953 and with Nicholas Damascus at the Henry Frye Museum School between 1954 and 1956. She also studied with Jacob Lawrence at the New School Painting Workshop in New York.

Okoshi's early style was influenced by the abstract trends prevalent in Seattle in the late 1940s and 1950s, in particular the work of Mark Tobey. Okoshi's work from the 1950s combines the subtle colors of Japanese art (gray, bronze, or earth tones) with the American concepts of Color Field painting and all-over composition, sometimes including linear networks. These formats continued through the early 1960s, but were supplanted by a series of works with simple, relatively geometric forms in the late 1960s. This latter series led to her recent work: collages that emphasize basic geometric patterns using stained rice papers and painted canvases, sometimes with wisps of gold and silver foil. *Y.H.*

SELECTED EXHIBITIONS: 1970 Miami Museum of Modern Art; 1974–77 *Japanese Artists Abroad,* Azuma Gallery, New York; 1977 Hudson River Museum, Yonkers, N.Y.; 1977 Metropolitan Museum of Art, New York; 1991 *The Fragmented Image,* National Academy of Sciences, Washington, D.C.; 1993 Hammond Museum, North Salem, N.Y.; 1993–94 *Paper on Paper,* Museum of the City of New York; 1994 *A View of One's Own: The National Association of Women Artists Collection at Rutgers,* Jane Voorhees Zimmerli Art Museum, Rutgers, The State University of New Jersey, New Brunswick.

SELECTED COLLECTIONS: Bank of Nagoya, New York; Hammond Museum, North Salem, N.Y.; Jane Voorhees Zimmerli Art Museum, Rutgers, The State University of New Jersey, New Brunswick; Lowe Art Museum, University of Miami, Coral Gables, Fla.; Miami Museum of Modern Art; National Academy of Sciences, Washington, D.C.

SELECTED BIBLIOGRAPHY: Bentley, Joelle. *The Fragmented Image* (Washington, D.C.: National Academy of Sciences, 1991); Brommer, Gerald. *Collage Techniques: A Guide for Artists and Illustrators* (New York: Watson-Guptill Publications, 1994); Harrison, Helen. "Japanese Abstraction, Looking West," *New York Times,* Long Island edition (December 29, 1985): 12; *The Japanese Culture: Tradition & Today* (Paramus, N.J.: Bergen Museum of Art and Science, 1983); Murase, Miyeko. *The Art of Sumiye Okoshi* (Miami: Miami Museum of Modern Art, 1970)

John PAI

Born 1937, Seoul, Korea; lives in Fairfield, Connecticut

John Pai moved to the United States with his family when he was eleven. He won a scholarship to Pratt Institute, New York, earning his Bachelor of Industrial Design in 1962 and his MFA in sculpture in 1964. He is currently Professor of Fine Arts at Pratt, previously holding positions as Chairman of the Sculpture Department and Director of the Division of Fine Arts. As early as 1965 Pai was appointed Chairman of the Undergraduate Sculpture Program at Pratt and designed an entire curriculum based on interdisciplinary studies.

Pai's welded steel sculptures from the early 1960s reveal influence from Theodore Roszak, whom he was then assisting. Pai's works of this period are suggestive of plants, coral, and

other branching natural motifs. In the mid-1960s he discovered the module as an organizing unit in his sculpture, which he intended as an allusion to "cells and atoms and other components of life" (Nadelman, 33). During this time his desire for order and balance in sculpture outweighed his earlier organic and gestural leanings. *C.G.*

SELECTED EXHIBITIONS: 1964 Pratt Institute, New York; 1973 American International Sculpture Symposium, CUNY Graduate Center, New York; 1977 *Four Contemporary Sculptors,* Alternative Center for International Art, New York; 1980 Two-person exhibition with Whanki Kim, FIAC, Grand Palais, Paris; 1982 Won Gallery, Seoul; 1987 Gallery Korea, New York; 1988 Souyun Yi Gallery, New York; 1993 Gallery Hyundai, Seoul; 1993 Whanki Museum, Seoul; 1994 Sigma Gallery, New York.

SELECTED COLLECTIONS: City College of New York; Höam Museum, Seoul; Kingsborough Community College, New York; National Museum of Contemporary Art, Seoul; Pratt Institute, New York; Walker Hill Art Center, Seoul; Whanki Museum, Seoul.

SELECTED BIBLIOGRAPHY: Nadelman, Cynthia. *John Pai: One on One* (New York: Sigma Gallery, 1994); Sharpe, Bruce. *John Pai: Sculpture 1983–1993* (Seoul: Gallery Hyundai, 1993); Sharpe, Bruce. *John Pai Sculptures* (Seoul: Won Gallery, 1982)

Tadashi SATO
Born 1923, Maui, Hawaii; lives in Wahikuli, Maui

Sato studied at Honolulu Academy of Arts, Brooklyn Museum Art School, Pratt Institute (with Stuart Davis, John Ferren, and Ralston Crawford), and at the New School of Social Research, New York. Like several Hawaiian artists of his generation, Sato spent several years in New York in order to have contact with contemporary trends in painting but ultimately found this environment unappealing and returned to Hawaii. His awards and scholarships include the Brooklyn Museum Art School Scholarship, 1948; Dallas Museum of Fine Arts, Honorable Mention, 1953; John Hay Whitney Fellowship, 1954; Honolulu Community Foundation Scholarship, 1955; and the Albert Kapp Award, 1958.

Sato's early works were hard-edged, reflecting an influence of the precisionist Ralston Crawford. Later his works took on a softer aspect, which the artist said was the result of his trip to Nova Scotia where the rise and fall of the tides reminded him of the waters of Maui. Many of his paintings utilize overlapping ellipses, shapes, shadows, and reflections derived from an important visual motif for the artist: the quiet tidal pools and submerged rocks of Maui's coast. Of his paintings, Sato says, "I prefer [those] that convey a mystical, metaphysical aspect." This particular quality, which also results from Sato's interest in Zen, is most evident in his paintings that are very subtle in coloration (sometimes only shades of white) and contain a few rounded forms and graceful lines. *Y.H.*

SELECTED EXHIBITIONS: 1952 *Young Painters of America,* Solomon R. Guggenheim Museum, New York; 1961 *The Theater Collects American Art,* Whitney Museum of American Art, New York; 1963 Contemporary Arts Center, Honolulu; 1963 *Pacific Heritage,* Los Angeles County Museum of Art; 1985 Honolulu Academy of Arts; 1992 Hui No'eau Visual Arts Center, Kaluanui, Hawaii.

SELECTED COLLECTIONS: Albright-Knox Art Gallery, Buffalo; Hawaii State Foundation on Culture and the Arts, Honolulu; Honolulu Academy of Arts; Joslyn Art Museum, Omaha; Solomon R. Guggenheim Museum, New York; Whitney Museum of American Art, New York.

SELECTED BIBLIOGRAPHY: *Pacific Heritage* (Los Angeles: Los Angeles County Museum of Art, 1963); *Paintings by Tadashi Sato* (Honolulu: Honolulu Academy of Arts, 1985); Rose, Joan. "Sato Retrospective Traces 40-year Evolution of Style," *Star-Bulletin and Advertiser,* Honolulu (January 12, 1992): F7; *Tadashi Sato* (Kaluanui, Hawaii: Hui No'eau Visual Arts Center, 1992)

Sueo SERISAWA
Born 1910, Yokohama, Japan; lives in Idyllwild, California

Serisawa emigrated from Japan to Seattle, Washington, in 1918 and by 1921 had moved to Long Beach, California. His father, Yoichi, was an artist and provided Sueo's initial instruction in art. Serisawa later studied at the Otis

Art Institute and the Art Institute of Chicago. In a highly unusual and fateful circumstance, the opening of a one-person show for Serisawa at the Los Angeles County Museum of Art was scheduled on December 7, 1941, the day of the Japanese attack on Pearl Harbor. To escape placement in the internment camps, Serisawa and his family left California, moving first to Chicago and later to New York. His experience in the New York art community from 1942 to 1947 (in particular, his contact with Yasuo Kuniyoshi) was highly significant in the development of his painting. He returned to California in 1947. He was an instructor of painting at Scripps College (1949–50) and at the University of Southern California, Idyllwild, beginning in 1975. He has also taught at Laguna Beach School of Art and the Palm Springs Museum of Art.

A trip to Japan in 1955 allowed Serisawa to reconnect with his cultural and artistic origins. As described by Michael Brown, Serisawa "felt the philosophy of art is universal and . . . coincided with Zen thinking. . . . Serisawa studied and practiced calligraphy, more as an aesthetic than as a strict literal practice. . . . He felt the abstract could never be literally stated, and that it has a language of its own" (Brown 1992, 52). *Y.H.*

SELECTED EXHIBITIONS: 1939 Oakland Art Gallery, Calif.; 1941 Los Angeles County Museum of Art; 1948 California Palace of the Legion of Honor, San Francisco; 1952 Annual Exhibition, Carnegie Institute, Pittsburgh; 1955 São Paulo Biennial, Brazil; 1960 Whitney Museum of American Art, New York; 1965 *Pacific Heritage,* Municipal Art Gallery, Los Angeles.

SELECTED COLLECTIONS: Los Angeles County Museum of Art; Metropolitan Museum of Art, New York; San Diego Museum of Art; Santa Barbara Museum of Art.

SELECTED BIBLIOGRAPHY: Biberman, Ed, director. *20 Artists* (film), Los Angeles County Museum of Art and University of California, Los Angeles, 1970; Brown, Michael D. *Views from Asian California 1920–1965, An Illustrated History* (San Francisco: Michael D. Brown, 1992); Millier, Arthur. "Sueo Serisawa: An Account of the Inner Development of a Young American Painter," *American Artist* (June 1950): 33–37+; Mugnaini, Joe. *Logics of Drawing* (New York: Reinholt, 1973); Mugnaini, Joe. *Oil Painting Techniques and Materials* (New York: Reinholt, 1969)

James Hiroshi SUZUKI
Born 1933, Yokohama, Japan; lives in Davis, California

Suzuki's art education in Japan was related to a single course in calligraphy plus some private study with the painter Yoshio Markino. Markino, who had traveled in the West, urged Suzuki to study abroad in order to absorb modern Western styles of art. Suzuki came to the United States in 1952, at first visiting Los Angeles and San Francisco. Later that year he entered the School of Fine and Applied Art in Portland, Maine, and then was awarded a scholarship, which allowed him to study at the Corcoran School of Art in Washington, D.C., in 1953. Suzuki soon moved to New York City, where he had his first one-person show at the Grand Gallery. In New York he became acquainted with many of the better-known Abstract Expressionists, including Pollock, Kline, and de Kooning, as well as many of the prominent Japanese American abstractionists who were in New York at the time, such as Okada and Hasegawa. He returned to California in 1962, teaching at the University of California at Berkeley (1962–63) and the California College of Arts and Crafts (1964–65). After several other teaching positions, in 1972 he began to teach at California State University at Sacramento, where he is now a professor of art.

Suzuki's paintings of the mid-1950s combine aspects of Japanese landscape, traditional Japanese decorative elements, and Western painterly brushwork to create an "abstract impressionist" effect. In the late 1950s he developed a highly energetic imagery of rapidly brushed calligraphic strokes. *Y.H.*

SELECTED EXHIBITIONS: 1956, 1958, 1960 Corcoran Biennial, Corcoran Gallery of Art, Washington, D.C.; 1958 *Contemporary Painters of Japanese Origin in America,* Institute of Contemporary Art, Boston; 1958 Everson Museum of Art, Syracuse; 1958 Painting and Sculpture Annual, Whitney Museum of American Art, New York; 1959 *Waning Moon and Rising Sun,* Museum of Fine Arts, Houston; 1964 *4th International Biennial Exhibition of Prints,* National Museum of

Modern Art, Tokyo; 1976 *Seven from Oakland,* Oakland Museum, Calif.

SELECTED COLLECTIONS: Corcoran Gallery of Art, Washington, D.C.; National Museum of Modern Art, Tokyo; Rockefeller Institute, New York; Toledo Museum of Art, Ohio; Wadsworth Athenaeum, Hartford, Conn.

SELECTED BIBLIOGRAPHY: Brown, Michael D. *Views from Asian California 1920–1965, An Illustrated History* (San Francisco: Michael D. Brown, 1992); Jenks, Anne L., and Thomas M. Messer. *Contemporary Painters of Japanese Origin in America* (Boston: Institute of Contemporary Art, 1958)

Toshiko TAKAEZU

Born 1922, Pepeekeo, Hawaii; lives in Quakertown, New Jersey

Takaezu's first professional position in ceramics was with the Hawaiian Potter's Guild in Honolulu in 1940. After attending classes at the Honolulu Art School (1947–49) Takaezu attended the University of Hawaii (1948–51), where she studied with Claude Horan. At the Cranbrook Academy of Art (1951–54), she studied with Bill McVey and Maija Grotell, becoming an assistant to the latter in 1953. She taught summer sessions at Cranbrook (1954–56) and at the Cleveland Institute of Art (1955–64), where she became head of the ceramic department. In 1965 she left her teaching position to move to New Jersey, ultimately establishing a permanent studio in Quakertown in 1975. From 1967 to 1992 she taught at the Creative Art Program (later named Visual Arts Program) of Princeton University.

Takaezu's oeuvre covers a wide range of mediums, including ceramics, weavings, bronzes, and paintings. She is noted for her pioneer work in ceramics and has played an important role in the international revival of interest in the ceramic arts. Her clay pieces include delicate teabowls, plates with glazes and decorations similar to Abstract Expressionist paintings, rounded seedlike forms, and huge ceramic cylinders that are sometimes grouped in forestlike arrangements. *Y.H.*

SELECTED EXHIBITIONS: 1955 University of Wisconsin, Madison; 1959 Cleveland Museum of Art; 1965 Society of Arts and Crafts, Boston; 1973 Hunterdon Art Center, Clinton, N.J.; 1988 Montclair Art Museum, N.J.; 1993 Contemporary Museum, Honolulu; 1993 Honolulu Academy of Arts; 1995 National Museum of Modern Art, Kyoto.

SELECTED COLLECTIONS: Cooper-Hewitt National Museum of Design, Smithsonian Institution, New York; Cranbrook Academy of Art, Bloomfield Hills, Mich.; Everson Museum of Art, Syracuse; Honolulu Academy of Arts; Metropolitan Museum of Art, New York; Museum of Contemporary Crafts, New York; Philadelphia Museum of Art.

SELECTED BIBLIOGRAPHY: *Toshiko Takaezu* (Honolulu: Honolulu Academy of Arts and Contemporary Arts Center, 1993); *Toshiko Takaezu: Four Decades* (Montclair, N.J.: Montclair Art Museum, 1988); *Toshiko Takaezu: 1989–1990* (Princeton, N.J.: Gallery at Bristol-Myers Squibb, 1990); *Toshiko Takaezu Retrospective* (Kyoto: National Museum of Modern Art, 1995)

Teiji TAKAI

Born 1911, Osaka, Japan; died 1986, Toyko, Japan

The following biographical note on Takai was published in Anne L. Jenks and Thomas M. Messer, *Contemporary Painters of Japanese Origin in America* (unpaginated):

"Childhood spent in Kobe where he met many Westerners. Early exposure to oil painting. In 1929 attended Shinanobashi Institute in Osaka and received Western academic training. At 19, became a professional artist when Nikakai accepted painting for exhibition. Early work showed influence of Fernand Léger in both style and content. During thirties was impressed by photographs of murals by Orozco, Rivera and Philip Guston. About 1936 turned towards landscapes and interiors in detailed realistic style that showed Dutch influence and which he considers 'academic.' During war, did sketches in China for the Army. In 1946, helped form the Kodo Party. Arrived in United States in 1955. In San Francisco saw first modern exhibition of American painting which included works of Kline, de Kooning and Okada. Felt immediate kinship for the 'vitality' in this 'art of today.' Settled in New York. First one-man show at the Collector's Gallery, New York in 1956. Likes two aspects of traditional Oriental art.

Finds specifically human feelings in 'broad, decorative and gorgeous' method of Korin. Believes works of Chinese artist Mu ch'i express complex meanings in extremely simplified manner with freshness, depth of feeling and definite spiritual quality. Special liking for Cézanne and Gauguin. Among American artists prefers Philip Guston, Tomlin and also Rothko, Kline and de Kooning. Feels Guston expresses poetic qualities and 'delicacy of human feelings.' Although he believes that he sees Western life with Japanese approach, he wants to create paintings that are universal and transcend East and West."

SELECTED EXHIBITIONS: 1956 Collector's Gallery, New York; 1959–72 Poindexter Gallery, New York; 1959, 1961 Whitney Museum of American Art, New York; 1961–62 Carnegie Institute, Pittsburgh; 1961–62 Corcoran Biennial, Corcoran Gallery of Art, Washington, D.C.; 1967 Takashimaya Gallery, Tokyo.
SELECTED COLLECTIONS: Columbia Museum of Art, S.C.; Corcoran Gallery of Art, Washington, D.C.; National Museum of Modern Art, Tokyo; Wakayama Modern Art Museum, Japan; Whitney Museum of American Art, New York.
SELECTED BIBLIOGRAPHY: Jenks, Anne L., and Thomas M. Messer. *Contemporary Painters of Japanese Origin in America* (Boston: Institute of Contemporary Art, 1958)

Walasse TING

Born 1929, Shanghai, China; lives in Amsterdam, The Netherlands, and New York, New York

A self-taught artist, Walasse Ting began to paint at an early age in the classic Chinese medium of "water ink." After studying at the Shanghai Art Academy, Ting left China for Hong Kong in 1949. Following a brief stay in Japan, he went to Paris in 1953, where he experimented with the medium of oil for the first time. He moved to New York in 1963 and received a Guggenheim Fellowship in 1970.

Ting has worked in many mediums, including ink, oil, lithography, and sculpture. His outgoing personality and exuberant approach to art and life led Ting to become one of the most prominent Asian American artists associated with the Abstract

Expressionist circles in New York. His free-wheeling approach to art is best manifested by his continuous variation of style, subject matter, and mediums; he creates both highly abstracted scenes and representational works, in which images of horses and women are prevalent. In the realm of abstraction, Ting's brushstroke is free and spontaneous, and he creates extremely gestural, spattered images, frequently based on calligraphy. His colors are often daring, high-pitched, and sometimes candylike. He also has produced hundreds of works in black and white, accelerating and broadening the traditional Eastern brush-stroke, often in paintings scaled to rival the large canvases of the New York School. Beginning in the 1950s Ting began to compose various spontaneous poems in purposefully broken English, which he sometimes would publish in books and albums in conjunction with his own abstract illustrations. *C.G.*

SELECTED EXHIBITIONS: 1957 Mi Chou Gallery, New York; 1959 Martha Jackson Gallery, New York; 1961 Carnegie International, Carnegie Institute, Pittsburgh; 1963–84 Lefebre Gallery, New York; 1964–68 Salon de Mai, Paris; 1975 National Museum of History, Taipei; 1977 Galleria Graphica Club, Milan; 1985 Taipei Fine Arts Museum; 1986 Alisan Fine Arts, Hong Kong; 1989 American Club, Hong Kong; 1991 Galerie Alcolea, Madrid; 1994 Tresors, Singapore (Alisan Fine Arts).
SELECTED COLLECTIONS: Albright-Knox Art Gallery, Buffalo; Art Institute of Chicago; Carnegie Institute, Pittsburgh; Detroit Institute of Arts; Museum of Fine Arts, Boston; Museum of Modern Art, New York; Philadelphia Museum of Art; Solomon R. Guggenheim Museum, New York; Stedelijk Museum, Amsterdam; Tate Gallery, London.
SELECTED BIBLIOGRAPHY: Alcolea, Fernando. *Walasse Ting* (Barcelona: Fernando Alcolea, 1988); Rivière, Yves, ed. *Walasse Ting, Jolies Dames* (Paris: Yves Rivière, 1988); Rivière, Yves, ed. *Walasse Ting, Rice Paper Paintings* (Paris and New York: Yves Rivière and Walasse Ting, 1984); Ting, Walasse. *Chinese Moonlight* (New York: Wittenborn, 1967); Ting, Walasse. *1 cent Life*, Sam Francis, ed. (Bern, Switzerland: Kornfeld and Klipstein, 1964); *Walasse Ting Album* (Taipei: n.p., 1992); *Walasse Ting Paintings* (New York: Galerie Chalette, 1957)

TSENG Yuho

Born 1924, Beijing, China; lives in Honolulu, Hawaii

Tseng Yuho received her BA from Fujen University in Beijing in 1942, her MFA from the University of Hawaii in 1966, and her PhD in art history from the Institute of Fine Arts, New York University, in 1972. Tseng was studio art instructor at the Honolulu Academy of Art from 1950 to 1963 and associate professor of Chinese art history at the University of Hawaii from 1963 to 1966, where she currently holds the titles of professor and program chairperson in the department of art history. She has written a number of books and articles on many aspects of traditional and modern Chinese art, including calligraphy, ink painting, Chinese artists' seals, and Chinese folk art.

By the time Tseng Yuho settled in Honolulu in 1949, she had mastered an extensive range of Chinese traditional painting styles. Through her contacts with Western art in Hawaii and the continental United States, she developed a heightened sense of abstraction in her work while always maintaining connections to Chinese artistic traditions, especially in her choice of mediums. First exhibited in 1955, her *dsui* paintings are her signature works, combining applications of gold and silver leaf and superimposed layers of rice paper with oil pigmentation. *C.G.*

SELECTED EXHIBITIONS: 1946–47 Chinese Council, London, and M. H. de Young Memorial Museum, San Francisco; 1952, 1959 Honolulu Academy of Arts; 1963 San Francisco Museum of Modern Art; 1965 *Pacific Heritage,* Municipal Art Gallery, Los Angeles; 1984 *20th-Century Chinese Painting,* Hong Kong Art Centre; 1992 Retrospective traveling exhibition, Shanghai Municipal Museum of Modern Art, China Art Museum, Beijing, Taipei Fine Arts Museum, Hong Kong Art Centre, National Museum of Singapore. SELECTED COLLECTIONS: Honolulu Academy of Arts; Munson-Williams-Proctor Institute, Utica, N.Y.; Musée Cernuschi, Paris; National Museum of Modern Art, Stockholm; Stanford University Museum of Art and T. W. Stanford Art Gallery, Calif.; Walker Art Center, Minneapolis.

SELECTED BIBLIOGRAPHY: *Dsui Hua, Tseng Yuho* (Hong Kong: Hanart T. Z. Gallery, 1992); Link, Howard, and Tseng Yuho. *The Art of Tseng Yuho* (Honolulu: Honolulu Academy of Arts, 1987); Tseng Yuho. *A History of the Art of Chinese Calligraphy* (Hong Kong: Chinese University of Hong Kong, 1993); Tseng Yuho. *Some Contemporary Elements in Classical Chinese Art* (Honolulu: University of Hawaii Press, 1963)

George TSUTAKAWA

Born 1910, Seattle, Washington; lives in Seattle

Tsutakawa was educated in Japan and the United States. During his early years in Japan (1917–27) he was influenced by Buddhism, Shintoism, and Zen philosophy. In the United States he studied sculpture with Dudley Pratt and Alexander Archipenko, watercolor with Ray Hill, and painting with Ambrose Patterson and Walter Isaacs at the University of Washington School of Art, receiving his MFA in 1937. Starting around 1938 Tsutakawa began a long association with several artists connected with the so-called School of the Pacific Northwest. This group included Mark Tobey, Morris Graves, Kenneth Callahan, and Guy Anderson, as well as Fay Chong and Kenjiro Nomura. These artists all shared mutual interest in the East; Tobey, in particular, influenced Tsutakawa in terms of *sumi* ink painting. From 1947 to 1948 Tsutakawa became a full-time art instructor at the University of Washington School of Art, where he resumed study to specialize in sculpture, receiving a second MFA in 1950. He was appointed full professor there in 1955, a position he retained until his retirement in 1980.

In 1956 Tsutakawa visited Japan to satisfy a personal growing interest in his Japanese artistic and cultural heritage. Upon his return to the United States, he began a series of small abstract wood sculptures that were fundamental in shaping his future direction in sculptural form and philosophy. This series, *Obos,* was named after the Tibetan practice of creating piles of rocks in tribute to nature. In his sculptures Tsutakawa intends to express spiritual as well as physical balance, a harmony of form and content that surpasses specific cultural references. His concern with merging Eastern and Western sculptural forms, as well

as his desire to infuse aspects of nature into his art, ultimately led Tsutakawa to the form that would be a major artistic preoccupation for the rest of his life: the abstract fountain. Tsutakawa completed more than sixty fountain sculptures in major public sites in the United States, Canada, and Japan between the years 1960 and 1990. *Y.H.*

SELECTED EXHIBITIONS: 1950 Henry Art Gallery, University of Washington, Seattle; 1957 Seattle Art Museum; 1960 San Francisco Museum of Art; 1965 M. H. de Young Memorial Museum, San Francisco; 1974 *Art of the Pacific Northwest,* National Collection of Fine Arts, Smithsonian Institution, Washington, D.C.; 1982 *Pacific Northwest Artists and Japan,* National Museum of Art, Osaka; 1990 Retrospective, Bellevue Art Museum, Wash.; 1995 *Jet Dreams: The '50s in the Northwest, Looking at the Art, Architecture and Craft of the Decade,* Tacoma Art Museum, Wash.

SELECTED COLLECTIONS: Bellevue Arts and Crafts Association, Wash.; Denver Art Museum; Henry Art Gallery, University of Washington, Seattle; Santa Barbara Museum of Art; Seattle Art Museum; Seattle Public Library; Suzzallo Library, University of Washington, Seattle.

SELECTED BIBLIOGRAPHY: Griffin, Rachael, and Martha Kingsbury. *Art of the Pacific Northwest: From the 1930s to the Present* (Washington, D.C.: Smithsonian Institution Press, 1974); Guenther, Bruce. *50 Northwest Artists* (San Francisco: Chronicle Books, 1983); Kingsbury, Martha. *George Tsutakawa* (Seattle: University of Washington Press, 1990); *Pacific Heritage* (Los Angeles: Los Angeles Municipal Art Gallery, 1965); *Pacific Northwest Artists and Japan* (Osaka: National Museum of Art, 1982); Tsutakawa, Mayumi, and Alan Chong Lau, eds. *Turning Shadows into Light: Art and Culture of the Northwest's Early Asian-Pacific Community* (Seattle: Young Pine Press, 1982)

Ansei UCHIMA

Born 1921, Stockton, California; lives in New York, New York

Uchima, the son of Japanese immigrants, grew up in Los Angeles. In 1940, in accordance with his father's wishes, he went to Tokyo to study architecture at Waseda University. When Japan entered World War II one year later, Uchima was cut off from home. He soon gravitated to the study of painting, which he pursued under the tutelage of Japanese masters and later on his own. His paintings won awards at the Jiyu Bijutsu Art Association annual exhibitions in 1953 and 1954. Uchima began to experiment with printmaking in Japan in 1957, and his work was immediately successful with collectors in Japan and abroad. That same year he shared an exhibition at the Yoseido Gallery in Tokyo with the sculptor Masayuki Nagare and showed his woodcuts in the Tokyo International Print Triennials in 1957 and 1960. In 1960 he returned to the United States with his family and two years later began teaching at Sarah Lawrence College in Bronxville, New York. After twenty years of teaching, he was named professor emeritus in 1988. In 1967 he became an adjunct professor of printmaking at Columbia University. Besides having over forty one-person exhibitions in the United States and Japan, he has also been included in numerous group exhibitions worldwide.

Uchima studied painting in oils, but since his involvement with the traditional woodblock method of *ukiyo-e* while he was in Japan, using *sumi* and tube watercolors, he has mainly worked in woodblock printing. Due to certain circumstances of the artist's life, in particular his long residence in Japan during his artistic formative years, Uchima's oeuvre represents an especially coherent example of the direct interaction of modern printmaking aesthetics in Japan and the United States. *Y.H.*

SELECTED EXHIBITIONS: 1953, 1954 Annual Exhibitions, Jiyu Bijutsu Art Association, Tokyo; 1957, 1960 Tokyo International Print Triennials; 1959 Fifth São Paulo International Biennial, Brazil; 1962 *American Prints Today,* traveling exhibition sponsored by Print Council of America; 1964 *American Graphic Arts,* traveling exhibition sponsored by USIA in Romania, Czechoslovakia, and Yugoslavia; 1967 Vancouver International Print Exhibition, Canada; 1970 35th Venice International Biennial; 1976 Suzuki Gallery, New York; 1981 Yoseido Gallery, Tokyo; 1985 Sarah Lawrence College Gallery, Bronxville, N.Y.; 1988 Retrospective Exhibition of Woodcuts, Associated American Artists, New York.

SELECTED COLLECTIONS: Art Institute of Chicago; British Museum, London; Brooklyn Museum; Metropolitan Museum of Art, New York; National Gallery of Art, Washington, D.C.; National Museum of Modern Art, Tokyo; Philadelphia Museum of Art; Rijksmuseum, Amsterdam; Whitney Museum of American Art, New York.

SELECTED BIBLIOGRAPHY: Acton, David. *A Spectrum of Innovation: Color in American Printmaking 1890–1960* (Boston: Worcester Art Museum, 1990); *Ansei Uchima, Retrospective* (Bronxville, N.Y.: Sarah Lawrence College, 1985); Heller, Jules. *Printmaking Today* (New York: Holt, Rinehart & Winston, 1970); Johnson, Una E. *American Prints and Printmakers* (New York: Doubleday & Co., 1980); Michener, James A. *Japanese Prints from the Early Masters to Modern* (Tokyo: Charles E. Tuttle Co., 1959); Saff, Donald, and Deli Sacilatto. *Printmaking: History and Process* (New York: Holt, Rinehart & Winston, 1977); *The World of Ansei Uchima: Symphony of Colors* (Tokyo: Gendai Hanga Center, 1982)

Toshiko UCHIMA
Born 1918, Manchuria, China; lives in New York, New York

Uchima studied drawing and oil painting at Dairen Art Studio in Dairen, Manchuria, and participated in the Manchuria Women's Art Association Annual Exhibitions. She continued her art studies under the tutelage of Ryohei Koisso in Kobe, Japan, and obtained her BA at Kobe Women's College in 1939. During the war, due to the heavy bombing of the Kansai region in Japan, all of the artist's work was destroyed. Sadajiro Kubo has written about some of the artist's early activities as follows: "The name of Toshiko Uchima comes first to my mind as one of a group of fresh, young artists in the Democrate, which was led by EiQ more than 20 years ago. In that residential seminar on art which was held in Karuizawa, Japan in 1952, she was seen among such other artists as EiQ, On Kawara, AY-O and Kei Mori. Her woodblock print was also included, along with the works of other artists in the same group, in the Sphinx, which was a collection of prints published in 1955 based on the poems of Shuzo Takiguchi. Those days, the Democrate was isolated in its efforts to advance the most avant-garde phi-

losophy in Japan" (*Toshiko Uchima*, n.p.).

She moved to New York City with her family in 1960, continuing her artistic activities. Uchima gained considerable success in the field of printmaking, exhibiting frequently in national and international exhibitions. Until 1966 she participated in the annual exhibitions of the Japan Women's Print Association, of which she was a founding member in 1955. Beginning in 1966 the artist focused on a new medium: collage and box assemblage, which has occupied her through the present. *Y.H.*

SELECTED EXHIBITIONS: 1955 Japan Women's Print Association, Tokyo; 1958 International Print Triennial Exhibition, Grenchen, Switzerland; 1960 Invitation Group Show, Art Institute of Chicago; 1963 Michigan State University, East Lansing; 1964 Nihonbashi Gallery, Tokyo; 1965 Four Women's Print Show, Pratt Graphic Art Center, New York; 1976 Shirota Gallery, Tokyo; 1980 Hunterdon Art Center, Clinton, N.J.; 1980 Sarah Lawrence College, Bronxville, N.Y.; 1994 Striped House Museum of Art, Tokyo.

SELECTED COLLECTIONS: Art Institute of Chicago; Brooklyn Museum; Hiroshima Museum of Modern Art; Jane Voorhees Zimmerli Art Museum, Rutgers, The State University of New Jersey, New Brunswick; Striped House Museum of Art, Tokyo.

SELECTED BIBLIOGRAPHY: *Toshiko Uchima 1953–1993* (Tokyo: Striped House Museum of Art, 1994); *Two Person Show by Ansei and Toshiko Uchima* (Tokyo: Striped House Museum of Art, 1994)

C. C. (Chi-Chien) WANG
Born 1907, Suzhou, China; lives in New York, New York

Born to a family that traced its ancestry back to the Song dynasty (960–1279), C. C. Wang was given a classical Chinese home education under the tutelage of his father and then with a private tutor. He studied calligraphy from his father beginning at age four or five and began to study painting in high school. He graduated from Suzhou University and completed a law degree at Suzhou University in Shanghai. While earning this degree, he studied painting with Wu Hu-fan. With his wife and children, Wang immigrated to New York in 1949, earning the status of "the first true

international Chinese artist." In 1950 he began to study Western painting at the Art Students League. Wang was a visiting lecturer at Columbia University in New York (1951–52) and at the University of California at Berkeley (1968–69), and was chairman of the art department at the Chinese University in Hong Kong (1962–64). Wang is also highly regarded as a connoisseur of Chinese painting, and over the years he has assembled an extensive and respected private collection of Chinese painting, calligraphy, and mounted rocks, selections from which have been displayed in museums and galleries.

Since his study with Wu Hu-fan in Shanghai, Wang has invigorated the subtle draftsmanship of his landscapes with the passion and directness of the art he encountered in the United States. While retaining close ties to traditional Chinese landscape painting, Wang's compositions have become bolder and his brushwork more vigorous. Perhaps the most strikingly untraditional element in his works is his use of color, which expands the limited palette of traditional Chinese painting to include more brilliant purples, ochers, blues, and reds. Perhaps representing a culmination of his interest in the concept of abstraction in reference to Chinese art, Wang has recently embarked on creating non-objective works in ink based on calligraphic gestures. *C.G.*

SELECTED EXHIBITIONS: 1966 *The New Chinese Landscape: Six Contemporary Chinese Artists,* American Federation of Arts, New York; 1968 M. H. de Young Memorial Museum, San Francisco; 1971 Los Angeles County Museum of Art; 1972 Honolulu Academy of Arts; 1973 Fogg Art Museum, Harvard University, Cambridge, Mass.; 1976 Chinese Cultural Center, San Francisco; 1983 National Museum of History, Taipei; 1984 Taipei Fine Arts Museum; 1986 Hong Kong Arts Center; 1989 *Six Twentieth Century Chinese Artists,* Los Angeles County Museum of Art.
SELECTED COLLECTIONS: Art Museum, Princeton University, N.J.; Bank of America, San Francisco; Brooklyn Museum; Fogg Art Museum, Harvard University, Cambridge, Mass.; Metropolitan Museum of Art, New York.
SELECTED BIBLIOGRAPHY: Cahill, James, ed. *C. C. Wang: Landscape Paintings* (Seattle: University of Washington Press, 1987); Hsu Hsiao-hu. *Mountains of the Mind: The Landscape Paintings of Wang Chi-ch'ien* (New York and Tokyo: John Weatherhill, Inc., 1970); Hsu Hsiao-hu. "Series of Interviews with C. C. Wang," *The National Palace Museum Monthly* nos. 13–29 (April 1984–August 1985); Katz, Lois, and C. C. Wang. *The Landscapes of C. C. Wang: Mountains of the Mind* (New York: Arthur M. Sackler Foundation, 1977)

WANG Ming
Born 1921, Hebei, China; lives in Washington, D.C.

Wang Ming was born Wu Qing. He completed Normal School in Zhengzhou in 1933 and Yu Ying Middle High School in Beijing in 1939. From 1939 to 1942 he attended National Northwest University in Chen Kuo, Shanxi Province, followed by a four-year service in the Chinese Air Force. From 1947 to 1951 Wang was Chief of the Civil Air Traffic Control Center in Guangzhou (Canton), China, and in Taipei, Taiwan. He began his artistic career in 1951, studying classical Chinese painting with Prince Pu Yu. Later that year, he immigrated to the United States, settling in Washington, D.C. In 1980 he began to devote full time to his painting. He also has taught calligraphy at George Washington University.

In Washington, D.C., Wang discovered an array of art museums exhibiting art from all over the world. In 1961 acrylic paint appeared on the market, and Wang began to utilize this medium because of its flexibility, variable fluidity, and ability to seal paper surfaces. Although he is continually experimenting, Wang has always related his work to the Chinese artistic tradition. Some of his works are highly extended variations on the traditional formats of scrolls or screens. Several of his abstract calligraphic paintings are composed with no specific orientation and may be viewed from various "points of entry." *C.G.*

SELECTED EXHIBITIONS: 1957 Collector's Corner, Washington, D.C.; 1962 Art Society of the International Monetary Fund, Washington, D.C.; 1967 Franz Bader Gallery, Washington, D.C.; 1974 Corcoran Gallery of Art, Washington, D.C.; 1979 Brooklyn Museum; 1982 George Washington University, Washington, D.C.; 1986 Addison/Ripley

Gallery, Washington, D.C.; 1986 National Academy of Sciences, Washington, D.C.; 1990 Tinjin Museum of Fine Art, China; 1994 National Gallery of Art, Beijing.

SELECTED COLLECTIONS: Brooklyn Museum; Corcoran Gallery of Art, Washington, D.C.; National Air and Space Museum, Washington, D.C.; National Museum of American Art, Washington, D.C.; Tinjin Fine Art College, China; Tinjin Museum of Fine Art, China; Woodward Foundation, Washington, D.C.

SELECTED BIBLIOGRAPHY: Baro, Gene. "Wang Ming Show: Stunning," *The Washington Post* (July 30, 1974): B4; Chengnan, Jiang. "Deep, Fervent Love for Homeland—Impressions on Wang Ming, an Overseas Chinese Artist in the United States," *China and World Culture Exchange* 1 (1995): 32; Tannous, David. "Unique Blend of East, West," *Washington Star-News* (August 10, 1974): B4; Wang Ming. "Exhibition Statement," in *Wang Ming* (Beijing: National Gallery of Art, 1994); Zabriskie, George. *Wang Ming, Selected Works from 1962 to 1988* (Washington, D.C.: Franz Bader Gallery, 1988)

Wucius WONG

Born 1936, Taiping, Guangdong, China; lives in Hong Kong and New York, New York

Wucius Wong moved to Hong Kong in 1946, cofounding the Modern Literature and Art Association in 1959 and organizing the first Hong Kong International Salon of Paintings in 1960. From 1958 to 1960 he studied classical Chinese painting with Lui Shou-kwan. He came to the United States in 1961 and began studies at the Columbus College of Art and Design in Ohio. In 1964 he received his BFA and MFA degrees at the Maryland Institute, College of Art, whereupon he returned to Hong Kong. In 1970 he was the recipient of a John D. Rockefeller III Fund Grant, which allowed him to work in New York and travel in the United States. He again returned to Hong Kong in 1972, where he later became Principal Lecturer of the Swire School of Design at Hong Kong Polytechnic. Wong finally moved to the United States in 1986 and became a visiting artist at Lawrence Institute of Technology in Michigan, Memphis College of Art in Tennessee, and St. John's University in Collegeville, Minnesota.

In the late 1950s Wucius Wong conceived of his semiabstract landscape paintings as counterparts to his poetry, in the tradition of the classic Chinese literati artists. From his teacher in Hong Kong, Lui Shou-kwan, Wong learned to use traditional Chinese materials and techniques in increasingly abstract compositions. During the 1960s at the Maryland Institute, College of Art, Wong's direct exposure to Abstract Expressionism and Pop art inspired new compositions that juxtaposed pop images, Chinese characters, and landscape elements. His exposure to oil painting created a new awareness of color. In his subsequent paintings based on the landscape, Wong has synthesized elements from Eastern and Western artistic traditions, combining an affinity with nature and a freedom of individual expression. *C.G.*

SELECTED EXHIBITIONS: 1959 British Council, Hong Kong; 1975 Goethe Institute, Hong Kong; 1979 Hong Kong Museum of Art; 1982 Printmakers Gallery, Taipei; 1987 Minneapolis Institute of Arts; 1988 Hsiung Shih Gallery, Taipei; 1989 Hanart Gallery, New York; 1991 Gallery 456, Chinese-American Arts Council, New York; 1992 Godfrey Far Eastern Art, London; 1994 Hanart T. Z. Gallery, Hong Kong.

SELECTED COLLECTIONS: Chase Manhattan Bank, New York; Hong Kong Museum of Art; Minneapolis Institute of Arts; Museum für Ostasiatische Kunst, Berlin; National Gallery of Victoria, Melbourne; University of Hong Kong; World Bank, Washington, D.C.

SELECTED BIBLIOGRAPHY: Chang Tsong-zung. *Wucius Wong: New Paintings* (Hong Kong: Hanart T. Z. Gallery, 1994); Jacobsen, Robert D. *Mountain Thoughts: Landscape Paintings by Wucius Wong* (Minneapolis: Minneapolis Institute of Arts, 1987); Wong, Wucius. *Principles of Color Design* (New York: Van Nostrand Reinhold, 1987); Wong, Wucius. *Principles of Form and Design* (New York: Van Nostrand Reinhold, 1993); Wong, Wucius. *The Tao of Chinese Landscape Painting, Principles and Methods* (New York: Design Press, 1991)

Noriko YAMAMOTO
Born 1929, Tsing Tao, China; lives in Pound Ridge, New York

Noriko Yamamoto's family moved to Tokyo soon after she was born, resided in Honolulu between 1935 and 1941, and returned to Tokyo in 1941. Her initial art training in calligraphy was given by her father. An interest in oil painting began when she moved to Honolulu, and her serious art studies commenced at the California College of Arts and Crafts (CCAC) in 1952, continuing through 1957. There she acquired her BA and MFA in painting. She continued graduate studies at Mills College in 1958.

Yamamoto was influenced by teachers Leon Goldin, Richard Diebenkorn, Nathan Olivera and Afro. In 1955 she studied under and became close friends with Sabro Hasegawa. Upon Hasegawa's untimely death, Yamamoto was chosen to taken over a class he had been teaching at CCAC. In the late 1950s and early 1960s she worked in a variety of abstract styles, often emphasizing gestural techniques and sometimes incorporating collage. The range of styles of those years—from "action painting," complete with drips and spatters, to reticent geometric arrangements of circles and squares in white on unprimed canvas—demonstrates Yamamoto's searching, spontaneous, and nondoctrinaire approach to imagery. Yamamoto has stated that her gestural abstractions derive in good measure from her intensive early training in calligraphy and her respect for the old Zen masters. *Y.H.*

SELECTED EXHIBITIONS: 1956, 1961 Gump's Gallery, San Francisco; 1957 Oakland Museum, Calif.; 1958 *Contemporary Painters of Japanese Origin in America,* Institute of Contemporary Art, Boston; 1960 M. H. de Young Memorial Museum, San Francisco; 1960 *Young America,* Whitney Museum of American Art, New York; 1969 *Japanese Art of the Sixties,* Roland Gibson Art Gallery, State University College at Potsdam, N.Y.; 1984 Yale University School of Medicine, New Haven, Conn.; 1985 *Japanese Abstractions,* Roland Gibson Art Gallery, State University College at Potsdam, N.Y.; 1991 Mono Art Gallery, Tokyo.
SELECTED COLLECTIONS: Chase Manhattan Bank, New York; Grey Art Gallery and Study Center, New York University, New York; Manhattanville College, New York; Roland Gibson Art Gallery, State University College at Potsdam, N.Y.; Sanwa Bank, New York; Sophia University, Tokyo.
SELECTED BIBLIOGRAPHY: Jenks, Anne L., and Thomas M. Messer. *Contemporary Painters of Japanese Origin in America* (Boston: Institute of Contemporary Art, 1958); *Noriko Yamamoto* (Tokyo: Minami Gallery, 1960); *Noriko Yamamoto* (Tokyo: Mono Art Gallery, 1991); *Young America* (New York: Whitney Museum of American Art, 1960)

Regional Views/Personal Views:

Asian American Culture and Art

Hybrid Worlds, Singular Visions: Hawai'i's Asian American Heritage and Art

by Marcia Morse

In recent years the people of Hawai'i have observed important anniversaries in the life of the state.[1] The year 1985 marked the centennial of the first Japanese contract laborers in the islands; 1989 was the bicentennial of the arrival of the first Chinese. More recently arrived groups, including Filipinos and Koreans, are already marking several decades, while the newest immigrants from Southeast Asia and Pacific Island cultures continue to add to the cultural diversity that is a hallmark of Hawai'i. The celebratory nature of such observances often tends to mask the more problematic aspects of Hawaiian history while at the same time reinforcing a deeply held belief in Hawai'i as a setting for productive forms of social accommodation and cultural pluralism. This belief persists even in the context of current debate about the sovereignty of Hawai'i's indigenous population and even on the occasions of the fiftieth anniversaries of the bombing of Hiroshima and Nagasaki, and the ending of World War II.

What is learned from a multicultural society, in new ways, with new inflections, is the nature of transcultural identity as it is shaped for both groups and individuals. Learning is a task for each person who seeks to integrate and reconcile what may be divergent imperatives involving everything from the nuances of social practice to a comprehensive world-view—or who most simply needs to live and work in a hybrid world. Learning is also a task for the artist, who may not only draw upon, comment upon this experience, but who may shape expressive or structural metaphors that become a language of knowing for others. It is in this context that Hawai'i as the locus of a particular, perhaps unique cultural climate for artmaking gains distinction. What we know of basic demographics and history can also inform our understanding of the more elusive considerations of the shaping of individual lives and the development of personal vision and style.

From 1940 to 1970 Hawai'i experienced major social and political changes, many of which were heightened or caused by its multicultural complexion. The war years, from the bombing of Pearl Harbor on December 7, 1941, to the surrender of Japan in the late summer of 1945, had a profound impact on a community that was then one-third Japanese. Expressions of Asian culture were muted or suppressed during this period, and manifestations of racist paranoia lamentably surfaced. However, it also became clear that Hawai'i's Japanese, many of them *nisei* (second-generation Americans), were able to declare their political allegiance to the United States while quietly adhering to cultural traditions that continued to provide stability and continuity. The postwar period saw the consolidation of Japanese American influence in the spheres of state politics and public education.

Hawai'i's attainment of statehood in 1959 was followed by a period of civic and cultural coming-of-age. In some instances, Hawai'i would be a follower, responding to trends generated in the continental United States. In some instances, Hawai'i would be a leader. In 1965 the State Foundation on Culture and the Arts was established as the official arts agency of the state. In 1967 Hawai'i became the first state to enact an "Art in State Buildings Law," generating substantial revenues for the commission and purchase of works of art. This legislation and the State Foundation, which

administers these and other funds, have played a crucial role in the legitimation and vitality of artmaking in the islands. These events, significant in the context of the state's social and political history, also contributed to the gradual shaping of Hawai'i's cultural profile, providing occasion for a more conscious and self-reflective assessment of what it means to live in an environment of multiple minorities, each of which might dominate a particular arena, but none of which would speak for the whole.

Against this broad-brush panorama we may view the lives and work of the artists included in this exhibition. Finding connections between a larger sociocultural context and individuals moving within it is at best a speculative enterprise—the more so, perhaps, when considering that artists live and work in ways that are often both solitary and against the grain. In addressing the question of the influence of Asian aesthetics and culture on Asian American artists of Hawai'i, essential clues are provided both by the artists' own reflections, by critical and aesthetic analyses of their work, and by the ambience within which it was created.

During the postwar period Hawai'i lacked the type of infrastructure considered essential for a flourishing art world. Local artists had few collectors and patrons, only one gallery (run by artist Takeo Gima and family) for exhibitions, and little in the way of critical writing. While the Honolulu Academy of Arts and the University of Hawai'i provided opportunities for formal schooling, more often these artists sought training at art schools and universities on the mainland. Many shared the perception that one had to leave the islands to be recognized as an artist. This was indeed the case for Isami Doi (1903–1965), the first artist from Hawai'i to receive international recognition and who served as mentor and friend to several Japanese American artists in the next generation. Satoru Abe (b. 1926), Sueko M. Kimura (b. 1912), Tetsuo Ochikubo (1923–1975), Tadashi Sato (b. 1923), and Toshiko Takaezu (b. 1922) were all in-house expatriates for significant periods of time. The East-West encounters of culture, which were so ingrained in Hawai'i as to be natural or normative, were revisited and reassessed as these artists came to terms not only with their own heritage but with the newer legacies of modernism to be explored in New York.

Several Japanese American artists also made trips to Japan as part of a conscious quest to make or restore connections to traditional culture. After two years at the Art Students League in New York, Abe went to Japan to seek a cultural identity and to immerse himself in an artistic environment. Kimura visited Japan as a child and returned for a year later in her life. Sato's travel reinforced the early discipline of calligraphy training at Japanese language school, while Takaezu was intent on understanding more fully the ceramic tradition of Japan that validated the medium as an art form.[2]

These artists were thus sorting and distilling information about and experience with Asian cultural tradition on three distinct though often interwoven levels. The first was tradition as known through the Japanese experience in Hawai'i, transmitted, nurtured, and kept intact by early plantation laborers and sharpened by the immigrant experience. The second was tradition as found at the source, in Japan itself, most often out of a general yearning for root connections rather than, as was the case with Takaezu, a specific aesthetic quest. The third was tradition as it provided an essential piece of the underpinning of modernism, ranging in such manifestations from the "japonisme" of the late nineteenth and early twentieth centuries to the influences on Pacific Northwest artists, such as Mark Tobey, to the contributions made to the informed gestural language of Abstract Expressionism. The years away from Hawai'i were thus significant to these artists not only for their personal growth and attainment of status, but for the intellectual appreciation of a cultural matrix that had been perceived initially in a more intuitive way.

A rather different paradigm of cultural provenance pertains in the case of Tseng Yuho. Born in Beijing in 1924, she came to Hawai'i in 1949 and has pursued dual professions of scholar and painter. Though European-style academies were active in China, Tseng was trained early in classical Chinese brush painting and mounting techniques. Her move to Hawai'i led to the development of a stylistic and aesthetic innovation that the artist calls *dsui* painting, literally "patchwork" painting, in which she creates a base collage of paper or

metal leaf fragments overlaid with brush-work.[3] Tseng's extended project has engaged ongoing research on calligraphy and the practice of that art as the foundation for contemporary work.

Who one is may become what one knows; who one is may also become what one does: the emergence of the person, the individual creative vision from the fluid boundaries of collective culture, is a wondrous and richly variable process. Where one is placed also has a powerful impact on that process, and Hawai'i as a place both ideal and actual has influenced the production of its artists on multiple levels.

Hybrid sensibility: Much has been written about Hawai'i's distinctive social chemistry and cultural pluralism. What is germane here is the development of a model of exchange that both validates the status and integrity of individual ethnic and cultural groups and also makes possible selective borrowing of or participation in diverse resources. In this context, Hawai'i's Asian American artists have drawn on the strength of their own cultural traditions (often differently learned, understood, or reinvented) even as they engage the issues of contemporary artmaking, without undue risk of aggressive assimilation.

Environmental matrix: One way or another, anyone living in the islands must come to terms with nature. The abundance and fragility, the power and delicacy of mountain, sky, ocean, flora, and fauna provide inspiration and insight. Hawai'i's environment was familiar to those who came from the other side of the Pacific to labor in its fields. The island has proved to be a remarkably malleable subject for artists, treated in a variety of ways ranging from unabashed romanticism to more ascetic distillations.

Metaphysics of place: An important part of the legacy of native Hawaiian culture has been the reverential attitude with which the natural environment is regarded. Nature is revered as a subject of highest importance in the painting traditions of Asia. It serves not only to position the human subject but becomes a vehicle for understanding large truths about the order of things. The islands thus invite a sense of affinity to nature for Asian American artists, both physically and metaphysically, again validating a spiritual dimension of art-

making that has generally been less clearly and comfortably articulated in Western art.

Language as artifact: Language is one of the strongest tools of cultural continuity and integrity and rests at the center of a cluster of important formal and conceptual issues for Asian American artists. The existence of several Chinese and Japanese language schools in Hawai'i and their reinstitution after the war are testament to the value placed on this tool. Learned in these schools, calligraphy, itself the result of pictographic abstraction, combines the imperatives of expressive utility and aesthetic discipline. In one context, calligraphic energy may serve to give form to meaning as codified in language; in another context, that energy may be more idiosyncratically directed and emerge as the track of individual will. The importance of the nuanced line that is so central to the art of calligraphy also informs the work of these artists.

The visible and the invisible: The seen and the unseen, the spoken and the unspoken, the implicit and the explicit—a sense of duality suffuses the work of art that is grounded in its own physicality while speaking of other things. One notion that has both cosmological as well as aesthetic implications is what artist Satoru Abe calls "dealing with the void."[4] Part of this is confronting the indeterminate spatiality of the picture plane, engaging in markmaking that allows an image or gesture to emerge from the "everywhere-and-nowhere" place of a sheet of white paper or an expanse of canvas. Abe as sculptor must also consider the implications of negative space within the overall contours of his work, while Takaezu often engages a strategy of containment in her closed columns and ovoid forms.

Another aspect of dealing with the void is again a metaphysical one, negotiating the boundaries of the ego or the self, acting with visible assertion in one field while at the same time understanding oneself to be immersed in an infinitely larger one.

Asian American artists of Hawai'i have made substantial contributions to the language of abstraction. For some, abstraction may ultimately be grounded in the observed world but separated from it through a process of distillation, getting to the heart of things. For others, abstraction is a tool to reveal things that otherwise elude literal representation—the eloquent mark, the expressive gesture, the sinuous or broken line, the energized track of the hand that follows the moment of contemplation. These qualities are found in the traditions of Asian art and are found again in the more individualized manifestations of twentieth-century abstract art.

Personalizing the Abstract: Asian American Artists in Seattle

by Kazuko Nakane

Asian American artists have played an integral and significant role in the development of Seattle's art history since the early twentieth century. From 1914 to 1920, the Seattle Fine Arts Society (founded in 1906) hosted one-person shows by Japanese American oil painter Yasushi Tanaka (1886–1941). The Seattle Camera Club was established in 1924 by a group of Japanese American photographers and included a few Caucasian members. They published the bilingual magazine *Notan* (1925-29), hosted the International Pictorial Photography Show, and invited noted speakers to their meetings, such as Mark Tobey. One member of the group, Frank Kunishige (1878–1960), who came to the United States in 1895, created evocative, refined photographs according to European aesthetics. Dr. Kyo Koike (1877–1947), on the other hand, created a poetic effect of inner expression more closely related to Asian aesthetics (for example, the brush painting tradition in East Asia of embodying a personal mood through landscape). Koike, arriving in Seattle in 1917, was inspired by *Composition,* a book by Arthur Wesley Dow, a leading artist in the Japonisme and Arts and Crafts movements. "Say less, and feel more," Koike said.[1]

In the 1930s Japanese American artists painted from the familiar surroundings of Seattle. Kenjiro Nomura (1896–1956), who came to the United States around 1906, began art lessons with Dutch American painter, Fokko Tadama at the age of sixteen. Since Nomura had a sign-painting business with another painter, Kamekichi Tokita (1897–1948), he could only paint on Sundays. In fact, these painters, including Takuichi Fujii, whose work regularly appeared in the Northwest

Annual exhibitions, were called "Sunday painters." These three painters were included in the publication *Group of Twelve* (1937) with other noted local artists. In 1932 Nomura won a Katherine B. Baker Purchase Prize with his painting *Street*. The next year, he had a one-person show at the Seattle Art Museum, which had just opened in a contemporary Art Deco style building. The museum's founder, Dr. Richard Fuller, both a collector of Asian art and a supporter of local art, hired a painter, Kenneth Callahan, to be curator of the museum. Callahan remained in that capacity until 1953. The Northwest Annual juried show, beginning in 1914, continued to be hosted by the Seattle Art Museum, which was the center of the local art scene.

For Pacific Northwest art, the 1930s was a formative period for American modern art with diverse influences. It was the era of the Great Depression and the New Deal, during which the government supported artists through the Federal Arts Projects. American artists saw the major Picasso and Surrealism exhibitions in the United States. Many traveled to Europe, Asia, and Mexico or studied the art of the Northwest Coast Indians in their search for a new expression of modern art. Art was a meaningful mission, the number of artists sharing these exciting years was still small and there was a sense of community among them. These artists, such as Mark Tobey, Guy Anderson, and Morris Graves, became closely associated with the region and shared their experience with Asian American artists.

Mark Tobey, before he arrived in Seattle in 1922, was already searching for ways to break free from the Renaissance perspective. A

member of the Baha'i faith since 1918, Tobey maintained a belief in humanity and the oneness of mankind. Pursuing his interest in line, he did fashion illustration in Chicago and New York, and took brush lessons from Teng Kuei, a student from China studying at the University of Washington. In 1925, after teaching art at the Cornish School of Music (founded in 1914), he left for Europe and the Near East, where he became fascinated with Arabic and Persian script. He accepted a resident artist position at Dartington Hall in Devonshire, England, from 1931 to 1938. The multiplicity of Tobey's styles in his trial-and-error search for modern art during the 1930s and 1940s was simply phenomenal. In 1934, when he visited China with Bernard Leach, Tobey contacted Teng Kuei, who again taught him calligraphy. In the following year, he painted *Broadway Norm* (fig. 189) with the all-over white lines for which he became renowned. The invention of the term "white writing," along with his one-person show in New York in 1944, crystallized his universal reputation. Tobey's new form of abstraction created ripples of sensation no artist in the Northwest could ignore.

Guy Anderson was a student of Eustace Ziegler in Seattle. In 1926 he received a scholarship to study at the Tiffany Estate on Long Island and saw paintings of the old masters—Rembrandt, Titian, Rubens, and El Greco—at the Metropolitan Museum of Art. Anderson passed through stages of Post-Impressionism and Cubism in his search for abstraction, reaching his mature style around 1960. His style incorporated bold linear images framed on a rectangular surface: the aesthetics of Northwest Coast Indian art. His limited earthy colors and strong palette, fused into a singular wide brushstroke, were continued and developed through his interest in the male figure. Like other artists of the Northwest, he was inspired to create a universal language by studying the Far East and other ancient civilizations and religions.

Morris Graves borrowed Anderson's palette in his satirical surrealist and Post-Impressionist still lifes. But Graves's future lay in his drawing and interest in the Asia he had visited in 1928 and 1930. By the late 1930s, Graves was a member of a group of like-minded friends: John Cage, who began teaching at the Cornish School of Music in 1937, shared Graves's interest in Dada and the East; Nancy Wilson Ross shared an interest in Eastern religions. Graves also picked up "white writing" from Tobey. A self-taught artist, Graves was accepted by the Museum of Modern Art, New York, in 1942, and a year later he had his own show at the Phillips Collection in Washington, D.C. The founding director, Duncan Phillips, called him "a citizen of the inner world of Eastern mysticism" (fig. 190).

In the 1930s the next generation of Asian American artists was emerging. George Tsutakawa was born in Seattle but educated in Japan, where he was exposed to European modern art as well as to traditional Japanese art. He returned to Seattle to attend Broadway High School, where he learned linoleum block and woodcut printing from Hannah Jones and Matilda Piper. There he met Morris Graves as well as a number of Asian American artists. Fay Chong (1912–1973), who was born near Guangzhou (Canton) and moved to Seattle in 1920, graduated from Broadway High School in 1933. Andrew Chinn (1915–1995), who was born in Seattle but educated in China, came back to Seattle in 1933 and also attended Broadway High School. Being bicultural, bilingual, and older than other students, Tsutakawa, Chong, and Chinn found common ground, and their interest in art further bound them together.

In 1933 young Chinese American artists Fay Chong, Andrew Chinn, Howard Eng, and Lawrence Chinn formed a loosely organized group called the Chinese Art Club, which held an exhibit at the new Chinese school.[2] Chong showed a block print, and Andrew Chinn exhibited a Chinese watercolor of a Seattle scene. The club was a place to socialize and to draw from the model outside of a classroom situation. Graves and Anderson often came by or accompanied them on sketching expeditions. George Tsutakawa was the one of the group to receive a formal art education at the University of Washington. He studied sculpture and had the opportunity to take classes with Alexander Archipenko, who visited the campus during the summers of 1935 and 1936. Tsutakawa had a broad understanding of art history. His painting in the 1940s was already highly abstracted, with flowing curvilinear lines and, in the 1950s, by dissected color blocks. He was interpreting European art in his work.

189. Mark Tobey. *Broadway Norm*. 1935. Tempera, 13¼ x 9¼". Collection of Carol Ely Harper, Seattle, Courtesy of Yoshii Gallery, New York

190. Morris Graves. *Waning Moon: No. 2*. 1943. Gouache on paper, 26½ x 30½". The Seattle Art Museum, Eugene Fuller Memorial Collection

191. Mark Tobey. *Space Ritual No. 1*. 1957. *Sumi* on paper, 21½ x 29¾". The Seattle Art Museum, Eugene Fuller Memorial Collection

The Federal Art Project had a wide-ranging effect on Asian American artists working in the Pacific Northwest. Under the Federal Art Project, the Art Center in Spokane opened in 1938. Carl Morris, a painter from California, led the center along with Hilda Grossman (a sculptor from New York who married Morris in 1940 upon leaving the center), Guy Anderson, and other artists. They communicated with Washington State University in Pullman, where Clyfford Still was teaching. Still was beginning to experiment with his own idioms of abstraction. Fay Chong, whose fiancée was in Spokane, also visited this stimulating environment. Beginning in 1936, Bruce Inverarity led the Federal Art Project in Seattle at Bailey Gatzert School, where Fay Chong submitted twenty-five prints out of twenty-seven he made and Andrew Chinn submitted two or three watercolors per week. In Rock Springs, Wyoming, Japanese artist Paul Horiuchi met Vincent Campanella, who was teaching for the Federal Art Project. Horiuchi had studied *sumi* brush painting for three years at Yamanashi Prefecture before coming to the United States at the age of sixteen. Through Campanella, he was trained in both oil- and water-based pigments and in Western composition.

Mark Tobey's love of people and city life was expressed in his 1941 figure sketches of Seattle's Pike Place Market. It was after World War II, however, that Tobey's personal friendships with Asian American artists developed. Most of the Japanese American artists on the West Coast were sent to internment camps during the war. Nomura and Tokita were sent to the camp at Minidoka, Idaho, where they continued to paint and document the internment experience. Tokita died shortly after returning to Seattle. Betty Bowen, an art patron and a friend of Tobey's, remembered that it was some time at the end of the 1940s that Tobey first met Tamotsu Takizaki (1882–1962).[3] Takizaki owned an antique store and was known for his mastery of kendo (Japanese swordsmanship) and his knowledge of Zen philosophy. Tobey and Takizaki discussed not only the matter of Zen, but also a serious approach to art.

In the early 1940s Tobey often visited Carl and Hilda Morris, who were living in Seattle. Although she was primarily searching for self-expression through sculpture, Hilda Morris

had been interested in Asian ideograms since her college days. In her later life, when she was no longer creating bronze sculpture, she concentrated on abstract *sumi* painting. During this time, Tobey was inspired by a book on Zen by Daisetz Suzuki and searched for its meaning through communication with Takizaki. When Horiuchi and Tsutakawa offered Tobey *sumi* ink and brushes, he found himself totally captivated and did spontaneous *sumi* abstractions intensively through the winter of 1956–57 (fig. 191). Though Tobey never returned to *sumi*, his interest in East Asian art spurred Asian American artists to be more aware of their own heritage.

In the 1950s Kenjiro Nomura continued to paint with the encouragement of Horiuchi and began to explore abstraction (see fig. 64). Horiuchi had moved to Seattle in 1946, having married Bernadette Suda in 1935. Soon after he settled in Seattle, he was introduced to Mark Tobey through Takizaki, who was Bernadette's guardian and had acted as a go-between for their marriage. Bernadette was a devoted Christian and Horiuchi took the baptismal name of Paul, although his birth name was Chikamasa. He said, "I took the name in honor of Paul Cézanne and Pablo Picasso, both of whom I admired very much."[4] For about ten years after moving to Seattle, Horiuchi painted mostly the slopes and contours of cityscapes in the Pacific Northwest.

The Zoe Dusanne Gallery in Seattle hosted a Japanese American art show in 1954; John Matsudaira (born 1922 in Seattle) was the youngest of the group. By 1958, inspired by Tobey, Matsudaira had moved from painting landscapes and nostalgic figures of children to portraying the city through linear abstraction. Fay Chong met Tobey in 1937, and in the late 1930s visited his private residence for a critique. Chong was known for his linoleum block prints, but around 1940 he began to do watercolors on rice paper.[5] He earned a master's degree in art education at the University of Washington after teaching watercolor and technical drawing. By the late 1950s, his familiar cityscape in Chinese watercolor began to shed its full-bodied dimensionality for rhythmic, nonmodulated linear patterns, although he continued to paint watercolors of the surrounding mountains and fields, trees and houses in Western perspective.

It took Horiuchi much trial and error before finding inspiration in a Chinese bulletin board in Chinatown. This led him to create his own renowned style in abstract rice paper collage in 1956. Like Tobey, Horiuchi did not paint pure abstraction. He often painted when he was deeply moved by music or a performance. His abstract collage, *The Wall*, 1960 (Seattle Art Museum Collection), was inspired by a drama based on John Hersey's novel of the destruction of Warsaw's Jews under the Nazis. *Echoes of the Temple Bell*, 1959 (see fig. 62), another abstract collage, is based on his trip to Kyoto, Japan, the previous year. A festival series in casein, one of his many series of abstractions in the late 1950s, has a dancing movement in its color harmonies and black calligraphic lines. In 1959 Horiuchi received a Ford Foundation Purchase Prize for *Fault* (Main branch Seattle Public Library, City of Seattle Collection). In *Fault*, light seeps through collaged and painted rocks set in slow movement by the wide brushstrokes. Horiuchi's work had drawn close to Japanese aesthetics by the mid-1960s, particularly to the elegance of the Heian court of the tenth through twelfth centuries; directness of experience was replaced with color harmony and balance.

George Tsutakawa taught at the University of Washington from 1947 to 1976. Upon returning from a trip to Japan in 1956, he made *Obos* (see figs. 120–22), his first series of wooden sculptures: a synthesis of nature and abstraction. He began to paint with the *sumi* brush around 1960. It was also in 1960 that Mark Tobey left for Basel, Switzerland. In 1967 Tsutakawa found the medium that would occupy more than twenty years of his creativity when he made the bronze sculpture fountain for the downtown Seattle Public Library with engineer Jack Uchida. The fountain retained the stability in delicate balance he had found in the *Obos*. Abstract curved forms welded from dark bronze sheets created an open structure that was completed by the sound, light, and calligraphic movement of the flowing water.

Seattle-born Frank Okada's fascination with painting started at the studio of Leon Derbyshire, who was fond of nineteenth-century French academic painting. There, Okada learned to build color composition. He was exposed to the Abstract Expressionist movement when he visited New York in 1954, the year he began his study at Cranbrook Academy of Art in Michigan. After he received fellowships to study in New York (1957–58) and in Japan (1959–60), Okada began doing abstract *sumi* painting, which Tobey praised (fig. 192). In the 1960s, his oil painting went through the same transformation as with ink drawing. By the time he visited Paris on a Guggenheim Fellowship (1966–67), the spontaneity of his earlier linear ink drawings had changed. There was now a subdued sense of motion, of timelessness; the jazzy colors and movement of his oil paintings quieted into textured color compositions. In 1968 Okada shared a studio with William Ivey, who had studied at the California Academy of Fine Arts with Mark Rothko and Clyfford Still in the late 1940s.

The artists discussed here represent only a few of the Asian American artists from Seattle whose work is connected to the East Asian calligraphic tradition and to contemporary Western abstract trends. As it happened in many other places, the regional qualities of the art in Seattle and the Pacific Northwest eventually became increasingly affected by contemporary national and international trends. This brief account has focused on regional achievements that in general occurred before these new art movements gradually took over the Seattle area art scene, a phenomenon that might be seen as starting with the exhibition of world art at the 1962 Seattle World's Fair and continuing through the early 1970s.

192. Frank Okada. *Untitled*. 1960. Ink on paper, 42 x 36". Collection unknown

From Enemy Alien to Zen Master: Japanese American Identity in California During the Postwar Period

by Karin Higa

In the period immediately following World War II, a Japanese American identity emerged that was marked by complexity and contradiction. That the war radically changed the tenor of all aspects of American life is not debated. But for Japanese Americans, the period between 1941 and 1946 represented a defining moment for the community's ideas about identity, experience, and expressions of national origin. This brief essay will trace some of the key elements in the identification and reception of Japanese Americans, Japanese American culture, and a relationship to the concept of Japan.[1] By examining some of the political and social forces operative in California in the immediate postwar period, it will be possible to suggest the fluidity of group identity and its expressions in the realm of culture. In particular, it is interesting to note the prominent role of *kibei* (American born but raised in Japan) and immigrant artists in the transmission of Japanese cultural and aesthetic beliefs in this period.

By 1946 most of the Japanese Americans incarcerated for the duration of the war were released.[2] The war did more than disrupt daily life for the 120,000 Japanese Americans living on the West Coast; it challenged the very foundations of their American identity. Since the incarceration was based solely on ethnicity and not behavior, legal status as citizens and acculturation in American values meant little. Fundamentally, Japanese Americans were singled out because they were thought to embody the spirit and sensibility of a Japanese person and, by extension, represent the interests of Japan. The fact that nearly two-thirds of those incarcerated were American citizens and that most had not

even visited Japan did little to change this perception. As Lt. General John L. Dewitt, Commander of the Western Defense Zone, summarized in early 1942, "A Jap's a Jap. They are a dangerous element . . . It makes no difference whether he is an American citizen. . . . You can't change him by giving him a piece of paper."[3]

Though recent scholarship has uncovered a greater number of "resisters" and critics of the incarceration than had been previously recognized, the general representation of Japanese Americans during this period is characterized by articulations of a hyper-American identity. This expression must be seen as a strategic one. Within hours of the bombing of Pearl Harbor, the FBI began rounding up selected Japanese Americans. In addition to leaders of Japanese American businesses and community organizations, practitioners of Japanese martial arts, Japanese language teachers, and others with identifiable connections to Japanese cultural activities were labeled as dangerous to American security. In the days and weeks following Pearl Harbor, many Japanese American families quickly moved to eliminate any physical representation connected to Japan; letters and photographs were burned, mementos and objects were carefully and purposefully discarded. Given the FBI's actions, it is not surprising that Japanese Americans would distance themselves from any overt ties to Japan and Japanese culture.

The *nisei*, the first American-born generation of Japanese Americans, vigorously voiced their opposition to Japanese aggression in the Pacific. The Japanese American Citizens League (JACL), a national organization

founded in the late 1920s by *nisei*, took an aggressively pro-American stance, encouraging the *nisei* to accept the incarceration as a way of "proving" their loyalty. Japanese American loyalty was further evidenced by the formation, in 1942, of the 100th Battalion in Hawaii, an all-*nisei* unit, and the subsequent organization of the 442nd Regimental Combat Team, composed largely of *nisei* drafted from the confines of the internment camps. Although the JACL was not above criticism from within the community during this period, it remained a powerful force in defining Japanese American identity both within the community itself and to the greater American public.

The Japanese American expression of an American identity was underscored by the representation and interpretation of the internment camps by War Relocation Authority (WRA) photographic documenters, as well as through private agencies such as the American Friends Service Committee (AFSC), which advocated on behalf of the rights of the Japanese Americans.[4] The WRA was the civilian authority established in 1942 to administer the incarceration. Presumably on opposing sides, the WRA and agencies like the AFSC benefited from representing the camps as civilized outposts of American loyalty. For the WRA, photographs of well-fed, clothed, hardworking, and "happy" Japanese Americans suggested a visual representation far from popular conceptions of prison camps and individuals held under duress. Critics of the internment used these same images to demonstrate the unfair abrogation of the rights of a community clearly depicted as cooperative and loyal.

These images differed drastically from the way Japanese Americans were depicted before the war. The onset of Japanese immigration in the 1880s was immediately met with hostility and anti-Asian sentiment. By the 1910s, the anti-Japanese movement had enough popular support to pass legislation that limited the rights of Japanese immigrants. In 1913 California enacted the first of several Alien Land Laws that prevented "aliens ineligible for citizenship" from owning land. Japanese immigrants, like many other non-European immigrants, were restricted from becoming naturalized citizens. Takao Ozawa's 1922 challenge to the discriminatory laws ended in the Supreme Court's decisive rejection of Japanese attempts at naturalization. The ruling stated that the original framers of the Constitution intended "to confer the privilege of citizenship upon that class of persons whom the fathers knew as white, and to deny it to all who could not be so classified."[5] In 1924 the anti-Japanese movement culminated in the passage of the comprehensive Immigration Act, which virtually halted further immigration from Asia, with a primary emphasis on limiting Japanese immigration.[6] California-based organizations like the Asiatic Exclusion League and the Native Sons and Daughters of the Golden West characterized the Japanese immigrant as a "Yellow Peril" to be feared and stopped at all costs.

Despite the pervasiveness of such negative depictions, it is necessary to be cautious in proclaiming all representations of Japanese as negative. In specific instances and locales Japanese Americans were afforded more generous treatment, especially in the realm of culture. The articles and reviews of the *issei*

(first-generation) artist Chiura Obata that appeared in the northern California press in the 1920s and 1930s are one such example.[7] After a lengthy review praising the artistic accomplishments of Obata, an *Oakland Tribune* writer commented on the contributions of Obata's wife, a practitioner of *ikebana,* and suggested the greater sophistication of Japanese aesthetics: "Mrs. Obata made two flower arrangements after the manner of the Japanese. Then, after the flowers had been arranged and the vases placed just so to fill a definite space, along came an American [who] plunked his derby down beside one of the vases. And that illustrates the difference between American and Japanese understanding and appreciation of art."[8]

The return and resettlement of Japanese Americans to normal living conditions after the war have yet to receive much scholarly attention. However, the logistical feat of organizing tens of thousands to return home should be obvious. While the WRA encouraged early resettlement into the Midwest and eastern states by single *nisei* as early as 1943, the collective reintegration of Japanese Americans after the war had differing effects. Primarily elderly *issei* and families, many without financial resources, remained in the camps until the end of 1945. After hastily leaving their belongings and communities in the spring of 1942, they cautiously returned under entirely different circumstances. The projected fear of a wartime Japanese invasion never materialized. The 100th/442nd returned home as decorated war heroes after battling on the European front. The linguistic skills of *nisei* in the Military Intelligence Service were of continued use in the occupation of Japan. Most important, the massive Japanese American "fifth column" was admitted to be a fabrication born of wartime hysteria. The return of formerly incarcerated Japanese Americans revealed a community devastated by the internment and that was hardly a serious social or economic threat. Throughout the late 1940 and 1950s, Japanese Americans put the experiences of the war years behind them, concentrating on reestablishing their livelihoods and their communities.

Although Japanese Americans were reintegrated into American society, Japanese immigration remained restricted in the postwar period. The McCarran-Walter Act of 1952 set new quotas on the number of immigrants allowed into the United States, but the entirety of Asia was granted an amount of less than three thousand immigrants per year.[9] From 1952 until 1965, nearly one-third of all new Asian immigrants settled in California.[10] The overhaul of the Immigration Act in 1965 was of greater significance for Asian migrants because it eliminated the national origins component of immigration legislation.[11] The act received support from a variety of sectors. The relative economic prosperity in the United States, the push for demonstrations of American democracy in the face of Cold War international relations, and the low domestic unemployment rate guaranteed widespread acceptance. Furthermore, the largest group of immigrants from 1952 to 1965 were Japanese "war brides." They made up 80 percent of all Japanese immigration during the 1950s.[12] By 1965, the Japanese American community was the only Asian group where women outnumbered men.[13] Coupled with the weak international status of Occupied Japan, the American conception of Japanese and Japanese Americans differed dramatically from the prewar and World War II periods. Japanese Americans ceased to be enemy aliens. The expression of Japanese culture was received in a cultural climate that valued different perspectives and viewpoints. It was also a time when the perceived Japanese threat to American social and cultural values was at its weakest.

One example of the positive reception of Japanese culture can be found in the widespread interest in Zen. By the time that *Time* magazine reported in 1958 that "Zen Buddhism is growing more chic by the minute,"[14] the popularization of Zen had reached dramatic heights in the American cultural arena. The individuals most associated with Zen's popularity included Dr. Daisetz T. Suzuki, who moved to the United States and lectured at Columbia University in the late 1950s, and the philosopher and author Alan W. Watts. In explaining the extraordinary interest in Zen, Watts writes in his preface to *The Way of Zen* (1957) that "it is connected, no doubt, with the prevalent enthusiasm for Japanese culture which is one of the constructive results of the late war."[15] However, Zen's appeal was not limited to the intellectual elite. *Mademoiselle* magazine published an article

titled "What Is Zen?" to help its young readers master the philosophy that had entered "cocktail party conversation" and that was "exerting a curious influence on a number of writers, painters, musicians and students in this country."[16] It is interesting to note that the article was illustrated with images of Japanese art, as well as with works by Mark Tobey and Morris Graves.

Asian Traditions/Modern Expressions demonstrates that Asian American artists were central to an investigation of abstraction in American painting. While it is necessary to consider the cultural climate that enabled the positive reception of these artists, it is also critical to examine how these artists identified themselves at different points in their lives and, more specifically, to investigate the particular circumstances of their immigration and acculturation. The most important of the abstract painters of Japanese ancestry in California—Matsumi Kanemitsu, James Suzuki, and Sabro Hasegawa—were either *kibei* or Japanese who migrated after World War II. Since the *kibei* traditionally occupied a position within the margins of the Japanese American community, the postwar acceptance of Japanese aesthetic practices proved to be an appropriate place for asserting a distinctly Japanese identity. The personal history of Matsumi Kanemitsu is illuminating. Though Kanemitsu was born in Ogden, Utah, in 1922, he lived in Japan for fourteen of his first eighteen years. Like many *kibei,* when Kanemitsu returned to the United States he recalled, "I was ashamed of my Japanese accent and poor English. . . . I was kind of a scapegoat for other Japanese Americans."[17] However, in the postwar period, Kanemitsu came to be seen as an important link to Japan and Japanese aesthetics.[18]

James Suzuki did not immigrate to the United States until after World War II. Although he eventually settled in California, his formative years as an artist in this country were spent on the East Coast, in New York and Washington, D.C., and his experiences as a Japanese in America would have been dramatically different from Japanese Americans who lived in the United States before and during the war. Sabro Hasegawa, though identified by others as Japanese American, actually lived a short time in this country. Aside from the duration of his lecture tours, he spent little time as a U.S. resident. Arguably, he might be characterized as a Japanese artist who happened to reside in the United States at the time of his death. Nevertheless, Hasegawa was closely connected to the popularization of Zen in America through his friendship with Watts, providing Watts with aesthetic assistance during his preparation of *The Way of Zen.*[19]

This essay does not mean to imply that the positive reception of Japanese and Japanese American abstract artists in the postwar period merely reflects an acceptance of Japanese cultural expression. Such an assertion would be a useless simplification of complex factors. However, it is interesting to examine how the Japanese American community and postwar Japanese immigrants emphasized specific aspects of their cultural heritage to create their own identity. This identity differed from both the insidious prewar "Yellow Peril" label applied to Japanese Americans and from the wholesale adoption of assimilated American expressions during the war years. This requires us to consider individual and group identity as fluid and strategically implemented. Here the use of the word "strategic" should not be interpreted cynically. Rather, individual agency in identity formation is a critical way of conceptualizing the dynamic interplay between external forces of identification and individual response. It suggests the tremendous fluidity of ethnic and community identity, the significance of varying external forces upon such identities, and the importance of examining such identities within specific cultural contexts.

A Brief Cultural History of the Chinese in California: From Early Beginnings to the 1970s

by Lorraine Dong and Marlon K. Hom

The Early Immigrants and Their Cultural Activities

For centuries the Chinese living along the southeastern coast of China have been known as expert seafarers whose extensive oceanic adventures reached the various regions of southeastern Asia and western Africa. These Cantonese Chinese, whose homes were already devastated by wars, natural disasters, and poverty, were especially attracted to California when news of the 1848 discovery of gold reached their villages. Thousands of workers were recruited as they began to arrive in America. During the first two decades of statehood, approximately 10 percent of California's census population was Chinese. The newly arrived Chinese participated in building California into a formidable region of economic growth, working in mines, fisheries, agricultural land reclamation, farming, and in building the western section of the transcontinental railroad from Sacramento, California, to Promontory Point, Utah. In urban centers, they participated in light industries such as cigar manufacturing, shoemaking, and shirtmaking. They were also active in service industries, working as laundrymen, restaurant workers, and domestics.

Upon arrival, Cantonese immigrants immediately established a variety of well-structured mutual aid organizations that were based on birthplace, geographical origin, and kinship lineage. San Francisco functioned as their headquarters. Along the walls and pillars of their organization halls were prominent displays of artistic and literary works such as poetry and couplet writings in the traditional art of calligraphy. There were carvings, paintings, and embroideries of deities, and various apparatus made by skilled craftsmen and artisans in temples and shrines.

By the early 1880s well-publicized literary clubs were established within major Chinese communities, which held poetry and essay contests reaching out to Cuba and Canada. In San Francisco, community newspapers appeared in 1875, followed by two daily newspapers in 1900 and 1909. By the early 1910s several bookstores were established. Some published local creative writings, such as the two 1911 and 1915 volumes of Cantonese American folk songs titled *Jinshan ge ji* (Songs of Gold Mountain). Chinese acrobats and Cantonese opera troupes entertained in Chinatowns as early as 1852, with over one hundred performers and a full orchestra. In 1879 a three-story Chinese theater was built in San Francisco. Photography studios also thrived in San Francisco's Chinatown. Among some of the well-known Chinese photographers from the 1850s to the early 1900s were Ka Chau, Lai Yong, Ann Ting Gock, Mary Tape of the California Camera Club, and Isabelle May Lee, who owned May Studio with her husband, Leo Chan Lee.

These early Chinese writers, craftsmen, and artists have been ignored in history because of linguistic and sociopolitical factors that isolated the Chinese American community from mainstream America. Whatever little recognition they received was usually patronizing and trivialized based on Eurocentric standards and critiques. At best these Chinese would be praised for being good imitators of the "Occidental," while Eurocentric America created its own imitations of the "Oriental" without much criticism.

As the Chinese settlers gained economic stability in the early 1870s, California initiated a series of anti-Chinese legislations that labeled Chinese workers as "undesirable aliens" who took jobs away from "real" Americans. Anti-Chinese rallies often led to the total destruction of Chinese businesses and communities. Influenced by a strong anti-Chinese California congressional delegation, the federal government eventually passed the Chinese Exclusion Act of 1882 to bar Chinese laborers and their wives and children from entering the United States. It was the first federal law to deny a person's entry into the United States on the basis of class and race. It also denied naturalization rights to Chinese immigrants already in the country. Subsequent laws and amendments to the 1882 law would further restrict the Chinese.

Birth of the First Native-Born Generation

The Chinese Exclusion Act tried to stop Chinese immigration and, in 1920, helped to reduce the Chinese American population by almost one-half, but it failed to totally remove the Chinese presence. By the early 1910s a significant second generation emerged, comprising 10 percent of the Chinese population. Known as the *touji* generation, they came of age in the 1930s.

At home, this first American-born generation was raised by immigrant parents with Chinese cultural traditions. At school, they were influenced by American culture. Chinese culture classes or establishments created specifically to teach Chinese dancing, music, and other cultural activities to the youth were

few and rare in Chinatowns. Some children watched Cantonese operas or were sent to Chinese language schools either locally or abroad in China. However, this second generation's formal education in public American schools and specialized schools like the California School of Fine Arts (now the San Francisco Art Institute) was dominated by Western culture. Christian churches and organizations like the YMCA, YWCA, and the Boy Scouts further encouraged a Eurocentric Americanization process.

Although the second generation championed their American heritage in the Chinatown community—as fluent English speakers; as individuals baptized in the Christian religion; as participants in American popular culture such as sports, movies, music, and dance; or as volunteers for charitable social services—their lives remained segregated within the confines of their own Chinatown community. Before World War II, Chinese American children in San Francisco attended the segregated Chinese Primary School (later renamed Oriental Public School). Some continued their formal education in American colleges and universities. This generation of students was mostly bilingual and practical, preparing themselves vocationally for economic security. Yet, few were able to find gainful employment in the field of their academic training.

Often viewed by mainstream America as a curiosity or novelty, Chinese Americans carried the burden of perpetuating racial stereotypes. Anna May Wong (1907–1961), a Los Angeles–born actress, gained national and international fame, but at the cost of portraying mainly stereotypical Chinese roles: the villainous "dragon lady" or the passive "lotus

blossom." When Chinese American vaudeville acts and nightclubs flourished, beginning with groups such as the Chung Wah Four Quartet in the 1910s and Andy Wong's Chinese Penthouse Nightclub in 1937, aspiring Chinese American singers and dancers were able to break into the entertainment industry, but also at a cost. Most had to speak "funny" English and wear so-called Chinese "costumes" for marketing purposes. Mainstream America judged these performers more as a novelty while the Chinese American community sometimes ostracized them for singing and dancing "shamelessly" in public.

Nevertheless, a few Chinese Americans did succeed in the California entertainment industry. Two-time Oscar-winning cinematographer James Wong Howe (1898–1975) was known in Hollywood for his innovative and artistic techniques in black-and-white films. He became the highest paid cameraman of the times. The Grandview (Daguan) Film Company was Chinese America's first film company, founded in 1933 by Larry Jew and Guan Wenqing. Two years later, it expanded its operations from San Francisco to Hong Kong. The company made its first film, *The Singing Lovers,* in 1934 and continued to produce over fifty Cantonese movies; it also was the first Chinese company to film in color and to use cinemascope and 3-D. Larry Jew was the main director, Harry Jew was one of the cameramen, and American-born Zhou Kunling became a popular Hong Kong actress after her start with Grandview.

A bicultural personality emerged from the *touji* generation and became a common theme in their literature. Native San Franciscan Pardee Lowe (b. 1905), in defining his bicultural upbringing, championed American qualities over his family's restrictive Chinese cultural practices in his autobiographical *Father and Glorious Descendant* (1943). Another San Franciscan writer, Jade Snow Wong (b. 1922), claimed in her *Fifth Chinese Daughter* (1945) that by combining her well-nurtured Chinese tradition and American ideas of individuality she was able to strive beyond the norms of a Chinese woman.

Chinese American artists of this period revealed a blend of techniques that sometimes created a unique bicultural style. Perhaps the most internationally known artist is Oakland-born Dong Kingman (b. 1911), whose water-color paintings brought life to the images of Chinese America. He attended the Fox Morgan Art School in Oakland, and by the 1930s, his watercolors could be found in many major museums. Other second-generation artists included Sacramento-born Eva Fong Chan (1897–1991) who attended the California School of Fine Arts and became a musician and Chinese opera singer, as well as an artist; George Chann (b. 1915) from Stockton who attended Otis Art Institute in Los Angeles and eventually taught art at the San Francisco School of Fine Arts; Jade Fon (Woo) (1911–1983) of San Jose who also attended Otis and founded his own watercolor workshop at Asilomar in 1962; Jake Lee (1915–1992) of Monterey, another Otis graduate, who was a watercolorist and taught art for the U.S. Air Force; and Oakland-born Nanying Stella Wong (b. 1914), an accomplished artist and writer who attended the California College of Arts and Crafts.

In 1926 modernist Yun Gee (1906–1963), who emigrated from China in 1921 and attended the California School of Fine Arts, founded the Chinese Revolutionary Artists Club. Together with Otis Oldfield, Gee later opened the avant-garde Modern Gallery in San Francisco. In 1935 the Chinese Art Association was established with a group exhibition at San Francisco's M. H. de Young Memorial Museum. The association's members included artists Nanying Stella Wong, David Paul Chun (b. 1899), Hon-Chew Hee (b. 1905), and Chee Chin S. Cheung Lee (b. 1896). Lee was also a member of the East West Art Society founded in 1921 and had his work exhibited in 1922 at the San Francisco Museum of Art.

A variety of Chinese American cultural groups were organized during this prewar period. In 1911 thirteen Chinese American boys aged eleven to sixteen formed the first Chinese American marching band and called themselves the Cathay Band in San Francisco. In 1924 seven Chinese American women joined to form the Square and Circle Club to serve the community; it is the oldest Chinese American women's service organization in the country today. In the 1930s Chinese martial arts and dance studios sprouted in Chinatowns. And in 1935 the Chinese American community read its first English language newspaper, the *Chinese Digest,* headquartered in San Francisco's Chinatown. In the last year of its existence in 1940, the newspaper became the official voice for the China Cultural Society of America, which was founded that same year to promote Chinese arts.

Successful Chinese American entrepreneurs of the 1920s and 1930s did not forget to donate their wealth back to the community, especially for cultural and educational purposes. Joe Shoong (1879–1961) became the wealthiest Chinese in America and established the Joe Shoong Foundation in 1946 with $1 million. He donated thousands of dollars to the University of California scholarship fund, the Chinese Hospital in San Francisco, churches in San Francisco, Oakland, and Berkeley, as well as Chinese language schools in San Francisco, Oakland, and Sacramento.

World War II and Its Aftermath

World War II brought major changes to the Chinese American community. The Chinese Exclusion Act and all the subsequent laws against the Chinese were repealed in 1943. Naturalization was now allowed for the Chinese. As necessitated by wartime politics, the Chinese were no longer an undesirable "Yellow Peril" but a brave codefender of democracy. Chinese men and women began to enlist in the U.S. armed forces. The wartime economy propelled many others into gainful employment outside Chinatown, and women found career opportunities never before opened to them.

Within the cultural scene, themes revolving around the liberation of China from

Japanese invasion were common. Writings and dramatic skits dealing with this political call abounded, functioning side by side with political lobbying, rallies, and demonstrations. Hoong Sing Koon and Kin Mon, two professional martial arts schools established during the 1930s, participated in parades and martial arts and lion dance performances to raise money for China's war effort. Many Chinese American women's groups from the Chinese Women's New Life Movement and Los Angeles's Mei Wah Club and Chinese Women's Club helped to raise money for war bonds. American-style fundraisers in Chinatown known as Rice Bowl Parties also brought in thousands of dollars to support the cause.

With the end of the war came various amendments to the 1945 War Brides Act that allowed Chinese American war veterans to petition for their Chinese spouses to come to America. Together with other postwar legislation, this resulted in the arrival of almost eight thousand Chinese women from 1946 to 1950. The transition from a "bachelor" society to a family society was slowly beginning to take place in the Chinese American community.

The Cold War Begins

When the People's Republic of China was established in 1949 and the United States entered the Cold War against Communism, the Chinese were once again viewed as the Yellow Peril. The political situation worsened during the Korean and Vietnam wars. During this period of anti-Communist hysteria and with the Japanese American internment during World War II still fresh in their minds, many Chinese Americans feared for their lives as they were easily suspected of being Communist spies. Some felt compelled to prove their loyalty to the United States by actively participating in as many American activities as possible, oftentimes totally denying their Chinese culture. This trend was reflected in the decline of Chinese language schools and cultural activities, and led to a gradual loss of Chinese heritage among the younger generation of American-born Chinese. However, for the sake of tourism, a few cultural practices were retained by Chinatowns. Some practices

slowly evolved into commercialized celebrations with the adaptation of American activities (for example, the Miss Chinatown Pageant began in 1958 as an integral part of the Chinese American New Year festivities).

Meanwhile, the Chinese American Democratic Youth League (also known as Mun Ching and the Chinese American Youth Club) was founded by American-born and immigrant Chinese in San Francisco during the late 1940s to promote Chinese culture, music, folk dance, and the vernacular drama of modern China. The group disbanded in 1959, but was quickly reorganized as the Haiyan (Petrel) Club and continued its cultural goals with the founding of the Chinese Folk Dance Group (now known as the Chinese Folk Dance Association).

Because America did not recognize Communist China, postwar Chinese immigration came mainly from Taiwan or Hong Kong. These new immigrants were from a different social class. They were either political refugees, government officials, professionals, businesspeople, intellectuals, or university students. As such, they introduced non-Cantonese Chinese culture to America. Instead of Cantonese opera, Peking opera was now recognized as Chinese opera and instead of Cantonese, Mandarin was now the accepted official Chinese language. This new generation of Chinese immigrants experienced a very different America from what the Cantonese laborers had encountered in the late nineteenth century. This was clearly reflected in the cultural and artistic expressions of both groups: the established Cantonese Americans generally discussed themes around biculturalism, discrimination, and nonacceptance, while the newly arrived Taiwanese writers and artists found themselves lamenting about their lost homeland and functioning in America more as cultural ambassadors in exile.

From the 1960s to the 1970s

The Immigration and Nationality Act of 1965 abolished the discriminatory immigration system and established a more equitable quota system of no more than twenty thousand per country. This was a huge increase from the quota of 105 Chinese immigrants per

year set by the 1943 Repeal Act. With the 1979 normalization of the relationship between the United States and the People's Republic of China, more Chinese immigrants began to come from mainland China. The impact of the liberalization of America's various immigration laws was considerable. The Chinese American population increased in Hawaii from 52,039 in 1970 to 56,260 in 1980; it doubled on the mainland from 382,795 in 1970 to 749,246 in 1980. Once again, the Chinese comprised approximately 10 percent of California's population. It should be noted that this does not take into account the thousands of ethnic Chinese arriving as refugees from war-torn Vietnam, Cambodia, and Laos. All these immigration waves have diversified the Chinese American population as well as its culture.

In an attempt to serve the ever-growing immigrant generation, regularly scheduled Chinese-language television programs began during the 1970s to provide news services as well as cultural programs. Chinese American radio programs also flourished. The *Golden Star Chinese Hour*, on the air from 1939 to 1978, was the only radio program in town until the 1970s when San Francisco saw the rise of more programs such as the *Hon Sing Chinese Community Hour*, the *Mandarin Chinese Youth Voice*, and *Dupont Guy*. Some were bilingual, but all provided informational services and cultural programs.

Chinese American stereotypes in the arts persisted in the 1960s and 1970s with Rodgers and Hammerstein's 1961 *Flower Drum Song* version of Chinese America and with the popularity of actors like Nancy Kwan and San Francisco–born Bruce Lee, who created new

images that inevitably evolved into new stereotypes. Nevertheless, the 1960s and 1970s saw the continuation of Chinese American artistic endeavors. Some of the artists from the 1920s and 1930s had become art teachers or commercial artists. A new and younger group of artists also sprouted, many of whom belonged to the Kearny Street Workshop founded in 1972. In the literary scene, Chinese American writers from the San Francisco Bay Area such as Frank Chin, Shawn Wong, and Jeffery Chan openly attacked America's racist love for the Chinese. Chin's *Chickencoop Chinaman* (1972) became the first Asian American play performed on the New York stage, and Stockton-born Maxine Hong Kingston's *Woman Warrior* (1976) took over the literary place of honor formerly occupied by Wong's *Fifth Chinese Daughter*. Once again, the debate over ethnic identity became a major topic among Chinese Americans, this time with America as a whole questioning issues of assimilation and ethnic maintenance.

As the Civil Rights Movement spread across the United States in the mid-1960s, the call for ethnic studies emerged. In the fall of 1969 the Asian American Studies Department was established at what is now known as San Francisco State University in the College of Ethnic Studies, the first and only college of its kind in the United States. In that same semester, Him Mark Lai and Philip P. Choy cotaught the nation's first course on Chinese American history. Asian American Studies programs were also established in the University of California campuses of Berkeley (1969) and Los Angeles (1970).

In addition to the above, a variety of California-based organizations thrived during the 1960s and 1970s and instilled a sense of ethnic cultural pride among the Chinese in America. The Chinese Historical Society of America was founded in 1963 in San Francisco as the first historical society to devote itself to the Chinese experience in America. It established the first Chinese American museum in the country and inspired similar groups such as the Chinese Historical Society of Southern California and the Chinese Historical Society of Greater San Diego and Baja California, Inc. In 1965 the Chinese Culture Foundation of San Francisco was founded with the objective to showcase works of art by Chinese and Chinese American artists. In 1966 the Chung

Ngai Dance Troupe was established to teach traditional Chinese dance to high school and college students. In 1972 the Flowing Stream Ensemble used both Chinese and European musical instruments to create a new sound for classical and contemporary Chinese music. In 1979 a group of Chinese American women writers and artists formed Unbound Feet with the goal of encouraging women's expression on stage. In addition, Chinese Americans participated in the founding of groups such as the East West Players (1965), the Asian American Theatre Workshop (1972), and the Asian American Theatre Company (1977) to promote Asian American theater.

Chinese Americans have journeyed long to develop and define their culture—from the first day the Cantonese arrived in nineteenth-century California with their culture fairly intact, to the early twentieth century when the second generation began to adopt Eurocentric American cultural values, to the Cold War period during which time some were driven to the point of denying their Chinese heritage. At present, during the 1980s and 1990s, Chinese American culture in California continues to undergo various stages of growth and definition within a diverse and multi-generational Chinese American community. It is a complex and dynamic process.

Nipponism and the Smell of Paint:
A Recollection of New York, circa 1958–1961

by Yoshiaki Shimizu

In the fall of 1959 in New York City I began what would, in the next two years, turn out to be the most enriching experience of my life in this country. I was twenty-three years old then; I had left my sophomore year at Harvard behind. With a group of three or four fellow undergraduate comrades, who, like me, were highly inspired by art and moved on to art schools, I left the college to attend an art school in Boston—only to return to college a few months later. Still unhappy, I traveled to Europe (to Hamburg, for I spoke German) for half a year and returned to the States. I reenrolled at the art school (why in-and-out of schools that often? because I was on a student visa which only allowed me to stay in the States if I maintained a school affiliation) but very unhappy with the curriculum, I left again. I went to New York, where I would live for a little over two years until the winter of 1961.

What hastened my decision to depart the Boston-Cambridge area for New York was a small, not widely publicized yet to me very significant exhibition: *Nipponism*, shown at the Institute of Contemporary Art, Boston, which occupied the second floor of the art school I was attending. The exhibition, organized and curated by Thomas Messer, showed a few dozen nonfigurative works by Japanese painters working outside their home country: among them, Yutaka Ohashi, working in Boston, and Kenzo Okada, Genichiro Inokuma, and James Suzuki, all working in New York. On the opening night of the exhibition I met Suzuki and Inokuma, and it was soon after this that I left Boston for New York. Before I situate myself in New York City, let me digress a bit to retrace how, in my

late teenage years, I happened to choose painting over academic life in the first place.

Hobby into Art

Painting happened to become part of my life as an extracurricular activity at a New England boarding school where I first began my American life—at age seventeen, fresh out of Japan, in the fall of 1953. Initially encouraged by an artist-teacher by the name of Bill Abbe, I was introduced to watercolor, with which I painted New Hampshire landscapes with abandoned barns. My penchant for painting such scenes was likely to have been the result of hearing a lecture by Frank Lloyd Wright in Boston; he expressed his total disdain for the ferroconcrete structures of urban Boston, and stated that the only architecture worthy of note in New England were the farmhouses and barns. Watercolor, I was to discover later, was a more difficult medium than oil. But Bill Abbe, who was a well-known watercolorist and printmaker, continued to introduce me to works he thought were great. These included watercolors by Winslow Homer that I was taken to view at the Currier Gallery of Art in Manchester—one of the most beautiful museums I came to know in this country—and the work of Dong Kingman, a Chinese American watercolorist who was making quite a splash in the American art scene in the 1950s, most notably in commercial art.

Art was not a part of the accredited curriculum for upperclassmen at my school then, so painting and drawing for me was entirely voluntary. I joined the school's Art

Association, whose members numbered less than ten, and became its president in the following year. It was certainly not because I was especially talented in painting, nor was it because Bill Abbe saw any promise in my watercolor, that I gradually became "artsy." The only artistic training I had before I came to this country consisted of unremarkable attempts at painting, as well as calligraphy classes I had taken as part of the normal curriculum at various Japanese schools from 1941 on, from elementary school and up. It was probably because I did not have much else to do outside the academic and compulsory sports programs at the boarding school—and also simply because I hung around with Bill Abbe more often than with anyone else—that I soon began to assume the identity of an artist at the school. That I found myself alone most of the time also contributed to my picking up painting. At graduation, I won the only art prize, an oil painting kit, given to a graduating student. In a sense, my role as an artist was due more to recognition by the school I was departing than through intense self-awareness.

Academia and Art

I entered Harvard in 1955 with a thousand other men, a considerably larger cohort than the one I graduated with from secondary school. If the boarding school I had happily attended was a comfortable oasis for young men of privileged means, Harvard was a merciless jungle of aggressive minds that demanded competitiveness, excellence, and originality of thought in scholarship; one had to be a

high achiever, able to take the rigor and vigor of its academic standards. At age nineteen, starting a new life at Harvard made me acutely aware that I was not ready for the four-year undergraduate career, for I was meeting contemporaries who seemed older and more sure of themselves than I was; some clearly showed far superior academic preparation to mine. Artistically, Harvard offered very little then. There were a couple of studio courses one could elect at the Fogg Museum, as a part of the Fine Arts departmental offerings taught by T. Lux Feininger (son of Lyonel Feininger, the Bauhaus artist) which were designed to meet the needs of Fine Arts majors. Once a week for three hours, these courses followed the trends of much academic art instruction: bits of theory mixed with demonstration. Beyond these intradepartmental offerings, there were no studio courses or space in which undergrads could paint. The absence of studio courses at Harvard, however, was less problematic than the academic requirements I was expected to meet but was unable to fulfill.

In the summer of 1956, after my freshman year, I attended the summer session of the Art Students' League in Woodstock, New York, where I enrolled in the oil painting class given by a realist teacher by the name of Reilly, whose illusionistic, if formulaic, oil technique met my initial need to learn how to handle oil. While I was not entirely persuaded to follow his methods, the technical control I could exercise in using oil paint undoubtedly helped me to understand better the European and American old masters I saw in the university museums. When I returned to Harvard the following fall, I painted with concentration and enthusiasm portraits of my college friends and copies of works by Copley and John Vanderlyn at the Fogg Museum. Being able to control oil painting techniques gave me mental confidence.

In many respects, college life was not conducive to or encouraging for someone who might want to paint with serious intention. To be sure, the university offered its superb collections of arts of the world in the Fogg Museum and the Busch Reisinger Museum in Cambridge; Boston had its Museum of Fine Arts. There were more than ample opportunities to visit these collections, and many Fine Arts majors and art lovers did, but there was hardly any opportunity for creative artists to experience a community of art. A saving grace was the presence of the painter Ben Shahn, a Charles Elliot Norton Lecturer at Harvard. He gave a series of lectures on the subject of artists in contemporary society in general, and in the academic environment in particular, which were eventually to become chapters of his important book, *The Shape of Content.* Shahn sympathetically answered issues facing young artists in contemporary society such as: How should one go about painting as a profession in the increasingly consumer oriented world? Ben Shahn's almost fatherly stature and presence gave me a sense of connectedness to the outside world; he was, to me, a mentor.

As my sophomore year progressed, my painting activities increased. I transferred to the School of the Museum of Fine Arts in Boston the following fall. My enrollment at the art school, however, was short. The art school curriculum, I determined, was not challenging enough. I was back at Harvard in the spring of 1958, but my attendance this time was also short-lived. Academically hardly inspired, I spent a great deal of my time in my studio.

After some months, I had accumulated enough works to show to a gallery called Paul Schuster Gallery, in Cambridge, which was on the upper floor of the famous Poet's Theater. In early April 1958, the gallery arranged my first one-man show, which included oils, watercolors, and drawings. Quite unexpectedly, the exhibition was financially satisfactory. It was even reviewed by the critic Dorothy Adlow of the *Christian Science Monitor*. The review was favorable, but it also said that "the young artist had not yet found himself." The description, in retrospect, was quite accurate. Once again restless, fearless, and also ignorant, I asked the college to let me leave once again, this time to go to Europe "to find myself."

Great Escape

In the late spring of 1958, I was living in Hamburg, attending the city's Landeskunsthochschule as a "visiting student." I can think of two main reasons why my German trip was artistically important to me. First, I was interested in German expressionists, such as Nolde, whose works, including many

unpublished ones, I saw at the Nolde Stiftung in Seebull. Second, I saw Jackson Pollock's impressive canvases firsthand in Hamburg's Kunsthalle.[1] This constituted my initiation to Abstract Expressionism, and it was an eye-opening experience. Viewing the oil-drip lay-ered surfaces of Pollock's canvases—many of them so huge that they took up an entire wall of the gallery—was like seeing flickering and sparkling lights against dark spaces, a swirling map of constellations. I had seen the work by Pollock and other American painters after viewing, at the same museum, the hard-edge, geometric abstract paintings of the Paris-based Russian painter, Serge Poliakoff (which hardly excited me), and the museum's omnipresent figurative works by Kollwitz, Munch, Corinth, and other expressionists. The Pollock paintings strongly impressed me as something totally fresh and free, yet having a rigorously structured space defined by the tactility of paint. My reaction to Pollock could not have been more surprising, since I knew of him and of his premature death in an acci-dent while I was attending the summer school of the Art Students' League in Woodstock two years earlier. Jolted by Pollock's works, and realizing that I had just come from the country that produced Pollock, I cut short my German trip, returning to America via Paris, in September of that year.

To Manhattan

My life in New York began on several fronts, the first and foremost of which was in the per-son of the painter James Suzuki, whose works I had seen in the *Nipponism* show in Boston and who lured me to Manhattan. He and his wife, Margie, were living uptown around 90th Street and Third Avenue, in a ground-floor apartment that had a bright front room that James used as his studio. When I looked him up he showed me some new canvases he was working on—large, with surfaces covered with sensual, buttery paint applied with a broad brush or, more correctly, pounded onto the canvas. This resulted in large pointillistic squares of paint—some merging, some super-imposed on each other—creating a sensuous field of vibrant colors. The color ranged from cool, silvery gray to warm chestnut brown (the word *shibui* came to mind), spreading

and converging, creating a constantly moving space. These works marked a shift toward more dynamic compositions from those by Suzuki that I had seen in Boston at the *Nipponism* show. These square "dots" moved like a flow of water in some areas, or created solid forms in others, as in some early Japanese paintings in which hundreds of cut squares of gold and silver leaf filled the "void" spaces. Suzuki's canvases were often filled with bright reds sprinkled among black dots, shaping surfaces of bubbling hues. The sheer sensuality of Suzuki's paint quality simply became addictive to me. I wanted to paint like Suzuki.

Suzuki knew that I was a newcomer to nonfigurative painting. He told me that sever-al years earlier, when he had first come to New York after studying at the Corcoran School of Art, he had gone to Kenzo Okada, who became Suzuki's mentor. Okada's prima-ry advice to Suzuki was simply: "Do one hun-dred paintings," and Suzuki proceeded to produce one hundred paintings. Suzuki said that at the beginning of the process, his works looked like Okada's. But the more Suzuki painted to achieve the goal of one hundred works, the more he discarded from his canvas-es what was not really his, the "Okada signs," and his own forms gradually emerged. This process, Suzuki said, was in fact eliminating what was "unnecessary." The paint surface began to look like an aggregate of colorful, tilelike forms as he painted out excesses. "However you paint," Suzuki told me, "you have to fill the canvas. Every part is a part of a whole—like the Japanese garden. You can fill up the space with few forms. Think of the rock garden. The rocks are sprinkled in the garden, but each one works right in the space it occupies and in relation to others." I am of course taking a few liberties in my remem-brance of Suzuki's comments and interpolat-ing a bit; but this was essentially his advice, and it had an authentic ring to it. It led me to think about the Ryoanji rock garden as well as the garden of the Shokintei teahouse at the Katsura Palace in Kyoto.

Suzuki's works were then handled by Graham Gallery on Madison Avenue. I went there several times to see the range of his works. Not surprisingly, Suzuki was a prolific painter, and the works I saw were examples of his many different artistic directions. Suzuki's

earlier works had been considerably different in composition and surface treatment. One work in the Boston show that left an indelible impression on me was a three-fold screen, predominantly monochromatic but accented with pastel-toned colors applied with the square brush. It was unmistakably inspired by the screen compositions of the Rimpa (school of Korin), with a broad, staggered, zigzagging horizontal band running across the panels. This screen clearly connected Suzuki with his native pictorial tradition, but the painting also showed definite links to the gutsy New York school of painting of the 1950s (admittedly, this observation is by hindsight), in that paint handling itself produced its expressive quality and artistic integrity. Suzuki's New York works were much bolder; his "self-conscious" artistic roots were no longer as readily palpable as with the earlier screen. The traditional artistry that had connected Suzuki with Japan was also present in Okada's early abstractions. They showed that Okada had visually analyzed the planar structural compositions of the early miniature-sized *yamato-e,* such as the famous *Tale of Genji* scroll fragments of the twelfth century. Both Okada and Suzuki demonstrated that artists may share communal artistic sources at one time or another during the diverse phases of their careers, but each will react in different ways.

Suzuki's older compatriot, Genichiro Inokuma, was also in New York, living on 95th Street and Lexington Avenue. Inokuma was a well-established painter in Japan. I was familiar with the Matisse-inspired cover designs he did for years for the Japanese monthly magazine *Bungei shunju.* My first meeting with Inokuma was in Boston, at the *Nipponism* exhibit. Thomas Messer, who organized the show, wrote in the accompanying brochure that Inokuma's monochromatic abstractions were rooted in the works of the ink painter, Sesshu (1420–1506). The famous *Winter Landscape* by this Zen painter-monk was illustrated in the brochure side by side with a picture of Inokuma's mammoth oil monochromatic abstraction. When I went to see Inokuma in his apartment, he gave me grandfatherly advice and encouragement: stick around in New York; don't think of working in Japan; New York is the place for painting, etc. I was expecting Inokuma to say that, for,

apart from my personal connection with Suzuki in the city, New York offered infinite excitement and opportunities to develop my art.

The Whitney Annual was then one of the most interesting venues for observing young contemporary artists' works in one sweep. So were many galleries in the midtown area along 57th Street and Madison Avenue, such as the Sidney Janis Gallery, which showed Guston and de Kooning. At that time, I was beginning to get the hang of living in Manhattan. I managed to see as many new paintings by contemporary painters, young and old, as I did the traditional paintings in the art museums, such as the Metropolitan and the Museum of Modern Art. The contemporary painterly canvases I saw were all large, by Sam Francis, Joan Mitchell, Grace Hartigan, Adolph Gottlieb, Robert Motherwell, and Helen Frankenthaler; Bradley Walker Tomlin's totemic canvases with monumental "calligraphic" signs; Conrad Marca-Relli's compositions of cloth and paint collages; and the omnipresent Pollock, Kline, Rothko, de Kooning, and Guston. These painters, especially Guston, were my favorites because their works were a vital part of the artistic context I sensed in the city. I could also relate to how Inokuma, Okada, and Suzuki, responding in their painterly manner, were connected to the New York avant-garde.

My fascination with abstract art extended to the works done by those who were working elsewhere, outside New York. At the Museum of Modern Art, I was drawn to the works of Mark Tobey, whose tempera painting showed that he had looked at and understood the morphology and aesthetic of East Asian, and especially Japanese cursive calligraphy. In those years, when I was still a fresh initiate into the world of abstract art, it was natural that I wanted to try every possible mode of painting that drew my attention and curiosity. The truth was that I was just as confused by these exciting works as I was enthused by them—the sign of youth, one might say.

A Perpetual Outsider

Perhaps because I went to New York straight from the Cambridge-Boston area, where I first saw myself as a painter, my life in New York

did not in a substantial way make me aware of my biographical roots in Japan. When I started visiting Suzuki's apartment, frequently socializing with him and his friends who had come directly from Japan, I felt most of the time quite alien to their observation of the city, to the art it offered, and even to their living habits. I met the painter Ay-O and the sculptor Toshio Odate in Suzuki's apartment, but no lasting camaraderie or personal friendship ensued from these meetings. I also met Yayoi Kusama in her gigantic loft in lower Manhattan and saw her bigger-than-life canvases of a "thousand dots." I was astounded by the energy and the single-mindedness of the artist. But at the same time, as I had felt with other artists from Japan working in New York, there was an enormous chasm between their artistic battles and mine. Ay-O and Odate were already established artists in their respective careers. The Japanese "modernism" rooted in Tokyo, Osaka, or Kyoto had virtually no bearing on my life in the city, although the Japanese modernists surely were not strangers to New York. Years later I was to learn that the Martha Jackson Gallery had mounted the first American exhibition of Japan's modernists, the Gutai group, in the fall of 1958, which had totally eluded me. Was there a community of Japanese artists in the city? I do not know. Perhaps there was, but, as was the case with my getting to know Suzuki, my contacts with my countrymen were almost exclusively with those in exile in one way or another. Besides, I was not quite comfortable in categorizing individual artistic expressions in terms of nationality. Isamu Noguchi, to whom I was introduced by the architect Minoru Takeyama (who was spending his post-Fulbright period in Manhattan), was to me someone who transcended cultural barriers, biographically and artistically.

It was with an admittedly ambivalent sense of self-identity that, in the spring of 1959, I chanced to meet the painter Joop Sanders. My first encounter was cursory; we both happened to be shopping for paint at Panoras off Fifth Avenue. Not long after, I visited Joop's studio on West Broadway. The studio, a typical New York converted loft space, was filled with works, both finished and in progress, large and small, on paper as well as canvas. He was working on the theme of structured color fields, if I may so characterize what I saw. They were not at all like Rothko's fluffy color fields; Joop's had a clear structure that had evolved out of a preoccupation with the structured abstraction of de Kooning. Like de Kooning, Joop came from Holland. I was fascinated and inspired by the fact that, though a generation or so younger than de Kooning, Joop knew him and his wife Elaine personally. (With the former, I had a very fleeting encounter: in the Cedar Bar's bathroom, facing the urinals. A short, gray-haired man with a cigarette dangling from his mouth stood to my right; he turned, saying, "Hi, I am Bill de Kooning.") Through other friends, I met Jack Tworkov, whose studio on the Bowery above the Blue Moon bar I would eventually sublet with another painter. But it was through Joop and his vivacious wife (and vocal artist) Isca, who lived in the Village, that I made my first connections with New York avant-garde art. From Joop I learned of the artistic events of the 1950s in the city, including accounts of many artists' fascination with Zen through D. T. Suzuki, who came to Manhattan to lecture.

To keep up my student status, I attended art classes at the Art Students' League. My own works were shown in bits and pieces: in Cambridge, where I had another show in 1961; in Boston, where one of my abstract collages made it into the Arts Festival in the Common (one of the jurists was Motherwell); and in New York, where I was able to show a pair of four-panel screens in oil on canvas (somewhat reminiscent of Monet's *Water Lilies*) at the Audubon Annual, held at the National Academy of Design, in the winter of 1960. By 1961, the *Nipponism* show that initially paved my way to abstraction seemed to be one of many transitional artistic epochs.

Return to Academia

By the winter of 1961, I was back at Harvard, starting my winter semester as a Fine Arts (art history) major; the chief reason for my return this time was that I wanted to rid myself of the terrible weight of remorse for not having finished my undergraduate education. There was another, more positive, reason, too. In 1960, a major exhibition of masterpieces of Chinese art from Taiwan's Palace Museum was touring America, which I

saw at the Metropolitan Museum of Art. It included some of the most impressive Chinese landscapes made on a monumental scale; I had seen nothing like them before. What these paintings told me was that though I came from East Asia, I hardly knew about my own cultural resources—those of Japan or of its neighbor, China. So this time, I felt that my reentry to Harvard represented, as it were, a chance to catch the last bus. It had been then four years since my initial departure from the college, and in spite of many flights from, and willful escapades beyond, the halls of academia, Harvard reinstated my scholarship and provided me with a spacious and bright studio space in an old factory building, facing the Charles River, then used by the School of Design. There I was able to stretch large canvases and was free to paint whenever I wanted. My elective courses included the Chinese language, the history of Chinese painting, and as many other art history courses as I could take, including Aegean archaeology. The pursuit of serious creative art and the life of an artist—I had tasted a modicum of each in New York, and I felt these were things that one did not need to parade in public—dwell within a person, or so I told myself then.

In the summer of 1963, I finally completed my bachelor's degree requirements from Harvard and left America for Japan, the homeland from which I was absent for exactly ten years. At just that time, the Carpenter Center for the Visual Arts, a ferroconcrete building designed by Le Corbusier to be used by students in creative art, including painting, went up next to the Fogg Museum of Art. Good timing has never been my life's forte.

Postscript

Many years later, I saw James Suzuki in California. This was in 1976 when I was teaching Japanese Art History at Berkeley. Suzuki had set up his house and studio in Oakland and was teaching at the University of California at Davis once a week. His canvases could not have been more different from those he did in the 1950s: they were figurative. However, the dynamic composition and rich paint quality they displayed were unmistakably his. The thematic priorities for Suzuki had changed, as had Guston's during his late years, moving away from abstraction and into figurative symbolism. The trailblazers of Nipponism in New York, Okada and Inokuma, both returned to Japan. Okada passed away in 1982, but his works, done both in New York and Japan, are still shown in New York, most recently at the Marisa del Re Gallery, in 1991. Inokuma, after returning to his native city of Takamatsu in the Kagawa Prefecture on the island of Shikoku, and with the willing patronage of the Prefectural Governor, became instrumental in luring other Japanese and Japanese American artists and craftsmen to the city by setting up an "artistic enclave" for contemporary arts. Among those who have been involved in the Takamatsu undertakings are Isamu Noguchi, Masayuki Nagare, another sculptor, and George Nakashima, the woodworking master, who worked in New Hope, Pennsylvania.

Reminiscences of Mi Chou:
The First Chinese Gallery
in America

by Frank Fulai Cho

This essay originally was published in Chinese American Forum *I (May 1985) and is reprinted here with permission of the publisher.*

In the early 1950s, the morale of the Chinese in America was extremely low. Some of my contemporaries had lost contact with their families in China for months or even years due to the turmoil of the Civil War years. Tragic stories of broken homes were frequently heard. The Nationalist government had been forced to move to Taiwan from the mainland in 1949. Communist Chinese troops were fighting alongside the North Koreans against the American forces during the Korean War. Many Americans at that time looked down upon the Chinese or viewed them with suspicion. In such an unfavorable climate, it was most difficult for a Chinese graduate, especially one without an immigration status, to find a job or to make a living.

In the spring of 1951, I was really lucky to find work in the Tea Department of a trading company in New York, newly formed by a well-known Indonesian Chinese family. I was able to support myself, but there was no intellectual outlet to speak of.

Probably owing to the influences of my grandfather, a good calligrapher and painter, and my uncle, a famous calligrapher specializing in Chang Tsao, I have always been interested in Chinese calligraphy and painting. In the summer of 1951, when I heard that Mr. C. C. Wang, the renowned collector and painter, began to teach Chinese painting and connoisseurship in his studio in New York, I immediately went for an interview, and luckily became his student for five years thereafter. Through him I had the opportunity to meet many other great Chinese artists including Messrs. Wang Chi-Yuan, Wang Ya-Chun, and Chang Dai-Chien.

After World War II, New York City replaced London as the world's financial center, and the world's art center also began to shift from Paris to New York. New galleries were springing up by the dozens. Also there were newly formed museums of stature such as the Museum of Modern Art, the Guggenheim Museum, and the American Craft Museum. Studying painting regularly, visiting museums and galleries every weekend, and going to art lectures often, I met many interesting young artists.

While it was hard for any young artist to find a place to show his or her work, it was even harder for a Chinese artist. Very few Americans had ever been exposed to Chinese art. There being little interest or demand, no gallery wanted to exhibit works by Chinese artists. Because I had an MBA degree, thus the reasoning went that I should have some idea about business. Therefore, it was often thought that I should be the one among my friends to try to form a gallery to exhibit works by Chinese artists. Some friends volunteered to gallery-sit and others volunteered to do various chores if such a gallery should be formed. Knowing well that the demand would be very limited, I was naturally hesitant. This subject came up frequently in discussion during late 1952 and throughout 1953. Those who encouraged me most were Gertrude Hung (daughter of the renowned historian, Professor William Hung of Harvard University) and Hsien-Liang Koo (then doing research at Columbia University and editor for the Chinese Art History Department of

the Encyclopaedia Britannica). Gradually this idea of introducing Chinese art to the American public became increasingly and intriguingly enticing to me. One Saturday morning after my art class, I broached this subject with my teacher C. C. Wang. He supported it wholeheartedly. In fact, just a few days later, he told me that he would be willing to let me use for this purpose at a nominal rent the rear ground floor of his house at 320 West 81st Street, which had a separate entrance. I thought this over for several days and finally went back to Mr. Wang to thank him and to accept his generous offer.

The following week I moved from the YMCA, where I had been living, to the gallery site. With some two-by-fours and wall boards, I built a wall at one corner of the main room to set aside a small space, barely enough for a bed. On the other side, some additional wall space was gained for picture hanging. The next weekend I painted all the walls a neutral gray. The charcoal black linoleum tiles on the floor were quite appropriate for a gallery. The following weekend I was able to enlist the help of my high school classmate Sheldon Chang (Professor and then Chairman of the Electrical Engineering Department of New York State University at Stony Brook, N.Y., later dean of the same institution) to wire the entire gallery room. We selected the same kind of swivel lights used in the Museum of Modern Art and installed them in strategic spots. All wires and fixtures were concealed in casings and painted a neutral gray. After the completion of the electrical work and decoration, we looked around with pride, and we were quite pleased. The interior compared favorably with the first-rate galleries in town, except that our space was smaller.

The gallery was named Mi Chou, a fine suggestion of Hsien-Liang Koo. It means literally Mi's Boat, after the boat of Mi Fei, the famous Sung Dynasty calligrapher, painter, and collector who usually traveled in his boat with some calligraphies and paintings from his magnificent collection. The purpose of Mi Chou was: to introduce and expose Chinese art to the American public, and, in a modest way, to work towards the goal of bridging the culture gap between the East and the West.

The first exhibition began at 6:30 P.M., April 29, 1954. Gallery hours were rather limited for I was holding a full-time job downtown during the week. Not until the following year were we able to extend the gallery hours from 2:00 to 6:00 P.M., Mondays through Saturdays, and until 10:00 P.M. on Thursdays. That was made possible by the volunteer gallery-sitting of my friends, Gertrude Hung, Ma Yan-Lan (daughter of the famous economist Ma Yin-Chu, the population expert), and Wing C. Dong, a modern painter.

During this first year, a dozen or so exhibits were held featuring traditional and modern paintings, ceramics, and architectural designs.[1] Because of financial and manpower limitations, many unexpected difficulties occurred. The only thing that kept the gallery going was enthusiasm.

To try to run a reputable art gallery, and to distinguish it from an art shop, it was important for us to hold exhibitions regularly and of good quality. Although we did enlist the support of a number of good artists from the beginning, it took time to accumulate sufficient selected works for one-man shows. Group shows, therefore, became the natural solution. Often the duration of the exhibition had to be extended to accommodate the preparations for the following show, such as designing and mailing out announcements and invitations, distribution of news releases, and advertising. Ideally, the ad or announcement would appear in the art section of the *New York Times* and *Art News*, two important publications, just before the opening of the show. Other chores included the dismantling and displaying of the works of art, adjusting the lighting, washing the floors, and so forth. All these chores I did myself with occasional help from my friends. Although the work involved was rather demanding and physically exhausting at times, the overall result was gratifying. Noted art critics like Howard Devree and Dore Ashton and special feature writer, Grace Glueck—all from the *New York Times*—came to this heretofore unheard of gallery way out on the west side of town. So did the critics Lawrence Campbell of *Art News* and Hugo Munsterberger of *Arts Magazine*. Probable reasons for the attention paid to this tiny unknown entity were that (1) Mi Chou provided a fresh look on the art scene, and (2) it showed works of worthy quality. To the Chinese community of New York, Mi Chou was quite a distance from Chinatown. Fortunately, the Chinese American Amity,

then newly founded by the Archbishop Yu Pin, sponsored many social activities, and was just around the corner on Riverside Drive. Thus quite a number of Chinese visited Mi Chou, "killing two birds with one stone," so to speak.

Thirty years have passed. A lot has been forgotten. However, I can still remember vividly the opening night, which featured a one-man show of Chi Pai-Shih's work. Thanks to Mr. Wang Ya-Chun, Mr. C. C. Wang, and other collectors who were willing to share their collections for this exhibition, the opening night was a great success, considerably beyond our expectations. Not only was the attendance excellent, but also quite a few paintings were sold at what were considered attractive prices at that time. For example, a magnificent vertical scroll, *Eagle and Pine,* and a large album leaf of morning glories, both of top quality, were bought by the famous concert pianist Ray Lev. Another outstanding album leaf, *Peony,* my personal favorite, was purchased by Ned and Pei-Chen Owyang. I had known both Ned and Pei-Chen back in China, but it was at this exhibition that our contact was renewed. Their growing interest in Mi Chou led to their participation in gallery activities and, subsequently, to their partnership in the gallery.

The second one-man show was of woodcut prints by Seong Moy. Mr. Moy was teaching oil painting and printmaking at the Art Students League in New York. He had already established a reputation for his works and had been showing them regularly at Grand Central Modern Gallery. Nonetheless, he was most supportive of Mi Chou. When I expressed the hope of showing his works, he immediately consented, offering a retrospective show of his woodcut prints, a very popular art form at that time. During the preview evening, many of his friends came. Some were well-known figures in the art world. I remember distinctly when Una Johnson, head of the Brooklyn Museum's print department, walked over with Seong Moy and said smilingly to me, "You know? We suggested to this man that he have a show like this at our museum, but he said that he had to do some preparation. Now you've 'stolen' it from us." We all burst into laughter. Seong Moy was very fond of Chinese opera. The first Chinese Opera Club in New York had just been formed

around this time, and I was one of the fiddle players of the Club. He and Mrs. Moy attended every performance that we were able to put on stage. The color and movement of Chinese opera apparently influenced his work during that period as shown in the Mi Chou exhibit as well as in the next show of oils at Grand Central Modern.

The last exhibition at 320-B West 81st Street was that of the architecture designs of Yale University's Professor King-Lui Wu. This kind of design exhibit was occasionally seen at museums but rarely at galleries, because it was difficult to display properly and it provided no income to the gallery. To Mi Chou, it was an experiment. We wanted to present some art form other than painting and ceramics. The attempt was a little too bold. Fortunately, Professor Wu came from New Haven the weekend before the opening and spent a whole day helping to set up the display. What we could do was simply limited by our meager budget. To this day, I regret that we did not do justice to his work in that exhibition.

After a year and a half in the gallery business, it became clear that, although we were able to induce the critics to come to the upper west side of town, this location was a handicap in attracting collectors. Usually the potential buyers would want to cover their museum and gallery visits in half a day. We were simply off their path. By late 1955, I was faced with an important decision: should we move to a more desirable location? Before this question could be answered, I had to find out what the rent was like in those areas. So I started paying attention to "For Rent" signs. Another question was whether there was the personnel to gallery-sit in order for us to open at normal hours so as to justify the higher rent. When Pei-Chen Owyang volunteered to fill this gap, I began to look more seriously.

Shortly before Christmas 1955, I was promoted to head of the Tea Department at my regular job, with a corresponding raise in salary. This boosted my courage in searching for a better location for the gallery. Towards the end of the year, a colleague of mine at work mentioned to me that he knew of an old gentleman who was looking after a small building midtown near Fifth Avenue. He lived alone on the second floor and was rather lonesome. He might consider renting the ground

floor to a suitable tenant. That very same evening I paid this old man, Mr. Rosenfeld, a visit. He told me that the building owner, a wealthy man, was his old friend. They were more interested in getting the right tenant than a good rent. Not only could the rent be lower than others in the vicinity, but it was also unnecessary to sign a lease. Luckily, when I made known to him the gallery idea, I was considered the right kind, and the rent he proposed was too good to be true. After a few days of consideration, I discussed it with my teacher, who was then also my landlord. A decision was made to move in the coming summer.

The new location of 36 West 56th Street was really ideal. Within a short walk was the Museum of American Crafts, and one block away was the Museum of Modern Art. It was also close to Mr. Wang Chi-Yuan's studio on West 57th Street and the hotel on West 58th Street where Mr. Chang Dai-Chien always stayed when he visited New York from Brazil.

The ground floor apartment that I was to move into had been used as a storage area. It was filthy and in poor shape. With the kind help of several friends, I spent many hot days cleaning up the place, and then we painted all the walls off-white. Track lights had just appeared on the market, so I bought some for the main wall. Other lights were brought from the old gallery. Again, I concealed my bed well by a curtain in the small room which served also as an office. Only by combining my living quarters with the gallery was I able to afford the gallery rent. Finally, the renovation and decoration were completed on Labor Day weekend.

Normally, the gallery season began the week following Labor Day. There being no time for us to prepare for the opening show, we simply displayed a few paintings and some ceramics. In spite of the absence of advertising and news releases, quite a number of people came in to view the works on display. A small plaque by the entrance of the building with MI CHOU engraved in both English and Chinese was enough to arouse the interest of many passersby.

Between October 1956 and May 1960, many artists exhibited their paintings, ceramics, and calligraphy at Mi Chou, either individually or in groups.[2]

During this period, Mi Chou gained some remarkable publicity as well as a following. We had a good number of repeat visitors and also out-of-town visitors. This fact was probably the result of a combination of three factors: (1) quality exhibits (2) the timing of the exhibits: by constantly talking to and learning from the artists, critics, collectors, and museum people, we were able to show the kind of work that was of interest at the time, and (3) the calibre of writers who introduced the shows. Let me explain by citing a few highlights.

To coincide with Katherine Choy's first one-man show at Mi Chou, we suggested that Dido Smith (ceramist and formerly art section editor of *Ceramic Age*) write an article, "Three Potters from China," which appeared in the April 1957 issue of *Craft Horizons* (a publication that was considered a sister enterprise of the American Craft Museum). Her consent came only after she had seen the works by the three artists and was impressed by their quality. In this ten-page article, with dozens of photographs of the artists, artists at work, and selected pieces of work, Smith gave an excellent introduction of the three potters: Katherine Choy (head of the Ceramics Department of Tulane University's Newcomb College); Fong Chow (ceramics instructor at Henry Street Settlement House and later a curator at the Metropolitan Museum); and Hui Ka-Kwong (head of the Ceramics Department of The Brooklyn Museum's Art School).

For Chang Dai-Chien's exhibition, we were fortunate to have Dr. Hu Shih write the introduction, in which he said,

My friend Chang Dai-Chien has achieved a very outstanding position in contemporary Chinese art through hard and patient work in three areas: his life-long experience as a discerning collector and conscientious student of the works of the great masters of the past; his wide and varied study-travels to practically all the great mountains and gorges throughout China; and his years of careful study and copying of the medieval frescoes at the cave-temples of Tunhuang and An-hsi, which brought him into direct contact with the Chinese artistic tradition of the great Tang era and the Pre-Tang centuries.

I take great pleasure to introduce him to the American public at the first public showing of his works in the United States.

During one of his visits to Mi Chou, we learned from Professor Nelson I. Wu of Yale's Art History Department that he had promised *Art News* magazine an article, but had not decided on what to write yet. We suggested Chen Chi-Kwan's paintings. Being an admirer of Chen Chi-Kwan's paintings himself, Professor Wu agreed and extended his stay that evening beyond normal gallery hours. He examined all of Chen's paintings in the gallery very carefully. We timed the first Chen Chi-Kwan's one-man show at Mi Chou to occur right after the distribution of the November 1957 issue of *Art News*, in which Professor Wu's article appeared. He also wrote the introduction for the show. A passage from it follows:

Chen Chi-Kwan is the first contemporary Chinese painter who can truly be called both modern and Chinese. Emancipated from the unfathomable depths of Chinese tradition, he emerges like a surging tide to rejuvenate that long quiet and glorious sea. Not a painter by training in that tradition, but an excellent architect, Chen is free from the curse of the fatigued conventional forms and modes. As an individual intensely interested in the life around him and in its various moments, pensive or joyous, Chen has turned to painting for his expression: he is greatly different from so many others who are mere technicians seeking for inspiration. It is fascinating enough just to imagine how modern Chinese painting should look, but it is especially exciting to see it realized in the works of Chen Chi-Kwan.

The response to that exhibit was overwhelming.

The task of exposing an unfamiliar subject such as Chinese calligraphy was immediately aided by the introductory words of a popular writer. Professor Chiang Yee (then teaching at Columbia University), author of *Chinese Calligraphy* (London, 1938; Cambridge, Mass., 1954) and the *Silent Traveler* series of travel books, was kind enough to write the introduction for the two calligraphy shows at Mi Chou.

Dr. Lin Yutang, probably the best known Oriental writer to the Western world, wrote for us the introduction for Wang Ya-Chun's one-man show.

C. C. Wang's first one-man show was introduced by Professor James F. Cahill, then director of the Freer Gallery of Art, Washington, D.C. His comments were most impressive, and I quote in part:

. . . Although endowed with a superb technique (one must, to appreciate this thoroughly, be aware that "technique" in Chinese painting is rather more complex than "good drawing" etc., with us), he is not overly dependent on it. Although his taste is strongly conditioned by his being a connoisseur and collector of the first rank, his art is not derivative. One detects in it echoes of the great Yuan, Ming and Ching masters, but he has, as the Chinese critics say, "completely transformed them," and the result meets the Chinese ideal of originality without perverse heterodoxy.

I am afraid that the subtle stylistic allusions in his paintings, and others of their most admirable qualities, may escape some casual Occidental viewers. Much of the finest Chinese painting of any period, alas, is likely to suffer the same handicap. But enough of Mr. Wang's real worth should be conveyed, in this major exhibition of his works, for him to be recognized as a leading modern representative of the great lineage of scholar-collector-artists in China.

The interesting part is not only his admiration of the artist, but also his frank assessment of the prevailing lack of understanding of Chinese art among Occidental viewers.

In September 1957, we were saddened by the news of the passing of Chi Pai-Shih. To commemorate this giant of contemporary art, we searched for his finest works for a special showing, including some private collections that had never been seen by the public. For example, a large vertical scroll, *Lotus*, was loaned by the late Professor George Rawley of Princeton University. A long vertical scroll, *Fisherman,* was lent by Professor Wang Fang-Yu (co-author of *Chi Pai-Shih's Paintings* with Professor Hsu Kai-Yu). A unique landscape, *Sails on the Yangtze*, was on loan from an anonymous collector. It took us several months to put the exhibit together. A total of twenty-one paintings of top quality were on exhibit, and over half of them were not for sale. Until today, as far as I know, no other exhibition of Chi's work outside of China has been able to match or come close to this one in quality and in scope.

Here is part of what Mi Chou said about this show in its news release.

Chi Pai-Shih, the giant of contemporary Chinese art, died on September 16, 1957 at the age of 97. In honor of his birthday, January 7, Mi Chou Gallery will present, beginning that day, the Chi Pai-Shih Commemorative Exhibition . . .

For the last half century Chi Pai-Shih has been the leading figure in Chinese painting, calligraphy, seal-carving, and poetry. Having gone through rigid traditional disciplines in his early years, he liberated himself from that mode during his late forties and sought freer expressions. An admirer of such masters as Chu Ta and Tao Chi, the famous monks who broke tradition at the end of the Ming Dynasty, Chi Pai-Shih developed great qualities of his own.

His paintings are powerful and profound. His colors are bright and vibrant, as shown in Bodhidharma *and* Chrysanthemums. *Spontaneity and clarity characterize his works.* Sails on the Yangtze *and* Faded Lotus *are excellent examples of his bold and original compositions. With broad, free yet controlled strokes, he creates the most beautiful tonal effects in black and white pictures, such as* Home-coming *and* Frogs and Taro Leaves.

Anyone interested in Chinese art should indeed not miss this important exhibition.

The attendance of this exhibition was very large. One unusually quiet late afternoon, a man walked into Mi Chou and spent a long time viewing and scrutinizing each painting. He then stepped quietly into the office to talk to me. It was the famous American painter Mark Tobey. During our conversation something caught his eye. It was a small, vertical landscape by Chi Pai-Shih on the wall of the office, not for sale and not in the exhibition catalog. It belonged to me. He complimented the exhibition and particularly this painting, and then left. That same evening, I received a telephone call from my painter friend, Charmion von Wiegand (student of the master of geometric painting, Piet Mondrian). She said that she was with Mark Tobey that evening and he liked my Chi Pai-Shih landscape very much, and would like to exchange for it one of his own paintings, if it was agreeable to me. I declined because I was quite attached to that painting myself. Being a collector herself, she could understand. However,

when I later mentioned this experience to some of my other friends, quite a few were surprised at my refusal, for the market value of Tobey's painting around that time could well be many times that of Chi's.

The exhibit that aroused a lot of interest but fetched no sales was the first showing of the Ton-Fan Group from Taiwan (January 5–30, 1959). Ton-Fan was the avant-garde group of nonrepresentational painters who worked courageously in rather unsympathetic circumstances. It was during a tea business trip that I first met these young artists in Taipei in an air raid shelter where some of them lived. Moved by their spirit and inspired by their talent, we decided to give them a show, knowing well that the possibility of sales would be remote. The number of viewers was far beyond our expectations. The *New York Times* gave this show good coverage in its art section. In fact, during our second show of the Ton-Fan Group in the following year, the *Times'* chief editor, Mr. Norton Taylor, came personally and bought a painting from that show.

At the 56th Street address, Mi Chou was able to open during normal afternoon hours plus some evenings. Pei-Chen Owyang would gallery-sit during the afternoon until I could arrive from my regular downtown job. When Ned came to pick her up, they often stayed on to help with much of the behind-the-scene work at the gallery.

For several days in the winter of 1959 we missed the usual greeting, "Good evening," from Mr. Rosenfeld. Finally, a telephone call came from the landlord's attorney telling us that Mr. Rosenfeld had had a heart attack and had passed away. The landlord, wanting to sell the building, asked us to move.

Mi Chou was thriving nicely. We did not want to stop, but if we were to move, it would again be upward in terms of rent. How could we afford it?!

Pei-Chen was my schoolmate in college and Ned's younger brother my classmate in high school. Our friendship, however, was developed during our association at the gallery. We all wanted to see Mi Chou grow. After several discussions, we decided to incorporate, and enlarge the financial base of Mi Chou. They and another friend participated with new capital in addition to what I invested. Ned became the president and I the vice president.

We planned to move to a new and still better location. We would also expand the scope of operation by including other Asian artists' works and old Japanese woodcut prints, in which field Ned had done quite a bit of research. It was our hope that these increased activities would generate more revenue to offset the heavier burden of rent.

In the summer of 1960, Mi Chou moved to Madison Avenue, right in the vicinity of the most prestigious galleries in town. We occupied the entire third floor of a small renovated building, which was equipped with an elevator. The address was 801 Madison Avenue.

In the fall of 1960, I married, and in the same year the tea business demanded more and more of my time. The gallery was under the full charge of Ned and Pei-Chen. I could go to the gallery only on weekends. When necessary, we also discussed gallery matters by telephone. After the birth of our first child in 1962, the frequency of my visits to the gallery had to be cut down further. When our second child came several years later, I realized that both financially and timewise there was no way that I could be of assistance to Mi Chou. At the end of 1968, I resigned. Mi Chou was carried on by the Owyangs. The lease was renewable every three years and there was an increase at every renewal. The increase in revenue could never keep pace with the increasing expenses. In 1971, the landlord sold the building. The new owner wanted Mi Chou and other tenants in the building to move, indicating his desire to bring down the structure to make room for a larger new building. Unfortunately, around the same time, Ned's health deteriorated. Mi Chou, finally, came to its end.

Between the formation and termination of Mi Chou were eighteen interesting years, sometimes exciting and at times difficult. About half of those years were under my care. I have tried to use my memories, as well as some limited material available, to tell about the life of Mi Chou, which is believed to be the first Chinese art gallery in America. The story of the second half will have to be left to the Owyangs.

In the past, quite a few friends urged me to write something about Mi Chou. I did not do it then because I questioned whether the subject would be of interest to readers so many years after, even though it was very meaning-ful to me as it saved my sanity during those trying years. Besides, there never seemed enough time during my life in New York. Five years ago, my family and I moved to Colorado. Our life here is much quieter. A few days ago while going through my old files, I came across some of Mi Chou's old announcement cards and news releases. Nostalgia enveloped me until I finally sat down and finished this article. Hopefully it will serve as my tribute to those who shared my joy as well as my sorrow during those years. To those who read this article, this story may help remind that Chinese art is one of the most outstanding and enduring contributions China has made to the world.

Notes

Finding the Middle Path (Wechsler)

1. Gordon Washburn, "Japanese Influences on Contemporary Art: A Dissenting View," in *Dialogue in Art: Japan and the West,* ed. Chiasburo F. Yamada (Tokyo: Kodansha International, 1976), 215.

2. Michael Sullivan, *An Introduction to Chinese Art* (Berkeley: University of California Press, 1961), 207.

3. It can be stated fairly that many American critics revile mid-century European painterly abstraction. They call it "decoration," timid art caught in the tradition of *"belle peinture"*; the artists are "pastry chefs," turning out not Abstract Expressionism but "cuisine." One particularly bombastic example will suffice to indicate the dismissive, nationalistic tone of the anti-European criticism: "[Jean] Fautrier was considered the brilliant young staff officer who would take over the field armies of the School of Paris when the batons fell from the hands of Picasso, Matisse, Braque, *et al.* . . . Object and anatomy [in Fautrier's art] is represented by a sign painted in a complicated island of paste floating on and under glazes; the surface glitters with colored dust. Cuisine has turned into confection. . . . [Fautrier] is an orthodox buck-eye. As the premonitioned School of Paris 1957 never arrived—being replaced by influences from American Abstract Expressionism—Fautrier's criticism of how it might have appeared is aimed at nothingness. [His art] is a solitary obsession directed by its own hermetic legislation, . . . and only his biography can redeem the pictures" (Thomas B. Hess, "Jean Fautrier," *Art News*, February 1957, 11).

4. Ad Reinhardt was a serious student of Eastern art and philosophy, specifically Chinese and Japanese painting and Islamic architectural decoration. He traveled to Japan, India, and the Middle East, wrote about Buddha images, and published an article in the January 1960 issue of *Art News* titled "Timeless in Asia." From the late 1930s to the early 1940s, Richard Pousette-Dart read many religious and spiritual texts of Eastern and Southern Asia, including the writings of Lao-Tzu, the Upanishads, and the Bhagavad Gita. Eastern symbols such as mandala and *yin-yang* configurations can be found in many of his paintings; he has written of his art, "I strive to express the spiritual nature of the Universe" (Artist's statement, exhibition catalogue of his one-person show at the Art of This Century Gallery, New York, 1947).

5. Politics pushed the two countries in opposite directions as well. After Japan's defeat in World War II, Japan was forcefully thrust into contact with American culture through American occupation, allowing greater access to information on American art trends. The advent of the Communist government in China in 1949 led to the rejection of modern art and the imposition of a Soviet-based Socialist Realism. By default, modernist experimentation in China became the purview of the small fraction of Chinese society in Taiwan and Hong Kong.

6. Among the many Asian American artists who created nongeometric abstractions between 1945 and 1970 who are not represented in the present exhibition are Ruth Asawa, Norio Azuma, George Chann, Yuen Yuey Chinn, Miyoko Ito, Tatsuo Kondo, James Kuo, George Miyasaki, Tad Miyashita, Jerry Okimoto, Taro Yamamoto, and John Young.

7. The artists included in this exhibition were Sabro Hasegawa, Genichiro Inokuma, Yutaka Ohashi, Kenzo Okada, James Suzuki, Teiji Takai, and Noriko Yamamoto.

8. Whanki Kim, quoted in Yo-Han Cho, "Harmony with Nature and Search for the Essence of Nature," in *Whanki Museum* (Seoul: Whanki Mueum, 1993), 62.

With the Suddenness of Creation (Munroe)

1. This comment by the Tang dynasty scholar Zhu Jingxuan appears in Shen C. Y. Fu, trans. and with major contributions by Jan Stuart, *Challenging the Past: The Paintings of Chang Dai-chien* (Washington, D.C.: Arthur M. Sackler Gallery, Smithsonian Institution, 1991), 73.

2. Clement Greenberg, "The Present Prospects of American Painting and Sculpture," *Horizon* 16, no. 93/94 (October 1947): 26.

3. Clement Greenberg, "'American-Type' Painting" (first published in 1955; revised in 1958) in *Art and Culture: Critical Essays* (Boston: Beacon Press, 1961), 178.

4. Robert Motherwell quoted in Max Kosloff, "American Painting During the Cold War" in Francis Frascina, ed., *Pollock and After: The Critical Debate* (New York: Harper and Row, 1985), 110.

5. Along with Betty Parsons, the New York dealers Miriam Willard Johnson and Martha Jackson did most to foster an Eastern "transcendentalism" in contemporary American art. The Willard Gallery, founded in 1940, showed the works of West Coast artists Mark Tobey and Morris Graves, while Martha Jackson showed Sam Francis, Adolph Gottlieb, Karel Appel, Lee Krasner, and Antoni Tàpies. A founding member and first chairman of the Asia Society Galleries Advisory Committee and a Trustee of the Asia Society from 1961 to 1982, Johnson's personal interest in Japanese art was related to her passion for the primitive, exotic, and spiritual. This aesthetic for the universal and archetypal in art was nurtured by her studies of Carl Jung and advanced by a group of writers and artists who gathered around her, including Dorothy Norman, Nancy Wilson Ross, and Alan Watts. See Alexandra Munroe, "Japanese Artists in the American Avant-Garde 1945–1970" in *Contemporary Japanese Art in America: Arita, Nakagawa, Sugimoto,* exh. cat. (New York: The Japan Society, 1987).

6. For more background on Tobey's friendship with the Chinese artist Teng Kuei and his activities in Asia, see Eliza Rathbone, *Mark Tobey: City Paintings* (Washington, D.C.: National Gallery of Art, 1984), 20–26.

7. For a comprehensive study of how the "Oriental Thought" tradition defined the philosophical attitudes of an entire generation of American artists and intellectuals, see David J. Clarke, *The Influence of Oriental Thought on Postwar American Painting and Sculpture* (New York: Garland Publishing, 1988).

8. Mark Tobey, quoted in Rathbone, *Mark Tobey,* 25, 67.

9. Ibid., 63.

10. In this essay, Japanese and Chinese proper names are given family name first, following those societies' conventional format.

11. Okakura Kakuzō (Tenshin), *The Ideals of the East with Special Reference to the Art of Japan* (Rutland, Vt. and Tokyo: Charles E. Tuttle, 1970), 224.

12. Onchi responded to late-nineteenth-century Symbolism in which the artist expressed his inner states analogously through the forms represented; from Cubist collage, he derived the concept of assemblage; and through Dada he

became more conscious of chance and coincidence in the formation of a work of art—all ideas reinforced by Organic Surrealism and its theories of automatism that were popular among the Japanese avant-garde in the 1930s.

13. See Nishida Kitarō, trans. and with an introduction by David A. Dilworth, *Last Writings: Nothingness and the Religious Worldview* (Honolulu: University of Hawaii Press, 1987).

14. Yoshimichi Sekiya (1967), reprinted in Norio Imaoka, Michiko Kazama, and Futoshi Tsuji, eds., *Bokujin yonjūnen* (Forty Years Bokujin) (Kifu City: Bokujinkai, 1991), 199.

15. Yoshihara Jirō (1956), in Alexandra Munroe, "To Challenge the Mid-Summer Sun: The Gutai Group," trans. Reiko Tomii, in Alexandra Munroe, *Japanese Art After 1945: Scream Against the Sky* (New York, Harry N. Abrams in association with the Yokohama Museum of Art, The Japan Foundation, The Guggenheim Museum, and San Francisco Museum of Modern Art, 1994), 84.

16. Isamu Noguchi, who was in Japan from 1950–51, introduced the work of Franz Kline to his close friend Hasegawa, who in turn recommended it to Morita. Alechinsky's film was completed in 1956, and was produced as a means to explore the affinities between Japanese calligraphy and contemporary abstract painting.

17. *Bokubi*, no. 1 (June 1951), n.p. For more on *Bokujinkai*, see Norio Imaoka, Michiko Kazama, and Futoshi Tsuji, eds., *Bokujin yonjūnen* (Forty Years Bokujin) (Kifu City: Bokujin-kai, 1991); Amano Kazuo, ed., *Sho to kaiga no atsuki jidai: 1945–1969/Calligraphy and Painting, The Passionate Age: 1945–1969,*

exh. cat. (Tokyo: O Art Museum, 1992); *Morita Shiryū to "Bokubi"* (Morita Shiryū and Bokubi), exh. cat. (Kobe: Hyōgo Prefectural Museum of Modern Art, 1992); and Alexandra Munroe, "Circle: Modernism and Tradition" in Munroe, *Japanese Art After 1945*, 125–47.

18. Tapié coined the term *Art Informel* (Art Without Form) in 1950 to describe the work of Wols, but extended it to artists Jean Dubuffet, Hans Hartung, Henri Michaux, Georges Mathieu, Jean Fautrier, Alberto Burri, Antoni Tàpies, and the CoBrA artists in an effort to identify a new, pan-European art movement. According to Tapié, *Art Informel* gives direct expression to subconscious fantasy and irrationality in contrast to the more rigorous abstractionist tendencies deriving from Cubism, geometric abstraction, and de Stijl. During the 1950s in Paris, Tapié was the advisor to Rodolphe Stadler, owner of the leading avant-garde gallery that showcased *Art Informel*. Stadler also exhibited the Japanese abstract painters Dōmoto Hisao and Imai Toshimitsu, who arrived in Paris in 1948 and 1955, respectively, and who were later recognized as *Art Informel* artists. In 1957 Dōmoto, a Kyoto artist and friend of Yoshihara's, showed the Gutai journals to Tapié and introduced him to their activities. The Frenchman was delighted to discover what he perceived as a Japanese manifestation of his revolutionary aesthetic. In September of that year, Tapié traveled to Japan with Mathieu, Imai, and the American painter Sam Francis, who was also a regular at the Stadler openings, to meet the Gutai group. It was the first of several visits. See

also, Paul and Esther Jenkins, eds., *Observations of Michel Tapié* (New York: George Wittenborn, 1956); and *Action et Emotion: Peintures des aneés 50: Informel, Gutai, Cobra,* exh. cat. (Osaka: The National Museum of Art, 1985).

19. As Julia F. Andrews explains, *guohua* is a recent term that has been used in the People's Republic of China to categorize any work painted in ink, with or without color, on a ground of Chinese paper or silk. It is used to distinguish Western-style oil painting (*xiyanghua*) from modern Chinese works in traditional mediums, and is usually translated as "traditional Chinese painting" even when such painting is not traditional in style at all. See Julia F. Andrews, "Traditional Painting in New China: *Guohua* and the Anti-Rightist Campaign," *The Journal for Asian Studies* 49, no. 3 (Aug. 1990).

20. Ibid., 556–57.

21. Shen, *Challenging the Past*, 71.

22. Aside from Liu Kuo-sung, the leading Fifth Moon artists include Chuang Che, Chen Ting-shih, Fong Chung-ray, Hung Hsien, and Chi-chung Hu. See Chu-tsing Li, Yu Kwang-chung, and Lawrence Sickman, *Five Chinese Painters: Fifth Moon Exhibition*, exh. cat. (Taipei: National Museum of History, 1970).

23. See Claude Roy, *Zao Wou-ki,* trans. Rita Barisse (New York: Grove Press, 1959), 12.

24. Yu Kwang-chung, "On From Clairvoyancism" in *Five Chinese Painters*, n.p.

25. Chuang Che, interview by author, New York, 16 January 1996.

International Abstraction in a National Context (Roe)

1. This distinction in painting styles is similar to the Japanese designations of

yoga (Western-style painting) and *nihonga* (traditional Japanese painting).

2. Donald Clark, *Korea Briefing, 1993* (New York: The Asia Society, 1993), 205.

3. Young Taek Park, "Shik'minji Shidae Saheo Guchoui Misul Un-dongui Sung-gwawa Han-gae" (Socialist Art Movement During Colonialism), in *Gundae Misul Non-chong* (Anthology on Modern Korean Art) (Seoul: Hakgojac, 1992).

4. Sung Rok Suh, *Han'gukui Hyundai Misul* (Contemporary Art in Korea) (Seoul: Moonyae Choolpan'sa, 1994), 18.

5. Clark, 205.

6. Suh, 33.

7. Beom Mo Yoon, *Han'guk Kundai Misului Hyung-sung* (The Formation of Modern Art in Korea) (Seoul: Mijin'sa, 1988), 342.

From Asian Traditions to Modern Expressions (Wechsler)

1. Sabro Hasegawa, quoted in an unpublished typescript for a book, *Sabro Hasegawa: Artist of the Controlled Accident,* 12. The authors of the final book were to be Alan W. Watts, Elise Grilli, and Paul Mills. The typescript was shown to this author by Kyoko Hasegawa.

2. C. C. Wang, interview by author, 27 February 1993.

3. See Don Ahn's comments in the roundtable discussion on page 51.

4. Noriko Yamamoto, interview by author, 18 April 1993.

5. Remarks to this effect were made by Hasegawa in 1956 to a class he was teaching at the California College of Arts and Crafts, Oakland, California. Hasegawa's comments were recalled by one of the students, Joyce Rezendes, in an interview with the author, 13 April 1995.

6. Sung-Woo Chun, interview by Chan E. Pae, tape recording, 24 November 1995.

7. Laurence C. S. Tam, introduction to *Wucius Wong,* exh. cat. (Hong Kong: The Urban Council and The Hong Kong Museum of Art, 1979), n.p.

8. Tam, *Wucius Wong,* n.p.

9. For example, George Tsutakawa recalled how he and Paul Horiuchi would observe Mark Tobey's use of *sumi* techniques, and how Tobey would knowledgeably discuss Eastern art and philosophy (Tsutakawa, interview by author, 27 January 1994). Tsutakawa also stated that "Tobey really taught me the importance of my heritage and what to look for in Asian art" (Tsutakawa, quoted in Martha Kingsbury, *George Tsutakawa* [Seattle: University of Washington Press, 1990], 75). Sumiye Okoshi also mentioned the importance of Tobey on the development of her art (Okoshi, interview by author, 26 March 1993).

10. Kingsbury, *George Tsutakawa,* 17.

11. George Tsutakawa, quoted in Kingsbury, *George Tsutakawa,* 13.

12. Yoshiaki Inui, quoted in Dore Ashton, *Noguchi East and West* (New York: Alfred A. Knopf, 1992), 138.

13. Thomas B. Hess, "Isamu Noguchi '46," *Art News,* September 1946, 34.

14. Ashton, *Noguchi,* 286.

15. Wang Ming, interview by author, 28 December 1994.

16. Unsigned review in "Reviews and Previews," *Art News,* November 1948, 47.

17. James Monte, "San Francisco," *Artforum,* June 1963, 41.

18. K. I. L., "The Japan Abstract Art Club," *Art News,* April 1954, 26.

19. Satoru Abe, interview by author, 20 January 1995.

20. James Fitzsimmons,

"Riopelle," *Arts and Architecture*, January 1958, 31.

21. Thomas B. Hess, "Modern Museum's 15: When U.S. Extremes Meet," *Art News*, April 1952, 65.

22. Eleanor C. Munro, "Kenzo Okada," *Art News*, November 1956, 7.

23. Lawrence Campbell, "Taiji Takai," *Art News*, September 1956, 17.

24. Satoru Abe, interview by author, 20 January 1995.

25. Ralph Iwamoto, interview by author, 4 November 1995.

26. Matsumi Kanemitsu quoting Ad Reinhardt, in Nancy Kapitanoff, "Kanemitsu Wave," *Los Angeles Times*, 17 January 1993, B5.

27. For example, an exhibition titled *Pacific Heritage* was organized for the Los Angeles Municipal Art Gallery in 1965, and traveled to San Francisco, Santa Barbara, and San Diego. The exhibition showcased "living artists of the Northwest, California and Hawaii" whose art had "managed to destroy the boundaries between East and West, either by virtue of direct Oriental heredity, [or] by deep intellectual and intuitive involvement with Eastern philosophies. . . . In one form or another, their poetic creations are concentrated on the essence of nature and its mystical, symbolic significance" (Henry J. Seldis, "Exhibition Preview: Pacific Heritage," *Art in America*, February 1965, 27).

28. Masayohi Homma, introduction to *Exhibition of Japanese Artists Abroad, Europe and America*, exh. cat. (Tokyo: The National Museum of Modern Art, 1965), n.p.

29. Hilton Kramer, "Francis: The Mallarmé of Painters?" *New York Times*, 24 December 1972, 25.

30. John Golding, *Cubism: A History and an Analysis, 1907–1914*, rev. ed. (New York: Harper and Row, 1968), 92–93.

31. David J. Clarke, *The Influence of Oriental Thought on Postwar American Painting and Sculpture* (New York: Garland Publishing, 1988), 23.

32. Minoru Niizuma, quoted in "Listening to Stone: Minoru Niizuma," in *Niizuma*, exh. cat. (Tokyo: Galerie Nichido, 1989), n.p.

33. Wang Ming, in *Wang Ming: Stoneman's Principles of Painting*, a self-published booklet of reviews and statements, undated, unpaginated.

34. Ruiko Kato, "The Art of Toshiko Takaezu," in *Toshiko Takaezu Retrospective*, exh. cat. (Kyoto: The National Museum of Modern Art, 1995), 14.

35. Clarke, *Influence of Oriental Thought*, 24.

36. George Rowley, *Principles of Chinese Painting*, rev. ed. (Princeton, N.J.: Princeton University Press, 1974), preface.

37. James Suzuki, interview by author, 10 October 1994.

38. Diana Kan, *The How and Why of Chinese Painting* (New York: Prentice Hall Press, 1986), 101.

39. C. C. Wang, interview by author, 27 February 1993.

40. James Leong, telephone interview by author, 27 December 1995.

41. Tadashi Sato, interview by author, 22 January 1995.

42. Anne G. Todd, quoted in Matthew Kangas, "East Looks West: Four Asian American Modernists," *The International Examiner*, 18 June 1986, 6.

43. Sueko Kimura, interview by author, 24 January 1995.

44. Soojai Lee, in a letter to the author, 9 January 1996.

45. John Pai, statement in *John Pai, Sculpture 1983–1993*, exh. cat. (Seoul: Gallery Hyundai, 1993), n.p.

46. John Pai, interview by author, 27 June 1995.

47. John Pai, quoted in William Fasolino, "A Weave of Voices: On the Work of John Pai," in *John Pai, Sculpture 1983–1993*, n.p.

48. John Pai, quoted in "Interview with John Pai and Gillian Jagger," in *John Pai Sculptures*, exh. cat. (Seoul: Won Gallery, 1982), n.p.

49. Kingsbury, *George Tsutakawa*, 80.

50. Toshio Odate, interview by author, 25 March 1995.

51. Minoru Niizuma, interview by author, 9 December 1994.

52. Bruce Altshuler, *Noguchi* (New York: Abbeville Press, 1994), 111.

53. Jennifer Saville, "Toshiko Takaezu: Listening to Clay," in *Toshiko Takaezu*, exh. cat. (Honolulu: Honolulu Academy of Arts, 1993), 9.

54. Christmas Humphries, *Buddhism, An Introduction and Guide*, 3rd ed. (Harmondworth, Middlesex, England: Penguin Books, 1985), 208.

55. Osvald Siren, "Ch'an (Zen) Buddhism and Its Relation to Art," *The Theosophical Path*, October 1934, quoted in Humphries, *Buddhism*, 208.

56. Sato, interview.

57. Victor H. Maur, *Tao Te Ching* (New York: Bantam Books, 1990), 132–33.

58. Rowley, *Chinese Painting*, 5.

59. Wang Ming, statement in a register of Chinese American painters maintained by the Chinese Cultural Center, San Francisco, 10 September 1993.

60. Tung Yu, quoted in Rowley, *Chinese Painting*, 5.

61. Chen Chi, interview by author, 31 May 1993.

62. Sung-Woo Chun, statement in *Twelfth Exhibition of Contemporary American Painting and Sculpture*, exh. cat. (Urbana: University of Illinois Press, 1965), 67.

63. Nong, interview by author, 28 December 1994.

64. Anonymous source, quoted in Rowley, *Chinese Painting*, 71.

65. Rowley, *Chinese Painting*, 34.

66. Pepe Karmel, "Seeing Franz Kline in Eastern Scrolls," *New York Times*, 1 December 1995, C20.

67. C. C. Wang, interview by author, 27 February 1993.

68. Sato, interview.

69. Po Kim, interview by author, 8 August 1993.

70. Thomas M. Messer, "Nipponism," *Art in America*, fall 1958, 58–61.

71. All quotations in this section referring to the Boston exhibition are taken from the unpaginated catalogue essay: Anne L. Jenks and Thomas M. Messer, *Contemporary Painters of Japanese Origin in America* (Boston: Institute of Contemporary Art), 1958.

72. For an extensive reference source of material on the subject of Japonisme, see Gabriel P. Weisberg and Yvonne M. L. Weisberg, *Japonisme: An Annotated Bibliography* (New York: Garland Publishing in association with Jane Voorhees Zimmerli Art Museum, New Brunswick, N.J., 1990).

73. David Acton, *A Spectrum of Innovation: Color in American Printmaking, 1890–1960* (New York: W. W. Norton, 1990), 244.

74. Messer, "Nipponism," 59.

75. Thomas M. Messer, interview by author, 30 March 1995.

76. American defenders of the "breakthrough" theory of Abstract Expressionism usually neglect any reference to another complicating factor: the presence of painterly abstraction in East Asia before and during the 1940s. For example, Hasegawa's *Metropolis* of 1936 was one of several paintings with abstract calligraphic networks made by the artist in the 1930s. Jiro Yoshihara, often considered the leader of Japan's Gutai group, created painterly abstractions in the 1930s. A nonobjective painting/collage of 1938 by Yoshihara is the first black-and-white illustration (positioned opposite the first page of text) in a book devoted to painterly abstraction in Japan: Michel Tapié and Tore Haga, *Continuite et avant-garde au Japon* (Torino, Italy: Edizioni d'Arte Fratelli Pozzo, 1961).

77. Sam Hunter, *American Art of the 20th Century* (New York: Harry N. Abrams, 1972), 172.

78. Liu Wen-tan, "A Look at the 'Painting Dramas' of Chuang Che," in *Chuang Che*, exh. cat. (Taichung, Taiwan: Galerie Pierre), 1993, n.p.

79. Liu Wen-tan, "'Painting Dramas' of Chuang Che," n.p.

80. Margo Machida, "Out of Asia: Negotiating Asian Identities in America," in *Asia/America: Identities in Contemporary Asian American Art*, exh. cat. (New York: The Asia Society Galleries and The New Press, 1994), 109.

81. Joan Stanley-Baker, *Japanese Art* (London: Thames and Hudson, 1984), 8.

82. Chinyee, interview by author, 9 May 1993.

83. Chen Chi, *Heart and Chance: Chen Chi Watercolors* (New York: Chen Chi Studio), 1993. The poem referred to reads as follows: "One, heart of / beginning / Two, heart of / doing, / Three, heart of / no returning, Four, heart of / building / un-building / re-building / ever-building" (p. 9).

84. The full title of the exhibition was *They Painted from Their Hearts: Pioneer Asian American Artists*, presented at the Wing Luke Asian Museum, Seattle, Washington, from September 9, 1994, to January 15, 1995.

85. Abe, interview.

86. For example, Walasse Ting has split his efforts between aggressive action painting and painterly figuration throughout his

career. Po Kim has alternated between abstraction and figuration, at one point following a period of very gestural abstract work with one of nearly photorealistic still life rendering. Don Ahn, who paints both abstractions and representational nature scenes based on traditional Eastern art, cannot understand why any artist would restrict himself to only one format or motif, and is puzzled by the obsessive repetition of motifs found in the work of some Abstract Expressionists.

87. Michael Sullivan, *The Meeting of Eastern and Western Art* (New York: New York Graphic Society, 1973), 257.

88. Noriko Yamamoto, statement in *Young America 1960*, exh. cat. (New York: Whitney Museum of American Art, 1960), 118.

89. Sullivan, *Eastern and Western Art*, 267.

Hybrid Worlds, Singular Visions (Morse)

1. The spelling of "Hawai'i" in this essay follows current practice of the written Hawaiian language. *Ed.*

2. Brief biographical statements are included in Francis Haar and Prithwish Neogy, *Artists of Hawaii*, vol. 1 (Honolulu: University of Hawaii Press, 1974); and Francis Haar and Murray Turnbull, *Artists of Hawaii*, vol. 2 (Honolulu: University of Hawaii Press, 1977).

3. Howard A. Link, "The Origin of Tseng Yuho's *Dsui* Painting," in *The Art of Tseng Yuho*, exh. cat. (Honolulu: Honolulu Academy of Arts, 1987).

4. Satoru Abe, interview by author, 29 August 1995.

Personalizing the Abstract (Nakane)

1. Dr. Kyo Koike, "Japanese Art in Photography," *Cam-*

era Craft 32 (March 1925): 110–15.

2. "Chinese Art Work Shown," *Seattle Times*, 3 December 1933, 33.

3. Betty Bowen, draft for 1974 talk at Seattle Art Museum, Betty Bowen Papers, Manuscripts, University of Washington.

4. Deloris Tarzan, "Paul Horiuchi: Accident Turned Laborer into Master Artist," *Seattle Times*, 23 March 1980, E11.

5. Fay Chong, interview by William Hoppe, tape recording, 17 July 1972, Fay Chong Papers, Manuscripts, University of Washington.

From Enemy Alien to Zen Master (Higa)

The author would like to thank Kristine M. Kim for her research assistance and Brian Niiya for his useful comments on the text.

1. My use of the term "Japanese American" includes Americans of Japanese ancestry as well as immigrants from Japan who were prevented by law from becoming naturalized American citizens until the McCarran-Walter Act of 1952.

2. By the end of 1945, nine out of ten of the War Relocation Authority camps were closed. Tule Lake, a special "segregation center" for those deemed "disloyal" and potentially disruptive, remained open until March 1946. Crystal City, a Justice Department internment camp which also included families, remained open until the end of 1947.

3. *Americans of Japanese Ancestry and the United States Constitution, 1787–1987* (San Francisco: National Japanese American Historical Society, 1987), 25.

4. For selected images, see Maisie and Richard Conrat, *Executive Order 9066*,

exh. cat. (Sacramento: California Historical Society, 1972).

5. See *Ozawa v. United States* (1922).

6. Sucheng Chan, *Asian Americans: An Interpretive History* (Boston: Twayne Publishers, 1991), 55.

7. *Oakland Tribune*, 11 March 1928; 11 December 1930; 5 March 1931; 24 March 1935; 12 June 1938; 11 September 1938; 12 December 1937; and 23 July 1939. *San Francisco Chronicle*, 23 November 1930. *San Francisco Examiner*, 4 January 1931.

8. *Oakland Tribune*, 3 November 1928.

9. Chan, *Asian Americans*, 146.

10. Bill Ong Hing, *Making and Remaking Asian America Through Immigration Policy, 1850–1990* (Stanford: Stanford University Press, 1993), 58.

11. Chan, *Asian Americans*, 145.

12. Chan, *Asian Americans*, 140.

13. Hing, *Making and Remaking*, 56.

14. *Time*, 21 July 1958, 49.

15. Alan W. Watts, *The Way of Zen* (New York: Pantheon, 1957), ix.

16. *Mademoiselle*, January 1948, 64.

17. Nancy Uyemura, "Portrait of an Artist," *Tozai Times*, December 1988, 10.

18. See for example, Gerald Nordland, *Kanemitsu: Selected Works, 1968–1978* (Los Angeles: Municipal Art Gallery, 1978).

19. Watts, *Way of Zen*, xv-xvi.

Nipponism and the Smell of Paint (Shimizu)

1. This exhibition was titled *Die neue amerikanische Malerei*, and was organized and sent by the Museum of Modern Art, New York. Years later I was to learn that the exhibition featured the big names of abstraction. See William C. Seitz, *Art in the Age of Aquarius: 1955–1970* (Wash-

ington, D.C.: Smithsonian Institution Press, 1992), 208.

Reminiscences of Mi Chou (Cho)

1. List of exhibitions from April 1954 to June 1956:

April 1954: Modern, group exhibit of Y. Y. Chinn, Wing Dong, et al.

June 1954: Traditional, group exhibit of Chang Dai-Chien, Fu Pao Shih, et al.

October 1954: General, group exhibit of Chen Chi, Wong Sui Ling, et al.

November 1954: One-man show of Chi Pai-Shih.

March 1955: Prints (1942–54) by Seong Moy.

May 1955: Ceramics and Watercolors by Katherine Choy and Hua Li.

October 1955: Watercolors, group exhibit.

November 1955: Ceramics, group exhibit.

January 1956: Oils of Wing Dong.

March 1956: Paintings of Chang Shu-Chi.

April 1956: Paintings of Z. Z. Li.

June 1956: Architecture design of King-Lui Wu.

2. List of exhibitions from October 1956 to April 1960:

October 1956: Watercolors by Frederick Wong.

November 1956 and March 1957: Ceramics by Fong Chow and Katherine Choy.

September 1957: Paintings of Chang Dai-Chien.

October 1957: Paintings, group exhibit of Wing Dong, Dale Joe, et al.

October 1957: Mong Q. Lee, Seong Moy, Walasse Ting, Wang Hui Ming, Zao Wou-Ki.

October 1957: Chrysanthemum paintings special, with flowers and plants from Chiu-Huang Garden.

November–December 1957: Paintings and ceramics of Chen Chi-Kwan and Ka-Kwong Hui.

January 1958: Commemorative exhibit for Chi Pai-Shih.

February 1958: 12 Masters of Ming and Ching Dynasties.

March–May 1958: Paintings by Chen Chi-Kwan and Wang Ya-Chun.

May 1958: Original prints by Chinn, Low, Moy, Wang, Zao, et al.

May 1958: Chinese calligraphy and calligraphic paintings.

September 1958: Masters of contemporary painting, Chang Dai-Chien, Chi Pai-Shih, Fu Pao-Shih, Hsu Pei-Hung.

September–November 1958: Five Whitney Fellows, Y. Y. Chinn, Dale Joe, James Leong, Seong Moy, Gary Woo (John H. Whitney Fellowship winners).

November–December 1958: Paintings and ceramics by Gary Woo and Yein-Koo Wang.

February–March 1959: Watercolors by Mong Q. Lee and paintings by C. C. Wang.

April 1959: Four Monks of the 17th century, Chu Ta, Tao Chi, Hung Jen, and Kun Tsan, collected by C. C. Wang.

May–July 1959: Watercolors and ceramics by Chen, Li, Woo; Win Ng, Marie Woo, Fong Chow, Ka-Kwong Hui, Yien-Koo Wang.

October–December 1959: Watercolors, ceramics, other painting by Frederick Wang, Win Ng, and Dale Joe.

January 1960: The Ton-Fan Group: Chen Dao-Min, Hsiao Chin, Hsiao Ming-Hsien, Huo Hsueh-Kang, Li Yuen-Chia, Oyan Wen-Yuen, Shia Yan, Tsai Hsia-Ling, Wu Hao.

February–April 1960: Oils and other paintings by Bing S. Gee and Chen Chi-Kwan.

April 1960: Chinese calligraphy by Tsou-Lin Tcheng.

About the Authors

FRANK FULAI CHO, a native of Beijing, came to the United States in 1947 and received his MBA in 1949 from the Harvard Graduate School of Business Administration. Beyond his business activities, he has maintained a lifelong interest in Chinese American cultural affairs and was a founder of the Chinese Opera Club (1951) and the Mi Chou Gallery (1954) in New York.

LORRAINE DONG is a Professor of Asian American Studies at San Francisco State University. She wrote *Sewing Woman* (1982), Arthur Dong's Oscar-nominated documentary short, and cowrote the films *Lotus* (1988) and *Forbidden City, U.S.A.* (1989). She also coauthored *The Coming Man: 19th Century American Perceptions of the Chinese* (1995) with Philip P. Choy and Marlon K. Hom.

KAREN HIGA, Curator of Art at the Japanese American National Museum in Los Angeles, organized *The View from Within: Japanese American Art from the Internment Camps, 1942–45* (1992). She coedited the exhibition catalogue *Identity and Access: Asian American Artists in Los Angeles* (1994) for the Museum of Contemporary Art, Los Angeles. Ms. Higa is currently in the doctoral program in art history at the University of California, Los Angeles.

MARLON K. HOM, born in Xinhui, China, immigrated to San Francisco at age fifteen. He has published several books on Chinese American literature, including *Songs of Gold Mountain, Cantonese Rhymes from San Francisco Chinatown* (1987) and was coauthor of *The Coming Man: 19th Century American Percep-*

tions of the Chinese (1995). Dr. Hom is Professor and Chair of the Asian American Studies Department, San Francisco State University.

MARCIA MORSE is an artist, writer, and teacher living in Hawaii. She is a Professor of Art at the University of Hawaii and was for eleven years the art critic for *The Honolulu Star Bulletin*. Her recent publications include reviews for *Artweek* and *American Craft*, and *Reflections of Internment: The Art of Hiroshi Honda*, a catalogue for The Honolulu Academy of Arts.

ALEXANDRA MUNROE is an independent art historian and curator specializing in modern Japanese art. A former curator at the Japan Society Gallery in New York, she has served as curator for exhibitions at both the Yokohama Museum of Art and the Solomon R. Guggenheim Museum in New York. She is the author of Abrams' *Japanese Art After 1945: Scream Against the Sky* (1994).

KAZUKO NAKANE is an independent writer on photography and modern art, particularly that of Asian American artists in the Pacific Northwest. She recently acted as a primary researcher for the first phase of the Northwest Asian American Artist Project, administered by the West Coast Regional Center for the Smithsonian Institution's Archives of American Art.

JAE-RYUNG ROE received her doctorate in art history from New York University. Previously a curator at the National Museum of Contemporary Art, Seoul, she is now a lecturer and freelance writer. She served as a consul-

tant to the Asia Society's 1996 exhibition *Contemporary Art in Asia: Traditions/Tensions* and is currently working on a book on contemporary Korean art.

YOSHIAKI SHIMIZU, who has taught at Princeton University since 1973, was named the Frederick Marquand Professor of Art and Archaeology in 1992. Dr. Shimizu is the author of numerous articles and exhibition catalogue essays on Japanese art, including "Japan: The Shaping of Daimyo Culture 1185–1868" for the National Gallery of Art, Washington, D.C. (1988).

TSENG YUHO is known internationally as both a scholar of Chinese art and as an artist. She currently holds the titles of Professor and Program Chairperson at the Department of Art History, University of Hawaii. Among her publications are *Some Contemporary Elements in Classical Chinese Art* (1963) and *A History of the Art of Chinese Calligraphy* (1993).

JEFFREY WECHSLER is Senior Curator at the Jane Voorhees Zimmerli Art Museum, Rutgers, The State University of New Jersey. Specializing in lesser-known aspects of twentieth-century American art, he has organized many exhibitions, including *Surrealism and American Art, 1931–1947* (1977), *Realism and Realities: The Other Side of American Painting, 1940–1960* (1982), and *Abstract Expressionism: Other Dimensions* (1989).

Index

Romanization and alphabetization of Asian names follow the preference of the named individuals, or general usage. **Boldface** page references indicate biographical sketches. *Italic* page references indicate illustrations.

Photograph Credits

The editor and publisher wish to thank
the galleries, libraries, museums, and private
collectors named in the picture captions for
permitting the reproduction of works of art
in their collections and for supplying the
necessary photographs. Other photograph
credits are listed below by figure number,
unless otherwise indicated.

Jack Abraham: 2, 3, 5, 8, 17, 19, 21, 48, 50, 51, 53,
54, 58–61, 65, 74, 81, 83, 85, 90, 91, 93–94, 96–100,
103, 105, 111, 118, 123, 126, 130–31, 134, 137, 142,
144, 154–55, 159–63, 165–69, 173–76, 184, 187,
pp. 4–5, p. 6, p. 20; Armen Photographers,
Newark: 104; Courtesy Ashiya City Museum
of Art and History, Ashiya: 36; Asia Society:
24; Oliver Baker: 140; Courtesy Michael D.
Brown: 75, 92, 156–57, 164, 172, 180, 185; Cour-
tesy Chen Chi: 87, 135, 183; Geoffrey Clements:
109, 115, 136; © 1997 Susan Dirk: 63, 101–2;
Courtesy Crosby Doe: 132–33; G. R. Farley
Photography, Utica, N.Y.: 150; Tibor Franyo:
152; Carmelo Guadagno © The Solomon R.
Guggenheim Foundation, New York: 151;
© Indianapolis Museum of Art: 143; Courtesy
Po Kim: 76, 138–39; Courtesy Masatoyo Kishi:
158; Paul Kodama: 9, 11–16, 20, 23, 82, 89, 113,
153, 178, 182, 186; Courtesy Soojai Lee: 114;
Tim Lee: 127; Paul Macapia: 67, 112, 121; John
Maggiotto: 86; W. Scott Miles: 106, 170; Cour-
tesy of Hugh Moss: 40; Kevin Noble: 70, 71, 73;
Michio Noguchi: 129; John D. Pai: 69; Dennis
Purse: 108, 181, 188; Victor Pustai: 119; Sally
Ritts © The Solomon R. Guggenheim Foun-
dation, New York: 146; Schopplein Studio,
San Francisco: 7, 55–57, 177; Courtesy Sigma
Gallery, Inc., New York: 6; Francis Miller
Smith: 116; © The Solomon R. Guggenheim
Foundation, New York: 148; Lee Stalsworth:
72, 125; Brad Stanton: 124, 171; Sue Tallon
Photography: 52, 78–80; Jerry L. Thompson:
117; © 1996 Trustees of Princeton University:
49; Courtesy George Tsutakawa: 120; Charles
Uht: 141, pp. 46–47; Courtesy Water Pine and
Stone Retreat Collection: 25–26